52nd International Art Exhibition

la Biennale di Venezia

52. Esposizione
Internazionale
d'Arte

think
with the
senses

feel
with the
mind

art in the present tense

52nd International Art Exhibition
Think with the Senses – Feel with the Mind. Art in the Present Tense

Director
Robert Storr

*Executive Curatorial
and Research Specialist*
Francesca Pietropaolo

Managing Director
Gaetano Guerci
(ad interim)

Renato Quaglia
(until April 2007)

*Artists' organising coordination
at the Arsenale*
Marina Bertaggia

*Artists' organising coordination
at the
Padiglione Italia*
Rita Bertoni

Organisation
Matteo De Vittor

Daniele Maruca
Francesca Aloisia Montorio
Luigi Ricciari
Micol Saleri

*Coordination Italian
Pavilion / DARC*
Paolo Cimarosti

*Participating Countries
Responsible exhibition venues*
Roberto Rosolen

*Collateral Events, International
collaborations and Jury*
Paolo Scibelli

Management's secretariat
Stefania Guerra
Maria Bruschi

Promotion Office
Martina Flaborea

Veronica Carniello
Lucia De Manincor
Valeria Di Tonto
Matteo Giannasi
Marta Plevani

Logistic Technical Services
Cristiano Frizzele

Nicola Bon
Lucio Ramelli
Pino Simeoni
Maurizio Urso

Insurance and Transports
Alessandra Durand
 de la Penne
Sandra Montagner
Matteo Liguigli
Luana Lovisetto
Angela Bianco
Elena Seghetti

*Purchasing and Hospitality
Office*
Fabio Pacifico

Annamaria Colonna
Maria Cristina Lion

Jasna Zoranovich
Giovanna Genta – Oltrex
Sabrina Mabilia – Oltrex

**La Biennale di Venezia
Servizi SpA**
Exhibition concept
Manuela Lucà Dazio

Set-up coordination
Massimiliano Bigarello
Gerardo Cejas
Ruggero Di Paola
Davide Testi
Francesco Zanon

Logistic, facilities and security
Angelo Boscolo

Organizing services
Maurizio Celoni
Elisabetta Parmesan
Jessica Giassi
Alessandro Mezzalira
Cristiana Scavone

*Technology
and information systems*
Andrea Bonaldo
Michele Schiavon
Leonardo Viale

Communication
Giovanna Usvardi

Assistant
Veronica Mozzetti-
 Monterumici

Management's Secretariat
Cristina Graziussi

Head of Art Press Office
Alessandra Santerini

Press Office
Elena Casadoro
Chiara Costa
Elisa Dalla Rosa
Giovanni Sgrignuoli

Accreditation
Alessandro Pezzin
Valentina Silvestrini
Francesca Volpato
Francesca Zorzi

*Coordination Biennale
Press Office*
Paolo Lughi

Carlo Zasio

*International accreditation
and Press Office*
Michela Lazzarin

Italian press accreditation
Fiorella Tagliapietra

Website
Giovanni Alberti

Communication graphic design
Dario e Fabio Zannier

Advertising and Graphic design
Michela Mason

Maddalena Pietragnoli
Lucia Toso

Graphics' realisation
Enrico Bardin
Nicola Monaco
Francesca Vianello Moro

Catalogue

Curated by
Robert Storr

Short texts by
Lindsay Harris
Joe Hill
Sarah Lewis
Anna Mecugni
Francesca Pietropaolo
Robert Storr

Editor of texts volume I
Harriet Bee

Catalogue graphic design
Dario e Fabio Zannier

Editorial coordination
Francesca Del Puglia

Chiara Calciolari
Valentina Vecchio
Lucia Veronesi

Protocol office and events
Elisa Ceri

Laura Aimone
Cristina Cinti
Eleonora Mayerle
Elisabetta Mistri
Elisa Torcutti

Marketing and Sponsorship
Francesco di Cesare

Marzia Cervellin
Paola Pavan

**President's office and
General Manager's office**
Daniela Barcaro
Roberta Savoldello

Valentina Baldessari

**Human Resources, Legal
and Institutional Affairs**
Debora Rossi

Cinzia Bernardi
Cristina Innocenti

Silvia Bruni
Graziano Carrer
Giovanni Drudi
Antonella Sfriso
Alessia Viviani

**Administration Finance
and Auditing**
Valentina Borsato

Martina Fiori
Bruna Gabbiato
Manuela Pellicciolli
Giorgio Vergombello
Sara Vianello
Leandro Zennaro

Special Projects
Pina Maugeri

Jörn Brandmeyer
Davide Ferrante
Arianna Laurenzi

**Archivio storico
delle Arti Contemporanee**
Giorgio Busetto
Antonia Possamai

Maria Elena Cazzaro
Valentina Da Tos
Erica De Luigi
Lia Durante
Roberta Fontanin
Giuliana Fusco
Michele Mangione
Giovanna Pasini
Adriana Scalise
Michela Stancescu

Archive pictures
Giorgio Zucchiatti

Catalogue production
Marsilio Editori

Editing and Layout
in.pagina srl
Mestre-Venezia

*Copy editing and
translations*
David Graham

Photolithography
Fotolito Veneta
San Martino Buonalbergo,
Verona

Press
Offset Print Veneta
Verona

Binding
Legatoria Laghetto
Vicenza

© 2007 Fondazione
La Biennale di Venezia
Ca' Giustinian
San Marco 1364/a
30124 Venezia
www.labiennale.org

ISBN 978-88-317-9256

Distributed in the UK
and Europe
by Windsor Books
The Boundary
Wheatley Road
Garsington, Oxford OX44 9EJ

First edition
June 2007

Automobile Club d'Italia

fantoni

by FREZA

1880
matteograssi.

BISAZZA
MOSAICO

DECIMA
italia srl

flex.it

Link

La Fondazione La Biennale di Venezia with Robert Storr moreover thank:

American Center Foundation
The projects for the 52nd International Art Exhibition by Riyas Komu, Rosario López,
Morrinho Project, Óscar Muñoz, José Alejandro Restrepo, Paula Trope,
were made possible in part by the **American Center Foundation**

Australian Government

Australia Council for the Arts, Sydney

CULTURESFRANCE, Paris

Institut für Auslandsbeziehungen – ifa, Stuttgart

The International Council of The Museum of Modern Art, New York

Mondriaan Foundation, Amsterdam

Peter Norton Family Foundation, Santa Monica

Introduction

Davide Croff
President
Fondazione La Biennale di Venezia

The particular symbolic value of the International Art Exhibition transcends the confines of *La Biennale di Venezia*, which originally founded it more than 110 years ago.
The Art Biennale has always borne witness to avant-garde trends, schools, movements and personalities, representing a model that has very often been taken up all over the world and still is today. The Biennale has remained an indisputable hub of artistic research throughout the last century and up to the present, despite the advancement of art models and art production and promotion systems, becoming a magnet for, and international creative laboratory of the contemporary.
In the context of this foundation's responsibility, international confrontation gives rise to an awareness that contemporary art exhibition and promotional models are in need of serious changes, of structural innovations to the way they are conducted and the way they are presented to the public.
In 2004 the new Biennale felt the duty and need to take a new direction toward redefining its role, launching initiatives that were to have a bearing on the 2005 and 2007 exhibitions.
It was also open to new ideas, gathering opinions and contributions from an important part of the contemporary art world at the big international symposium organised in Venice in December 2005 entitled *Modernità molteplici e Salon globale*.
It was decided to give the Biennale's artistic directors (and not only those of the Visual Arts Section) a longer time span for their work allowing continuity of their involvement with the Biennale rather than its previous episodic nature.
Unlike in the past, when the artistic director was announced just before his first event, Robert Storr was appointed in 2004, allowing him to develop his action over the course of three years.

The 52nd International Art Exhibition may therefore be seen as a stage on a complex pathway the Biennale set out on in 2004, which has so far included: ample time being given for preparation of the exhibition by allowing three years for this; two curators being appointed to direct the exhibition for the first time in 2005; space being provided for new considerations of contemporary art with the symposium; and a pavilion dedicated exclusively to Italian culture being reopened. The latter was introduced at the 10th International Architecture Exhibition and now makes its debut at the Art Exhibition, representing one of its main innovations.
The Biennale has for the first time invited an American critic, Robert Storr, to direct the exhibition. In this turn of mind two cultures came together in this exhibition to explore and document the new artistic realities emerging from every corner of the world, thus expanding its perspective.
Think with the Senses – Feel with the Mind: Art in the Present Tense is the result of Robert Storr's look beyond the new frontiers of world art; not only to rapidly developing artistic languages, but also to personalities, countries and emerging trends on all five continents, otherwise at the margins of the more consolidated art scene. In particular, Storr wanted to add Turkey with its own national pavilion (in the Artiglierie dell'Arsenale) and an exhibition representing the contemporary art of the African continent.
In confirmation of the international vocation of this institution, there is a greater number of foreign countries at our exhibition than ever before – a good 76 – and with several debuts, including a country on the difficult road to peace and reconstruction: Lebanon. National participation has always been an essential, distinctive and extraordinarily rich aspect of the Art Biennale. This contribution must be acclaimed because

our exhibition was the first and is now the only one to have permanent national pavilions. In this context, the presence of the People's Republic of China since 2005 at the Arsenale – where the Biennale will in future be developing exhibition spaces – is a first sign of its opening up to new parts of the world.

Furthermore, the anomalous absence of a specific area dedicated to Italian art has been definitively resolved.

The new Italian Pavilion, created in the Tese delle Vergini at the Arsenale – in association with the Ministry of Culture's DARC (Direzione Generale per l'Architettura e le Arti Contemporanee) – has this year been entrusted to a curator of international prestige, Ida Gianelli.

Again thanks to the DARC, another significant exhibition of Italian Art will be added to the collateral events of the 52nd Exhibition, featuring the winners of the competition for young artists.

The important return of Veneto artists to the Venice Pavilion, where they were in the past, must also be pointed out.

This has been made possible by contributions from the Veneto regional administration, the provincial administration and the Venice city council.

Finally, note must be made of an important initiative that is emblematic of the spirit with which this four year period in contemporary art has been faced by the Biennale.

In 2006, while the International Architecture Exhibition was still being organised, the Visual Arts Section began discussions with the organisers of Documenta Kassel, Skultur Projekte Münster and Art Basel.

La Biennale di Venezia suggested setting up an alliance, which has led to a European network project. This resulted in the staff of the four institutions comparing their respective methods in order to launch a shared promotional campaign aimed at the media and cultural magazines all over the world (including the Far East, Asia, Africa and Latin America).

This means that the four institutions are now offering their visitors a new, additional service. Venice, Kassel, Münster and Basel have together opened a website (www.grandtour2007. com) where visitors can find all the relevant information on these events. The aim is to raise awareness of and increase attendance at the most important contemporary art events in the world, creating a European Grand Tour, which, due to the different timings, is possible only once every ten years.

There is a precise idea behind these international examples of organisational cooperation, shared promotion and useful public services: a project of cultural networking and collaborative relationships between institutions that respect the differences and cultural identity of each event, and at the same time place them in a wider and more important context of propagating art and culture.

The new Biennale is convinced that formulas and cultural models must be structurally and courageously updated. Much has been changed in our way of working, in our organisation of the *vernissages*, in our visitor services and in our care of the exhibitions and various sections, with new ideas being introduced to every sector. These include the length of the exhibition itself, which, since the last Architecture Exhibition, now goes on until the end of November.

In these four years the Foundation has updated the Biennale on several sides and at different levels. There is still much to be done and the 52nd Exhibition is only one stage on this pathway. It must be read in the complexity of its four-year development since 2004, in its commitment to art and to renewing the means of giving it greater diffusion.

Contents

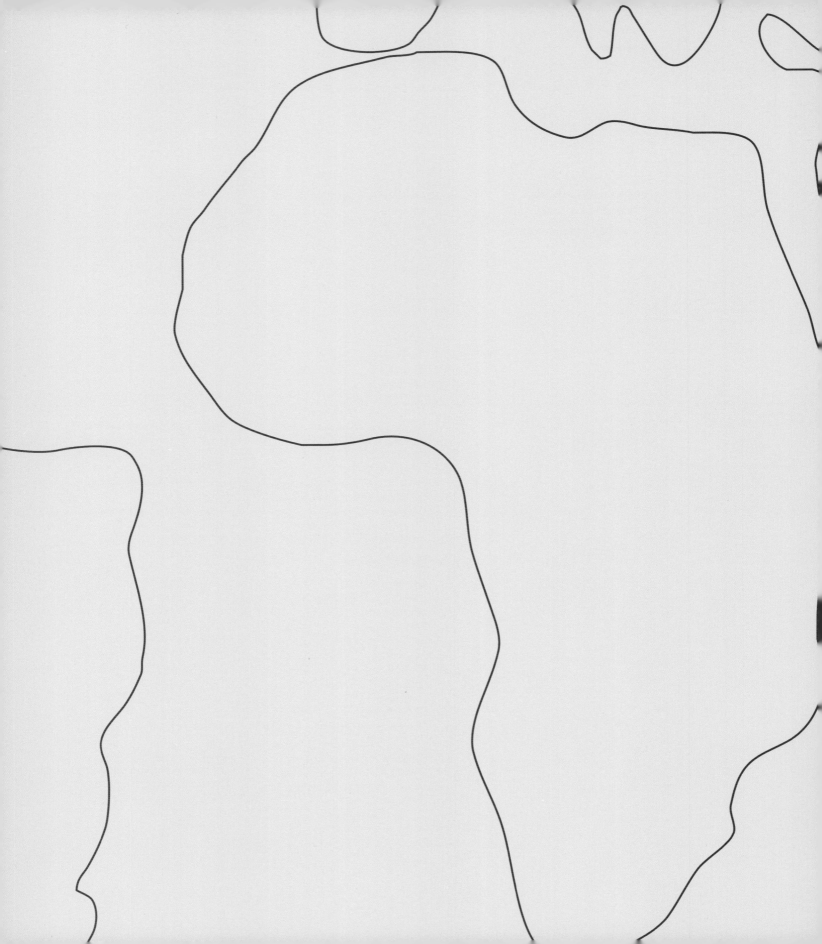

Check List-Luanda Pop
Exhibition selected by a panel chaired by Robert Storr

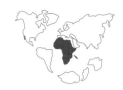

Check List-Luanda Pop
African Pavilion

The emotion of being seen

'Whatever were you expecting when you removed the gag that closed these black mouths? That they would sing your praises? Did you perhaps think that when these heads, which our fathers had forcefully bent to the ground, were raised up again, they would look at you with adoring eyes? Here rather are men standing, looking at us, and I hope feeling, like me, the profound emotion of being seen. Because for three thousand years the white man has enjoyed the privilege of seeing without being seen. It was pure look, the light of his eyes drew everything from the native shadow; the whiteness of his skin was also another look, a condensed light. The white man, white because he was man, white like the day, white like truth, white like virtue, illuminated creation like a torch and revealed the secret, white essence of beings' (J.-P. Sartre, *Orphée Noir*, preface to L. Sedar Senghor, *Anthologie de la Nouvelle poésie nègre et malgache de langue française*, Paris, PUF, 1948).

We must first of all point out that the word 'black' does not refer to any particular colour. As Fanon was later to explain, it means more than anything expressing a humanity. As in England in the '80s, when the term 'black' in a single discourse covered all those not of British origin, even to a certain point including the Greek Cypriots. The word 'black' needs to be given a metaphorical value, considering it the password of those who Fanon, once again, had defined as 'the damned of the Earth'. At the same time it is necessary to recognise in Sartre's claims a contrast between the colonial powers and the colonised peoples. The emotion of being seen, therefore, is no longer a mere ontological experience, but is part of a political strategy inescapably destined to lead to independence, announcing the beginning of a process of awareness in those who see. If the object of this new ability to see is the ex-master, it is up to him to accept it passively or convert it into an element of reflection. But the ex-master should here play only a secondary role. Whether or not he is capable of internalising the changes that his sudden objectification sets before him depends on him. The story of the post-colonial years would tend to show that the West has been incapable of integrating the new relationships of power generated by the advent of new, independent nations, whose aspirations could no longer be reconciled with the hegemonic and monolithic intentions that had until then been imposed on them. But let's leave the West out of this. Our aim is not to go into a psychoanalysis of the ex-rulers, but to explore the mechanisms that, after political emancipation, will determine an intellectual emancipation of the 'black' continent. The possibility of seeing the old positions and the status quo of the past undermined and the metamorphosis of the ex-colonised person into a responsible being whose aspirations to think and project himself in time and space is manifested with the energy and urgency linked to centuries of silence. In this play of mirrors, the transformation of the statute of the other leads to a different relationship with oneself that foresees for the ex-colonised the move from the role of object to that of actor and the faculty of exercising what Merleau-Ponty calls 'seeing power': 'My body is

The exhibition has been selected by a panel of expert composed by Meskerem Assegued, Ekow Eshun, Lyle Ashton Harris, Kellie Jones, Bisi Silva and chaired by Robert Storr to represent the African continent at the 52nd International Art Exhibition

Curators
Fernando Alvim (Angola)
Simon Njami (Cameroun)

Produced and organised by
Fundaçao Sindika Dokolo

Sponsors
Fundação Sindika Dokolo
Banco Bic, Angola
Banco Nacional de Angola, Angola
Banco Privado Angola, Angola
Banco de Negócios Internacional, Angola
Ensa Seguros de Angola, Angola
Inalca, Angola
Intertransports Centre S.P.A. Matera, Angola
Eni, Angola
Grupo Américo Amorim

Artists
Ghada Amer
Oladélé Bamgboyé
Miquel Barceló
Jean Michel Basquiat
Mario Benjamin
Bili Bidjocka
Zoulikha Bouabdellah
Loulou Cherinet
Marlène Dumas
Mounir Fatmi
Kendell Geers
Kiluanji Kia Henda
Ihosvanny
Alfredo Jaar
Paulo Kapela
Amal Kenawy
Paul D. Miller Aka DJ Spooky
Santu Mofokeng
Nástio Mosquito
Ndilo Mutima
Ingrid Mwangi
Chris Ofili
Olu Oguibe
Tracey Rose
Ruth Sacks
Yinka Shonibare
Minette Vari
Viteix
Andy Warhol
Yonamine

at the same time seeing and visible. Looking at every thing, it can also look at itself and recognise in what it sees the "other side" of its seeing power' (M. Merleau-Ponty, *L'oeil et l'esprit*, Paris, Gallimard, 1985).

The first effects of this metamorphosis, which, apart from a few exceptions, took place between the '50s and the early '80s, and in some cases also the '90s, with the end of Apartheid and the start of the peace process in Angola, are the end of colonisation and the advent of African independence.

The emotion of being seen has generated the need for Africa to think for itself and to launch itself into the existential experience represented by the invention of references free of the detritus of a history from which it has long been excluded. In the years prior to independence, there were thinkers who took it upon themselves to theorise this desire to free themselves from alienation. Precursors like W.B. Dubois and later Aimé Césaire or Frantz Fanon, to mention just a few, committed themselves to building a specific critical system for the ex-colonised. And if the continent at times conveys a sense of chronic powerlessness, this must not be seen as its inability to make itself the author of its own destiny, but the consequence of the jolts related to a process made complex by the redistribution of the map of the world and by the games of the big economic powers. On the other hand, a political reflection on the meaning of what Achille Mbembé defined as post-colony is under way. The disappointments that followed the '70s and the end of a series of myths now allow us to make an inventory of the 50 years just past in order to draw important lessons from them. Although the economic and political spheres still seem to have difficulty in defining an original methodology, the reflection under

way in the field of contemporary art starting from the early '80s is having extremely tangible effects. The biennials of Dakar and Bamako, the newly launched triennial of Luanda, publications like the emblematic *Revue Noire*, *CoArt News*, *Nka* and *Arts South Africa* have created the conditions for an endogenous debate without which the concept of African contemporary art would remain pure abstraction. That which Sartre called the 'exile from the self' is clarified through these experiences: 'The herald of the black soul has passed through the whites' schools on the basis of the iron law that the oppressed is refused all the arms he has not been able to steal from the oppressor: and precisely thanks to the clash with white culture, Negritude has moved from immediate existence to the reflexive state. But at the same time the poet, more or less, has stopped living there. Choosing to see that which is, he had already gone into exile from himself, he felt bound to show himself' (Sartre, *Orphée Noir*, cit.).

Showing himself probably means arousing an artistic awareness. To be capable of taking the distance from oneself necessary for any work. This leads to the importance of finding a language suited to the expression of a world of sensations in harmony with a history that emerges in an original project. Not in an exhaustive demonstration of the mastery of new tools, but in appropriating a message and an aesthetics that will be its vehicle. The mere reproduction of imported concepts is not enough. Taking exile from himself, the African is forced to turn a critical gaze at others and himself, to reinvent himself and to deconstruct endogenous and exogenous perceptions. In other words, he is forced to rewrite his own story with a vocabulary and syntax that open up unexplored perspectives. This is the

price of the presence of contemporary creativity in Africa. It is why *Check List* is not intended as simply an exhibition. What importance could yet another exhibition of African art have if it is not founded on the past to further advance the debate on Africa? Who could be interested in 'discovering' new artists to fling into the system? The African Pavilion officially instituted for the first time at the Venice Biennale requires the staging of a space for reflection, comparison and proposal. A space where everyone is invited to look at the works and their contextualisation for what they are and not for what they might be wanted to be. We want to appeal to the senses and sense. To bodies and minds. It is a project – we know – that is both modest and arrogant at the same time. Indeed, we refuse to believe that there is good art and bad art, or African art that develops parallel to world art. *Check List* is proposed as a manifesto whose fundamental aim is expression, far from fashions or conventions, aimed at pursuing the history that was denied to the memory of the artist El Anatsui who, only a few years ago, wrote these words: 'The last one I wrote to you on Africa / I used headed parchment / There are lots of empty spaces in the letter... / Now I can fill many of those spaces, because... / I have grown older' (El Anatsui, in 'International Review of African American Art', 9, 3, 1993, cit. in S. Njami, *El Anatsui: A Sculpted History of Africa*, London, Saffron Books & October Gallery, 1998).

The empty spaces of that parchment began to be filled in the library of Alexandria, in the universities of Timbuktu and many other places. The authors came one after the other, writing since the dawn of time. Their names: Martin Luther King, Nasser, Neto, Lumumba, Um Nyobe, Sankara, Ben barka, Cabral... Some are still among us, like Mandela. A new cultural story has begun to be written, of independence, through the Festival mondial des arts nègres of Dakar in 1966, promoted by Léopold Sédar Senghor; then there have been the pan-African assemblies in Algiers and Lagos; the Biennial of Cairo, the Fespaco, the biennials of Dakar and Bamako, and that of Johannesburg, closed too quickly. The launch, three years ago, of the Sindika Dokolo Collection, the first private African collection of contemporary art, and the advent, shortly after, of a triennial in Luanda, represent a new chapter in the book that is being written day by day before our eyes. Luanda, a vibrant example of the concept of chaos and metamorphosis, is emblematic for various reasons. The African capital of a country torn apart by an excessively long war of independence, then by a civil war in which the two big coalitions, trusting

in a macabre chess game, have divided the country into two apparently irreconcilable parts, Luanda is gradually recovering and beginning to tend its wounds. The symbol of an Africa that must still fight to assert its freedom and its autonomy, the country is coming back to life. It is the inalterable power of an entire continent that is expressing its will to live, its vital thrust. Luanda Pop is a metaphor for this desire to return to the world. It is not the case here to circumscribe this movement in a particular geography, on the contrary. It is rather a case of once again writing a new chapter through the experience of a moment that is taking shape before our eyes. It is a case of placing it in a temporal perspective, of reconnecting with the first surges that mapped out the contours of a possible Africa and of asserting, contrary to what some would have us believe, that the continent is not an immobile space, nor a heart of darkness. Africa is young. Its population, encouraged by the incessant fight it has had to make for survival, shows, by the simple fact of being alive, that there is no inevitability. This is the sense of our project, which must be analysed cold, for what it is. Far from sterile passions and commonplaces, from unreal projections and worn out certainties. The artists represented are not seeking recognition, nor sympathy. They are simply expressing themselves. And their voices, nourished by centuries of history, are raised with renewed power and energy. We are not looking for a new representation of the eternal battle that sets the centre against the periphery, because these diatribes of other times no longer have any interest in our view. There is no centre, no periphery. Understanding this and definitively admitting it means accepting full immersion in the inexorable flow of time. It is not much, perhaps, but I think it is the central nucleus of every contemporary artist's research. Wherever they come from. It is the only way to accede to that which Deleuze defined as the world of perception: 'this world of perception with its singularity-events, presents a neutrality that is essential to it. Not only because it glosses over the dimensions according to which it will be ordered so as to acquire meaning, appearance and designation; but because it glosses over the renewal of its energy as potential energy; that is, the execution of its events, which may be both internal and external, collective and individual, according to the contact surface or the neutral surface limit that transcends distance and ensures continuity on both its sides' (G. Deleuze, *Logique du sens*, Paris, Éditions de Minuit, 1969).

—Simon Njami

Participating Countries

Albania

Albanian Tectonies

I take enormous pleasure in presenting the Albanian Pavilion at the 52. Exhibition of the Venice Biennale to art critics and the public. The experience of its construction is something that will stay with me forever, mainly because of the exhilaration of working with the Albanian artists' community.

There is a school of thought that says the past usually attracts more of our increasingly atomised attention than the future. True I'd say, possibly because the past is more known. A battle already won; or lost. But we are now at a moment in Albania's cultural history when the future is slowly becoming more interesting than the past. Change has already come, though this is still new enough to display a fully fleshed body of what it is, and there is duly a feeling more of an end than a new beginning. But the end of an era is the beginning of another one and a new sensitivity is coming with it.

The renowned American curator Bonnie Clearwater – a person who truly deserves the name *omnium curiositatum explorator*: an explorer of everything interesting – offers the world a first-hand opportunity to see some of the best work of young Albanian artists through an inspired and far reaching selection. Because of the artistic inheritance of the last six decades in Albania, the sudden collapse of the dominant socio-realist school and recent developments in the arts of the mainly post-modern world in which these artists live, the curator's task of developing a Pavilion that will best portray the history and concerns of a country undergoing a rapid mental and material change has been a difficult one. And it is the coming to terms of a whole nation with this change and its shocking consequences that Bonnie Clearwater so masterfully manages to capture and display in this, hopefully unforgettable, Pavilion.

In seeing these works it is easy to forget how difficult Albania's past has been in the twentieth century. One of the most tyrannical communist regimes ruled the country for half a century and 'art', in the words of José Ortega y Gasset, 'was expected to take upon itself nothing less than the salvation of mankind'. If the previous artistic output somehow 'failed to save enough people' through its contamination with party directives, these young artists are starting anew to try to crystallise their artistic endeavours in an attempt to implant radical vistas, youthfulness and debate in a tiresome old order as a reaction against academia, the prevailing artistic establishment and the utterly familiar. *Plus ça change!*

Two distinctive features are evident in their works. One is that Albania, its history and people remain the preferred stream of subject matter from which these artists repeatedly 'drink', despite the fact that most of them live in European countries. The second is the strong social agenda that each of these works convincingly displays.

Some of the artworks here would undoubtedly be better understood with some familiarity with Albanian history, but the haunting videos of Armando Lulaj and Alban Hajdinaj, the deconstructivist-Derridean vision of Heldi Pema, the idiosyncratic installation of Helidon Gjergji and the intriguingly layered 'futuristic' graphics of Genti Gjokola nevertheless manage to transcend national barriers to offer an eerie autopsy of current Albanian society and more.

—Rubens Shima

Commissioner
Rubens Shima

Curator
Bonnie Clearwater

With the support of
The Council of Ministers
of the Republic of Albania
The Ministry of Culture, Tourism, Youth
and Sports, Tirana, Albania
The National Gallery of Arts, Tirana,
Albania

Artists
Helidon Gjergji
Genti Gjokola
Alban Hajdinaj
Armando Lulaj
Heldi Pema

1-4 Heldi Pema, *The Client*, 2004. Video projection DVD, 5''. Courtesy Heldi Pema

1

2

3

4

5

9

6

10

7

11

8

12

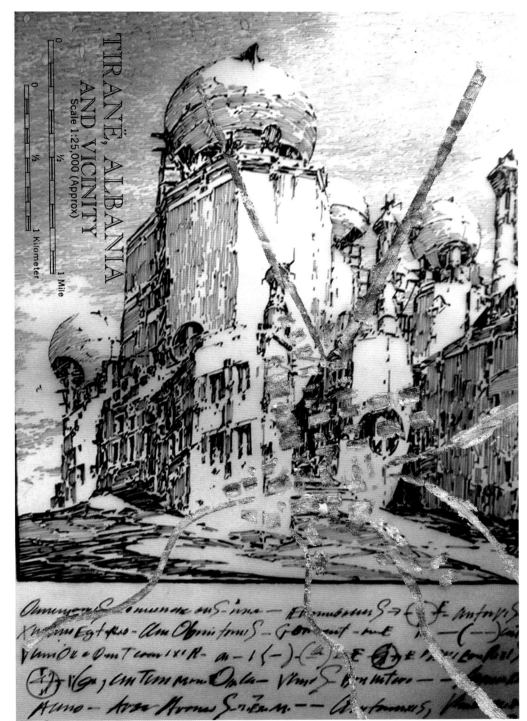

5-8 **Alban Hajdinaj**, *Diskovery*, 2007. Video projection DVD, 27'33". Courtesy the Artist

9-12 **Armando Lulaj**, *Time Out of Joint*, 2006. Video projection, double projection, color, sound, 15'39". Courtesy the Artist

13 **Genti Gjokola**, architectural drawings

13

Argentina

Guillermo Kuitca, How Late is Now

Since the late 1980s Guillermo Kuitca has worked on a system of relationships between series, based on the shifting of technical languages, either neutral or anti-authorial, to the formal and conceptual domain of painting. This operation included a paradox: the work should continue to assert itself as a painting even if – in the series of maps and plans – a shift was being forced from systems based on the horizontality of a working table to the contemplative, vertical position of the painting, and although drawing and design would limit the strictly pictorial up to the point of it nearly fading away from Kuitca's universe.

Until 2006, as if following a definitive path, the logic of the work could be summarised in these terms. But that was when, rather unexpectedly, the pictorial element imposed itself and focused the attention of the artist, provoking a true revolution in the artwork, to the point of creating a new paradigm.

The pictures presented in this Venice Biennale recover the imprint of a cubist construction consisting of an array of short straight lines that divide two refractory plans and create the optical illusion of a prismatic folding on the surface of the picture. 'At the beginning, the only idea was to advance on the picture on the basis of the act of walking', explains Kuitca. In this process, the cubist image appeared as the perfect resource to work on the picture by simply inscribing lines and plans like rhythms. The first picture of the series defined the character of this new stage. It is a Pollockian format *allover*, which led Kuitca to work with cubism as a style or alphabet which can be abused while technical and grafting skills are tried out, but now, for the first time in years strictly pictorial: he mixes different cubist names in a single picture, he does Latin American cubism and, finally, he combines the impossible: the cubist illusion of plan folding with a representation of Fontana's cut.

But these techniques are more complex than postmodern appropriation, because they recover languages and gestures from the past in a cheerful spirit, without cynicism, from the position of a new start rather than an end. In any case, they appear to connect with the old tradition of mystification and wild cannibalism of the peripheral modernities rather than with the melancholic trends linked to the death of painting as theorised in the last decades.

The theoretical dimension of this new work is being built in a process that is not yet closed, but the following can be stated: in an attempt to recover painting as the result of physical mechanics, Kuitca makes two discoveries. On the one hand, that cubism, specific as it may have been in its resources and aspirations, turned into a sort of state of the nature of painting, to which we can return from any place. And in the cheerful interaction with that language, Kuitca discovers what it would be like to paint from a present time without attributes, a present time without presentness but as full of pastness as it is of vitality.

At the Ateneo Veneto venue where Argentina will be represented at the Venice Biennale, everything conspires against the present time. Too much mannerism in the religious paintings of the ceiling and walls, too much history. Powerful and new, Kuitca's paintings are installed and are both indifferent to the context and characterised by the same deliberate lack of presentness.

—Inés Katzenstein

Commissioners
Sergio Baur
Mercedes Parodi

Curator
Inés Katzenstein

Web Site
www.argentinaenvenecia.com.ar

Artist
Guillermo Kuitca

Guillermo Kuitca, *Sin título*, 2006. Oil on linen, 195 x 333 cm. Courtesy Sperone Westwater, New York

Australia

Callum Morton
Valhalla

Ruins have come to stand as metaphors for shattered optimism, and simultaneously as symbols of the opportunity for renewal. Buildings, in pristine upstanding-ness and dishevelment are the active protagonists in this scenario of modernity in flux. Buildings are tangible evidence of a society's egocentrism. Tall buildings like skyscrapers offer the symbolism of phallic power; buildings with domes, like Saint Peter's Basilica or the White House, represent a maternal house. When you cause terror and trauma to buildings, break them down, penetrate them, explode or implode them, you then have a powerful, libidinous act of psychoanalytic proportions that shatters the fragile ego which architecture may be seen to represent.

Callum Morton knows this. For many years his project has been to excavate and unleash the uncanny forces at work in the architectural enterprise, through an art practice that recasts buildings as sculptures, through pictures and environments, which are given phantasmic, chimerical centres, and all with a twist of Hollywood. However, rather than focusing on the corporate, ecclesiastic, or civic building, Morton is mostly drawn to tamper with iconic domestic dwellings: architecture that connotes both father and mother site.

In Venice, Morton's project brings all his key elements together; architecture of the modernist, domestic kind; a phantasmic presence indicated from within; a conundrum space pitched between the external smaller scale and the echoing interior. We step from the dilapidated domestic exterior into the 'schmick' corporate cavity. Lift shafts light up and malfunction, screams are heard, seismic shudders are felt, and all the while Muzak becalms our shattered twenty-first-century nerves.

Allusions to the Hollywood scenography of modern catastrophe movies and corporate subterfuge are coupled with the traumatic site of domestic destruction. Morton proposes a ruined site, a collapsed home and new Piranesi fantasy from which shafts of light will emanate as if indicating the arrival of a new alien, or betraying the inhabitation of a familial poltergeist. Once again Morton proposes the psychic intensity of architecture while continuing to pursue the hybridisation of the modern conceptual project: land art collapsing the minimal cube.

Susan Norrie
HAVOC

Susan Norrie's concern for the environment has seen her create some of the most compelling and awesome images to emerge from Australia, a place perennially attached to imaging its traumatised landscape. Operatic in scale and immersive in display, Norrie has engulfed audiences in a shifting picture of an environment made toxic and unstable by the interventions of industrial and military progress.

The diabolical cocktail of industrial damage, nuclear testing and climate change has been explored by Norrie via symptomatic events: earthquakes, volcanic eruptions, dust storms, toxic fires, freeze-overs and drought. Lava, mud, oil and other naturally occurring mucks have filled up her screens in excessive blurts and convulsions to become a hellish form of minimal painting. Sounds fill space with sonic menace to instil in the viewer a sense of dread.

Norrie's video making differs significantly from the 'documentary' or 'interview' style that dominates a lot of art concerned with issues. Hers is a visual approach above all, and links fundamentally to her earlier processes as a painter. Norrie employs the sensibilities

Commissioner
John Kaldor AM

Senior curatorial advisor
Juliana Engberg

Web Site
www.australiavenicebiennale.com.au

Artists
Callum Morton
Susan Norrie
Daniel von Sturmer

1 **Callum Morton**, detail of work in construction, *Valhalla*, 2007. Steel, polystyrene, epoxy resin, silicon, marble, wood, acrylic paint, lights, sound, 465 x 900 x 1,450 cm. Courtesy the Artist, Roslyn Oxley9 Gallery, Sydney and Anna Schwartz Gallery, Melbourne
PHOTO THE ARTIST

2 **Callum Morton**, *Myoora Road*, 1979
PHOTO IAN MORTON

3 **Callum Morton**, study, *Valhalla*, 2007. Digital image. Courtesy the Artist, Roslyn Oxley9 Gallery, Sydney and Anna Schwartz Gallery, Melbourne

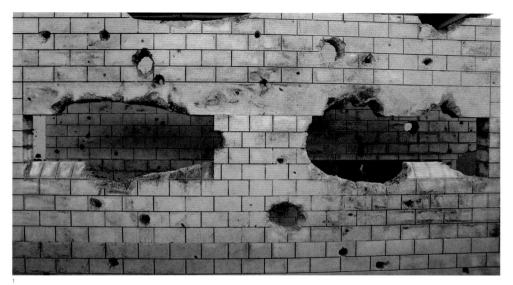

1

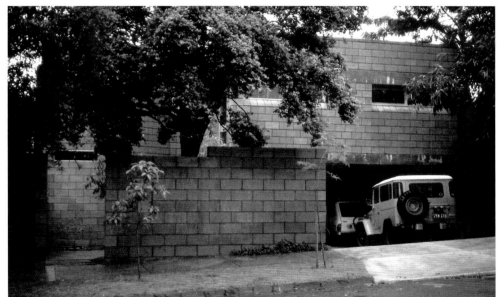

2

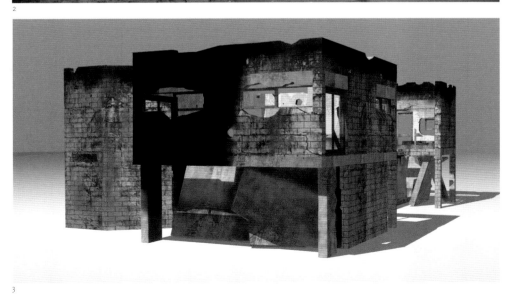

3

of the grotesque (springing from Romanticism and its twentieth-century descendant, surrealism), and the cinematic collage to construct her fragments of awesome beauty and sublime terror. Hers is a visceral video making, made thicker and more stretched by a tampering with tempo that slows time in an unsettling warp. For her Venice project, Norrie focuses on the geographical region of Oceania. Norrie has followed the volcanic, seismic and climatic disturbances that of late have delivered circumstances of devastation to the indigenous peoples of the region. In these times of havoc the indigenous populations resort to faith: mudslides, tsunamis, cyclonic behaviours and volcanic eruptions have encouraged a return to ancient rituals. Norrie bears witness to the frenzy of animism, voodoo and sacrifice, which are encountered as primordial antidotes to the woes of a world in breakdown. She also shows the amazing resilience and resistance of the indigenous people.

Daniel von Sturmer
The Object of Things
Daniel von Sturmer creates sculptural films and object installations that ask the viewer to look and decipher illusion and solids in kinetic interaction. Scale, distance, horizontality, verticality, generality and quiddity are all encountered in von Sturmer's own play with the perceptible, in which empirical evidence is constantly called into question. Von Sturmer delights in converting the banal object into a thing of curiosity. Through his use of the video camera with its capacity to zoom in and out, pan, track, enlarge and diminish items he can help common things

behave in eccentric ways, draw attention to their innate physical potential and activate an inquisitive engagement with a viewer whose apprehension of those things has been altered by a shift in visual context. Platforms have also become important elements within von Sturmer's visual events. Large, purpose-built floating planes accentuate space and help objects and moving images levitate within architectural delineated spaces, and they establish a further physical relationship with the body of the viewer. In his recent large room installation *The Field Equation*, von Sturmer used over 50 plinth-like platforms to build colonies of visual experiments around and through which the audience walked to encounter ever unfolding linkages between visual things. Von Sturmer has given his projects titles such as *The Truth Effect, Limits of the model, Material from another medium* and *The Field Equation* to give emphasis to his tools and trade. Truth is an important aspect in his practice and it is worth mentioning in an age when special effects seem seamless and easy in the world of digital manipulation and post-production editing.

In Venice, Daniel von Sturmer's newest project occupies the Australian Pavilion in the Giardini. In this instance, the Pavilion provides a unique spatial architecture to encounter and syncopate. With its split-level and various ceiling heights, the Pavilion encourages a different approach to a straightforward linear event. Platforms, objects and moving images will articulate the space and deliver new vistas for the audience to decipher in von Sturmer's site-related work, in which the play of the perceptible will unfold and punctuate the Pavilion's membrane.

—Juliana Engberg

4-5 Daniel von Sturmer, *The Field Equation*, 2006. Installation views, 8 screens (7 sequences), digital video installation (6 single channel videos, 1 dual channel video), 8 custom built screens, 17 objects, 59 plinths. Australian Centre for Contemporary Art, Melbourne, Australia; Helen Macpherson Smith Trust Commission 2006. Courtesy the Artist and Anna Schwartz Gallery
PHOTO ANDREW CURTIS

6 Daniel von Sturmer, *The Field Equation*, 2006. Installation detail, 8 screens (7 sequences), digital video installation (6 single channel videos, 1 dual channel video), 8 custom built screens, 17 objects, 59 plinths. Australian Centre for Contemporary Art, Melbourne, Australia; Helen Macpherson Smith Trust Commission 2006. Courtesy the Artist and Anna Schwartz Gallery
PHOTO ANDREW CURTIS

7 Susan Norrie, *HAVOC*, 2006-2007. Still from DVD installation, dimensions variable. Courtesy the Artist, Justin Hale and David Mackenzie

4

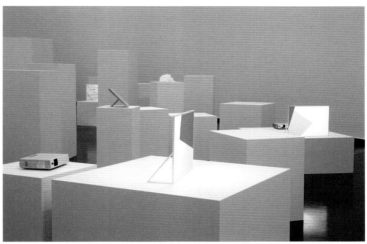

5

6

7

Austria

For over 20 years, Herbert Brandl (born 1959 in Graz, lives in Vienna) has been creating a painterly oeuvre of truly international status. It is quite unprecedented in the manner in which it explores the possibilities of colour and as regards both figuration and abstraction has made a series of significant contributions to contemporary iconography and the debate on painting. It seems apposite to present this outstanding position on painting today in the particular context of the Venice Biennale precisely at a time when across the board people are rediscovering painting in contemporary art. Herbert Brandl will be displaying around 20 new paintings in the Austrian Pavilion at the 52. Venice Biennale, the majority of which he has created especially for the exhibition. His picture series and single works are in different sizes and show both the figurative and non-figurative/abstract. The Pavilion's architecture will undergo several discreet modifications that were conceived together with the artist specially for the presentation of his pictures. The idea is to recreate the original impression the setting had back when Josef Hoffmann, the architect of the Pavilion, was Austrian Commissioner of the Biennale (1948 to 1956). The show will feature the possibilities of contemporary painting at different levels, whereby the virtuosity and power of Brandl's painting will be highlighted in an anti-decorative vein by means of fractures and dividing lines. The autonomy of painterly material is what ensures Herbert Brandl's work is independent of iconographic assignation and limits. He defines the intensities and current of the material but never prevents it developing.

—Robert Fleck

Commissioner
Robert Fleck

Web Site
www.biennale07.at

Artist
Herbert Brandl

Herbert Brandl, *Ohne Titel*, 2007. Oil on canvas, 401 x 301 cm. Courtesy Galerie Bärbel Grässlin, Frankfurt; Galerie nächst St. Stephan, Vienna
PHOTO EKTA

Belgium
Palace of Mirrors and Discoveries

Since the middle of the 1980s, Eric Duyckaerts has elaborated an oeuvre combining performances in the form of improvised conferences and videos of these performances. More recently, he has also started exhibiting installations in which he often stages his performances, as well as 'analogical' sculptures, 'radiographies' of museum walls and decorative interlaces, works that all pursue his reflection on the labyrinth of the *logos*.

Since *Magister*, a video from 1989 in which he developed in various episodes a conference about the links between art and knowledge, such as law, mathematics, technical history, anthropology and literature, Eric Duyckaerts has been making demonstrations with inane or illogical conclusions. He incarnates the figure of the knowledgeable professor who pushes the logos from its pedestal by means of absurdity.

For instance in 1993, in *La Main à Deux Pouces*, Duyckaerts demonstrated the existence of a second thumb on the hands of pre-*homo sapiens* man, whose survival would have ensured greater virtuosity to painters, had evolution not led to its disappearance. Using very elaborate drawings to emphasise this theory as well as an academic tone of voice, Duyckaerts explained the inexplicable whilst mocking intellectuals and their painfully minute hypotheses.

In Venice, Eric Duyckaerts will create a piece specially designed for the Belgian Pavilion, *Palais des Glaces et de la Découverte*, which draws from his reflection upon the labyrinth-like essence of knowledge, which finds itself naturally amplified by the ultimate incarnation of the maze that is the city of Venice itself. He conceived a maze made of glass, with mirrors in its corners, invading the entire Pavilion, which will become one single room where the visitor will come across different screens showing performances by the artist. These performances were held throughout the year preceding the Biennale. They took place in France, Belgium and the United States and are all based on the figure of the intellectual-impostor. In this case we are confronted with a double imposture, on the one hand that of the intellectual mimicked and mocked by the artist, on the other that of the artist himself, whose position is inextricably connected to the very imposture.

During the opening, Eric Duyckaerts will be at the Pavilion entrance, dressed-up as a chic juggler in an outfit by Eley Kishimoto, improvising new conferences which will thereafter be screened inside the installation, thus becoming an echo room for a confrontation and a reflection in the double sense of the word: both a mirror and a reflective thought, a conference eternally repeated.

—Christine Macel

Commissioner
The French Speaking Community
of Belgium (Wallonia-Brussels)

Curator
Christine Macel

Assistant
Dorothée Dupuis

Production
AIA Productions
Renaud Sabari, producer
Alexandra Cohen, production manager

Web Site
www.lepavillonbelge.com

Artist
Eric Duyckaerts

Eric Duyckaerts, *Dear Friends, do you hear me better? M/M (Paris)*, 2007. 3 colours silkscreened poster, 120 x 176 cm approx.

ERIC DUYCKAERTS

CHERS AMIS, EST CE QUE
VOUS M'ENTENDEZ MIEUX?
DONC, NOUS ALLONS PARLER
DE VENISE. POUR PARLER DE VENISE,
IL EST IMPORTANT DE PARLER DES LABYRINTHES.
LA VILLE DE VENISE EST GROSSO MODO CONSTRUITE COMME CELA,
SI ON PREND ICI LE GRAND CANAL
ÇA FAIT UNE BOUCLE À DOUBLE MÉANDRE
MAIS C'EST UNE DOUBLE GRANDE SPIRALE
DE DEUX LABYRINTHES: UN LABYRINTHE
QUI S'ENROULE PAR LÀ ET UN AUTRE
QUI S'ENROULE PAR LÀ.

Alors qu'est ce qu'un labyrinthe? Pour le savoir nous devons dessiner un labyrinthe et un labyrinthe au sens étymologique du terme, un labyrinthe crétois. Un labyrinthe crétois, ça se dessine comme ça. Alors là, il faut suivre très, très, très, très, attentivement, autrement, vous n'arriverez jamais à dessiner des labyrinthes crétois. "Vous m'entendez mal, ouais, bon, c'est un problème je vais essayer de le régler. Mais moi, quand je m'entends, je m'entends avec du retard et ça me... perturbe. Alors le labyrinthe crétois un petit peu de patience c'est comme ça qu'on le dessine. Vous voyez finalement, ça ressemble un peu à un cerveau. Et c'est un labyrinthe en spirale, en fait, dans ce genre de labyrinthe, contrairement à la légende de Thésée et à la légende du fil d'Ariane, on ne s'y perd pas, car il n'y a qu'un seul chemin, et cet unique chemin, on peut le suivre assez facilement, comme ça, en rouge, lac, lac, en s'éloigne du centre, en croit qu'on s'en rapproche, mais on s'éloigne à nouveau, et puis

en se rééloigne et puis on se reapproche et puis on se rééloigne et puis finalement, finalement, en arrive là et en se fait manger par le Minotaure. Donc le, le fil rouge, heu, heu c'est le fil d'Ariane, mais ce n'est certainement pas un fil pour ne pas se perdre, c'est le chemin obligatoire pour arriver à se faire manger par le Minotaure, de la même façon, à, à Venise en tombe toujours sur le Rialto ou, heu, la place St M', et ou la place St Marc, enfin bon, enfin, les gens qui ont l'habitude de se perdre à Venise savent, de quoi il s'agit. Maintenant, arrêtons-nous sur les labyrinthes greco-crétois, mazes et amazing, oublions ça, et, oeyens dans la langue allemande, dans la langue allemande, les labyrinthes sont des err quelque chose, irrgarten, ou bien errgang, et err, c'est la racine de err, err, erreur, errance, tout ça. Il faut bien comprendre que dans un labyrinthe c'est un endroit où en est plutôt,

comme un être humain en train d'errer, puisque il est écrit que errare humanum est, il y a deux propres de l'homme, le premier, c'est d'errer, et le deuxième, c'est de rire. Le rapport du labyrinthe à la danse est essentiel, ensuite, l'interprétation qu'en donne de ces différents labyrinthes crétois et qu'on retrouve sur des pierres dans le monde entier et tout ça, ou bien dans la cathédrale de Chartres, c'est une interprétation, un thème de, rituel de naissance, et je tiens d'y insister, rituel de danse, donc, ce soir, en sa savoir un rituel de danse, je pense, pour la plupart d'entre nous et peut-être, de naissance ou de renaissance, pour certains. Je vous remercie de votre attention.

Brazil

How to build an image

The famous story by Suárez Miranda told in Borges' *A Universal History of Infamy*, mentions a map made in full-scale so as to coincide, point by point, with the immense empire and reproduce its every detail. Borges does not explain further, but it is fascinating to try to imagine the map in all its detail, to envisage how it overlaid the buildings, streets and squares, to ask how and up to what point it reproduced the details of the world. Did it resort to rough ideograms, to a universal but limited language of primary colours in pastel tones, or did it venture rather to show the marks on the pavements of the city streets, the scrolls of a baroque window opened onto a square, the shadings of a grain of sand in a river bed? In short, what was the map's resolution? From what sidereal distance did you have to look at it to read its image, and not stay restricted to the surface of its points?

Borges liked notes. He would certainly have liked a work that is looked at from nearby and a distance at the same time, like the map wanted by his cartographers, and that, what's more, is a note: *Note on a lighted scene, or 10,000 yellow pencils* (*Nota sobre uma cena acesa ou dez mil lápis amarelos*, 2000, pencils on wall, variable dimensions). The pencils of the title draw the scene without wasting even an ounce of their graphite. They are all inserted straight into a wall, almost turning into the pixels of a computerised image. This is a reflection on the theme of constructing an image, like most of José Damasceno's work. In this highly personal universe, a line may become three dimensional and, while he draws a mountainous landscape, to help a flight of compasses remain on their points, as in a dance choreography (*Cartograma*, 2000, iron and compasses, variable dimensions), the memory of the steps of another dance, solidifying in marble (retaliation of the weight that the dance tries at all costs to annul) may be miraculously transformed into a super-light sculpture (*Dance floor. Step by step*, 2006, marble, variable dimensions), and a ball rests, almost forgotten, on the floor of the Brazil Pavilion in Venice, in silent tribute to Meliés' cardboard moon...

...or to the catalogue of shining stars, source of Detanico and Lain's prints, in which the names of the stars visible to the naked eye are written in the Helvetica Concentrated typeface they invented. The names reflect the migrations of the catalogue, which was created in Babylonia, redrafted in Greece, given refuge in Arabia and finally returned to the West in a Latin translation. In this latest chapter of their eternal journey between culture and myth, the names of the stars become white circles on a black background, points of vibrant, expanding light. So once again points, pixels, like those in *White Noise*, another work by the couple, that give rise (here, too!) to a dance. But the movement is false, it is only an impression given by the Photoshop selection control that, one at a time, reads and removes all the colours, converting the image into an enormous white field. The image, it is worth emphasising, is that of a satellite photo; in other words, the world seen from the sidereal distance at which it is not possible to distinguish it from its own map. Perhaps what we are seeing, then, is only another version of the story of Suárez Miranda's map and its decomposition, from the time of its creation through to a still remote future, passing rapidly by the epoch in which, in the western deserts, "despedazadas ruinas del mapa, habitadas por animales y por mendigos...".

—Jacopo Crivelli Visconti

Commissioner
Manoel Francisco Pires da Costa

Curator
Jacopo Crivelli Visconti

Production
Fundação Bienal de São Paulo

Web Site
www.bienalsaopaulo.org.br

Artists
José Damasceno
Angela Detanico & Rafael Lain

▲1 ▼2

1 **Angela Detanico & Rafael Lain,**
Alpheratz, 2007. Inkjet print on paper,
acrylic engraved with laser, 40 x 40 cm.
Courtesy Martine Aboucaya, Galeria
Vermelho, São Paulo

2 **Angela Detanico & Rafael Lain,**
Ruchbah, 2007. Inkjet print on paper,
acrylic engraved with laser, 40 x 40 cm.
Courtesy Martine Aboucaya, Galeria
Vermelho, São Paulo

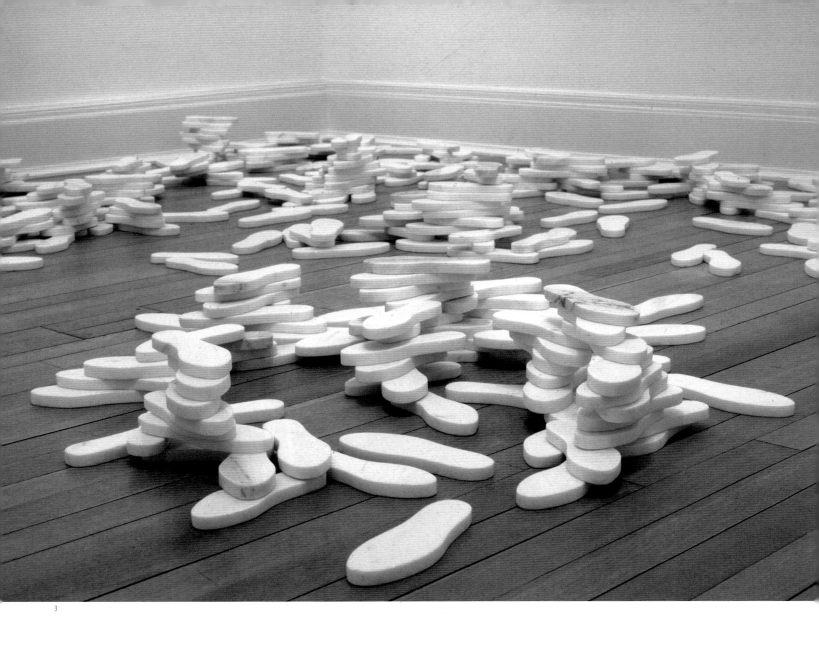

3

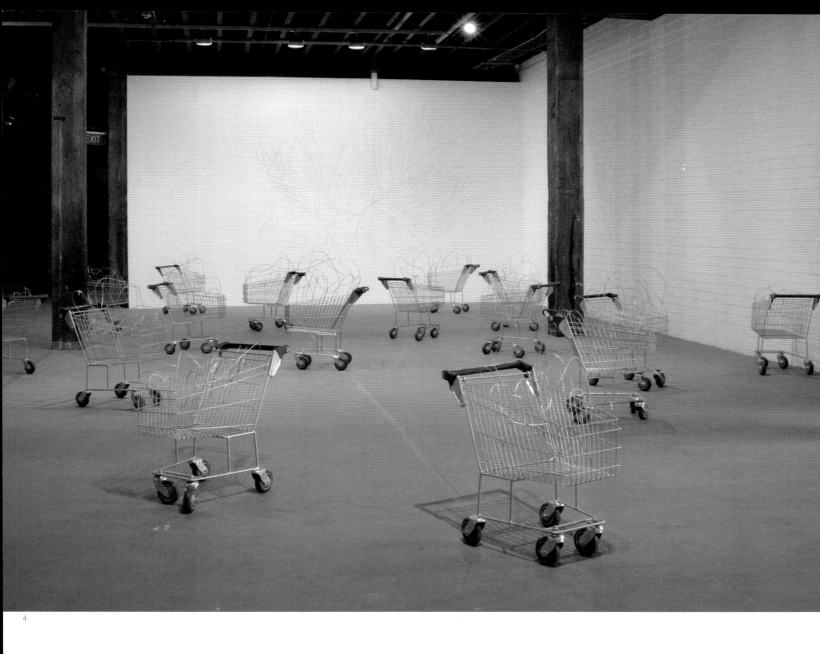

4

3 José Damasceno, *Dance Floor (step by step)*, 2006. Marble, dimensions variable. Exhibition view *Inframarket* at Thomas Dane Gallery, London. Dimitris Daskalopoulos Collection, Greece. Courtesy Galeria Fortes Vilaça, São Paulo

PHOTO THIERRY BAL

4 José Damasceno, *From another distance (morphic flip cart)*, 2006. Metal and plastic and ink on wall, dimensions variable. Exhibition view 2006 Biennale of Sydney, Artspace, each trolley 100 x 50 x 70 cm approx, wall drawing 280 x 500 cm approx. Private collection, London. Courtesy Galeria Fortes Vilaça, São Paulo

PHOTO SILVERSALT PHOTOGRAPH

Bulgaria
A Place You Have Never Been Before

When Marco Polo sailed off from the Venetian coast, he could hardly have imagined that one day his journey would be viewed as a harbinger of European colonialism and cultural imperialism. But he was of course no mere wanderer, following the whims of curiosity. His travels were part of the search for new trade routes to the East, his passion to understand and tell about the other, a tale of unheard marvels. Since Marco Polo's time no journey can claim innocence: no place, once discovered, remains the same, no tale is free of consequences.

Although Bulgaria has already participated in the International Art Exhibition in Venice – in 1910, 1928, 1942, 1964 and 1999 – we find ourselves in a new place and role presenting Bulgarian art at the 52. Biennale. In January 2007 our country joined the European Union, which represents a landmark in the transformation process Bulgaria embarked on 17 years ago. Now we find the very meaning of our participation has changed. What does it mean to be in Venice as part of a common European culture of which, until recently, Bulgaria represented the periphery?

In the space enclosed by the courtyard of Palazzo Zorzi, with its graceful Renaissance proportions, three Bulgarian artists – Pravdoliub Ivanov (1964), Ivan Moudov (1975) and Stefan Nikolaev (1970) – address the question of where we are today and try to map the terrain of the place we have not been before.

In the middle of the courtyard, over what was once a well, Stefan Nikolaev transforms an everyday object into a monument. A three-metre tall, metal-cast lighter is burning and its undying flame signals something irretrievably lost. The theme of the right to free choice, the rebellion of the individual and the refusal to accept any imposed limit can also be represented by the banal act of smoking, which in several works by this artist is treated as a gesture of individual freedom. In the film Sickkiss (2006) two characters – a young girl and an elderly man – communicate through cigarette smoke, which appears as a cinematographic metaphor for the untold, for seduction and self-destruction.

The work presented by Ivan Moudov oversteps the physical boundaries of the architectural space in an attempt to create a kind of community among the national Pavilions scattered across Venice. The artist is producing a wine specially for the 52. Venice Biennale, which will be offered at the openings of the Pavilions. His much disputed series of fragments (Fragments, 2002/05), consisting of bits of art pieces literally stolen from international museums and galleries, puts into question the history and the institutional role of the museum. The artist creates his own pilfered art collection by appropriating part of the history of contemporary art and thus legitimating his place within it.

Pravdoliub Ivanov's installations and objects are often in dialogue with space, searching for the rupture in every context, unveiling the fault in every system. His subtle interventions aspire more to tracing transformations than to imposing change. Under the slender columns and arches of Palazzo Zorzi's portico, Pravdoliub Ivanov inserts a disturbing, static object. The artist reminds us that every passage to a given space disrupts its completeness and arouses uneasiness, suggesting perhaps that the voyage towards a new place is never innocent.

—Vessela Nozharova, Dessislava Dimova

Commissioner
Boris Danailov

Curator
Vessela Nozharova

Organisation
National Art Gallery, Sofia
Ministry of Culture of Bulgaria

With the support of
UNESCO Office in Venice

Web Site
www.bulgarianpavilion-venice.org

Artists
Pravdoliub Ivanov
Ivan Moudov
Stefan Nikolaev

1 Pravdoliub Ivanov, *Pessimism No More*, 2002-2004. Installation detail. Cheese, plasters, bandages, cotton, school desks and chairs

2 Pravdoliub Ivanov, *Pessimism No More*, 2002-2004. Installation view. Cheese, plasters, bandages, cotton, school desks and chairs

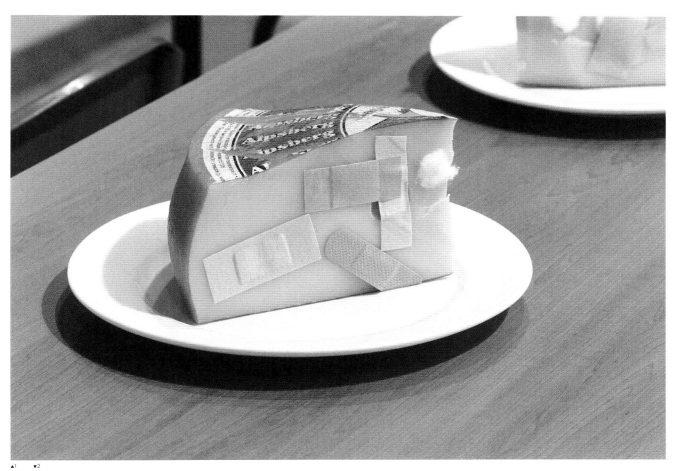

▲1 ▼2

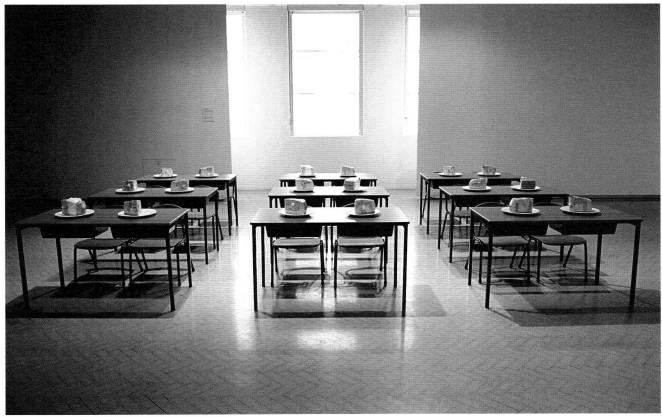

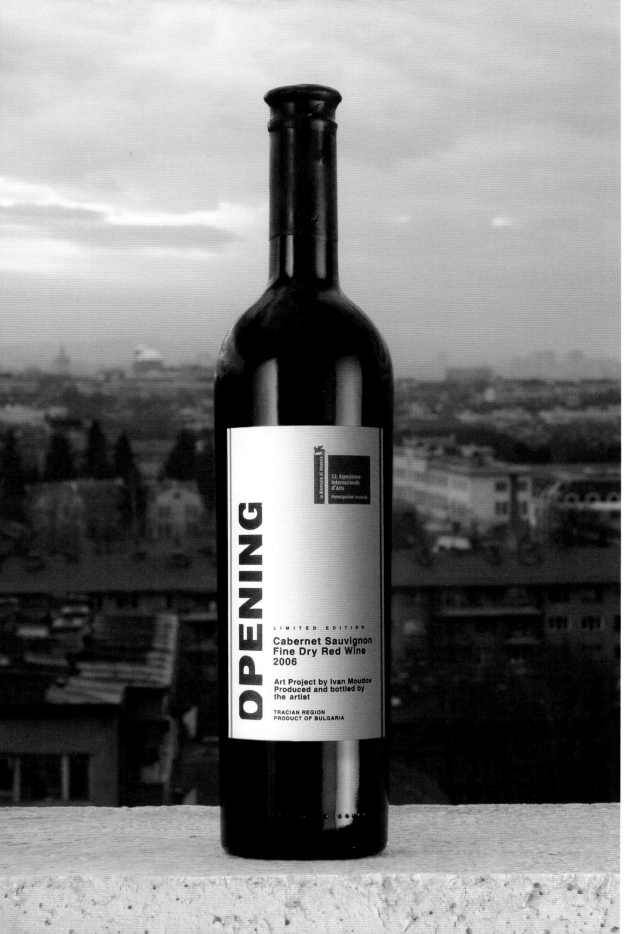

3 Ivan Moudov, *Wine for Openings*,
2006-2007. Action. Cabernet Sauvignon,
dry red wine, glass, specially produced
label, 32 x 7 cm. Courtesy the Artist
PHOTO ALEXANDER GERGANOV

4 Stefan Nikolaev, *Sickkiss*, 2006. 35-
mm film transferred to DVD, colour,
sound, 6'25'', edition of 3 + 1 A.P.
Courtesy the Artist and Galerie Michel
Rein, Paris

5 Stefan Nikolaev, *Return to glory*, 2005.
Engraved granite, gold, 120 x 77 x 30.5
cm. Courtesy the Artist and Galerie
Michel Rein, Paris
PHOTO A. MORIN

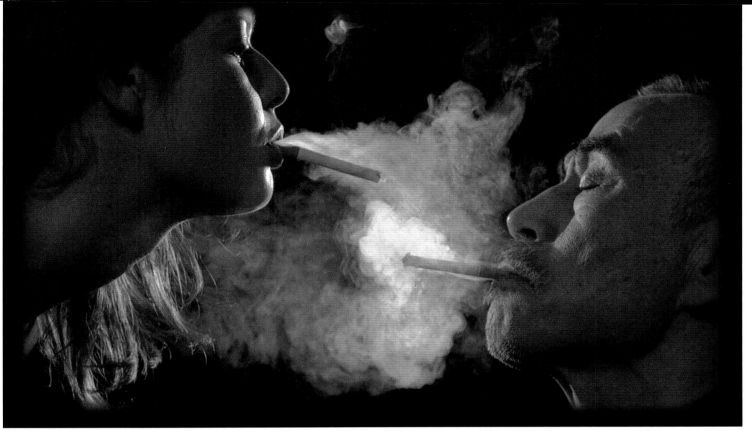

Canada

The Other Side of the Looking Glass

The work of David Altmejd forces our gaze toward strange regions, plunges us into the hollows of the imagination and allows us to glimpse a cavernous space where reality can spark its own reinvention. His sculptures present themselves as a place of exhilaration favouring sensory excess. Paradoxically, the works also exile themselves to the heart of a dense shadow that veils them in slumber, in a state of latency. It is the image of Borges's library that emerges: the galleries and well shafts, the balustrades and staircases, the bookshelves and cabinets that at once confine and reveal the richness of Babel. But Altmejd's Borgesian work is peopled with mutating half-human, half-animal creatures. The impression of improbability it creates is nonetheless transmuted by a reference to the primal instincts that are unleashed by the body, sexuality and death. The monsters, giants, werewolves and birdmen in this work concoct a fantastic zoology where the entire being – body and soul – is 'animalised' and the instability of the gaze is ceaselessly activated by an interplay of reflections, shimmers and transparency.

David Altmejd proposes the concept of energy as the catalyst of all change. He expresses what seems very close to a personal philosophy wherein nature, despite its often disturbing violence, guarantees the idealised immortality he seeks to express. Thus, he set about making, with the greatest of care, monster body parts inspired by archetypal images from stories, legends, myths and science-fiction movies. These fragments of a body, moulded in resin, coloured, then covered with hair and ornamented with synthetic flowers, birds, crystals, jewellery, beads – are enough like the human body to constitute a strict referent to it, a mysterious allusion, to the point of cracking symbolic power wide open.

The project he has created for the Venice Biennale consists of two works. *The Index* enters into a particular resonance with the architecture of the helicoid Pavilion, designed in keeping with an architectural philosophy that favours implanting a building organically in its natural setting, its windows opening onto a small grove in the Giardini Pubblici. The artist immediately associated the building's peculiarities with an aviary function, imagining it as a shelter where birds can safely nest, feed and reproduce. The work is made up of various structures and bridges of wood, steel and mirror glass, layered, interconnected and assembled. They are inhabited by flocks of stuffed birds, birds fabricated from materials at hand and fragmented bodies of half-men, half-birds, the whole richly ornamented with tree sections, quartz crystals, mirror shards and so on. The imposing sculpture lies in a glass display case with mirrored sides, which exacerbates its formal and material possibilities. The work itself becomes an architectural space, a sort of habitat that, like a glove turned inside out to show its structure and form, reveals its cavities and protuberances, its solids and voids, its mysteries and truths. The title, *The Index*, refers to the principle of collection and the diversity of species, to their classification and organisation into an avifauna with an internal balance that ensures the perpetuity of this system, which may indeed refer to the ineluctable unity of all life.

On the far side of a living tree housed in the Pavilion in a glass structure is a second work – an imposing giant that sits upon the ground. Though set off in a more isolated space, it is extremely present because of its visual luxuriance, attended by all manner of stuffed and sculpted birds nesting in it. *The Giant 2* acts like a body inhabiting space, but unlike *The Index*, looks primarily like a habitat in itself. This immense body is a welcoming space, the inviting cavities offered by its head and chest aswarm with wildlife ensuring its own survival.

—Louise Déry

Commissioner
Louise Déry

Artist
David Altmejd

David Altmejd, *The Giant 2*, 2007.
Foam, magic sculpt, paint, wood, glass, decorative acorns, taxidermy animals, Plexiglas, mirror, lightning system, glitter, silicone, quartz, pyrite, decorative chicken feathers, horse hair etc., 275 x 215 cm. Collection Courtesy Andrea Rosen Gallery, New York, and Stuart Shave, Modern Art, London

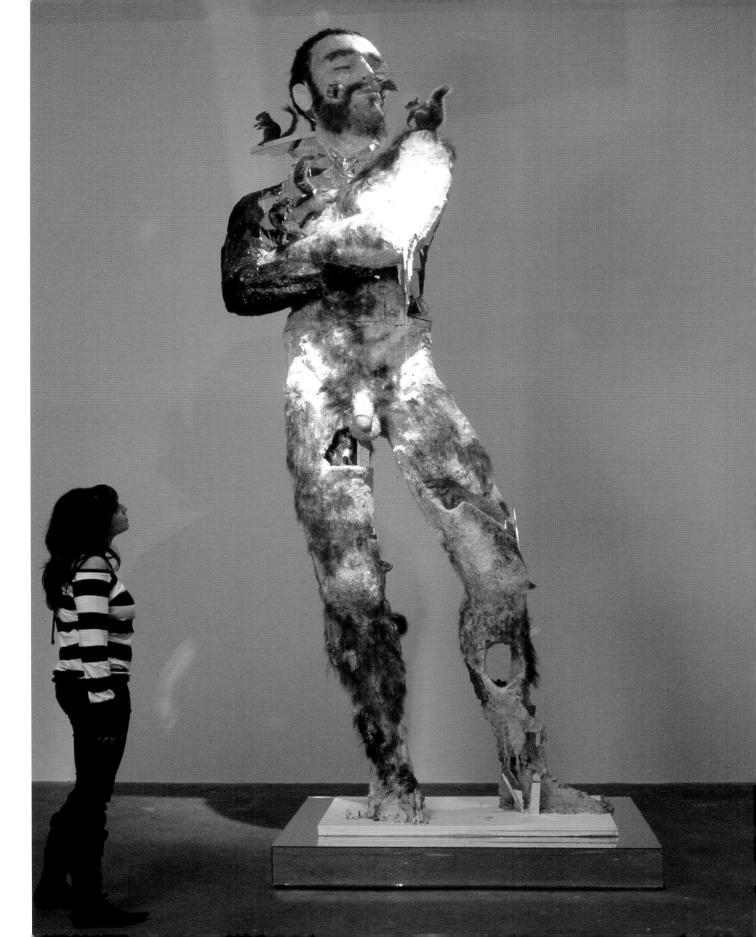

Croatia
Latency

Second Spaces

Ivana Franke studied graphic arts, which substantially influenced her overall art strategy. Regardless of the fact that this young, extremely sensitive artist finds live spaces more attractive – whether she constructs new ones or moves into someone else's already existing ones – her experience in graphic arts is decisive in the production of visually discreet ambiences.

Architecture is, therefore, a domain or medium of her research, ranging from the museum rooms in which a close crash between electric lamps and fake crystals produced a series of mirages in front of curious visitors (MSU, Zagreb, 2005), to the white rooms interwoven with fishing lines, transparent adhesive tape or neon. In the process, at certain venues (PS1, New York, 2001) she left visitors a choice as to whether they would enter such a room or not, while at another one (MSU, Zagreb, 2003), she strictly forbade any entrance whatsoever. As a member of an art team at the 9th International Architecture Exhibition (Arsenale, Venice, 2004) she offered visitors a unique experience – a walk, at their own risk, through a mechanical tunnel made of glass lamellae. Even when her interest returned to specifically graphic work, such as catalogue design and publishing transparent art books, a spatial complex remained an unavoidable production feature. Though maybe not as obvious at such points, this feature is crucial for comprehending Ivana's artistic *credo*.

She borrowed a model of graphic behaviour in space from the artists who, during the 1960s, gathered around *Nove tendencije* (*New Tendencies*) exhibitions. At those times the European modernists' optimism and intense faith in the healing power of architecture spread throughout the world. So it is not strange that Ivana Franke, adopting one-time modernist optics, simultaneously embraced that strategy's more important part – confidence in architecture that heals and provokes, that transforms both perception and social context. Though her interventions in museums, exhibition venue courtyards and public spaces are mild and unobtrusive, and demonstrate formal nature when taken at face value, it is impossible to exclude the above-mentioned options. No doubt the latter should include the ritual nature of Franke's ambiences and their refined provocation, since visitors must take a risk to experience the threatening sharpness of a fishing line or glass lamellae on their own skin.

The expert board of the Fondazione Querini Stampalia offered Ivana Franke a choice between two spaces. The first of these, the Scarpa area, is extremely sophisticated and defined – and stimulating as well – being part of Italy's 1960s cultural heritage. The other is the compact, rudimentary, eight-metre high Mario Botta Auditorium, also on the ground floor.

The artist quickly opted for the Scarpa area. Her spatial grid has recently most often been luminous or transparent, colourless and discrete. At a certain point she even considered intentionally flooding the sophisticated ground floor. One thing is sure – Franke is going to stigmatise a cold museum organism with her grids, to the extent that curious visitors will be able to perceive the contours of the second space.

—Željko Kipke

Commissioner
Željko Kipke

Curator
Branko Franceschi

Collaborators / Organisation
Petar Mišković
Silvio Vujičić

Web Site
www.mmsu.hr/maljkovic

Artist
Ivana Franke

1 Ivana Franke (In collaboration with Damir Očko and Silvio Vujičić), *Floor*, 2005. Textile, glass pearls, 9 light bulbs, 2,000 x 250 m. Installation view, Museum of Contemporary Art, Zagreb. Filip Trade Collection of Contemporary Art. Courtesy the Artists
PHOTO KRISTINA LENARD

2 Ivana Franke, *Projection*, 2006. Fabric, metal construction, 3 slide projectors, slides, 520 x 520 x 520 cm. Installation view, Mochvara, Zagreb. Collection of the artist. Courtesy the Artist
PHOTO IVANA FRANKE

3 Ivana Franke (in collaboration with Petar Mišković, Lea Pelivan, Toma Plejič), *Frameworks*, 2004. Steel construction 632 x 664 x 315 cm, glass frames 250 x 250 x 3 cm (93), electric motor 1.1 kW, concrete platforms 120 x 120 x 30 cm (2). Installation view, Arsenale, Venice. Museum of Contemporary Art, Zagreb. Courtesy the Artists
PHOTO ROBERT LEŠ

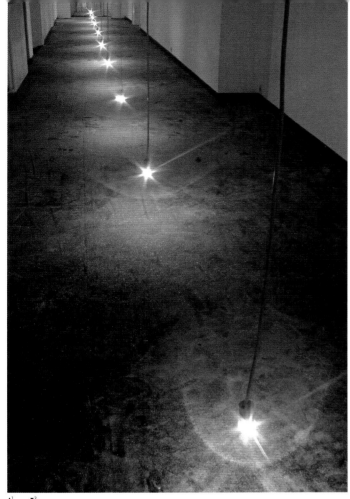

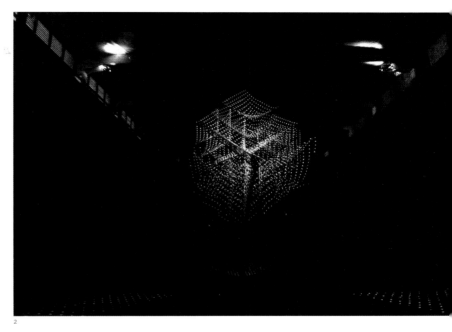

Denmark
Troels Wörsel

Troels Wörsel's painting addresses the art of painting. Whereas his first works were influenced by late 1960s Pop, Minimalism and Concept Art, he subsequently opposed his roots: since the late 1970s, he has developed a vein of painting which represents an uninterrupted, expansive declaration of love of painting on the one hand and a deeply reflected investigation into the essence of painting on the other.

From Pop Art we recognise the many everyday scenes and photographic source materials: signs, wine labels, city maps. From the realm of concept art and from his experiences with Zen painting, Wörsel retains an ideal ambition to be 'styleless', meaning that he very deliberately seeks to abolish all traces of himself in the painting.

In 1986 Wörsel published the small, yet pivotal volume *Notes come & go* (T. Wörsel, *Notes come & go I-III*, Galerie Fred Jahn, Munich 1986). It was written at a time when painting had (yet again) become the artistic mantra of the times. The treatise sums up the experiences accumulated by Wörsel since the watershed year of 1977. *Notes* is, then, a manifesto in which Wörsel systematically breaks down the mythology and confusion, both linguistic and conceptual that surrounds the celebrated and notorious medium of painting.

Wörsel's works deal with the semantics of painting rather than with its formal properties. The art of painting is not used to present or promote personal beliefs or emotions. Nor does one find ideological or dogmatic attitudes on how the art of painting should be practised. In this respect his oeuvre constitutes a systematic investigation into the art of painting – and an open dialogue with the great masters of art history.

Troels Wörsel has a vibrant relationship with art history. He feels, entirely without any excess of sentiment, part of the history of painting. Indeed, his paintings combine innovation and experimentation with a striving towards a classical, monumental idiom.

In 1985 Troels Wörsel began work on his so-called 'food pictures'. The fact that they were actually about roasting foods and making sauces, thus being allegories of the painterly process, was not immediately apparent; in fact this information was only available to those who read a small pamphlet published the same year. Wörsel had created an updated version of Marcel Duchamp's *The Large Glass* (1915-1923), where the images can only be understood if one reads the information in his *Green Box*.

The series of food pictures was originally conceived as a single, long image that presented an allegorical summarising of the artist's thoughts about painting. Such summing up, 'the grand image' with a grand theme has always captured Troels Wörsel's attention. An example is *Der Rauch geht zu den Schönen* from 1983. The image measures 200 x 900 cm and is held entirely in black and white. The source material is a poor-quality satellite image which gave Troels Wörsel an opportunity to address one of the great, most fruitful problems of painting: the relationship between figure and background.

In 2003 Wörsel exhibited a series of paintings that addressed the same issue with playful, teasing elegance. Here, all subject matter is painted onto the back of the canvas and across the stretcher. The subject matter itself is words in Italian painted in reverse, as mirror images, often onto yellow or green surfaces. On the one hand the reversed words indicate the creation of an illusionistic space: we see them 'through' the canvas, supposing them to have been painted onto the front side of the canvas. On the other hand the entire stretcher is incorporated into the painting, creating a real-life three-dimensional quality that imbues the piece with an object-like feel. The works recall Dutch trompe l'oeil paintings from the 17th century and belong to the considerable part of Troels Wörsel's oeuvre in which he establishes a dialogue with great masters of painting, e.g. Velázquez, Degas, and Francis Picabia, updating important aspects of their painterly works. In doing so, Wörsel pulls history into an ongoing, vibrant discussion of contemporary painting.

—Holger Reenberg

Commissioner / Curator
Holger Reenberg

Deputy commissioner
Stinna Toft Christensen

Assistant curator
Thilde Nyborg Nielsen

Project manager
Anette Østerby

Coordination and organisation
M+B studio

With the support of
Danish Arts Council - The Committee for International Visual Art

Web Sites
www.danisharts.info
www.venedigbiennalen.dk

Artist
Troels Wörsel

▲1 ▼3

2

▼5

▲4 ▼6

1 **Troels Wörsel**, *Untitled*, 2006. Acrylic on canvas, two parts, 200 x 200 cm each. © Troels Wörsel

2 **Troels Wörsel**, *Untitled*, 2007. Acrylic on canvas, 250 x 200 cm. © Troels Wörsel

3 **Troels Wörsel**, *Untitled*, 2006. Acrylic on canvas, 180 x 300 cm. © Troels Wörsel

4 **Troels Wörsel**, *Untitled*, 2007. Acrylic on canvas, 250 x 200 cm. © Troels Wörsel

5 **Troels Wörsel**, *Untitled*, 2004. Acrylic on canvas, 180 x 150 cm. © Anders Sune Berg

6 **Troels Wörsel**, *Untitled*, 1996. Acrylic on canvas, 180 x 150 cm. Kunsthalle Kiel, Germany. © Planet/Bent Ryberg

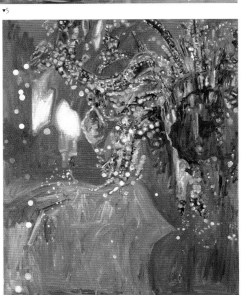

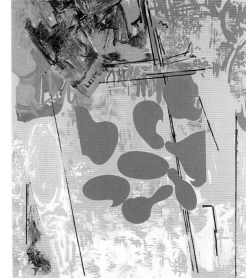

Egypt
Egypt... source of civilisation... and junction of cultures

Knowledge and information technology, means of communication and media are playing a very important role in bringing the Earth's inhabitants closer. In spite of our recognition of the many privileges presented by this tremendous scientific progress, it reveals daily the extreme contradiction between human cultures. It also reveals the weakness of the spirituality that controls people's humanity. The cold war between east and west ended many years ago, but it seems that the means of ending it and settling its results have induced and cultivated many events that target the nobler and more beautiful side of man. The way this war was ended negatively affected man's nature, innocence and will, along with the intrusion of religious cultures into this cursed political strife. There is currently a sharp contradiction between amazing scientific progress and recognised human, spiritual and ethical regression. The world is now experiencing the problem of simultaneous scientific association and spiritual and cultural dissociation.

The Egyptian Pavilion at the 52nd Venice Biennale adapts a concept connected to this cultural dilemma 'Egypt ...source of civilisation and junction of cultures' through a collective work by six young Egyptian artists: Haiam Abd El-Baky, Sahar Dergham, Ayman El-Semary, George Fikry, Hadil Nazmy and Tarek El-Koumy.

These artists closely feel the current world state and are dealing with the cultural aspects that form their sentiments and conscience.

They have adapted the intellectual concept of the Pavilion that regards Egypt as the place where the first identification and differentiation of human conscience took place and was the primary place for accepting diverse cults, cultures and civilisations for more than 5000 years. Egypt welcomed the prophets Abraham, Joseph, Moses and Jesus – peace be with them – and established in Alexandria a variant society that embraced Roman and Greek cultures along with ancient Egyptian culture. It also blended and created homogeneity between Jewish, Christian and Islamic cultures. The six artists are adapting Egypt's old civilisational message and agree on giving art a positive attitude. They agree on receiving the positive and forgiving aspects in Egypt's soul and its spiritual warmth to recirculate to contemporary Egyptians and the whole world. This installed work in the Egyptian Pavilion is the result of group and individual efforts. They inspire good, cheerful and hopeful deeds, those invoked by wisdom and a brave disposition. The Egyptian Pavilion has arrived with a message for the future that helps restore trust between different cultures and ensure the connection between past, present and future. The artists have brought thousands of significant material pieces with them from Cairo, Alexandria and Giza to form and construct this huge work, which is huge in meaning and message, and embraces much passion and melancholy.

—Farghali Abdel Hafiz

Commissioner
Farghali Abdel Hafiz

Deputy commissioner
Khaled Sorour

Web Site
www.egyptvenicebiennale.com

Artists
Haiam Abd El-Baky
Sahar Dergham
Tarek El-Koumy
Ayman El-Semary
George Fikry
Hadil Nazmy

The Egyptian Pavilion at the 52nd International Art Exhibition is composed of an installation of words in two parts – one chart and six towers in the hall participate in the construction of the six Egyptian artists' work and include collective action on several areas such as painting, digital imaging, digital audio and sculpture. The other work has been carried out as a whole with 'Greed', which is the raw Egyptian material located throughout Egypt, especially in rural Upper Egypt, a palm branches widespread in Egypt. With the formation and installation of the six artists in addition to several other raw materials such as cotton, paper, stone, wires and electrical equipment, voice and other things, the work is finally seeing one involving six towers in the vicinity of each wing, where the single artist separately identify functional vision in each tower to be working at the end to form the installation

Estonia
Loser's Paradise

The World's Most Naive Artist

Marko Mäetamm has a confession to make. He wants to tell it all, and he wants us to listen to his worries and problems. Mäetamm is confused, he feels weak and almost completely inadequate when facing the demands and challenges of the contemporary world. He is afraid of failing, of losing his job, of not being able to pay his bank loan. He feels miserable without his wife and kids but feels equally unhappy when being with them. In other words, Mäetamm seems to be in a deep mess. But hold on, are these confessions as works of art true? Does he really mean it? Sure, of course they are both-and. These litanies of failures of coping with modern life are obviously and painstakingly as true as they are blue, but at the same time, they are also something else. They are stories made, re-shaped and coloured by a wide variety of white lies.

The project Marko Mäetamm presents at the Estonian Pavilion has the title of *Loser's Paradise*. A title that again simultaneously tells it all while quickly camouflaging the actions and covering their traces. It is a project that constantly and with amazing coherence plays with the double act of telling and showing it all and not telling and showing anything at all. With the strategy of going head on against our contemporary problems, Mäetamm is able to combine something personal with something very common and general.

I don't think Mäetamm is actually doing it for us – a kind of biblical character for taking the blame and facing the blows for others. He is much too smart for this, and much too clever. He certainly has the magic touch of orchestrating and constructing an identity within a specific and particular site of a story. When taking on the role of the world's most naive artist, he must have sensed a kind of liberating relief. He lets us think that he pours it all out, claiming that 'I have a great feeling of helplessness, I don't know what to do...'

And sure, there is no way of denying it. Mäetamm feels like a murderer. He dreams of houses that burst out with blood and terror. He does think he is worth nothing at all. But the irony, the deep-seated pleasure of the whole act of acting as naive as possible is the trick of turning it all around. Whining and moaning, he gets closer to all the things that he dislikes and fears in his daily life. At the end, he has crawled into a position where he is so small and so vulnerable that it is impossible not to feel pity for and anger at him. We are confronted with such an amount of sentimental trash that we simply can't take it anymore. We need to consider violence, we need to look for the chance to lurk behind this annoying artist and really give him the kick he deserves.

But no, we will not do it. We will walk through the rooms at the Pavilion, and we will get more confused, more surprised, more annoyed and also more entertained. Slowly but surely, the more time you spend with his paintings, sculptures and videos, the more you will appreciate that this is all not that serious. It is a carnival. Admittedly, it is a very peculiar type of a carnival. A celebration of failure – but, please pay attention, not in order to fail more, or even to fail better, but as an act of private and public disgrace. It is about subtle humiliation done by free will. It is a carnival of the most clever kind. A carnival that in a perverse way turns out to be a very accurate and effective way of criticising the contemporary ideology of market-led one-size-fits-all consumer culture. By carefully bringing up all the ways Mäetamm cannot cope with the demands of the culture of all-encompassing consumerism, he not only articulates the ways he is completely useless to the system, but how he, step by step, liberates and distances himself from the semi-fascist orthodoxy that anything and everything in our daily life world must be products we sell, trade, buy, steal, confiscate, recycle and throw away.

Mäetamm's *Loser's Paradise* is full of hope. It shows us a way out of the current demagogy of no alternatives. There is always a choice, always a way out. Always something to hold on to, always something to be told to someone else that makes all of us feel a little bit less lost and lonely.

—Mika Hannula

Commissioner
Johannes Saar

Curator
Mika Hannula

Deputy commissioners
Andris Brinkmanis
Elin Kard

Web Site
www.cca.ee

Artist
Marko Mäetamm

1 Marko Mäetamm, *Bear*, 2006. Plywood, rubber, plastic, moleskin, 120 x 200 cm. Courtesy the Artist

2 Marko Mäetamm, *No Title*, 2006. Video on DVD, b/w, with sound, 11'49''. Courtesy the Artist

3 Marko Mäetamm, *Sand-box*, 2006. Plywood, wood, sand, toys, 230 x 150 cm. Courtesy the Artist

There's constantly less and
less time to do art – a few hours
in the morning before going to work
and in the evening after 17.00,
when I should actually go home and
spend time with my child

Former Yugoslav Republic of Macedonia
Logical Paintings

Matrices and Edges

Logical paintings is a project based on the mobility and permutation possibilities of (basically) one element whose structure can be multiplied in numbers and combinations allowing an infinite number of particular realisations. Because this building element is often arranged in large linked series, the appearance of the particular elements can never be the same. One gets the impression of looking at a black body that creates 'a strong presence in space'.

Blagoja Manevski's intention was to make a system that could always deliver certain meanings – in the form of particular projects in certain (gallery) rooms, but also in any other positions or conditions the *Logical Paintings* might appear, intentionally or accidentally. Their structure is meant to provide those who will relate to them with a constant fluctuation of possibilities.

Besides the numerous variations in his atelier, *Logical Paintings* there have so far been two presentations in the form of installations, objects or buildings: in 2002 at the Museum of Contemporary Art in Skopje, titled *Logical Paintings – Different Rooms, Different Voices* and in 2006 at the Museum of the City of Skopje titled *Logical Paintings – Here and Now*. When reviewing these artworks, as with all the other works by this artist, we must bear in mind the certain influences of minimalism, which Manevski often uses as a direct, immediate influence on the viewer. As he has done many times before, in these projects he produces certain kinds of dark bodies or surfaces areas that must immediately make contact with anyone who is in the room where they are displayed. But it is only a beginning of the relationship with them. When referring to this artist's artworks, art criticism in the Republic of Macedonia often implies the existence of edges, that is, the joining of different elements and 'double coding' that constantly prevents the particular form or attitude from acquiring any kind of completed form. In that sense the *Logical Paintings* are artworks of joining edges that require new bodies of their own.

Manevski's latest achievements are aimed at following the basic structure of the applied matrix and are constantly in the dimension of monotony. Rhythm is avoided because of the deforming effect of 'the usual run of time' which should be interrupted in these artworks as seldom as possible. The artist needs a real object, body, building in space that will tend or intend, even wish to displace the viewer from the position of receiving a manipulated artefact in order to help her/him, or ease the illusion that she/he is in front of an object that is usual and logical, in the sequence of other objects around her/him.

In the end we must point out that Blagoja Manevski's *Logical Paintings* offer the possibility of being perceived in a free association game. They are a kind of plastic riddle. It is possible that they imply a parabola on the identical nature of all matrices. In the spaces they produce, in search of the edges of new possibilities, in the field of sameness, we recall the words of a mystic, whom children hate to study: 'You will realise, inasmuch as is possible for a mortal, that nature is similar to itself in everything'.

—Lazo Plavevski

Commissioner
Frosina Zafirovska

Curator
Lazo Plavevski

Deputy commissioner
Jovan Šurbanoski

Organisation
Museum of the City of Skopje

Artist
Blagoja Manevski

Blagoja Manevski, *Logical Paintings (Different Rooms, Different Voices)*, 2002. Installation, 2 x 630 x 420 cm, realised in the Museum of Contemporary Art, Skopje. Courtesy the Artist
PHOTO LAZO PLAVEVSKI

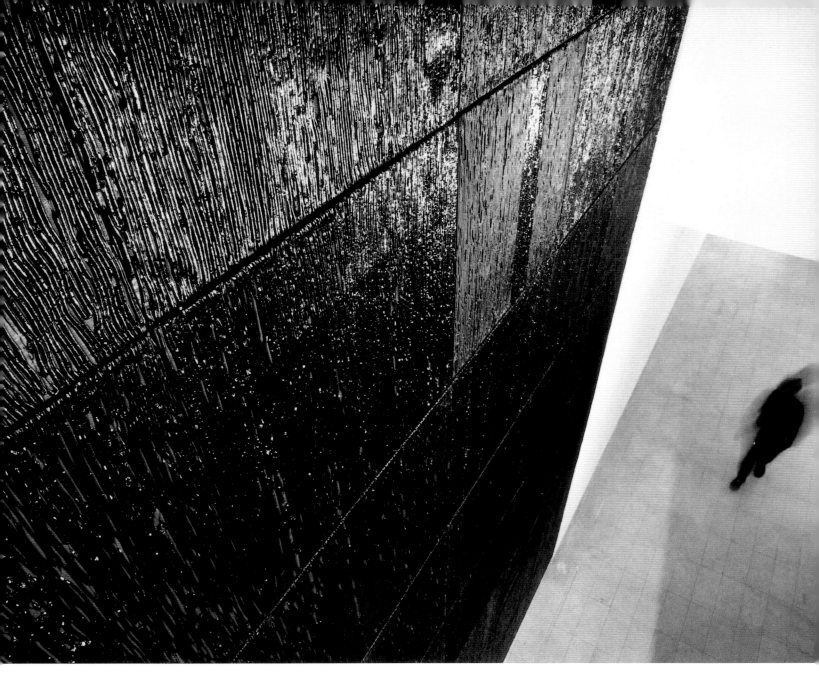

France
Take Care of Yourself, 2007

Place here classified advertisements by Sophie Calle:
images 9 & 10

Traditionally, the authorities select a curator, who is then given a free hand to invite the artist or artists of his/her choice.

When it comes to the French Pavilion though, over the past ten years or so these same authorities have reversed the rules.

They invite an artist, who in turn invites the curator of his/her choice to come and support the venture.

Until Sophie Calle came along, all of the artists invited under this arrangement had in turn invited someone from the 'establishment', generally from an institutional background.

Theirs was a perfectly logical choice: banal even and traditional.

In their desire for the best possible support, it is only normal that artists choose from among the art world's most influential and significant professionals.

Sophie Calle has turned all this on its head.

For the first time ever, an artist has taken advantage of the opportunity offered to her to call the offer itself into question!

In penning her classified advertisement, she highlights a number of issues and raises as many questions.

First and foremost, she displays a magnificent refusal to be bound by what is established, and a supreme detachment.

She also displays – and with great finesse – a rather caustic sense of humour.

Is there anyone who didn't smile, or even laugh out loud, on reading her ad?

Is it a joke? Is it serious?

But as we all know, Sophie is curious, very curious.

In this case, she watches, waits and designates.

She also seems to ask: Who will be bold enough to offer their services? Who won't be? Who will accept grappling with illustrious nobodies? Who takes a real interest in my work?.

Her advertisement also suggests that perhaps she doesn't really need a curator; that she doesn't really subscribe to such a request.

Do I really need a curator? she asks. Is it really essential?

With simplicity and even a sort of childish candour, her advertisement nonetheless poses a series of essential questions on the position of the artist in our society and in the artistic community itself.

And this in itself is none too common, at a time when the prevailing cynicism would appear to have banished this sort of questioning.

As soon as I read this advertisement, it struck me as the beginnings of a project, just like Sophie Calle's 'operations'. It was as if, a year before the opening, she was already making her public entrance into the 52. Venice Biennale. More importantly though, it struck me as a critical expectation, challenging what others expected of the artist's choice.

Instead of rushing off to choose the best possible professional curator, as was expected of her, Sophie Calle launched an open competition; anyone bold enough to reply does so at their own risk.

Sophie Calle's advertisement posed the problem of the curator/artist relationship and left the way open for people other than curators or critics to apply.

So I replied, with all the seriousness required to join in someone's game.

Over 200 people did likewise and Sophie Calle finally opted for me: an artist/artist partnership.

—Daniel Buren

Commissioner
CULTURESFRANCE, with the
collaboration of DAP/CNAP

Guest curator
Daniel Buren

Production
AIA Productions

Artist
Sophie Calle

Sophie Calle, Advertisement *Libération*, 16 June 2006. Courtesy Galerie Emmanuel Perrotin, Paris; Arndt & Partner, Berlin; Paula Cooper Gallery, New York; Gallery Koyanagi, Tokyo

LIBERATION

VENDREDI 16 JUIN 2006

LIBERATION.COM/EMPLOI

emploi

Contact → Julie Le Bihan (01 44 78 30 00)

culture

enseignement

Sophie Calle,
artiste sélectionnée pour
représenter la France à la 52è
Biennale d'art contemporain
de Venise, recherche toute
personne enthousiaste pouvant
remplir la fonction de
Commissaire d'Exposition.
Références exigées.
Rémunération à négocier.
Anglais courant souhaité.
Envoyer CV et lettre de motivation
à scbiennale@galerieperrotin.com

Le lycée autogéré de Paris
rech pr année scolaire 2006-2007
plusieurs enseignants de l'EN,
volontaires pr participer à une
expérience pédago. originale
(gestion établissement) sur postes
ou demi postes susceptibles
d'être vacants en anglais, espagnol,
arts plast/ciné.
Envoyer CV + lettre
de motivation au LAP, 393 rue
de Vaugirard, 75015 Paris
Tél. : 01.42.50.39.46/47

Contact → Mustapha Ouamrane (01 44 78 30 03)

formation

formation@espaces.liberation.fr

Georgia

The Georgian Pavilion at the 52nd International Art Exhibition in Venice presents projects and works that seem largely different from one another. It is not only artistic taste and world outlook that distinguish the featured artists, but also a range of modern and traditional means and media they use in their works. The art of Georgia has always been remarkable for its diversity and originality. Rooted in local traditions, Georgian art has also benefitted at different times from foreign styles and movements. Contemporary Georgian art is trying to establish itself on the world map of art. The Georgian artistic community has certainly become much more 'open' than it was in previous decades. Contemporary art is being built on an analysis of the past, a revision of values and a search for and adoption of new forms and media, with frequent instances of blind imitation, along with the desire to maintain local values, traditions and aesthetics. Contemporary artists respond differently to the social, political and cultural processes unfolding in their country. The works presented at the exhibition only partly reflect the creative processes taking place in contemporary Georgian art.
Eteri Chkadua has been living in the USA since 1980, when she left Georgia. The artist remains faithful to traditional artistic media, painting her medium-sized and large realistic figures on canvas with brush and paints in a manner that largely relies on the experience of a generation of earlier artists and was taught to her at the Georgian Academy of Fine Arts. Eteri Chkadua creates a hybrid of New York, Jamaican, Miami and Georgian impressions. She portrays a woman's world as seen by a woman – a multi-layered form with a polished surface beyond which one can read impulsiveness almost bordering the primitive state. Hallucinatory perception echoes her emotions and impulses.

'My image of a woman is simultaneously characterised by ethnic-, pop-art-, tourism- and emigrant-related elements. It has become universal as I have made geography and time vanish'.
The RE-TURN project by Tamara Kvesitadze, with co-artists Paata Sanaia and Zura Gugulashvili, consists of one installation and several mechanical figures. The materials used are fibreglass, metal and mechanisms. The mechanical figures represent the process of transformation in movement, which is reflected in their surroundings. The concept of the work is based on the correlation between the mechanical and organic.
'Mechanical vs. organic. Organic nature of the mechanical – orderliness of the organic – mechanical nature of the orderliness'.
Sophia Tabatadze portrays the state of a human being with architectural forms. Her interpretation of architecture goes beyond the primary meaning of the word. In her project entitled Humacon Undercon, Tabatadze shows human traces in an urban environment that has become thoroughly inhuman. To underline this imbalance, she emphasises certain details, leaving others uncompleted. She aims to show our inability to perceive things in their totality – a totality that includes space and time. It is this inability that lies behind our present condition of constant amnesia in which we choose to overlook certain aspects of our collective past.
'My work draws on the urban environment and the things that happen in it. In order to bring these happenings close to myself I process them through my own body by physically making work about it. By doing so I try to accept my surroundings at a time when their aesthetics and directions do not match with mine!'.
—Nino Tchogoshvili

Commissioners
Paolo De Grandis
Zviad Mchedlishvili
Manana Muskhelishvili

Curators
Tamara Lortkifanidze
Nino Tchogoshvili

Organisation
Ministry of Culture, Monument Protection and Sport of Georgia

Organisation in Venice
Arte Communications

Web Site
www.georgianseason.ge

Artists
Eteri Chkadua
Tamara Kvesitadze with Paata Sanaia and Zura Gugulashvili
Sophia Tabatadze

1 Eteri Chkadua, Madness, 2006. Oil on linen, 134.6 x 165.1 cm. Collection Gian Enzo Sperone, New York. Courtesy Sperone Westwater, New York

2

2 Sophia Tabatadze, *Humanconone*,
2007. Fabric, silkprint, black-white print,
embroidery, ink, dimensions variable.
Courtesy the Artist

3 Tamara Kvesitadze with Paata Sanaia
and Zura Gugulashvili, *Sitting Man*,
2005. Fiber glass, mechanism, 95 x 80
cm. © the Artist

Germany
Oil

About Isa Genzken

For over thirty years, Isa Genzken has been creating a multi-faceted oeuvre, which is continuously developing and revealing new approaches. Her extensive body of work consists of sculptures and installations, photographs, collages and films. For the German Pavilion, Isa Genzken has developed a site- and context-specific work over the course of one year. The commissioner of this year's German Pavilion, Nicolaus Schafhausen, says of the artist: 'Isa Genzken is one of the most uncompromising artists of today. She captures current times like practically no other contemporary artist'.

Isa Genzken is a sculptor. However, this seemingly simple realisation is relatively complex in view of her work, in which the classic concept of the genre of sculpture is both questioned and reinforced. 'We are very fortunate to have this artist', says Schafhausen. 'She introduces her viewers to new and complicated correlations. She discusses matters that truly move and affect us as a society'.

The choice and combination of different materials are of great significance in Isa Genzken's works. She finds the necessary 'components' at DIY centres, architecture supply shops and department stores. While she previously worked mainly with wood, plaster, epoxy resins and concrete – the substances of modernity – she now favours plastic, synthetic materials and a large variety of mirrors. She also uses basic commodities and consumer goods, such as classic designer pieces, as well as cheap camping furniture, pieces of clothing, kitschy figurines, plastic dolls and animals. The unusual combination and precise settings and arrangements of these materials result in fragile yet monumental constructions reflecting the surrounding world and the frailty of human existence. In this way, Isa Genzken dissolves formally and conceptually rigid structures and ideas with an unrestricted freedom.

Her oeuvre explores the space between publicity and private artistic autonomy. It reveals the interface where personal feelings touch on universality. During a conversation with Wolfgang Tillmans, Isa Genzken explained what a sculpture should look like in her opinion: 'It should have a certain connection with reality. That is to say, not muddle-headed and certainly not made-up – sort of off the mark and polite [...] a sculpture is actually like a photo – it can be crazy but it must also include an aspect of reality.' (*Camera Austria*, No. 81/2003)

The aesthetic understanding apparent in Isa Genzken's work stems from a multi-dimensional framework of references, commenting on social as well as artistic notions. Isa Genzken's 'productions' have a strong theatrical element, which challenges the viewer both intellectually and emotionally. For her, life and existence are just as complex as art itself. Her creative work stands in contradiction to a 'one-trick pony' society and culture, which searches for happiness in simple answers. This is perhaps why she is so important and influential to so many international artists of subsequent generations.

Commissioner / Curator
Nicolaus Schafhausen

Assistant curator
Sophie von Olfers

With the support of
The Foreign Office of the Federal
Republic of Germany

Organisation
Germany's Institute for Foreign Cultural
Relations

Sponsors
Deutsche Bank
Media partners are DW-TV Deutsche
Welle and Vogue Germany

Supported by
AXA Art Kunstversicherung AG and
technically realised by the production
team of Witte de With, Center for
Contemporary Art

Web Site
www.deutscher-pavilion.org

Artist
Isa Genzken

Isa Genzken, *Oil*, 2007, detail. Mixed media, dimensions variable

Japan
Is There a Future for Our Past? The Dark Face of the Light

Ours is an age caught in a paradox about time. On the one hand, advances in science and technology have enabled us to know history in greater detail, replicate it more accurately, and restore and preserve it better than ever before. On the other, that same history is under unprecedented threat of annihilation from pollution, regional conflicts, and the increasingly high-paced and urbanised society that rapid globalisation and population growth are engendering. Our civilisation is simultaneously discovering and erasing the past. As the proliferation of information technologies in late capitalism brings profound changes both materially and in our memories and records of the past, humanity now faces important questions about how to pass on its common heritage to future generations.

Centering around key examples of the lifework series of frottages by artist Masao Okabe, this exhibition will consider, from the viewpoint of art, the possibilities and conditions for preserving humanity's past into the future. The subject of the frottages is Hiroshima's Ujina district, which was once a major military port. From the Sino-Japanese War of 1894-1895 until World War II, the port train station was a gathering point for masses of cargo and people bound for other parts of Asia, and also became one of the sites affected by the atomic bombing of the city. Okabe spent nine years making some 4,000 frottages of the curbstones of the station platform. The station has since been demolished to allow construction of an expressway, but with the elemental tools of pencil and paper Okabe has recorded a piece of what once was.

Ujina's past makes it an evocative focal point for rethinking Japan's place in Asia today. In addition to holding exhibitions and conducting numerous workshops involving local residents in different parts of Japan, Okabe has sent frottage impressions of historical remains as aerograms to and from different parts of the world. Through these imprints of the surfaces of things, he guilelessly demonstrates the joy of discovering the unexpected aspects they can reveal. But beyond the level of fun, this work points to clues that can aid contemporary humanity in its search for ways to come to terms with the past. In today's world, where the threat of new conflicts looms even sixty years since the last global war, this humble form of artistic expression could constitute a kind of social activism aimed at sharing the past and promoting positive dialogue on the future.

Venice has a long been a point of convergence and interaction of diverse cultures, and in that context, too, this exhibition promises to contribute significantly to constructive dialogue within the broader discourse on civilisation.

—Chihiro Minato

Commissioner
Chihiro Minato

Deputy commissioners
Shuji Takatori
Rie Takauchi

Organisation
The Japan Foundation

Web Site
www.jpf.go.jp/venezia-biennale/art/e/index.html

Artist
Masao Okabe

1 Masao Okabe, *Is There a Future for Our Past? The Dark Face of the Light*, 1996-2007. Installation, paper, pencil, frottage, video and mixed media, dimensions variable. Courtesy Hokkaido Museum of Modern Art, Hiroshima City Museum of Contemporary Art. © the Artist, Hokkaido Museum of Modern Art, Hiroshima City Museum of Contemporary Art

2 Masao Okabe, *Is There a Future for Our Past? The Dark Face of the Light*, 1996-2007. Installation, paper, pencil, frottage, video and mixed media, dimensions variable. Courtesy Hokkaido Museum of Modern Art, Hiroshima City Museum of Contemporary Art. © the Artist, Hokkaido Museum of Modern Art, Hiroshima City Museum of Contemporary Art

The Dark Face of The Light

THE PLATFORM OF THE OLD UJINA STATION, HIROSHIMA
1894/1945/2001

The Dark Face of The Light

THE PLATFORM OF THE OLD UJINA STATION, HIROSHIMA
1894/1945/2001

1

2

Great Britain
Borrowed Light

Tracey Emin: British Pavilion, Venice Biennale 2007

Tracey Emin's exhibition for the 52nd International Art Exhibition is entitled *Borrowed Light*. The title is handwritten in neon on the facade of the British Pavilion, a neo-classical building in which successive generations of British artists have laid claim to their pre-eminence at this cultural Olympiad. No-one, perhaps, has a better call on that title than Tracey Emin, whose name is inextricably bound up with the concepts of fame and prowess, and whose art tells the story of her life with seemingly breathtaking – even shocking – candour.

Born in London in 1963 to an English mother and Turkish Cypriot father, Emin spent her childhood in Margate where her mother ran a hotel. Her father spent his time between his family in Margate and his legitimate family elsewhere, until the hotel business collapsed and he returned to his 'first' family, when Tracey was seven. From then on, the Margate family moved down the social scale. At 13, Emin was raped, and sex became an occupation, which she documents in her film *Tracey Emin's CV: Cunt Vernacular* (1997).

In much of her later work the bite and alarm of this period remains unnervingly intact, her ability to access the feelings of an inchoate 13 year-old undiminished by the years in-between. In *Why I never became a Dancer* (1995) she continues the story, being booed off the dance floor by men yelling 'slag, slag' at her. Determined to make something of herself, she gets onto a fashion course at Medway College of Design (and transfers onto the art course), does incredibly well, and goes to the Royal College of Art, where she graduates with an MA. It is a rags to riches story, with touches of *Cinderella*, *Bluebeard* and *What Katy Did Next* all thrown in.

What Tracey did next became something of a legend in the London art world of the last decade; an art world fuelled by new money, the explosion of new media, photography and video; the advent of reality TV; and an obsession with all things of and about 'the people' – their confessions, their intimate moments – all writ large for tabloid consumption, instantly communicated blogs or globally broadcast programmes. Emin has worked both with and against this grain, giving her work a unique rub that catches the tenor of the times while at the same time criticising it. Her drawings and monotypes, often with snatches of direct speech written across them, are like bulletins without stories: nervously drawn young girls (usually herself) isolated in the middle of a large white space, dazedly reporting what has just happened, or what might yet happen (usually about sex, or drink). Her embroideries refer to the conventions of 'women's work', then prick pretensions by tacking on statements that our mothers would have never made, such as 'rot in hell'; 'they shouted nigger lover'. Her paintings and watercolours, lyrical and full of light, thinly skate over the distinction between sentiment and sentimentality, often straying way over the line – abortions and masturbation on one hand, bird and cats on the other. Neons in pink and pale blue brightly transmit her handwritten thoughts – thoughts most people leave unsaid, or confide only to a secret diary: 'My cunt is wet with fear'; 'Every part of me's bleeding'.

When her work was shown at the Stedelijk Museum, Amsterdam, in 2002, Rudi Fuchs wrote that 'it is basically uncontrolled and lachrymose and fickle and coquettish and driven by an immoderate, female sentiment which, by its very immoderation and absence of any shame, is painful or humiliating to see or to experience in our world'. Part of her enormous popular appeal – she is, next to Damien Hirst, the most famous of the YBA's – is due to her apparent lack of self-consciousness, her ability to hit directly on unspoken truths, and 'to open the valves of feeling', as Francis Bacon said of his own work. In the managed and mechanised society in which we live, this is a freedom fiercely fought for, and held.

—Andrea Rose

Commissioner
Andrea Rose

Deputy commissioner
Paul Docherty
Hannah Hunt

Web Site
www.britishcouncil.org/venicebiennale

Artist
Tracey Emin

If I could just go back + start again Tracey Emin 1995

Grand-Duchy of Luxembourg
Endless Lust

Venice lives off her myths. And they are numerous. That is what makes this sleeping beauty last, every one of them making her even younger, turning her into an arena of countless lovers' passions and, every two years, into the epicentre of the art world. Ever more myths, laid on with a trowel, in that last sentence alone.

And yet myths disregard bodies, make them anaemic, make them wander in an almost inaccessible, unreal time dimension.

So how then are we to experience Venice, experience art, experience life itself?

Maybe by deploying all our given senses in the present moment, by penetrating a space vibrant with possible futures, instead of being weighed down by impossible pasts. By plunging right into a perfectly sensual ambience, assembled of desirable elsewheres and infused with their lights, colours, sounds, rhythms, scents, skins and materials.

And by trusting those senses, too.

Invent yourself. Give yourself. Scrap the rulebook with all its usual expectations. Eroticise spaces, in the present, obsessively, and then without end.

—Enrico Lunghi

Commissioner
Enrico Lunghi

Curator
Kevin Muhlen

Organisators
Casino Luxembourg - Forum d'art contemporain
Ministry of Culture, of Higher Education and of Research

Artist
Jill Mercedes

Jill Mercedes, *Hotel Desire - 'An Emotional déjà-vu'*, 2001. Installation. Courtesy Stéphaneackermann agence d'art contemporain, Luxembourg

Greece
THE END

Synastria
On the work of Nikos Alexiou
'The dialectical image [...] creates its form much like a constellation of sparkling dots'.
Walter Benjamin

In this time of expanded understanding and re-orientation of contemporary art, the Greek participation in the 52nd. Biennale of Venice focuses on the possibilities of the different, the critical re-negotiation of the concepts of identity, the repetition of the same as different, the new condition of handicraft, the sensory materiality and the multiplicity of artistic practices. Nikos Alexiou (b. 1960) is the artist who adds tension to these characteristics, representing the emergence of alterity and the innovative relationships between minor and major. In terms of cultural politics, this kind of attitude seems to embody the ambiguities and the dormant potential of the minor 'local scene' for participation in the international cultural discourse. Alexiou belongs to that generation of artists who, during the 1980s, expanded the object of art into the realm of installation, with strong sensual and evocative settings, using disparate materials, textures and techniques as a reaction to the physical and tactile annihilation to which contemporary art had been led by the ascendancy of images. He turned from the outset to a fragile and ephemeral world that he introduced into the artistic language, setting the obsessive use of non figurative grids, patterns, decorations and repetitive structures as a kind of existential metaphor.

In Venice Alexiou presents a modular installation inspired by the floor mosaic in the Catholicon of the Iviron Monastery on Mount Athos (tenth-eleventh centuries). The artist has made frequent visits to Mount Athos and has been hosted at Iviron Monastery at various times since 1995, where he has got to know the spirituality, the quickening of the soul and the strange interpersonal experiences of coexisting in monastic communal life, all in a suggestive setting under the infinity of the sky. During this time, after much copying and redesigning of the mosaic he attempted to understand the mysteries it contains as he sought its semantic structure as well as its vortex. One could describe this 'mobile immobility' of this floor as a composite ideogram, a symbolically packed system, the kind of condensing of the whole that we now call 'data storage'.

We must remember here the close relation that has always existed in non Western and Eastern cultures between intensive practice in repetition and the techniques of ecstasy. This is why the appropriation of the monastery mosaic enables us to trace the characteristics of a broader change that many have tried to describe under various terms in recent years. The 'post-productive' artist is not a new phenomenon; it forms part of a model of cultural behaviour that has existed throughout the history of manual creations. It is the artist who, according to Nietzsche's model, processes the tensions and deviations of his own 'eternal return'. So it is no wonder that the interconnective allegories of appropriation are pushing the blurry boundaries between the abstract tradition of modern art and far-reaching religious tradition. It is an unfinished and repeated process which one could even associate with the vertigo of expanded consciousness, the cosmological imaginary, the visual elements of rave culture or techno-psychedelic experiences. Intensifying the vibrating patterns of the floor, Alexiou exploits the limits of human sight at the intersection with the psycho geography of experience in the age we live in.
—Yorgos Tzirtzilakis

Commissioner / Curator
Yorgos Tzirtzilakis

Deputy curator
Nadja Argyropoulou

Organisation
D.ART

Web Sites
www.nikosalexiou.com
www.labiennale.org/en/art/exhibition/
en/73805.2.html

Artist
Nikos Alexiou

1-2 **Nikos Alexiou**, *THE END*, 2007.
Mixed media, dimensions variable.
© Courtesy the Artist
3-4 **Nikos Alexiou**, *THE END*, 2007. 3D
sketch of the installation, mixed media,
dimensions variable.
© Courtesy the Artist

1

2

▲3 ▼4

Ireland

Gerard Byrne, Ireland's sole representative in the 52nd International Art Exhibition, is known in the contemporary art world for his large-scale video installation and photographic projects. His use of documentary materials, culled from popular sources such as magazines and newspapers, re-enacts and recalls key moments of the latter part of the twentieth century, tapping into attitudes and conventions of our recent past.

The project *1984 and Beyond* (2005, commissioned by *If I Can't Dance I Don't Want To Be Part Of Your Revolution* – NL, and *Momentum*, the Nordic Biennial – NO) features a discussion between twelve science-fiction writers that originally took place in 1963. Filmed in two locations in the Netherlands, the Sonsbeek Pavilion in the Kröller-Müller Museum and the Provinci Huis in den Bos, *1984 and Beyond* gathers such characters as Arthur C. Clarke and Rod Serling, who occupy these quasi-Brutalist settings to ponder Life on Mars, artificial intelligence and over-population. A conflation of scientific fact and extraordinary speculation, as Emily Pethick remarks, *1984 and Beyond* is 'by no means a simple reconstruction of a document, but a collection of multiple narratives and parallel histories that lead tangentially outwards, forming connections between three time periods, 1963, 1984, and 2005' (E. Pethick, *On 1984 and Beyond*, *If I Can't Dance...*, Episode Publishers NL, 2006).

New Sexual Lifestyles (2003) reveals both our proximity to a bygone era and just how far we have come. The 'hip' experts that populate the film (derived from a 1973 round table in 'Playboy' magazine) seem utterly out-of-touch and naïve. Here, a notion of 'retro' is disarmingly awkward. The discussion progresses to reveal a complexity of social values that represent 'the cultural revolution' in historically loaded terms. Playing up architecture as a cultural backdrop, Byrne sets the piece in a unique late-Modernist house in rural Ireland, built in the year the round table was published.

In an extensive photographic project, *A Country Road. A Tree. Evening* (2006 – ongoing) Byrne takes as a starting point the famous stage directions that open Beckett's *Waiting for Godot*. Each photograph repeats the theatricality of this line, which effects a process of research that combines historical details of Beckett's life with Byrne's own conjecture.

This continual play reveals an attitude towards contemporary art practice that regards art-making as a continual renegotiation of conflicting realities. In *Why it's time for Imperial, Again...*, a staged conversation between Lee Iacocca and Frank Sinatra written for an ad for the 1981 Chrysler Imperial, 'recasting' these iconic personalities amidst the decaying backdrop of New York's Long Island City. Each jump-cut emphasises a corporate inclination for technical jargon and high-powered speak that, through its over-the-top inaccessibility, defaults to parody.

Byrne's interests extend beyond image-based projects to performance-based works like *In repertory* and *Exercise for two actors and one listener*. Both made in-situ to address the conventions of the gallery-event, each uses performance as a means of critically challenging norms of production, mediation and consumption in contemporary art. Similar to prescient works such as *Translations* by the Irish playwright Brian Friel, Byrne revisits the past as a means to reconsider the present, and in doing so Byrne offers translations of sorts, for all their difficulties and inconsistencies, their relevance and applications.

Culture Ireland, the organisation founded to promote Irish culture internationally, joins together with the Arts Council of Ireland in this presentation of a significant body of work by Gerard Byrne, in a new venue in the Istituto Santa Maria della Pietà. In 2007 for the first time both the Ireland and the Northern Ireland Pavilion, which features the work of Willie Doherty, are in the same building.

—Mike Fitzpatrick

Commissioner / Curator
Mike Fitzpatrick

Assistant commissioner
Sheila Deegan

Technical manager
Mark McLoughlin

Collaborators
Troels Bruun, Daniela Murgia
(M+B studio), Francesca Bonetta

With the support of
Culture Ireland and The Arts Council of Ireland

Artist
Gerard Byrne

Gerard Byrne, *A Country Road. A Tree. Evening - The Road to Little Bray, Between Ballyman and Old Connaught, North Wicklow*, 2006. Colour photograph, 88 x 110 cm. Private collection

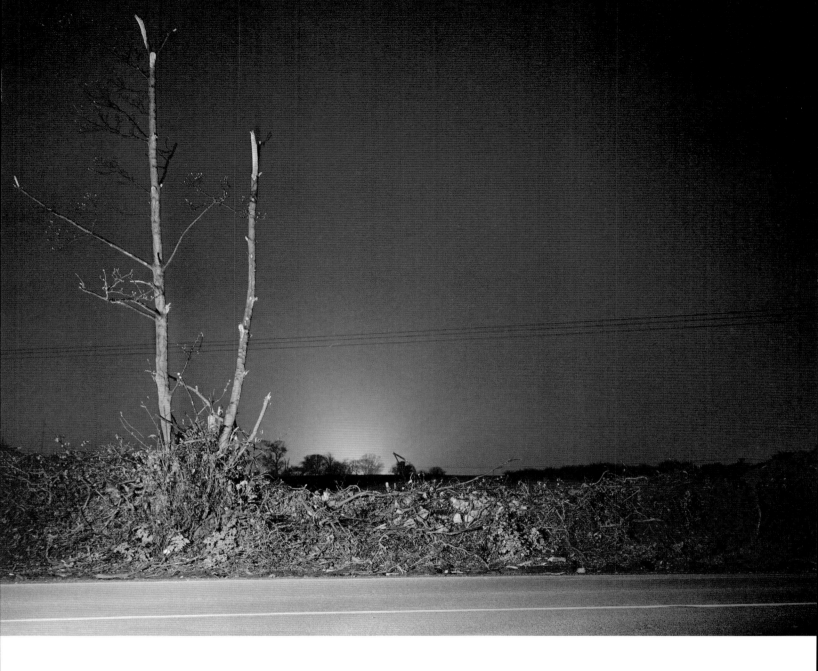

Iceland
Steingrimur Eyfjörd: The Golden Plover Has Arrived

'Visual art grants a certain freedom and I am allowed to work unconsciously, present hypotheses, which are neither right nor wrong'
Steingrimur Eyfjörd

For his exhibition in the Icelandic Pavilion Steingrimur Eyfjörd presents a new group of works, collectively entitled *The Golden Plover Has Arrived*. In the working process, he consulted a medium who put him in contact with an old elf or hidden person – the terms 'elves' and 'hidden people' are used interchangeably in Icelandic mythology to describe a group of beings, much like humans in size, appearance and lifestyle, that inhabit hills and mounds in the landscape; hidden people cannot be perceived by humans unless they themselves want to be seen – who appears to live in the south of Iceland beneath a golf course, in another dimension where life is still as it was in our world 300 years ago. The purpose of this act was to buy a hidden sheep for *The Sheep-pen*, the main work in *The Golden Plover*.

Eyfjörd weaves together seemingly arbitrary threads of culture, economy and politics from various moments in Icelandic history, without attempting to link them in any discernible way. By the displacement of familiar frames of reference, his works reveal an unexpected approach to established ways of seeing. Displacement and condensation are mechanisms that he employs unrestrainedly, metonymic processes that belie the depth of the deconstruction that is taking place.

Displacement is an important feature of jokes and humour is present in a large way in Eyfjörd's works. They are uncanny and baffling at times, but the twists they perform on our habitual patterns of thought are invariably of a humorous kind. The nodal point where Eyfjörd's threads intersect is a moment of friction; a critical and a creative one.

The work's problem lies in the non-articulated questions and contradictions that abound in it. What emerges is a determined resistance to any reductive system of analysis, be it formal, conceptual or cognitive. On one hand the contradiction lies in Eyfjörd's critical approach to the cultural myths he seeks to deconstruct and, on the other, in his emotional attachment to and identification with those same myths.

'The belief in elves is a quality of life', Eyfjörd told me at the start of this project, referring to his exploration of the myth of elves or hidden people, suggesting that this belief is a collective and individual *fantasy*, an imaginative process that is crucial to a healthy existence and enriches it at the same time. Fantasy, then, is a quality of life – or is it an essential concept in understanding how an individual or social identity is formed? Slavoj Žižek has defined fantasy as 'a scenario filling out the empty space of a fundamental impossibility, a screen masking a void' (S. Žižek, *The Sublime Object of Ideology*, London, 1989, p. 126. Cited in B. Diken, *The Aesthetic Critique of Capitalism and Transpolitics of Immigration printed in Under [De]Construction: Perspectives on Cultural Diversity in Visual and Performing Arts*, Nifca, Helsinki, 2002) in one's own and the 'other's' identity (B. Diken, *The Aesthetic Critique of Capitalism...*, cit., p. 60). Can the belief in elves be defined as the fantasy that masks that void, that 'enables the illusion that identity existed in the first place' concealing 'the fact that the identity never existed, that it is constructed retroactively by the fantasy itself?' (B. Diken, *The Aesthetic Critique of Capitalism...*, cit., p. 61).

Through an analogous reasoning, *The Golden Plover* may be seen to examine how the paradigm of the myth can be applied to a very different context where the discursive production of an 'other' is being redefined in terms of a much changed contemporary reality and a post-colonial past.

The golden plover is a small wading bird, long regarded as the harbinger of spring in Iceland. Its arrival in the country in late March, early April, announced in the local media, is the source of a general optimism and joy, as the first sign of the end of the long winter months characteristic of northern regions.

—Hanna Styrmisdóttir

Commissioner
Christian Schoen

Curator
Hanna Styrmisdóttir

Assistant commissioner
Rebekka Silvia Ragnarsdóttir

Organisation
CIA.IS - Center for Icelandic Art

Coordination
M+B studio

Web Site
www.cia.is/venice

Artist
Steingrimur Eyfjörd

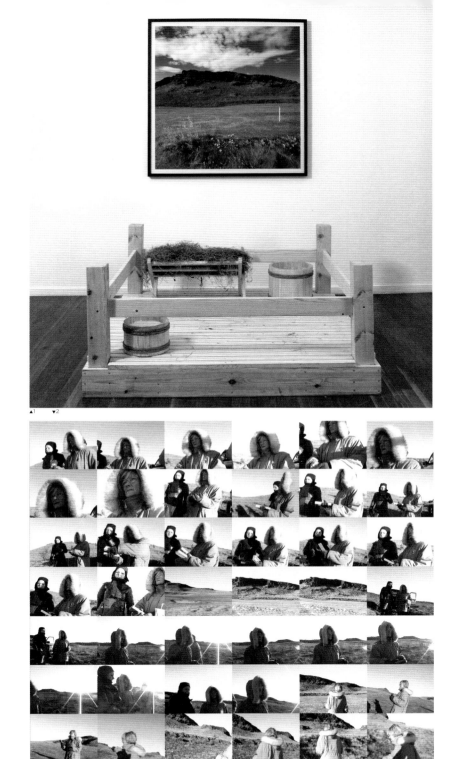

1 Steingrimur Eyfjörd, *The Sheep-pen*, 2007. Mixed media, dimensions variable. Courtesy the Artist
PHOTO SPESSI

2 Steingrimur Eyfjörd, *The Sheep-pen*, 2007, detail. Mixed media, dimensions variable. Courtesy the Artist
PHOTO STEINGRIMUR EYFJÖRD

67

Israel
The Guardians of the Threshold

The concrete modernist building of the Israeli Pavilion was transformed for the duration of the 2007 Venice Biennale into an outer shell for Yehudit Sasportas's complex installation, *The Guardians of the Threshold*. A symbiosis of drawing, painting, sculpture and architecture, her work subordinates the given space to multi-layered readings.

Sasportas's artistic practice has, from the very outset, displayed an affinity for modernist architecture, an echo of its 'utopian vision' which she absorbed during her childhood in Israel. Thus, not only does the Pavilion building in the Giardini appear congruent with Sasportas's interest in modernism; it becomes an integral part of the work as a whole. The installation is strewn with architectural elements: from the blind at the entrance and the monumental structure (a modernist façade with windows and trees) covering the highest wall of the building opposite the entrance, through the two gates with the sliding doors in the intermediate level, to the large gate on the upper level. The Pavilion's clearly-defined real space has been transformed into an optional outdoor space; the doors and windows have opened it into a realm of fantasy, a virtual, apocalyptic space.

Entering the Pavilion/installation, which is shrouded in darkness and conjured up through the shadows of trees, one encounters several openings that function as sources of light: light-absorbing and light-emitting drawings and paintings depicting forests, glades and mountains. The 'hole' projected on a wall on the second floor opens into an enigmatic landscape with a swamp, evaporating into a distant mist – possibly twilight, possibly dawn. The viewer experiences an illusionist view, which stretches out behind the plane of the wall, exposing a picture of another world, a point of departure. The two paintings inside the adjacent gates reveal the only urban images in the installation. The fragmentary geometric forms combined with shapes of quasi-buildings produce entropy, a metamorphosis towards another fictional reality and other vistas. Reduced to hues of black, grey and blue, the colour scale reinforces the nocturnal atmosphere of the entire installation.

The swamp image reverberates in a large three-dimensional round sculpture on the top level, with a reflection of the forest clearing in the painting installed next to it. Countless thin sticks/needles come out of the swamp, hinting at an underwater world and occurrences. The large sticks lying around the swamp are possibly magnified tree-needles, parts of roots or spears guarding the threshold, the subliminal, while playing in a three-dimensional drawing of lines in space.

Like excavation strata, the multiple sources of Sasportas's drawings and paintings overlap in a process of hybridisation. Drawings based on memory of her direct experience of nature blend with drawings executed intuitively from memory or from another still-life drawing in the studio and with yet other drawings traced through the technological mediation of a projector screening photographs taken by the artist. Sasportas refers to her memory as 'the archive of the unconscious', which duplicates itself, refracting and reflecting images and perspectives, turning inward and outward – an inner world in which dreams and reality blend and merge. Sasportas's installation is a synthesis of many dual identities and dichotomous meanings – East and West, nature (forest) and culture (architecture), rational and spiritual; it embodies tensions between the modernist, formal sculptural structure and the emotional and painterly ones, between the rhetoric of intellectual discipline and the narrative content. The technically clear compositions of rectangular forms contrast and simultaneously blend with the drawings and paintings – the result of a time-consuming process of artisan virtuosity and the source of spiritual and revealing experience – to form a single unit, attesting to the totality and post-postmodern heterogeneity of Sasportas's approach.

—Suzanne Landau

Commissioner / Curator
Suzanne Landau

Deputy commissioners
Diana Shoef
Arad Turgeman

Artist
Yehudit Sasportas

Yehudit Sasportas, *The Guardians of the Threshold,* 2007. Space installation (digital simulation). Israeli Pavilion, 52nd International Art Exhibition, La Biennale di Venezia 2007. Mixed media. Courtesy Sommer Contemporary Art, Tel Aviv; Galerie EIGEN + ART Leipzig/Berlin

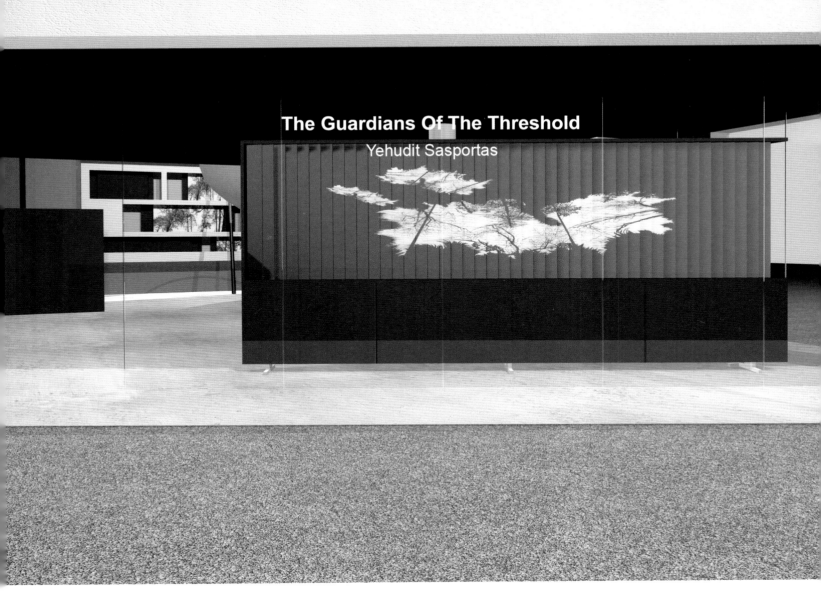

Italy

Ministero per i Beni e le Attività Culturali
Dipartimento per i Beni Culturali e Paesaggistici
DARC - Direzione generale per l'architettura
e l'arte contemporanee e Fondazione la Biennale di Venezia

With the joint support of DARC – the Cultural Ministry's Directorate-General for Architecture and Contemporary Art – and the Venice Biennale Foundation the Italian Pavilion will reopen at the 52nd International Art Exhibition. This joint project renews DARC's commitment to promote contemporary Italian art and the role of the International Art Exhibition as a prestigious international stage for contemporary creativity. The choice to once again assign a specific exhibition space is intended to correct the absence of Italian artists at previous Biennale exhibitions, presenting them within a framework designed to emphasise comparisons in aesthetic investigations taking place in different national contexts. The decision to put Ida Gianelli, the director of one of the most significant national museums of contemporary art, in charge of the Italian Pavilion is an endorsement of the strengthened collaboration, exchange and support among the various institutions that are involved with contemporary art. The Italian Pavilion will present a juxtaposition and comparison of two artists: Giuseppe Penone and Francesco Vezzoli. From different generations and with different backgrounds and expressive choices, they represent two distant but complementary lines in Italian contemporary art in its relationship with the most up-to-date international context. Giuseppe Penone addresses the evocative potential of materials, and Francesco Vezzoli focuses on the representation of the boundary between reality and appearance; both artists articulate innovative approaches to modalities of perception.
—Pio Baldi
Italian Pavilion Commissioner and General Director of DARC

After an absence of eight years, Italy once again has a presence at the 52nd International Art Exhibition, with its pavilion at the Tese delle Vergini of the Arsenale, which will present works by Giuseppe Penone and Francesco Vezzoli.
Sculture di linfa (Lymph Sculptures), the title of the large installation conceived and created by Penone specifically for the space, occupies an area of 600 square metres. Penone's

research has evolved through a rational idea about formal relationships with the morphologies of nature, and it deals with the materials employed in classical antiquity, such as wood, terracotta, bronze, marble and glass, renewing the language of sculpture and endowing it with new life.
Francesco Vezzoli has created *Democrazy*, a video projection that presents two election ads developed using two teams of professional American political consultants. The two hypothetical candidates are competing for one of the most important international political offices.
Once again, the crude mechanisms of the systems of contemporary communication and their manipulation are the subject of Vezzoli's investigation. In keeping with the world that he delights in discovering and in which he wishes to take part, he uses new technologies to expose its excesses and weaknesses. While they belong to different generations and use dissimilar languages, both artists are leading figures in contemporary art, and through their work they express the depth and richness of contemporary life.
—Ida Gianelli

Giuseppe Penone, Lymph Sculptures

Spaces covered by the hands,
spaces emptied by the hands,
the space of the sculpture filled with lymph.
The flow of the hand that glides over the bark of the trees,
that reveals the form of the wood and the veins of the marble.

Giuseppe Penone (Garessio, 1947) is considered one of the most important contemporary Italian artists. Beginning with his earliest pieces, which date from 1967, his work has been noted for the vast range of materials employed, for his adoption of a sculptural practice related to the material's process of development, and for his attention to natural phenomena. Starting from personal reflections associated with the cultural context in which he was raised and to the historical moment when he emerged as a sculptor, the artist translates his connection to the earth and the landscape into his own linguistic code. Carving, incising and making casts constitute the basis for his technique, and his works, whether sculptures or installations, reflect on human gestures such as touching, sculpting

Commissioner
Pio Baldi

Curator
Ida Gianelli

Deputy commissioner
Anna Mattirolo

With the support of
UniCredit Group

Artists
Giuseppe Penone
Francesco Vezzoli

and modelling. A leading figure in Arte Povera, the critical theory developed by German Celant, Penone directs the contents of his investigation both toward the plant world, attempting to visualise and modify the elements' processes of natural growth, and toward the human body, which has always been a subject of his research. Each of his works is constructed within the space as a place of exchange and interaction between the human being and the world. Demonstrating a sensibility capable of concisely embracing every form or material, his works examine mechanisms tied to the transformation of elements and assert his intention to construct an evolutive continuity with the linguistic aspects of classical sculpture. After focusing on the study of the surfaces of forms and their tactile qualities, through individual sculptural groupings, in his more recent works he has investigated the aesthetics of images through large installations and compositions of great breadth, developing visual and sensory pathways into his expressive world.

For the Italian Pavilion, the artist has created a new installation, *Sculture di linfa (Lymph Sculptures)*, made up of five large-scale works created specifically for the space and in dialogue with each other. The work finds poetic implications in sap as a preeminent source of nourishment for the earth and a symbol of energy. Lymph, or sap, as a vital element that runs through the bark of trees, reveals the form of the wood and the veins of marble, and it represents a connecting ring that unites man and nature, in a continuous state of participation and symbiosis.

—Gaia Casagrande

Francesco Vezzoli, Democrazy

The project conceived for the Italian Pavilion at the 52. Venice Art Biennale is intended to continue the study and analysis, begun with the previous video projects, of contemporary communications systems, their manipulation by powerful forces and their effect on the collective imagination.

Taking its cue from the forthcoming 2008 American presidential elections, which have already overwhelmingly invaded the media at every level, the project will take the form of the production of an authentic election campaign, presenting the Biennale public with a clash between two hypothetical candidates for one of the most important international political offices.

Two election ads, made in association with two teams of media advisors, real professionals of American politics, one led by Mark McKinnon (chief advisor for George W. Bush's 2004 election campaign), the other by Bill Knapp (Bill Clinton's spokesman in the run for the White House in 1996), contrast two identities, two different political and human visions, highlighting the momentous strategies of electoral communication and raising questions on how fame, media power and manipulation of the truth contort the meaning of democracy.

An original inventor of his own artistic language, Francesco Vezzoli (Brescia, 1971) is a leading figure in the new generation of Italian artists. His works – in the form of video productions, petit-point embroidery, photographs and performances – examine the mechanisms of media communications and the production of the collective imagination. Beginning with personal obsessions, including an in-depth knowledge of the history of cinema, a love of embroidery, and a passion for icons of popular culture, the artist unites 'high' and so-called 'low' culture to construct works within which quotations, references and fragments proliferate. Brought together in each project, these compose stories and images steeped in beauty and decadence, drama and humour, sorrow and cynicism.

Developing each project around the figure of a star or figures well-known to the public at large, the artist always reveals their more intensely human side, an aspect that is most exposed to the severity of the mechanisms that govern the construction of fame and power. Specifically, after having devoted himself to an analysis of television language and the related exploitation of private feelings, in his more recent works Vezzoli has investigated the aesthetics of mainstream Hollywood films and the appropriation of European history and culture.

Democrazy is the title of the project the artist is presenting in the Italian Pavilion; the work is inspired by the electoral campaigns for the presidency of the United States. Presenting two unknown candidates whose identities can provoke contrasting reactions, the piece mixes fiction and reality and describes politics in a way that no one has dared to do before.

—Marcella Beccaria
(translation by Marguerite Shore)

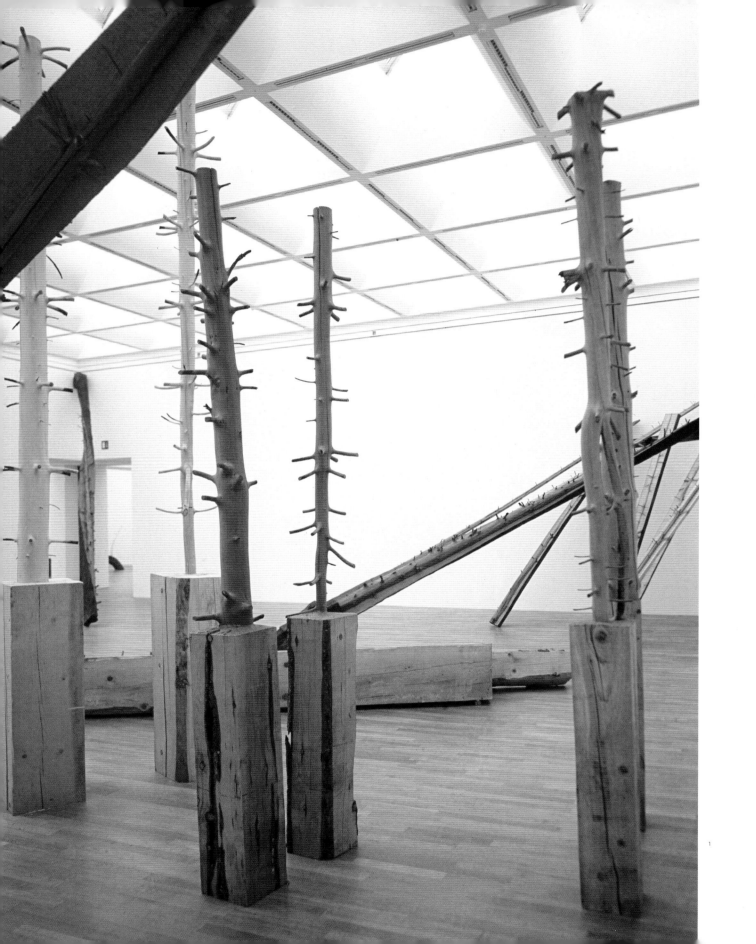

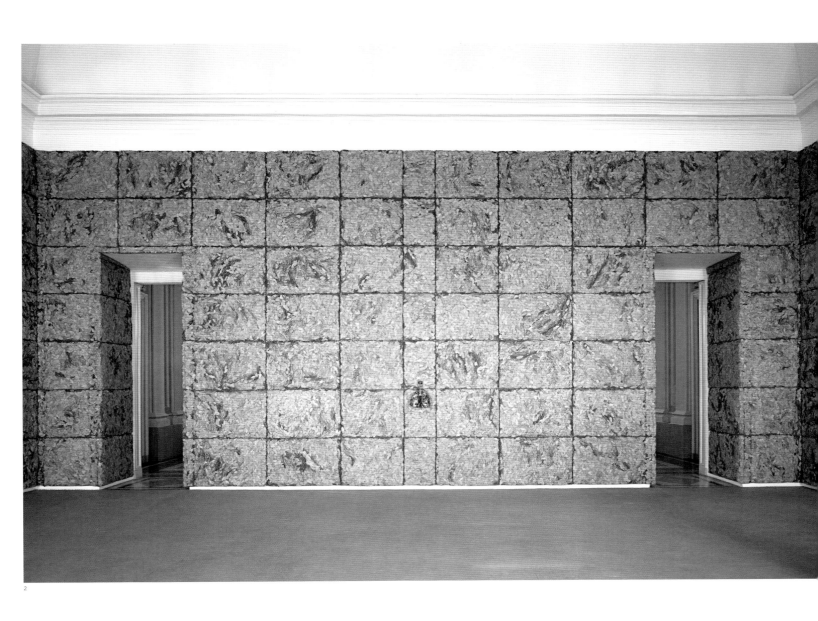

2

1 Giuseppe Penone, *Ripetere il bosco
(Repeating the Forest)*, 1969-1997.
Wood, dimensions determined by the
space. Installation Kunstmuseum, Bonn

2 Giuseppe Penone, *Respirare l'ombra
(Breathing the Shadow)*, 1999. 199
wire mesh modules, laurel leaves, gold
element, dimensions determined by
the space. Castello di Rivoli Museum
of Contemporary Art, Rivoli-Torino.
Permanent loan. CRT Foundation
for Modern and Contemporary Art

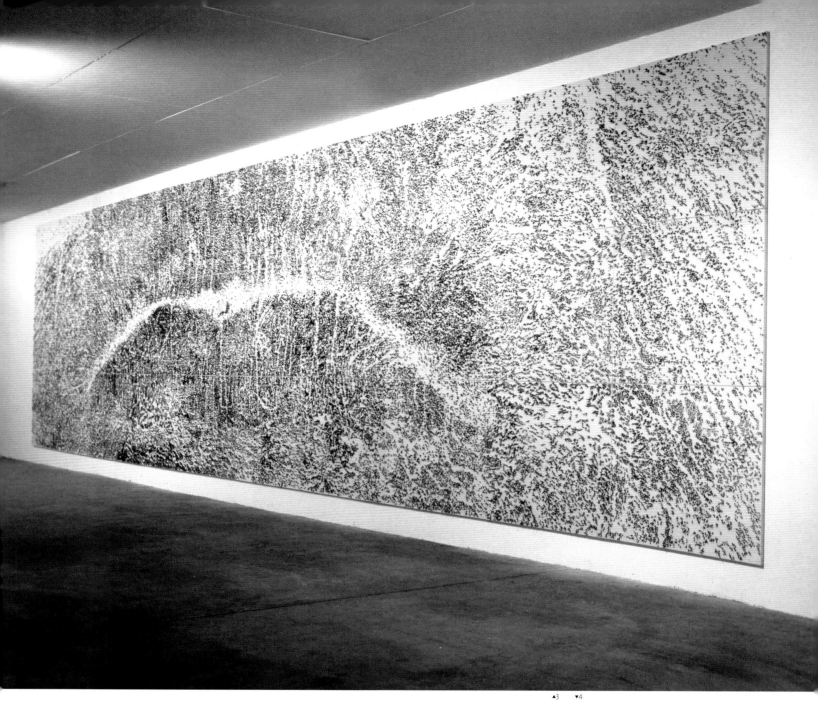

3 Giuseppe Penone, *Spoglia d'oro su spine d'acacia (bocca) (Golden Skin on Acacia Thorns - mouth)*, 2001-2002. Silk, acacia thorns, gold, 300 x 1,200 cm. Installation, Spazio per l'arte contemporanea Tor Bella Monaca, Roma. Courtesy Galleria Nazionale d'Arte Moderna, Roma

PHOTO CLAUDIO ABATE

4 Giuseppe Penone, *Spoglia d'oro su spine d'acacia (bocca) (Golden Skin on Acacia Thorns - mouth)*, 2001-2002. Silk, acacia thorns, gold, 300 x 1,200 cm. Installation detail. Installation Spazio per l'arte contemporanea Tor Bella Monaca, Roma. Courtesy Galleria Nazionale d'Arte Moderna, Roma

PHOTO CLAUDIO ABATE

5 Giuseppe Penone, *Scultura di linfa*, 2006. Wood, resin. 2 elementi, 40 x 20 x 500 cm each

5

6 Francesco Vezzoli, *Trailer for a Remake of Gore Vidal's Caligula*, 2005. Video projection, DVD, color, sound, 5'. Production image

6

7

▲8 ▼9

7 Francesco Vezzoli, *Trailer for a Remake of Gore Vidal's Caligula*, 2005. Video projection, DVD, color, sound, 5'. Video still

8 Francesco Vezzoli, *Trailer for a Remake of Gore Vidal's Caligula*, 2005. Video projection, DVD, color, sound, 5'. Production image
PHOTO MATTHIAS VRIENS

9 Francesco Vezzoli, *Trailer for a Remake of Gore Vidal's Caligula*, 2005. Video projection, DVD, color, sound, 5'. Video still

10

11

12

13

14

15

10-21 Francesco Vezzoli, *Marlene Redux: A True Hollywood Story!*, 2006. Video projection, DVD, color, sound, 15'. Collection François Pinault. Video stills

16

17

18

19

20

21

Latvia
Paramirrors

Historically, Venice has justifiably been regarded as the birthplace of smooth crystal mirrors and this seems only natural because the city itself is reflected in the waters. In the sixteenth century the masters of Murano developed the technology of glass manufacturing to a standard of quality that has not been surpassed to this day. Anyone revealing the secret of glass manufacturing could face the death penalty. The love of Louis XIV or the Sun King (1638-1715) for the beautiful almost ruined France when he bought Venetian mirrors in great quantity to decorate his palace at Versailles. To compare, at the time a 115 x 65 cm painting by Raphael cost 3,000 lira but a mirror of the same size would have cost 38,000 lira. In order to save the state from bankruptcy, the minister of finance Colbert sent agents to Murano to get the secret of glass making. The operation was successful. Two Venetian glass masters were brought to France and Venice's 400 year-old monopoly on glass was at an end. The mirror also has another history – esoteric, mystical and occult. Many stories and concrete descriptions survive of how mirrors interact with human consciousness, visions are called up that can relate equally to real events in the past, present and future as well as to visions in the most 'sophisticated' of worlds. However, if these visions exist, then what are they and can a rational explanation be found for such phenomenon – the interaction of a mirror with human consciousness, by examining the property of a mirror, the ability to reflect light? When light is reflected from a smooth, shiny surface such as a mirror or water, it becomes polarised. The effects of polarised light on living organisms had already been discovered by scientists in the nineteenth century. Modern day laboratory experiments have proved that polarised light affects cells, micro-organisms and the germination of seeds, as well as human consciousness. I think many people have themselves felt the strange effects of the light of the full moon. Regardless of the fact that the light of the full moon is 6,000 times weaker, it is nevertheless the same sunlight only reflected and therefore polarised. Nevertheless, the question remains of why the effects of the full moon do not disappear when one is isolated from the direct light of the moon because light (electromagnetic wave) does not pass through walls. What is this 'secret component that can reach everywhere' and links such apparently different things as the brightness of the moon and human consciousness? It has to be a component that is tied to polarised light. There is a hypothesis that the physiological and psychological effects associated with the light of the full moon are caused by the so-called torsion or spin fields. One of the properties of the radiation emitted by torsion fields is that they instantly transmit information unlimited by the speed of light (about 300,000 km/s). Similarly, it has been proposed that the properties of these fields include the ability to influence the structure of space-time. Torsion fields have been specifically credited with the role of being a carrier of universal consciousness and thought. 'When we say torsion fields are connected to parapsychological phenomena we are talking about a strictly proven fact: the fields generated by psychics are torsion fields. This fact has been confirmed by tens of experiments' (A.E. Akimov). Therefore one of the sources of radiation of these fields is human and that permits us to speak of consciousness as a physical reality.

—Gints Gabrāns

Commissioner
Ieva Kulakova

Deputy commissioners
Gundega Tihi
Paivi Tirkkonen

Organisation
Pareizā Ķīmija, Latvia
Arte Communications, Venice

With the support of
Ministry of Culture of the Republic
of Latvia
State Culture Capital Foundation
of Latvia and Riga City Council

Sponsors
Air Baltic
Arctic Paper Baltic States
Jelgava printing house
Uksus

Web Site
www.gabrans.com

Artist
Gints Gabrāns

Gints Gabrāns, *Beauty Mirror*, 2007.
Installation, mixed media, 400 x 450 cm.
© the Artist

BEAUTY MIRROR

MIRROR IS REFLECTING A SPECIFIC POLARIZED LIGHT THAT STIMULATES THE TISSUE AND REJUVENATES YOUR FACIAL SKIN

Lebanon
Foreword

This exhibition marks Lebanon's inaugural participation in the Venice Biennale. Because Lebanon is joining the Biennale 112 years into the history of the event and because it is doing so at a time of grave political crisis in the country – when the concept of the nation has once again been called rather roughly, even violently, into question – this exhibition does not seek to represent Lebanon by showcasing a single Lebanese artist, but attempts to probe the intimacy of lived experience by bringing together five artists from Lebanon whose works cohere in form and content around a single underlying theme.

The theme of the exhibition is meant to be taken loosely and encompasses a number of artistic practices – personal narratives, acts of bearing witness, collected testimonies – and cuts through the skin of political turmoil and historical events to reach the bone of intimate expression.

This collective exhibition is fitting, given Lebanon's reputation, clichéd as it may be, as a mosaic, a country of coexistence, a hothouse of multiple communities living together in a tangled mix of languages and religions. Indeed, the artists commissioned for the Lebanese Pavilion come from different backgrounds, work in different media and are at varying stages of their respective careers, from emerging to established. More than that, however, they are all, each in their own fashion, questioning the formation and experience of self, individualism, and citizenship in ways that are illuminating well beyond Lebanon's borders.

What goes on in the lives of those buried beneath news headlines that speak of war, ceasefire, strife, stalemate and inevitable showdown? What occupies the minds of those who find themselves bereft in a widening gap between opposing 'sides'? Where is the break between public and private experience? What does it mean to be the subject of a nation or the representative of a state in the early twenty-first century, anyway, and particularly at a time when those notions of nation and state are open to ever more considerable debate, and in a context where it is not at all certain that a small, tumultuous country like Lebanon currently has any capacity to claim, celebrate or even speak for its artists? How does one find a beginning, a starting point, for the story one wants to tell?

This exhibition presents five distinct yet related bodies of work that mark different attempts to answer a similar set of questions – all of which revolve around a more general query, where to begin?

Parallel to the exhibition are screenings on the mezzanine level of video works created in Lebanon over the past 15 years. An opportunity to throw open the theme of personal testimonies, lived experience and intimate narrative even further, these videos bear witness to the cultural vitality that remains in Lebanon despite prevailing conditions that would seem to suggest otherwise.

Commissioners
Saleh Barakat
Sandra Dagher
Vittorio Urbani

Curators
Saleh Barakat
Sandra Dagher

Organisation in Venice
Nuova Icona associazione culturale per le arti, Venice

Web Site
www.lebanonvenicebiennale.com

Artists
Fouad Elkoury
Lamia Joreige
Walid Sadek
Mounira Al Solh
Akram Zaatari

1 **Fouad Elkoury**, *On War and Love*, July 22, 2006. Silver bromide print, 48 x 60 cm. Courtesy of Tanit Galerie.
© Fouad Elkoury

Today is no day for heroism

▲2 ▼3

I help them immigrate legally to the country where they had achieved their studies and I am a Law expert in Paris, Lyon and Marseille basically.
In this video, I like the fact that I still look the same although I was much younger!
I like as well the noisy sound coming from Marianne's studio at Saint Maur street.

▲4　▼5

لا تستوي أصابع في يد. فالسبابة إسم والنسيان إبهام في الغم

مصطفى فَرّوخ (١٩٠١–١٩٥٧)　Moustafa Farroukh (1901–1957)

منظر من بيروت　**View of Beirut**
أهداه الفنان سنة ١٩٢٩　Offered by the painter in 1929
إلى السيد نجيب أبو صوان،　to Mr Négib Aboussouan,
وزير التربية الوطنية آنذاك　Minister of National Education
زيت على قماش　Oil on canvas
٦٨ x ٥٠ سم　50 x 68 cm
مجموعة السفير　Collection of the Ambassador
سمير مبارك　Samir Moubarak

2 Lamia Joreige, *Je d'histoires*, 2006.
Video still. © Lamia Joreige

3 Mounira Al Solh, *As if I Don't Fit
There*, 2006. Video still. © Mounira
Al Solh

4 Akram Zaatari, *Video in Five
Movements*, 2006. Video still. © Sfeir
Semler Gallery and the Artist

5 Walid Sadek, *Love Is Blind*, 2006.
Installation, detail. © Walid Sadek

Lithuania
Villa Lituania

Villa Lituania: flying in the face of history

Villa Lituania is a grand house that stands at Via Nomentana 116 in a respectable district of Rome. A number of national embassies to Italy are situated on Via Nomentana including the Villa Torlonia, the historical property bestowed on Mussolini by the Roman nobility. Recently restored, the Villa Torlonia languished in disrepair for 60 years because of its brush with the irruption of mid-twentieth-century history.

The project for the 52nd International Art Exhibition by Lithuanian artists Nomeda & Gediminas Urbonas is an anarchitectural restoration of Villa Lituania. As the name of the property suggests, the building is associated with the Lithuanian nation: it was the embassy of the first independent Republic of Lithuania (1918-1940) to Italy. The embassy operated from 1933-1940 but became a possession of the USSR after the Soviet occupation of Lithuania. The keys to the property, which had been in safekeeping, were handed by Italian government representatives to Soviet officials in line with the alliance of powers signalled by the Molotov-Ribbentrop Pact (1939).

Since the disintegration of the Soviet Union in 1990-1991 and the formation of the Republic of Lithuania, the Villa has remained the property of Russia; operating as its consulate in Rome. It is considered the last occupied territory of Lithuania, and Lithuanian governments have lobbied internationally for its restitution. Now two of the nation's leading artists are taking up its cause. Their approach – qua the anarchitects Acconci, Matta-Clark, and Smithson – belongs to the symbolical field.

Working with pigeon breeders in Italy and Lithuania, Nomeda & Gediminas Urbonas are staging two pigeon races from Venice to Rome. A pigeon-loft is being constructed in the Eternal City and the birds specially bred and trained for several months under the auspices of an Italian professional (the fledglings will come from Italy, Lithuania, Poland and Russia). Pigeon's adopt the loft they make their first flight from as home and always return to that location when released – hence the nomenclature 'homing pigeon'. The artistic team involved in the project are making every effort to gain permission to build the pigeon loft in the grounds of Villa Lituania – a process that is being documented. If that effort fails, the loft, to be christened Villa Lituania, will be constructed in neutral territory in Rome.

The project's symbolism is clear – sending a sign of peace from Lithuania to Villa Lituania, Russia, and Italy. The pigeon is a fundamental avatar: it is a daily presence in St Mark's Square in Venice and in Rome. Moreover, the colomba della pace is an important motif within Baroque art and ornament; none more prominent than those adorning Bernini's Baldachin (1624-1632) and apse of the Triumph of the Chair of St Peter (1666) comprising the high altar of St Peter's Basilica at the Vatican. Homing pigeons faced extinction at the hands of the Nazi's, who attempted to exterminate them and erase their espionage potential. (Stocks were saved, at great risk, by a family in Belgium and their birds remain the principal racing pigeon bloodline). Picasso even based his Dove of Peace (1949) on a pigeon – a bird that appears many times in his work – as they are more peaceful than doves (ironically, doves are fiercely aggressive and territorial birds). Picasso's symbolism lost its innocence, however, when lent to Stalin's USSR. Even after the revelations of Stalin's crimes and the invasion of Hungary in 1956 Picasso refused to renounce his faith in Soviet communism and as late as 1981 his Dove appeared on a Soviet postage stamp. This story about Picasso is just a shadow as his Dove of Peace has flown around the world and registers in the collective unconscious as a symbol of goodwill.

At a moment when birds are high in the public-mind, and are truly considered agents of change, Nomeda & Gediminas Urbonas are attempting to harness their symbolic power to change the fate of the Villa Lituania. Even if the realpolitik remains grounded, the concept will fly like Homer's Epea pteroenta 'winged words'.

—Simon Rees

Commissioner
Simon Rees

Collaborators
Julija Fomina
Mindaugas Masaitis
Valdas Ozarinskas

Artists
Nomeda & Gediminas Urbonas

1 **Nomeda & Gediminas Urbonas,** *Villa Lituania*, Rome, c 1939

2 **Nomeda & Gediminas Urbonas,** *Portrait of an Ambassador in Exile: Kazys Lozoraitis*, 2007. Video still

3 **Nomeda & Gediminas Urbonas,** research documentation: artists and assistant with pigeons, St Mark's Square, Venice 2007

1

Mexico
Some Things Happen More Often Than All of the Time

Mexico's first presence at the Venice Biennale was over 50 years ago at its 25th edition. Fernando Gamboa, a leading promoter of Mexican art and commissioner of the Mexican Pavilion, presented the works of Orozco, Rivera, Siqueiros and Tamayo, giving rise to what European critics called *The revelation of Mexican painting*. During the art show Gamboa declared that 'A new world has been opened for a lot of people, a world of independent thought, of strength and passion, of monumental concepts, of epic poetry' (Fernando Gamboa, 1950).

The 52nd International Art Exhibition of the Venice Biennale is a great opportunity for Mexico to reopen an institutional door for its contemporary art to an international forum. Achieving an active presence of Mexican artists on the world stage is a shared desire of Mexican society and its national cultural institutions.

The Mexican Pavilion is located in the Gothic Palazzo Soranzo Van Axel in central Venice, bordering the famous Chiesa dei Miracoli, not far from the official grounds of the Biennale di Venezia. Architecturally beautiful, the Pavilion comprises over 1,000 square metres of exhibition space where Rafael Lozano-Hemmer will present his work.

Exhibition *Some Things Happen More Often Than All of the Time*

Rafael Lozano-Hemmer (Mexico City, 1967) is an electronic artist who develops interactive installations that are at the intersection of architecture and performance art. His main interest is in creating platforms for public participation, by perverting technologies such as robotics, computerised surveillance or telematic networks. Inspired by phantasmagoria, carnival and animatronics, his huge light and shadow works are 'antimonuments for alien agency'.

For the exhibition *Some Things Happen More Often Than All of the Time*, Lozano-Hemmer has developed a series of interventions for the palazzo that address intimacy, self-representation and metonymy. The pieces include reactive kinetic sculptures, lighting arrays controlled by biometric sensors, responsive environments powered by computerized surveillance and sound installations. The thread that connects these pieces is an understanding of technology not as something 'new' or 'original' but rather as an inevitable language of globalisation that needs to be questioned and reinvented.

There is a rich tradition of technological experimentation in Mexico: from the radio interventions made by the Estridentista poets in the 1920s to the research by Weiner and Rosenbleuth at the Mexican Institute of Cardiology that led to the postulation of the theory of cybernetics in the 1940s. Gonzalez Camarena's early patent for colour television, Morton Heilig's virtual reality helmet prototypes made in Cuernavaca and Juan García Esquivel's pioneering stereo recordings are other examples of this creative, interdisciplinary, empiricist tradition. Lozano-Hemmer's work is presented in Venice as a continuation of this legacy.

Commissioners
CONACULTA / INBA / SRE

Curators
Priamo Lozada
Bárbara Perea

Production manager
Gastón Ramírez Feltrín

Coordination in Venice
Ziva Kraus

With the support of
The National Council for Culture
and the Arts (CONACULTA)
The Institute for the Fine Arts (INBA)
The Mexican Ministry of Foreign Affairs

Web Site
www.mexicobienal.org

Artist
Rafael Lozano-Hemmer

Rafael Lozano-Hemmer, *Pulse Room*, 2006. Incandescent lightbulbs controlled by heart rate sensors, computer, dimmers, dimensions variable. Collection of the artist. Courtesy Puebla 2031 and Galería OMR, Mexico
PHOTO ALEJANDRO BLÁZQUEZ

The Netherlands
Citizens and Subjects

Citizens and Subjects is a three-part project consisting of new work by artist Aernout Mik in the Dutch Pavilion, a critical reader, and an 'extension' of the Pavilion taking place in the Netherlands in autumn this year.

In response to the protocol of national representation upon which the Venice Biennale historically and by convention insists, *Citizens and Subjects* reflects on the nation-state in the present day circumstances of the so-called West and asks how we can negotiate its prospects vis-à-vis the challenges posited by that which defines our contemporary condition: (illegal) immigration. In the face of a lack of political imagination needed to address this issue, we seem to have handed over responsibility for regulation and enforcement to the police. The project proposes this predicament as the paradigm of our contemporaneity and prompts us to think further about other possible ways that a new kind of political community could emerge.

To put it simply, a *subject* is a person who is under the rule or authority of a sovereign, state or a governing power and who owes allegiance and obedience. *Citizens*, by contrast, are generally those with rights, entitled to the full privileges of belonging to a state or nation. In his complex multi-channel video installation enveloped in an architectural intervention in the Pavilion, Aernout Mik brings such defining dichotomies of the privileged and disadvantaged into intricate interplay, exploring the mechanisms of power, fear and violence involved. The starting point for him is the question of how the police learn and make use of various methods of enforcing the law against refugees. Not only does Mik stage and film a 'training' situation (testing how stand-ins temporarily adopt the roles of policemen and refugees), he also employs documentary 'rushes' from actual police exercises or real situations in which violence is deployed against asylum seekers. It becomes clear that this is part of the larger context of how we train ourselves to respond to crises and threats to national security in general. On multiple levels, the work questions the simplified distinction between subjects and citizens today, asking: 'Aren't we all actually subjected in the same way to this disquieting reality?'. Yet, Mik seems to suggest, it is from here that new possibilities can perhaps emerge. What if we interpret the scenes he stages before us not as training for the enforcement of law and the maintenance of power, but rather as a ritual through which to transgress the status quo consensus today? In this way, Mik's *Citizens and Subjects* represents an instance of cultural resistance that functions through the appropriation of existing modes of the politics of domination, reminding us of a field of ambiguity between subjection and possible liberation. Parody, building of irrational access, mimicry and re-enactment of situations can be read as a ceremony of inversion, overcoming the divide between subjects and citizens by questioning to what extent, and if at all, the traditional citizenry can offer a foundation from which to address the acute challenges of our day.

The critical reader, edited by Rosi Braidotti, Charles Esche and Maria Hlavajova, as well as the debates and discussions taking place in the 'extension' of the Pavilion (autumn 2007) are sites for further theoretical elaboration of the issues brought forward by *Citizens and Subjects*.

—Maria Hlavajova

Commissioner
Mondriaan Foundation

Curator
Maria Hlavajova

Collaborators
Rosi Braidotti
Charles Esche

Artist
Aernout Mik

1-3 **Aernout Mik**, *Training Ground*, 2007.
2 channel video installation video stills.
Courtesy carlier | gebauer, Berlin and
The Project, New York

1

▲2 ▼3

Nordic Countries: Finland, Norway, Sweden
Welfare - Fare Well

Marketta Seppälä You are the first curator for the Nordic Pavilion who comes from outside the Nordic countries. While working on your international projects, you have developed a comprehensive knowledge of the Nordic art scene and demonstrated an interest in the cultural and historical background of the region. After your trip to the North in 2001, during the preparations of the exhibition *40 Years: Fluxus and Its Influence* to Wiesbaden, you wrote about your impression, pondering what young Nordic art of today has to do with Fluxus: 'The results of my research may be comforting: nothing at all. Nonetheless many young artists have more to do with it than they might realise.' In a way, all the artists you have invited into the Nordic Pavilion draw upon ordinary life and their daily surroundings. Did you have a special (Fluxus) concept in mind and how is your particular interest in the possible future forms of international art events and biennials reflected in this year's Nordic Pavilion?

René Block Actually, I didn't start by designing an artistic concept, but concentrated much more on the space. The extraordinary Nordic Pavilion is probably the most beautiful, but also the most difficult space to gather artists' works. Secondly, I was, of course, aware of the Biennale situation. The Venice Biennale is a vanity fair and the international art audience wants to be entertained. It mainly comes and takes it as a vacation: Prosecco and Art and Prosecco. We have to serve the audience by playing. At the same time I want to create layers of meaning, hoping that after a while the viewers may get a kick out of it. This matches Fluxus, of course. What started around the middle of the last century was a new definition of the relation between Art and Life, including art as a 'social sculpture' as Beuys used to say. Today all these Fluxus aspects belong to our everyday aesthetic and intellectual vocabulary.

In the context of the Venice Biennale, where countries started installing National Pavilions in the Giardini from 1907 on and where the sizes and locations of the Pavilions have reflected changes in international politics and power structures in the course of a century, the Nordic Pavilion (1962) is a late-comer and rare exception as a joint project of three countries, Finland, Norway and Sweden. For me a biennial in general is at its best a workshop, an opportunity for artists to interact and work together. This year in the Nordic Pavilion there are six projects by artists who didn't know each other from across their national borders. This may emphasise that the Nordic countries are not a homogenous entity, but together in the pavilion the projects of the invited artists reflect in many ways the contemporary Nordic societies.

MS In the course of the formation of national identities a certain image of the North has been constructed. However, geographical maps and foundations of cultural identities are under re-formation today, even in the North. By inviting artists from different national backgrounds, do you emphasise the fact that specificity of geographical location and art produced in that location no longer necessarily correspond to each other?

RB Certain definitions of the North may have functioned as a generator in defining the exhibition. The younger generation of artists has grown up in the Nordic welfare society. In the pavilion there are five artists of Nordic origin, but also Iraqi born Adel Abidin, who has lived and studied in Helsinki since 2001 and Iranian born Sirous Namazi, who has lived and studied in Sweden since his teens.
Adel has constructed his interactive *Abidin Travels* agency in the office of the pavilion to welcome art tourists to Baghdad, while Sirous transfers typical everyday suburban elements to

Commissioner
Marketta Seppälä

Curator
René Block

Artists
Adel Abidin
Jacob Dahlgren
Toril Goksøyr and Camilla Martens
Sirous Namazi
Lars Ø. Ramberg
Maaria Wirkkala

▲ 2 ▼ 3

1 Jacob Dahlgren, *I, the World, Things, Life*, 2004. Installation of dartboards at the Norrköpings Konstmuseum 2004, 572 x 1,729 cm. Courtesy Galleri Charlotte Lund, Stockholm
PHOTO TEDD SOOST

2 Lars Ø. Ramberg, *Liberté*, 2005. Mixed media (concrete, steel, plastic, water), an interactive sculpture consisting of three toilets. Supported by JCDecaux Oslo
PHOTO LARS Ø. RAMBERG

3 Toril Goksøyr and Camilla Martens, *It Would Be Nice to Do Something Political*, 2006. Poster on window, 208 x 358 cm / performance. Photo Goksøyr and Martens, Art, Life & Confusion - 47th October Salon in Belgrade, September-October 2006. © Toril Goksøyr & Camilla Martens

contextual translations that reflect social issues in contemporary society. Lars Ramberg's *Liberté* (2005), which was created to celebrate the centenary of Norwegian independence is an interactive sculpture made out of three French automated public toilets painted in the French and Norwegian national colours and re-named *Liberté, Egalité, Fraternité*. It is a new Statue of Liberty for both countries, recalling the French Revolution in the formation of modern democracy, catching up with a contemporary discourse on national and political identity and asking: 'Where do our values come from and where are they heading to?'. Toril Goksøyr and Camilla Martens also comment on Nordic societies, which have a desire to be seen as caring and helping nations in the global context, yet wanting to keep their own borders closed and striving to ensure that their part of the world retains its economic sovereignty. Those who are granted residence must do work that no one else wants to do. In Toril's and Camilla's work immigrants keep the outdoor window of the Nordic Pavilion clean, while on the other side of the same window, inside the Pavilion Jacob Dahlgren's interactive work consisting of hundreds of dart boards invites viewers to a

competition for the best score. Maaria Wirkkala has created a site specific project for the Aalto Pavilion, designed in 1956 by Alvar Aalto, an icon of Finnish architecture and design.

MS The Nordic welfare society has, however, deteriorated during the last decades, usually under the banner of global competitiveness. Immigrants cleaning the window outside the Pavilion are not allowed to get to the other side and participate in the popular recreational game. Is this a metaphor for a confusion when confronting the question: 'How come these most affluent societies in world history practise policies which, as everybody knows, increase social polarisation and nourish fear, cynicism, powerlessness and racism?'.

RB Yes, all of this is part of this small Nordic exhibition in Venice. Therefore I've chosen a title that intends to confuse: *Welfare - Fare Well* does not stand for the theme or concept, but is a motto. May welfare fare well! Unfortunately, however, 'fare well' can also be understood as 'farewell', as 'goodbye'. I'd like to leave some space for individual interpretation.

4

4 **Adel Abidin**, *Abidin Travels - Welcome to Baghdad*, 2006. Video installation, three monitors, three DVD players, three videos, posters, website, brochures of Tourist Guide, computers. © Adel Abidin

5 **Sirous Namazi**, *Periphery*, 2002. Aluminium, profiled sheet metal, wood, concrete, satellite dish, 150 x 220 x 190 cm. Courtesy Moderna Museet
PHOTO ALBIN DAHLSTRÖM

6 **Maaria Wirkkala**, *Unaccompanied luggage*. Site specific installation at Instanbul Biennial 1995
PHOTO MANUEL GITAK

5

6

95

Poland
1:1

Monika Sosnowska, *1:1*

Monika Sosnowska studies architecture from the point of view of its failures, she is interested in places encumbered with error, knocked out of functionality, in absurd ideas and absurd implementations. Her works are often peculiar mementos of architectural utopias brought out from the past, inspired by architecture's psychedelic properties. The main reference point for Sosnowska are the experiences of postwar modernisation – to the inhabitants of Eastern Europe, the all-too-familiar landscape of housing blocks, service Pavilions, train stations and shopping centres.

The artist's latest project, called *1:1*, is not, however, a nostalgic return to communist Poland's favourite architectural solutions but rather the consequence of a reflection on the postwar architectural concepts analysed from the angle of the surprisingly vital, local, Eastern European mutation of the International Movement. During the People's Poland era, progress was often restricted to impulsive, rash (and often absurdity-producing) modernisation. The requirement of 'modernity' in postwar Poland was a top-down imposed decision, controlled through a series of orders.

Today, modernist buildings in Poland, as elsewhere in Central and Eastern Europe, are being modified. In contemporary realities, governed by the brutal laws of the free-market economy, the coarse charm of the architectural 'ballast' of past decades' is being laboriously painted over. The practice of 'repackaging' unattractive buildings has become widespread and new facades are often erected to conceal earlier structures. Many important postwar architectural works in Poland have been slated for demolition, such as the Supersam department store in Warsaw (opened 1962), one of the era's most notable designs. Some highly industrialised regions, such as Upper Silesia, are today turning into cemeteries of post-industrial structures, remaining since the 1990s in a state of semi-decay.

In a number of recent works Monika Sosnowska has transgressed the more or less artificial border between contemporary art and architecture. In her own words: 'It seems to me that what I do is somehow in opposition to what architecture stands for. I also think that my art is a completely different discipline, even though I focus on the same problems as architecture does: the forming of space. Utilitarianism is architecture's fundamental attribute. My works introduce chaos and uncertainty instead'.

Uncertainty is also an irremovable part of the latest project. The additional structure emerging in the Polish Pavilion is almost organic – it 'parasitises' the almost 70-year-old exhibition venue. The installation *1:1*, like Sosnowska's other works from the last couple of years, can be viewed as a reference to the practices of the artists of the 1970s (G. Matta-Clark, R. Smithson and others) and a continuation of the reflection on decay and destruction, but also as a criticism of the art institution via a radical intervention in its architectural tissue. After all, the project serves to 'exhibit' the Polish Pavilion itself – a building representative of the 1930s, which, as one of the work's elements, 'wrestles' with another construction growing out from inside it. Sosnowska's project fits both the local context and the global discourse on the search for functionality, on moving away from modernism's stylisation and pro-community tasks.

—Sebastian Cichocki

Commissioner
Agnieszka Morawińska

Curator
Sebastian Cichocki

Deputy commissioner
Zofia Machnicka

Assistant commissioner
Zofia Machnicka

Web Site
www.labiennale.art.pl

Artist
Monika Sosnowska

1 Construction in Polish Pavilion
PHOTO MONIKA SOSNOWSKA, 2007

2 Demolition of the 'Supersam' supermarket in Warsaw, 2006
PHOTO MONIKA SOSNOWSKA

3 **Monika Sosnowska**, model of *1:1* installation, 2006
PHOTO MONIKA SOSNOWSKA

1

2

3

Portugal
MAISON TROPICAL

Ângela Ferreira's Invisible Constructions

Driven by political issues, Ângela Ferreira scrutinises the use of theories – in particular art history theories – and their relationship with and impact on contemporary art, calling on art's inherent and unique communicative potential to negotiate complex subject matter. Ferreira subtly stimulates viewers to articulate questions in their encounters with her objects, which take the shape of skilfully executed and aesthetically appealing modernist sculptures, often combined in installations with texts, photographs and videos. The questions raised throw doubt on what we have come to consider as 'givens' in art history. In her proposition of art history as a construct, one might ask, as Douglas Crimp once did: 'which history, whose history and history to what purpose?'. Venice – a city with its own unique record of more than a century of Biennals, with its national presentations of art and its never-ending negotiations with (post) modernism – is a perfect platform for Ferreira to confront these questions.

Born in the Portuguese colony of Mozambique in 1958, Ângela Ferreira studied in apartheid South Africa and has lived in Portugal and South Africa since the early 1990s. Her 'in-between' status – inherent to the identity of many Portuguese – drives her intense exploration of different universes in centres and peripheries, highlighting the importance of perspective.

Ângela Ferreira's oeuvre can be situated conceptually between the failure of modernism in the so-called centres, and the conflicting impact of colonisers attempting to implement modernism across Africa, and in any other colony around the world. However, the utopian goal of the emancipation of mankind, combined with art's potential as a critical tool, which was an essential drive of the avant-garde as it manifested itself in the centres, seemed not to apply in colonised territories.

The end of the avant-garde and its inherent qualities, its history and the impact of that history are now also discussed in these so-called peripheries, and the centre has lost its prerogative to proclaim the political significance of modernism when it comes to notions of utopia and emancipation.

Paraphrasing a contemporary art theorist, Ângela Ferreira's practice not only survives the proclaimed end of the avant-garde but also again evokes the issue of emancipation and utopian ideals by reformulating the critique of utopias as a critique on utopias. Her work reveals the artistic freedom promised by modernism as deceptive in the centres and as a false autonomy in the periphery, because of the lack of political latitude.

Grand narratives appear to us now as countless, smaller fragments. On the one hand, we sometimes yearn for the well-known comfortable methods of classifying the historical avant-garde, the never-ending string of neatly identifiable styles and methodologies in modern art and 'International Style' architecture. On the other hand, Ângela Ferreira's work underlines the possibilities that have opened up through the tremendous changes these narratives are undergoing. In dismantling the often dogmatic, basic strategies of 'given' notions, her work offers a social, political and critical approach to the outcomes of modernism, to the old centres of its creation and their remote consequences. In applying the modernist methodology of profound analysis to modernism itself, she proposes this method as a 'local' alternative for dealing with modernism, rather than simply simulating it. Ângela Ferreira's concerns are materialised in 'sculptures organised in installations', which are not subjugated by the political. The critical proposition of her objects is not up front, but simmers subtly below the surface of her beautiful sculptures, offering a space between the 'object and the political', a space for the viewer to occupy. Ângela Ferreira does not seek to teach us anything, but to stimulate our own political, imaginary and critical comprehension.

—Jürgen Bock

Commissioner / Curator
Jürgen Bock

Organisation
Ministério da Cultura / Instituto das Artes

Collaborators
Cláudia Castelo
Alexandra Fonseca
Adelaide Ginga
Inês Lamim
Mário Valente
Domingos Valido

Organisation in Venice
Arte Communications

Web Site
www.iartes.pt/veneza2007/

Artist
Ângela Ferreira

Ângela Ferreira, Jean Prouvé's Tropical House, prefabricated in France in the 1950s and flown into the French colony of Congo. Seen here as photographed in Brazzaville in 1996, the house was recently 'returned' by a collector and subsequently exhibited in Paris
PHOTO © BERNARD RENOUX

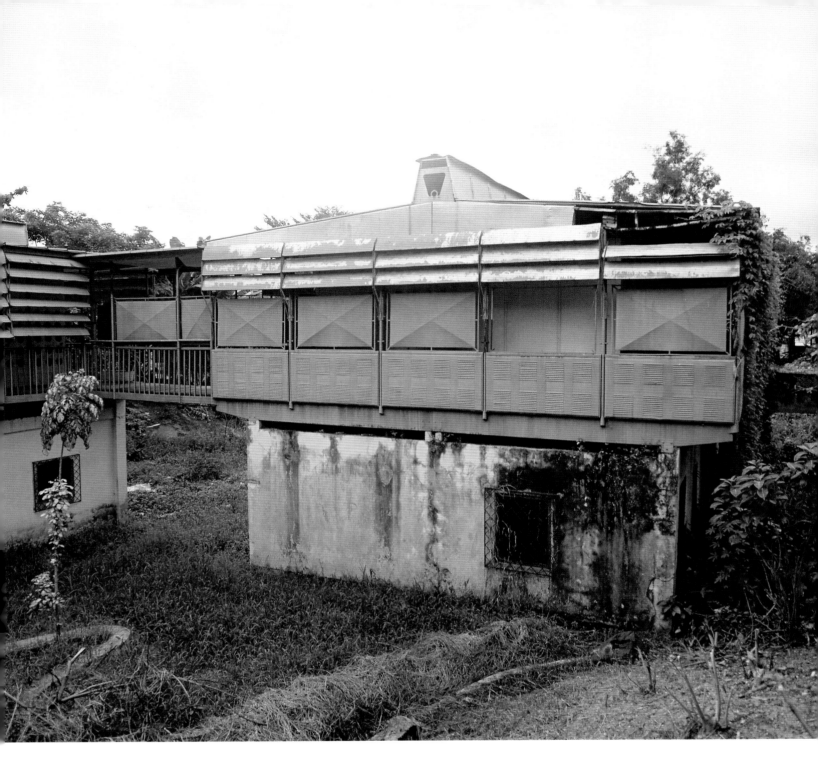

Syrian Arab Republic
On the Streets of Damascus

The city of Damascus has been recognised as one of the privileged places of the 'life of forms' and tradition for centuries. It is no mere chance that the Syrian capital symbolises the most intense metabolism of artistic languages, a place of interference, friction and symbiosis between the cultures of East and West, a watershed of history and at the same time a recurring sign of the most ambitious goals for a meeting of civilisations and the growth of human understanding, beyond any difference of religion, race or political order. The exhibition of contemporary art in the Syrian Pavilion at the Venice Biennale is intended to correspond to this general need for reciprocal cultural attention. Significantly entitled *On the streets of Damascus*, it features a selection of artists working in the host nation (Bassem Dahdouh and Nasser Naassan Agha), while also highlighting more recent works by Italians of different generations (Concetto Pozzati, Renato Mambor, Alfredo Rapetti, Stefano Bombardieri, Donato Piccolo and Dario Arcidiacono) along with an artist of Provencal origin (Philippe Pastor). The comparison of expressive experiences is the premiss for dialogue and a lateral exchange of forms: that which in their most tortured and complex history has always determined the interweaving and rich visual osmosis between the civilisations reflected in the Mediterranean Sea. Themes such as the collective imagination, irony and manipulation of formal and chromatic solutions, representative icons of the sentiments and needs emerging from the spiritual depths of distant worlds, also correlated with or brought together by existential concurrency, by socio-political conditions and technical and computer validations can be read in the works displayed in *On the Streets of Damascus*. They are marked by fairly dissimilar but also convergent views in a choreography of aesthetic motifs and moral questions on the main paradoxes and the most fervent hopes in the drama of the contemporary.

The prevailing ironic-linguistic artifice of the Italians, (Pozzati and Mambor, but also Arcidiacono, Bombardieri and Piccolo) is accompanied by close attention to the problem of painting-writing (Rapetti), while the Monégasque Pastor accentuates an existential expressiveness that unites the gesture and the material in the image. Meanwhile, the exponents of Syrian art measure themselves against the theme of contemporary language in a dramatic vision of reality decanted by colour-light (Nasser Naassan Agha) and by gestural and expressive intensity (Bassem Dahdouh). In contrasting the most vibrant, dramatic experiences of the contemporary, reformulated through painting, photography and other visual techniques, the exhibition intends summarising all the varieties of human expression and its constituent cultural motifs in a network of possible consonances.

—Duccio Trombadori

Commissioners
Christian Maretti
Miria Vicini

Curator
Duccio Trombadori

With the contribution of
Fondazione Valerio Riva

Artists
Stefano Bombardieri
Bassem Dahdouh
Nasser Naassan Agha
con Dario Arcidiacono
Renato Mambor
Philippe Pastor
Donato Piccolo
Concetto Pozzati
Alfredo Rapetti

1 Bassem Dahdouh, *Women 1*, 1996. Mixed technique on canvas, 120 x 200 cm. © Bassem Dahdouh

2 Donato Piccolo, *Perché non ti accorgi del vento*, 2007. Installation, fiberglass, LED-display, iron, dimensions variable. © Donato Piccolo

3 Renato Mambor, *Progetto per Karma mutabile*, 2006. Mixed technique on paper, 43 x 49 cm. Private collection

4 Nasser Naassan Agha, *Senza titolo*, 2006. Oil on canvas, 140 x 140 x 2 cm. © Nasser Naassan Agha

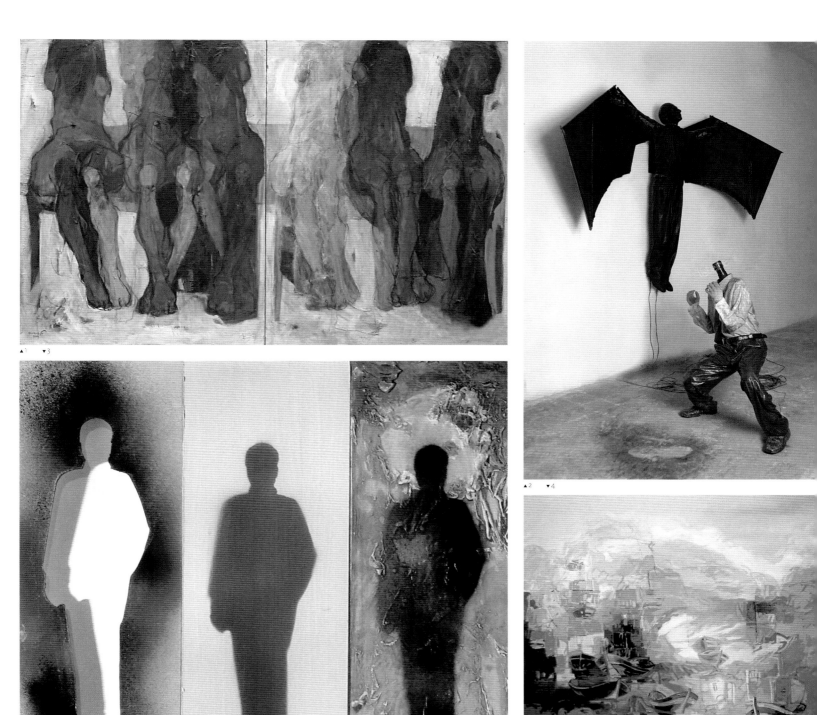

▲1 ▼3

▲2 ▼4

▲5 ▼7 6

5 Dario Arcidiacono, *Emblematum 1*, 2007. Acrylic on printed glossy paper, 167 x 90 x 4.5 cm. © Dario Arcidiacono

6 Philippe Pastor, *Libertà*, 2006. Pigment on canvas, 475 x 315 cm

7 Concetto Pozzati, *Studio per Croce-fissione*, 2005. Mixed technique on paper, 25 x 35 cm

8 Stefano Bombardieri, *Senza titolo*, 2007. Fiber glass, 2,000 x 2,000 x 600 cm. © Stefano Bombardieri

9 Alfredo Rapetti, *Lettera a Damasco*, 2006. Acrylic on canvas, 140 x 140 cm. © Alfredo Rapetti

▲8 ▼9

Czech Republic and Slovak Republic
Collection - Series

Irena Jůzová presents a lukopren cast of her body in the Czech and Slovak Pavilion at the Venice Biennale. The idea to cast and exhibit the surface of one's own body, or somebody else's body is not new in art – what is new and significant is the input of this artist in the context of contemporary culture. In a study on Michel Foucault, Gilles Deleuze writes that 'we continue to produce ourselves as a subject on the basis of old modes which do not correspond to our problems'. Irena Jůzová puts her own body on display, not as a sexually attractive, or topical gender motif, but as an industrial product. Her self-presentation is an attempt to strip the body of certain motifs that are easily usurped by mass communication and market forces in favour of the emotions and instincts by which this form of power achieves its victory over art. In this sense the presentation of the imprint of one's body in the context of a luxury boutique made of prefabricated paper architecture is an act of detachment, of inquiry as well as critique.

The artist herself regards exposing and reflecting on a cast of her body as a turning point in both her life and work. More than the traditional meanings of shedding one's skin as we know them from nature, Irena Ju°zová's installation has more to do with the definition of *la pensée du dehors*, the thought from outside, that is, with a paradigm of art distinct from those operating in the culture of the classical era, bound as they were to the norm of art as a metaphysical transcendence of the world of objects. Instead of metaphysics, there is fact; instead of singularity, there is mass-production. Instead of empathy, there is self-visualisation.

The lukopren skin bears no visible signs of a singular message, but has all the appearance of merchandise being displayed in shop-windows, and presented in industrially produced packaging. Artificial skin, 'purged' of artistic connotations, thus opens the way to other meanings than those persistent in art, which remains subordinate to power.

In Irena Jůzová's work, the stripping and shedding of one's skin has a purifying, regenerating meaning, if only in the sense that it saves the artist from the possibility, or expected obligation, of any kind of personal or artistic confession. Artificial skin is a signifier of her physical absence. All that the artist leaves behind is an imprint, the writing of a plastic text in showcases and boxes bearing the imprinted name, Irena Jůzová.

Just as the lukopren cast is a sign of the artist's absence, the concept of the installation in the Pavilion as such is a sign of the absence of traditional structure of architecture. It is not made of tectonic functional elements, but serially-produced paper casts. According to Adolf Loos, architecture as art in the traditional sense can only be realised as sculpture or tombstone. The architectural set of Irena Jůzová's installation draws you into its game of loss of identity and the revelations of secondary authenticity. Within the setting of the Czech and Slovak Pavilion, Irena Jůzová presents a game not only with the imprint of her body, but also with the imprints of architectural elements as a daring metaphor of a memorial or mausoleum of art as manipulated by the market.

—Tomáš Vlcek

Commissioner / Curator
Tomáš Vlcek

Coordinator
Lucie Šiklová

Organisation
National Gallery in Prague

Artist
Irena Jůzová

1 Irena Jůzová, *Collection - Series*, 2007. Visualization of the *Collection - Series*. Private collection. Courtesy the Artist

2 Irena Jůzová, *Collection - Series*, 2007. Visualization of the *Collection - Series*, night view. Private collection. Courtesy the Artist

3 Irena Jůzová, *Collection - Series*, 2007. Plaster cast of body in transparent Lukopren in paper box, 125 x 50 x 20 cm. Private collection
PHOTO COURTESY THE ARTIST

1

▲2 ▼3

Republic of Azerbaijan
Omnia mea...

The Azerbaijani artists presented here belong to several generations of contemporary art. Their work not only involves a spectrum of media and innovative visual approaches, but reflects trends that dominate the contemporary art world in Azerbaijan.

One such trend is the constant reflection on the past – an attempt to address ancient traditions and rituals. This approach is typical of artists whose vision was formed during the Soviet period. Represented by Chingiz Babayev (fruit carpets) and the artists of the *Labyrinth* group (performance with fire), this approach introduces traditional Azerbaijani ethnic themes of carpet weaving and fire worship to such contemporary media as land-art and environmental sculpture. These artists balance between giving a direct social message about the state of the environment in Azerbaijan and using a very contemplative and esoteric visual language, a kind of self-enclosed ritual.

The artists of the younger generation who began working at the beginning of the new millennium demonstrate a defiant detachment from their past and their national heritage. They choose a more global artistic language, a vision developed in the post-Soviet period, with Azerbaijan an independent nation – its society looking towards global integration. The epoch of globalisation forces artists to adapt to the new transnational visual language, as the use of modern technology pushes artists far from any manifestation of their 'exotic' national context. Consequently, performance art by Ali Hasanov, video-art by Rauf Khalilov, Tamilla Ibrahimova and Tora Aghabeyova, photography by Rena Effendi and Orkhan Aslanov and multi-media projects by Elshan Ibrahimov, Fayig Ahmed, Orkhan Huseynov and Rashad Alakbarov constitute a universal visual language that reflects the artists' attitude towards their ever-changing reality. The global art audience will be able to understand these artists' work without specific cultural reference to Azerbaijan. The process of globalisation continues to erase borders and cultural difference while commenting on social problems that are common to all: terrorism and global security, the power of the mass media, alienation, a lack of cultural dialogue and information overload. These are the issues Azerbaijani contemporary artists are concerned with and communicate in a language that is both unique and universal.

Commissioner / Curator
Leyla Akhundzada

Curator
Sabina Shikhlinskaya

Deputy commissioner
Vittorio Urbani

Organisation
Ministry of Culture and Tourism
of Republic of Azerbaijan

Web Sites
www.azgallery.org
www.wings.aznet.org

Artists
Tora Aghabeyova
Fayig Ahmed
Rashad Alakbarov
Orkhan Aslanov
Chingiz T. Babayev
Rena Effendi

Ali Hasanov
Orkhan Huseynov
Elshan Ibrahimov
Tamilla Ibrahimova
Rauf Khalilov
Labyrinth art group

1 **Chingiz T. Babayev**, *Silk Way*, Mark Block University, Strasbourg, France, 2002. Flowers, fruits, vegetables, branches, leaves, color cardboard

2 **Chingiz T. Babayev**, *Hand Made Carpet*, International Art in Nature Biennale *Arte Sella*, Borgo Valsugana, Italy, 1996. Installation, flowers, fruits, vegetables, leaves, 800 x 600 cm

3 **Rauf Khalilov**, *Leadership and Power*, 2004. Animation, 3'08"

4 **Rauf Khalilov**, *Univarsal Game*, 2005. Animation, 7'19"

▲1　▼2

▲3　▼4

5

▲6 ▼7

▲8 ▼9

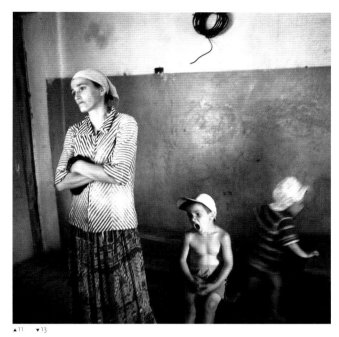

▲10　▼12

▲11　▼13

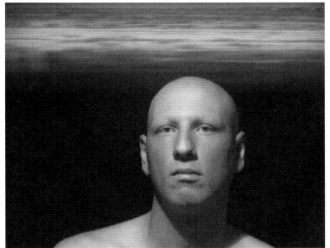

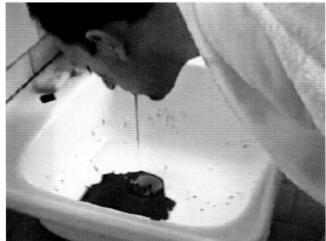

5 Ali Hasanov, *Keelcoushe*, 2000. Performance (performed by the author), 40', leather costume, leather strings. Original music Ali Hasanov

6 Elshan Ibrahimov, *The Smile Machine*, 2003, Baku, Azerbaijan. Interactive animation, 10-12''

7 Labirint, *Fire Project*, 1999. Print series, video, 70 x 100 x 10 cm

8 Faig Ahmed, *Toys for Terrorists' Children*, 2006. Print series, dimensions variable

9 Orkhan Aslanov, *I Want Clouds*, 2006. Photo series, dimensions variable

10 Rashad Alakbarov, *Looking at Two Cities from One Point of View*, 2002. Mixed media installation, light, dimensions variable

11 Rena Effendi, *Lives in Conflict*

12 Tamilla Ibrahimova, *Opposition*, 2005. Video, 1'50"

13 Tora Aghabeyova, *Mood*, 2001. Video, 1'30"

14 Orkhan Huseynov, *Geography Lesson. Homework*, 2003. Interactive drawing, pencils, marker, erasers, white wall. Viewers invited to re-draw, change and erase borders on the world map

14

Republic of Armenia
Who Is the Victim?

Sonia Balassanian *Who Is the Victim?*

The media confront us daily with an excess of brutal war imagery. Yet the information content that these media images convey on specific conflicts is thin. In particular since war has ceased to refer exclusively to war between nations, but involves more complex structures and dislocations, such images present an unchanging picture of misery as a universal constant of global crisis. New conflicts, no less than protracted or abiding ones, can no longer be viewed in isolation, but are components of a global, fear-fuelling apparatus of war.

Sonia Balassanian's video images tap into this universalised misery and suffering. A projection of her multipart video work *Who Is the Victim?* for the Pavilion of the Republic of Armenia at the 52nd International Art Exhibition shows a man in camouflage fatigues relating his war experiences in a quiet, monotonous voice and a woman overcome by grief for the husband she has lost in war. The soldier's direct experience is no less intangible than the woman's ideas of war based on media reports and memories of her husband. Both figures have been broken by the futility of death through war – the soldier succumbs to blank apathy, the woman to despair. Gender-specific differences in dealing with war are also brought out. While the woman is left alone with her grief, the soldier is left with a shattered psyche.

Wars and crisis areas are a constant feature of Balassanian's biography. Of Armenian extraction, she grew up in Iran and now lives in New York and Yerevan. Concrete political events such as the fall of the Shah in Iran in her collages *Hostages* (1980) figured in her earlier works. Balassanian's concern in her more recent video works are the ramifications of a general war being waged against the individual.

The images of places and landscapes in *Who Is the Victim?* can be read as the soldier's and the woman's memories. Memory assumes a central role in the lives of people who experience war and henceforth shift between two extremes, the collective need to remember and the individual desire to forget. The images were all shot in Armenia, but they could be anywhere, having more the nature of generic images of positively or negatively connoted sites of memory.

What is involved when a viewer of war images takes an interest in or empathises with human suffering in far-off conflict zones? Not only those killed by war and their relatives are the victims, but all whom the fear of war afflicts. Similarly, every viewer today, no matter where, experiences victimhood in the face of the part real, part propaganda-induced fear of the proliferating warfare represented by terrorist attacks. But sympathy puts us in a position where we can passively shirk responsibility and ignore our own role as accessories: 'Compassion is an unstable emotion. It needs to be translated into action, or it withers' (S. Sontag, *Regarding the Pain of Others*, New York, Farrar, Straus and Giroux, 2003, p. 131). The question as to how art – as producer of knowledge, as a form of activism or enlightenment – can tackle the subject of war is answered by Balassanian's work with just this notion of sympathy and the necessity of its transcendence arising from insight into the fact that the universalised suffering in question is the outcome of a global strategy of war. 'Everyone is asleep, crisis is coming' (Sontag, *Regarding the Pain of Others*, cit.) is how the soldier describes the current lethargy vis-à-vis this ominous situation, thus offering a potential lead-in to critical protest against an economy of global war.

—**Nina Möntmann**
(translation by Christopher Jenkin-Jones)

Honorary commissioner
Jean Boghossian

Curator
Nina Möntmann

Assistant commissioners
Patrick Azadian
Samuel Baghdassarian
Craig Buckley
Koko Garabetian

Assistants curators
Rey Akdogan
Arne Z. Balassanian
Gagik Ghazareh
Sevada Petrossian Abramian

Coordination in Venice
Fr. Samuel Baghdassarian

Web Site
www.accea.info

Artist
Sonia Balassanian

Sonia Balassanian, *Who Is the Victim?*, 2006-2007. Multi-screen spatial video installation in multiple rooms, dimensions variable. © Sonia Balassanian, 2006

Republic of Cyprus
Old Earth, No More Lies, I've Seen You...

The Risk of Art

What else could this 'Pavilion' for Cyprus represent than something of the risk entailed in art that raises doubt as to the truths in the representations of a culture, and to arrive at less secure ways of encountering this culture. Consider Nietzsche's interest in the very making of work as a risk, that it be driven by 'interest' as opposed to, say, the 'disinterestedness' of Kant. Consider the ramifications of our time that Agamben has lamented and warned us against, 'only because art has left the sphere of interest to become merely interesting do we [now] welcome it so warmly'.

The works of Haris Epaminonda and Mustafa Hulusi show what might be at stake in the manipulation and circulation of images in our culture – in Cyprus in particular – all the while being 'possessed' of them. Epaminonda speaks of 'loosening thought'. How then to propose meanings, a new 'scene' not compromised by the absorption of the failures of modernity: born of the fantasies of the enlightenment and the international diplomacy that in its wake has left Cyprus as a divided country? Hulusi's large scale, Technicolor, photo-realist painting-assemblage of flora and fruit native to Cyprus risk their existence in a territory between estrangement and enchantment, in form and scale they also risk their existence as painting. A Turkish Cypriot – part of the Diaspora born in London – his previous work was based on his photographs of Cyprus and to Cyprus he returns. Entitled *The Elysian Paintings* the photographs are transmitters for the paintings created from them. Painted in collaboration with a professional illustrator, with traces of the bucolic ideal/kitsch of Chinese and Korean political propaganda posters, their luminous surfaces show a less solid flesh than we expect to find in this world. One of his many poster works appropriated a photographic portrait of British prime minister Tony Blair where a 'less solid flesh' arises again through the imposition of Hulusi's name. He mimics *The Elysian Fields*, the island of bliss in the after-life, yet Hulusi's 'field' is *of* this earth. The Lebanese writer Jalal Toufic speaks of the value of one who works in relation to a place when one is not there. Hulusi is both there and 'not there' to produce these luminous presences: paintings that also say something of the 'presencing' that all borders generate.

Epaminonda's installations of videos, collage and photographs are a series of mediations on image and sense – an encounter with the vicissitudes of memory and history. Accessing TV broadcast archives in Cyprus, the work fragments and re-transmits Cypriot television broadcasts from the late 1950's. Whether symptomatic 'soaps' or news broadcasts, they become breaches in memory. Her collages are agitated, temporary stoppages of vision and, by implication, speech; excoriating, they give a dark twist to her sources. Cutting into the pages of 1950's French magazines the work refuses the teleology of history, holding us on the sway of another time. It spatialises time, as Walter Benjamin would say, so that we can get our hands on it. Her earlier video works filmed off TV screens in Cyprus and the broader Eastern Mediterranean region, are a montage of moments. In *Tarahi II* the effect of a woman's gaze withdraws from the symptomatic utterances of the soap opera. In the film *Barka* a face in a still photograph, immersed by a sound track is breached by the film frame itself: a small empty boat adrift on a dark sea – hollowing out our gaze. Her work continues from this breach, between one archive and another – a timely twist on modernism's fascinations.

—Denise Robinson

Commissioner
Louli Michaelidou

Curator
Denise Robinson

Deputy commissioner
Stavroula Andreou

Deputy curator
Andre Zivanaris

Web Site
www.cyprusinvenice.org

Artists
Haris Epaminonda
Mustafa Hulusi

1 **Haris Epaminonda**, *Untitled 16*, 2005-2006. Collage, 20.5 x 20.5 cm. Courtesy the Artist

2 **Haris Epaminonda**, *Postcard*, 2005. Video still
PHOTO COURTESY THE ARTIST

▲1 ▼2

3

3 **Mustafa Hulusi**, *Untitled (White Flower and Hand)*, 2005. Oil on canvas, 213.5 x 300.5 cm. Courtesy private collection

4 **Mustafa Hulusi**, *Untitled (Ceylan Flower)*, 2005. Oil on canvas, 213.5 x 300.5 cm. Courtesy Samantha Lewis

4

Republic of Korea

Lee Hyungkoo: Pseudo-Scientist inventing Reality

The works of Lee Hyungkoo, apparently comic and wicked, reflect a cultural complex that is widespread in the periphery of First World nations. According to Deng Xiaoping's definition, Korea should be part of the capitalist world. However, despite its dramatic economic growth, Korea has not been freed from the suspicion of cultural 'Third World-ness' to develop its own self-identity. While proud of their great traditional cultures and rapid strides in recent times, Koreans are still following the Western cultural criterion. As long as the vision of economic, cultural and entertainment models is set by the West, Koreans will accept the ever-changing social value system geared toward the so-called 'global standard'. But, this kind of reality is challenged by the ingenious fabrication of alternating between acceptance and rejection, identification and differentiation. Lee confronts the confusing and even discouraging reality to create and explore his own fake realities in a pseudo-scientific manner.

His concerns about the body as a cultural artefact were drawn from a bitter sense of 'undersized Asian men' while studying in the USA. Born and raised in Korea, where a male-centred culture is relatively predominant, Lee may have felt a strange dwarfness in this new environment. From these experiences Lee created his first body transformer *A Device that Makes My Hand Bigger* (1999), *Satisfaction Device* (2001) etc. Simultaneously, as a gesture of psychological therapy and cosmetic surgery, Lee developed the *Helmet* series. Referring to the notions of the post-human perspective, Lee's personal playfulness has distinctive characteristics with his micro-mechanical inventions and attempts at instant metamorphosis. As the title *The Objectuals* suggests, these devices are channelled toward a different mode of visual field in terms of the politics of gaze. By putting on the optical devices himself and mimicking a self-possessed doctor, Lee becomes an active object to be seen and achieves a new subjective point of view against the material world around him. Lee's fictitious medical clinic is, then, a stage for the subversion of values where not only the empowered position of seeing but also the authoritative standard of beauty and the given hierarchy of culture are challenged.

The deformed faces of the *Helmet* series are not so far from the cartoon characters of the *Animatus* series. 'Exploring the interim or tentative possibilities of the anatomical authority lacking in evidential figures', Lee seriously uses imaginary creatures based on animal anatomy to craft extremely elaborate fossil-like skeleton specimens. These created or 'discovered' things are given new zoological names in Latin. Even though Korea has become a major force in exporting animation, characters like 'Tom and Jerry' have been the heroes of Korean households for half a century. The idea of bringing the simulacra into reality could be the defining statement noting that the boundary between the two has become obscure. At the same time it brings innovation, certainty and actual existence to where there is neither originality nor fact. Using archaeological excavations and the imaginary world of Hollywood animation, Lee breaks in between the virtual and the real to present a new order of reality in reversed time. If art is what redefines the future, suggesting various answers to the questions that confront contemporary life, Lee Hyungkoo is facing these issues with humour.

—**Ahn Soyeon**

Commissioner
Ahn Soyeon

Sponsors
Arts Council Korea
Samsung Foundation of Culture
Arario Gallery

Web Site
www.korean-pavilion.or.kr

Artist
Lee Hyungkoo

1 **Lee Hyungkoo**, *Mus Animatus* (left), *Felis Catus Animatus* (right), 2006. Resin, aluminum sticks, stainless steel wires, springs, oil paint, dimensions variable, 127 x 58 x 64.8 cm (FCA). Installation view at Fondazione Sandretto Re Rebaudengo, Turin, Italy
PHOTO COURTESY THE ARTIST AND ARARIO

2 **Lee Hyungkoo**, *Altering Facial Features with Pink-H1*, 2003. Digital print, 120 x 150 cm. Courtesy the Artist and Arario

▲1 ▼2

Republic of Moldova
Feel & Crash

Svetlana Ostapovici: *Feel & Crash*

An introduction to the historical context of Moldovan contemporary art is indispensable. The nation is a young hope of European art, investments are arriving and the results are tangible and visible to all. It is necessary to add that much remains to be planned, but the Republic of Moldova has considerable human energy and the commitment typical of emerging nations. The life blood of those with an objective, and especially who know what to say, artistically speaking, is a resource that deserves attention. The Venice Biennale is therefore an inviting and undeniable opportunity.

The unique city of Venice is where Svetlana Ostapovici assembles her works. The artist from Moldova, a country only recently active on the European art scene, does not devote herself to representations of her own culture, she transcends it.

Svetlana Ostapovici moves to Italy and, innovating, perceives an absolute art support like the mosaic. The artist is the only one in the world who uses the vitreous tesserae as if they were brushes; the intrinsic colours of the mosaic have a creative value. The observer looking at Svetlana's 'pictorial mosaics' is witness to an epiphany; an ancient concept like the mosaic is grafted onto contemporary art generating a new classical order. The order is the rigidity of the vitreous tesserae and their special and balanced dimension, the new classicism is eurhythmy, the basic tool for formalising the pictorial mosaic.

Svetlana Ostapovici creates fragrant works of art. They seem like bas reliefs, as in *Identificazione*, or genuine pictorial works, as in *Pentito*, but the absolute transcendence is the emotive nature of reality combined with chromatic variation created not by paints from a tube, but by the vitreous tesserae, which, moulded by the artist, lose their connotations and take on a new form. The basic theme of the works shown is linked to the willed act of existence. The face pushing up from the depth of the mosaic chromatism is the palpable example of a contemporary society fighting for life intended as the innate human right to expression; it is the genetic DNA of the artist Svetlana Ostapovici. As they say here in Venice: the future develops from the past.

—**Francesco Elisei**

Commissioner
Germano Donato

Curator
Francesco Elisei

Deputy commissioners
Anita Madaluni
Claudio Zappalà

Sponsors
Mega Network srl
Fonti di Vinadio SpA
Università Popolare Internazionale
di Roma

Artist
Svetlana Ostapovici

Svetlana Ostapovici, *Identificazione*, 2007, detail. Painted mosaic, 80 x 80 cm. © Svetlana Ostapovici
PHOTO GERMANO DONATO

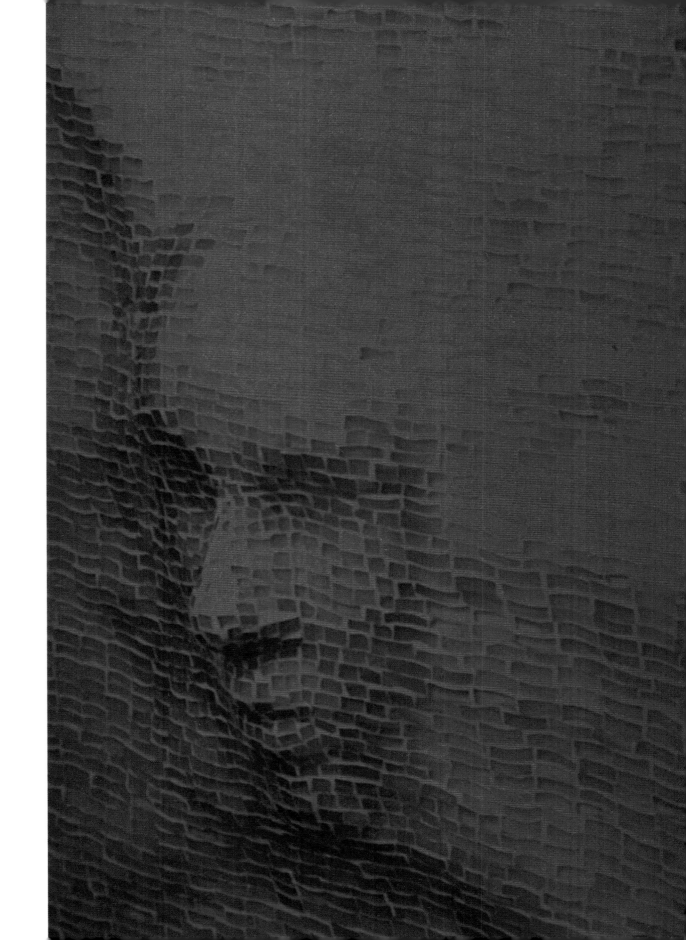

Republic of Slovenia
Venetian, Atmospheric

Tobias Putrih, *Venetian, Atmospheric*

Tobias Putrih grew up in the particular cultural context of the 1990s, which was marked by political and societal transition in Europe and abroad. Within this framework, many emerging artists managed to find a shared ground where they could develop a self-reflexive process, and from which to take a new conceptual approach, while remaining attentive to geo-political considerations. Some of them share a strong interest in an 'open' model, one that questions the notion of a work of art as a finished artefact, and that favours an object deliberately left 'nearly finished' (e.g. maps, in situ interventions, manuals, maquettes). Since the beginning of his career, Tobias Putrih has investigated and reconsidered the role of design within contemporary society. In *Venetian, Atmospheric*, he lucidly and ironically examines cinema architecture of the watershed 1920s, casting light on the relationship between architectural space and the scale models that precede it. The subject of his research is the movie theatre itself, an interior space designed to facilitate illusions, a liminal space between projected dreams and the physical architecture where those projections take place. The reference to historical examples in which the exhibition space and the exhibited object or projection have played an equal role – as in the atmospheric theatres of the architect John Eberson – points out the artist's fascination with the rules of the apparatus of spectacle. Putrih is interested in unveiling its mechanisms, offering us the possibility of becoming involved and conscious participants within it.

The design of cinema interiors at the beginning of the twentieth century seemed to invert the roles that stage and public had played in traditional theatre up to then. In modernist cinemas, the fundamental role of theatre design in the suspension of disbelief was performed on the side of the stage where the public sat. The spectator was thus placed to become the leading actor in the cinematographic machine. Absorbed in the set design, which often resembled a biomorphic cave designed to induce a state of daydream, the public became responsible for activation of the apparatus. The role of interior décor in the mechanism of spectacle was therefore fundamental for facilitation of the cinematic projection performed by the spectator, who symbolically casts a series of effects and precepts stemming from the unconscious onto the film he or she watches on the screen.

Using inexpensive materials like wood and cardboard, Tobias Putrih builds aesthetically fascinating experimental structures that are conceived as instruments for generating illusions in the real world. As Putrih explains: 'The starting point is mainly an effort to understand the social phenomenon or interchange between individuals (if there is any) caused by my structures'. Rather than dealing with utopian projects or artificial models, Putrih's work proposes practical solutions and thereby locates his investigations on an empirical level. How can we create a collective illusion? And to what extent does a structure allow for a collective possibility to emerge?

—Mara Ambrožič, Francesco Manacorda

Commissioner
Aleksander Bassin

Curator
Mara Ambrožič

Deputy commissioner
Sarival Sosič

Deputy curator
Francesco Manacorda

With the collaboration of
Aurora Fonda (Galleria A+A)
Luka Melon
MK3 d.o.o e Strid

Web Sites
www.mestna-galerija.si
www.aplusa.it

Artist
Tobias Putrih

1-2 **Tobias Putrih**, *Cineclub at Thomas Dane*, 2005. Cardboard, MDF, 500 x 365 x 695 cm. Installation view, Thomas Dane Gallery, London
PHOTO THIERRY BAL

3-5 **Tobias Putrih**, *Cineclub at Thomas Dane*, 2005. Cardboard, MDF, 500 x 365 x 695 cm. Setting up of the installation, Thomas Dane Gallery, London
PHOTO THIERRY BAL

1

2

3

4

5

People's Republic of China
Everyday Miracles

Shen Yuan, Yin Xiuzhen, Kan Xuan, Cao Fei
Four Woman Artists in the Chinese Pavilion,
Venice Biennale 2007

After examining carefully the general situation of today's Chinese art scene and the specific context of the 52. Biennale, we decide to focus the Chinese Pavilion on the work of four female artists, Shen Yuan, Yin Xiuzhen, Kan Xuan and Cao Fei. Ranging in age from the mid-forties to the late twenties, they exemplify in particular ways the evolution of the engaging relationship between female artists and the Chinese art scene, and speak to the claims of women on the rapidly changing Chinese society of the last two decades.

Both inside and outside China, the passion for Chinese contemporary art often overlooks the particular importance of woman artists as well as intellectual and social issues related to the particular roles of women in China's contemporary life. China's modernisation process has rested upon a highly masculine vision of the world: rational, linear, speedy, vertical, progressive, efficient and utopian. Accordingly, the social structure remains essentially male-centric. And this tendency has been increasingly enforced by a reality that systematically pursues material growth. The contemporary art scene in China today embodies a similar vision celebrating the spectacular, the sublime and the powerful. This leads to conflicts between progress and harmony. In terms of cultural and artistic production, the obsession with quantity and material efficiency considerably reduce the space for real imagination and poetry, as well as psychological life. It is no surprise that the presence of woman artists, with their particular modalities of imagination, expression and action, is largely marginalised. However, a significant number of woman artists have been creating some of the most sensitive, profound and innovative works, although they are often discreet and somehow marginalised. Their work often shows the most authentically creative and spiritually liberated aspects of the Chinese art scene today. This distant position and intellectual freedom allow them to acquire the most independent individuality and adopt the most original strategies of negotiation with the outside world.

Also, the presence of woman artists in the 'mainstream' of the international art world is still relatively insufficient. This urges us to reconsider the very mandate of the Pavilion itself. It is time to make it into a break-through and an exemplary case for both the Chinese and international art worlds to reconsider their inquiries of imagination, values and meaning production. For the Pavilion, Shen Yuan, Yin Xiuzhen, Kan Xuan and Cao Fei are working on new and site-specific projects. Based on their diverse experiences, they will produce highly personal but complementary installations to form a common project in the Pavilion spaces, the petrol warehouse (Cisterne Building) and the garden (Giardino delle Vergini). Shen Yuan, living in Paris, focuses her concerns on the relationship between non-Western female identity and cultural conflicts. Yin Xiuzhen, based in Beijing, resorts to everyday objects such as clothing and textiles to construct testimonies to the mutation of the city and its impacts on her personal, familiar and social life in the process of China's integration into the global economy and power system. Kan Xuan chooses to concentrate her energy on building up a sphere of solitude around herself and on turning that particular state of being into a spiritual and transcendent yet beautiful image flux in her video installations. Cao Fei opens herself to embrace the fresh, exciting and increasingly globalised lifestyles of the urban youth at the turn of the millennium, navigating through electronic entertainment, pop culture, virtual reality and adventurous urban drifting etc. and turning these into multimedia and trans-disciplinary expressions. At the end, in spite of the apparent differences of their experiences in dealing with the everyday, these four artists have a remarkably common talent: they always manage to transform everyday objects and experiences into miraculously innovative and affecting pieces of art. In other words, they turn the everyday into the miraculous.

—Hou Hanru

Commissioner
China Arts and Entertainment Group

Curator
Hou Hanru

Coordination
Ou Ning

Production
Universal Studios, Beijing

Web Site
www.biennale.org.cn

Artists
Cao Fei
Kan Xuan
Shen Yuan
Yin Xiuzhen

1 Cao Fei, *China Tracy*, 2007. Multimedia installation, 1,000 x 1,000 x 400 cm. © the Artist

2 Kan Xuan, *Object*, 2003. Video, 7'. Courtesy the Artist

3 Shen Yuan, *La grand muraille du pays sud*, 2005. Installation, ceramic, wood, 1,500 x 1,000 x 200 cm. Triennal Guang Zhou, Guang Dong, China

4 Yin Xiuzhen, *Armoury*, 2007. Installation, cloth, 400 x 800 cm

2

Romania
Low-Budget Monuments

Imagine this implausible meeting: on the grass right next to Maya Lin's Vietnam Veterans Memorial in Washington stands its mobile version – the Dignity Memorial Vietnam Wall, designed to crisscross America and reach those who cannot or will not travel to the capital and see it in its relation to site and adjoining landmarks. The two are accompanied by Chris Burden's *The Other Vietnam Memorial*, produced for MOMA's *Dislocations*, in which a few million names picked from a Vietnamese phone book have been inscribed onto a vague replica of Lin's design. Could this assemblage (or assembly) be conceived as articulating a single monument of a new kind, that propagates a plural point of view on the Vietnam war and addresses more than one of the collectivities that war has affected?

How can the monument be detached from glorification or commemoration, from the rhetorical overload that burdens the history of the practice, and still be a monument? Can the monument be reprogrammed as an artistic instrument that does not serve to illustrate doubtful victories or abruptly terminated debates, and what other fundamental operation should be assigned to it? Can the monument incorporate social and political antagonism into a matrix other than the separation of winners and losers, one that allows for the continuous recalibration of social forces? Are monuments for terrorism or law, globalisation or locality, liberalism or communism conceivable?

Low-Budget Monuments is the first episode in a long-term project that aims to rethink the contemporary monument, its possibility and relevance. It stems from the belief that monuments are 'impossible necessities' (Laurent Liefooghe), that, in their infernal difficulty, monuments are problematic knots entangling decisive questions about the modes of memory, history and ideology that constitute or condition communities.

In the shadow of traditional monuments, strategies of dominance, historical fallacies, collective Freudian slips and nationalist deformities concatenate. They have been conceived as opaque screens for homogenous histories or denouements in fabricated narratives. The recent history of monuments registers sporadic advances, with artists like Hans Haacke, Rachel Whiteread or Thomas Hirschhorn participating, with various merits, in rewriting the script of the monument. Even if they do not amount yet to a change of paradigm, convergent efforts in different domains have indicated that monuments need to be extricated from ideological distortions or the perversions of populism, and restored, as viable attractors in new urban schemes, to the contemporary city. Partial redefinitions have emerged, advocating complicated monuments for complicated social facts, whose singularity rests not on formal features, on monumental scale or solemn isolation from everyday life, but derives from their enactment of conflictual consensus, of new forms of social coherence, of strategies meant to integrate what society ignores, forgets or excludes. They are monuments that link centre and margin, that permanently irritate the nerves of the social body; polemic monuments incorporating inevitably plural purposes and actions, tensions rather than epiphanies; monuments that do not evacuate contradiction; monuments that are *powerless* in both senses of the word; non-ephemeral modes of public artistic action that perform a plural, contradictory function. This could plausibly act as a zero degree from which the monument can be built, and it is precisely the strategy uniting the works in the Romanian Pavilion.

—**Mihnea Mircan**

Commissioner
Mihai Pop

Curator
Mihnea Mircan

Deputy commissioner
Bertha Niculescu

Artists
Victor Man
Cristi Pogacean
Mona Vatamanu & Florin Tudor

1 **Cristi Pogacean**, *2544*, 2006. DVD video, 5'. Courtesy galeria Plan B
PHOTO CRISTI POGACEAN

2

3

4

2 Mona Vatamanu & Florin Tudor,
Vacaresti, 2003. Photograph,
dimensions variable. Courtesy
the Artists

3·4 Mona Vatamanu & Florin Tudor,
Vacaresti, 2006. Performance, video,
22'26''. Video still. Courtesy the Artists

▲5 ▼6

5 **Victor Man**, *Untitled*, 2006. Two
photograps found framed, 30 x 24 cm
each, wooden object, 111 x 110.5 x 44
cm, painting, oil on canvas, 30 x 39 cm.
Courtesy the Artist and Annet Gelink
Gallery, Amsterdam

6 **Victor Man**, *Untitled (Without going
into the extravagance that's in the trees)*,
2006. Painting assembly, oil on canvas
mounted on board, 30 x 39.9 cm, one
drawing, felt-tip pen on acetate with
adhesive tape, 54 x 53.5 cm. Courtesy
the Artist e Annet Gelink Gallery,
Amsterdam

Russia
CLICKIHOPE

At the dawn of the twenty-first century, the question is once again posed of creating a structural system of coordinates that would establish the strategy of individual and social self-determination in the light of the intensification of flows of information that pour over us and the impetuous development of globalisation processes. Installations by Julia Milner, Aleksander Ponomarev, Arseni Meshcheriakov, Andrey Bartenev and the AES+F GROUP are presented in the Russian Pavilion.

Aleksandr Ponomarev and Arseni Meshcheriakov have highlighted the relationships between the natural world and the media world. The installation *Shower*, consisting of monitors on which thousands of TV channels from around the world are screened live, represents the absolute domination of television that prevents us detaching from the 'informative unity'; leaving only the illusory freedom of moving from one channel to another.

Aleksandr Ponomarev's installations, *Windshield Wipers* and *Wave* are variants of research into a way out. The monitors covering an entire wall act as a special kind of window on whose surface television is also seen in real time. Like the windscreen wipers that remove traces of dirt from the car windscreen, the wipers on each monitor clean off the programmes transmitted with water. At a certain moment, all the television programmes are replaced by a horizon line, fixed by a camera set up on the terrace of the Russian Pavilion, from where there is a splendid view of the lagoon.

Aleksandr Ponomarev's *Wave* is a 12-metre-long tunnel of glass, inside which there is a wave generated by the breath of the artist, whose image is projected onto a monitor. This installation is a technological metaphor of the wave as carrying mechanism of the electronic era, restored, thanks to the artistic act, to its original matter as watery element.

The *Last insurrection* by the AES+F GROUP (Tatiana Arzamasova, Lev Evzovich, Evgeny Svjatsky + Vladimir Fridkes) is a 3D animation that produces a cyber space model. The animated panorama of the new paradise in which time does not pass is populated by beautiful androgynous adolescents. The progeny play together to the music of Wagner in a war-insurrection in which there is no difference between victim and assailant, male and female, good and evil, destiny and free will.

Andrei Bartenev's installation *Lost Connection* is a tunnel of mirrors filled with 50 spheres emitting Led lights, with the words 'Lost Connection' appearing around their orbit. A heart placed inside each sphere symbolises the danger of frustration looming over anyone living in a world made up of virtual and indirect relationships. At the same time, communication of the lost connection, by way of a multiplication and proliferation of Led characters and mirrors, gives rise to a new, complete, connective structure.

Julia Milner creates a personal version of a new cyber-behaviour game. The installation consists of a Led screen on the facade of the Russian Pavilion showing her net-art project *Click I Hope* (www.clickihope.com). The sentence 'I hope' is repeated in the 50 languages of the 70 countries taking part in the 52nd International Art Exhibition. A counter shows how many people have entered the site and clicked the sentence in one of the languages available. The writing in different languages is enlarged or reduced in proportion to the number of users that click from any part of the world. *Click I Hope* is a virtual accumulator of hope.

—Olga Sviblova

Commissioner
Vasily Tsereteli

Curator
Olga Sviblova

Organisator
Sergey Mironenko

Co-organisator
Ekaterina Kondranina

With the support of
Federal Agency of Culture and Cinematography
'Russian Avant-guard' Foundation (President S. Gordeyev)
TsUM Department Store, 2 Petrovka str., Moscow
Interros Publishing Program
Art Media Group
TMK
MasterCard Europe

Works of AES+F GROUP presented with support of 'Triumph' gallery

Artists
AES+F GROUP (Tatiana Arzamasova, Lev Evzovich, Evgeny Svyatsky + Vladimir Fridkes)
Andrei Bartenev
Arseny Meshcheryakov
Julia Milner
Alexander Ponomarev
Georgy Frangulyan

1 AES+F GROUP (Tatiana Arzamasova, Lev Evzovich, Evgeny Sviatsky + Vladimir Fridkes), *Last Riot*, 2007. Video-installation, 3D animation, 3 screens (300 x 300 cm), 3 DVD players, 3 projectors. Collection of the artists. Courtesy Multimedia Complex of Actual Arts, Triumph Gallery

2 Andrei Bartenev, *Lost Connection*, 2007. Installation, mixed media, 50 revolving light-emitting diode balls (diameter of each ball 38 cm), mirror tunnel (300 x 800 x 350 cm). Collection of the artist. Courtesy Multimedia Complex of Actual Arts, Moscow Museum of Modern Art

▲1 ▼2

▲3 ▼4

Click I hope...

I hope 我希望 Espero 私は望む Ich hoffe J'espère 내가 바랍니다 Spero

Я надеюсь

Eu espero Saya harap Ik hoop لما نا Mam nadzieję

Jag hoppas ความหวัง Umutlar Tôi hy vọng مرادیما نم Eu sper Já doufat תוויקתה Jeg håbe Minä toivon

Én remél Εγώ ελπίζω Надам се Jeg håpe Ja dúfať Nadam se Я сподіваюся अरबत आसरा Jaz upati Ég vona

Аз се надявам Мен көре затармын Aš tikiuosi Ես հուսալու եմ Es ceru Я спадзяюся Мен ишенії

ਮੈਨੂੰ ਆਸਾਬ ਸੀਬ ਪੀਉਕਾਮੀਦੇ Ako nade' Tá súil agam sin Men baxay Aku harap நம்பக்கை நம்பிக்கையிலுடை நடக்கு

Gobeithia felly Ako umasa pagayon Ma loodan

0000001500

3 Alexander Ponomarev, Arseny Mescheryakov, *Shower*, 2007. Installation, 235 LCD monitors with live transmission of 470 international TV-channels, 280 x 170 x 170 cm. Collection of the artists. Courtesy Multimedia Complex of Actual Arts, Moscow Museum of Modern Art

4 Julia Milner, *CLICKIHOPE*, 2007. Web-site www.clickihope.com, shown on a 300 x 600 cm screen, installed on the façade of the pavilion, touching-screen 120 x 165 cm. Net-art. Collection of the artist. Courtesy Multimedia Complex of Actual Arts, Moscow Museum of Modern Art

5 Alexander Ponomarev, *Windshield Wipers*, 2007. Installation, mixed media, 36 screens with a live video projection of international TV channels, 36 windshield wipers, 4 DVD players, 4 projectors, system of automatic control, water, size of installation 266 x 1,106 cm

6 Alexander Ponomarev, *Wave*, 2007. Installation, mixed media, glass construction (size of the construction: 100 x 1,360 x 200 cm), filled with water, wave generator, automatic control system, video, screen 300 x 600 cm, DVD player, projector. Collection of the artist. Courtesy Multimedia Complex of Actual Arts, Moscow Museum of Modern Art

▲5 ▼6

Serbia

How Mrdjan Bajić Became a Serb

First selected to exhibit in the national pavilion at the 1993 Biennale, Mrdjan Bajić didn't make it to Venice after all. Cultural embargo, part of the economic sanctions against the country still called Yugoslavia at the time, was an interesting concept the international community had thought could stop the war and devastation in the Balkans. Boycotting artists from the state in which an egg cost thirty million and a dollar was worth five billion – hadn't stopped anything, but had unexpectedly and inadvertently started a long process of artistic reflection over one's own national, state or political identity.

In the nineties, a decade of wars, artists were suddenly forced to clearly define themselves as belonging to a state or a people, even the ones who never found a national dimension relating to their personal identities, even when, out of protest against the not quite endemic war, they consciously and deliberately refused the affiliation. Nevertheless, both the prevailing nationalism and gestures of boycott and isolation reduced our identities to the issue around which the war was fought – the matter of national and state affiliation, acquired by birth and chance, with no personal decision whatsoever. Then the wars finally passed and the country carried out democratic changes, but also faced the new brutality of a free market world, persistently creating new – as interesting as they were cruel – circumstances for the work of an artist.

Throughout those years, Mrdjan Bajic´ was working and exhibiting, writing and speaking very loudly; continually questioning – how to create under political and social circumstances one must not consent to? Why create at all? What's the purpose of that? Should it have a purpose at all? Then the most concrete of all – where to live, why and under what circumstances, whether to remain in one's own country or leave because of the dissent, how to live at all and what's the purpose of *that*, what is artistic responsibility, and what is artists' identity – these, among others, are the life and creativity related dilemmas of an artist who approaches them intelligently, avoiding the trap of the anecdotal and always searching for a universal context.

Mrdjan Bajić has now been selected to exhibit at the national pavilion for the second time. And this little house in Venice has in fact gone through a process very similar to the artist's: a search for identity, positioning itself in contradictory historical circumstances that have changed many times over, changing its name and citizenship four times, but without ever moving from the Venetian Giardini. The pavilion that carried the name of communist Yugoslavia, then the smaller, wartime Yugoslavia, and then the even smaller, nervous union of Serbia and Montenegro, has now become the national pavilion of a little state called Serbia. The name that for years was a symbol of war and devastation in the simplified views of public opinion, now resumes its right to be something other than that.

Mrdjan Bajić presents in it the map of his ego-history, showing that the artist is the one who creates national identity, and not the other way round; the artist is the one who creates historical truth, not the other way round. Mrdjan Bajić serenely assumes his place as an artist from Serbia, but a Serbia he creates himself, with his universal values, loud existence, eternal dissent and artistic truth more accurate than any other.

—Biljana Srbljanović

Commissioner
Vladimir Veličković

Curator
Maja Ćirić

Associate commissioner
Dušan Ercegovac

Coordination in Venice
Živa Kraus

Technical coordination
Maja Gavrić
Dragan Djordjević (assistant)
Dragiša Popovic
Milijan Dimitrijevic

Web Site
www.yugomuzey.com

Artist
Mrdjan Bajić

1 **Mrdjan Bajić**, Project for National Pavilion, 2007. Digital print

2 **Mrdjan Bajić**, *Grounded Sun*, 2004. Project, digital print

3 **Mrdjan Bajić**, *Yugomuseum*, 2001. Installation view at Centre for Cultural Decontamination, Belgrade

4 **Mrdjan Bajić**, *Monument*, 2001. Digital print, wood, 18 x 14 x 12 cm

5 **Mrdjan Bajić**, *Heart*, 1996. Aluminum, iron, wood and polyester, 260 x 140 x 160 cm, 240 x 135 x 150 cm. Private collection, Munich

1

2

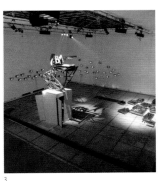

3

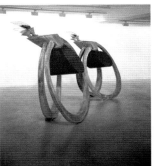

4

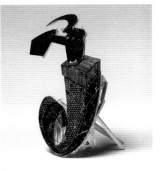

5

Singapore

Figments, Fictions and Fantasies

Figments, Fictions and Fantasies marks the fourth showing of the Singapore Pavilion at the Venice Biennale, since its inaugural exhibition in 2001. The Pavilion, this year sited at the Palazzo Cavalli Franchetti, features the works of four notable Singapore artists: Tang Da Wu (b. 1943), Vincent Leow (b. 1961), Jason Lim (b. 1966) and Zulkifle Mahmod (b. 1975).

The theme emerged from the curatorial assessment of the site-specific pieces developed for the Pavilion. One of the curatorial intentions was to probe the possibilities of artistic practices that extend beyond individual 'passion' (which is celebrated so problematically in Singapore). The idea was to explore practices that retain individual expression but also show a sense of relation to and with the larger community. Passion, with *com*passion (a passion for the community, it is contended) – in its feeling for, awareness of, if not responsibility toward, the community – offered greater nuance and complexity to their practices.

The four artists share intersecting histories of piloting art collectives in Singapore. Some of these experiences have resulted in radical episodes and *coup de grâce* gestures that have shaped the course and complexion of Singapore contemporary art. But more than their involvement with art collectives, their works harbour the potential to harness certain ideals that offer alternative perspectives, if not alternative paradigms, for the larger polity.

This potential is evident in the works for this Pavilion. Under the curatorial rubric of *Figments, Fictions and Fantasies*, the artworks stoke the ideas of empire, the nomadic traveller, of hybridity, and finally, at its core, the idea of freedoms. This project has been shaped in no small part by the writings of cultural theorists and thinkers including cinematic and literary sources, such as the concept of *lo real maravilloso* ('the marvellous reality').

In the context of Singapore's art development, the notion of freedoms assumes the weight and resonance of its own history – tied to the State regulations and permits on performance art from 1994-2003 and the implications of the liberalising of policies since then. The presentation of four performance artists at the Singapore Pavilion adds another current of negotiation to the dynamics between State and independent artists, and the expectations for 'national Pavilions'.

It is also impossible *not* to appreciate the subtexts of the artists' constructions of 'freedoms' in relation to the spectacle of current world affairs, in which entire wars and occupations are planned and justified by peddling the ideas of defending freedom, democracy and a particular way of life. The artists never quite suggest the absolute removal of restrictions for liberation to occur – perhaps subscribing to the maxim that a world without prohibitions is at best corrupt and at worst boring. Their works register a sense of fragmentation and the 'aesthetics of estrangement' in which different realities collide and interface. Their works offer perspectives on 'freedoms' that resist easy summary, and their propositions are still resonant at a time when fundamental freedoms are still being traded, compromised and breached.

—Lindy Poh

Commissioner
Lim Chwee Seng

Curator
Lindy Poh

Coordination
Troels Bruun (Venice)
Philip Francis (Singapore)

With the support of
National Arts Council Singapore
& Singapore Art Museum

Sponsor
Anil Thadani of Symphony Capital
Partners (Asia) Pte. Ltd.

Web Site
www.nac.gov.sg/eve/eve11.asp

Artists
Vincent Leow
Jason Lim
Zulkifle Mahmod
Tang Da Wu

1 Jason Lim, *Just Dharma*, 2007.
Installation, unglased porcelain, light
bulbs, 300 x 120 cm

2

2 Vincent Leow, *Andy's Addiction*, 1996.
Painting, oil on canvas, 123 x 153 cm
3 Zulkifle Mahmod, *WOMB*, 2006.
Installation, recycled egg trays, air
bed, lights, ventilations fans, sound,
240 x 300 x 240 cm

3

Spain
Broken Paradise

The project for the Spanish Pavilion at the Venice Biennale (2007) was drawn up on the basis of two conceptual guidelines. On the one hand, the idea of the positive hybridisation of contemporary artistic practice, and on the other, the symbolic idiosyncrasy (cultural, environmental, geopolitical and historical) of the city itself, especially through the re-reading of fundamental reference points of modern culture such as Ezra Pound, Friedrich Nietzsche and Marcel Proust, who contemplated, considered and lived the city of the canals as a paradigm of exceptional creativity and vitality, capable of producing models of knowledge, and radically-reworked artistic approaches in the field of contemporary aesthetic practice. Paraphrasing Nietzsche, we could say that before the urban, cultural reality of Venice we stand as if before a *leap of joy*: a continual upsurge of invigorating flow and potency, of whole-hearted productivity and expansion; life, in short, not seen as just a state but rather as an eternal flowing, a coming into being, but a being made up of a succession of events all laden with *heroic merriment*. As a matter of urgency we must transform reality's emptiness or breakdown into the joy of what is to come, restoring to the passage of time the blaze of vertigo and of worlds unknown. 'Let us reinvent reality'; like somebody erecting a fundamental fiction, a *fiction supreme*, a new mapping in which a potent *imaginarius* may be transmitted.

The exhibition endorses an ambition to study and cultivate 'the forms or modes by which the perception and contemplation of Duration, or of Time, are transformed'. This is what Marcel Proust termed 'time regained', that is, unlocking memory's gates; redemption; the pursuit of beauty. This thematic hub would then be orbited by kindred topics such as the oeuvre to be created, and the appropriation and resurrection of the past.

The exhibition was thus conceived, inspired and influenced by Pound's hybrid poetry, responding to images (photography, moving images), gestures, sound, voice and music. We seek to reflect on the image of *paradise*, of a landscape ripped out and saved from a stupefying reality. Paradise viewed as a sculptor's blinding image of poetic light, only existing in unexpected shards (Pound). 'Paradise, in short, as a model envisioned'.

We believe that contemporary artistic possibilities are defined in these non-territorialised regions, where artists may re-create new creative or productive functions, applying operative signs to them, free of rigidly predetermined, bounded and/or shaped aims. The goal we pursue is that of an ordered interdisciplinarity, in accordance with a project by four artists of widely varying histories, ages and creative media but who, to some extent, may converge at a given reference point. Hence, in the case of the Catalan film director José Luis Guerín (Barcelona, 1960), what this artist does as a cinematographer will be utilised and enhanced within a new location in the area of plastic art and within a specific exhibition space; similarly, poetic writing, as the foundation or fuel for visual debate may contribute to contemporary photography, in the case of the Galician photographer Manuel Vilariño (A Coruña, 1952). In short, work that is almost theatrical, using voice and gestures, may inspire and further the work of artists in the field of action or performance, such as Los Torreznos (a duo of action artists, resident in Madrid), or installations making use of very different domains (time, the human body, natural elements, objects, light) created by the young artist Rubén Ramos Balsa (Santiago de Compostela, 1978).

—Alberto Ruiz de Samaniego

Commissioner
Alberto Ruiz de Samaniego

Artists
Rubén Ramos Balsa
José Luis Guerín
Los Torreznos (Rafael Lamata
& Jaime Vallare)
Manuel Vilariño

1 Manuel Vilariño, *Animal insomne*, 2007. 480 x 240 cm
PHOTO COURTESY THE ARTIST

2 Manuel Vilariño, *Metamorfosis de las sombras*, 2002. 220 x 1,210 cm
PHOTO COURTESY THE ARTIST

3-4 José Luis Guerín, *Tren de sombras*, 1997. Dimensions variable
PHOTO ALEX GAULTIER

1

2

▲3 ▼4

5

6

5-6 Los Torreznos, *35 minutos (fragmento)*, 2007. Videoperformance, 35mm, music and adaptation
Los Torreznos

7 Rubén Ramos Balsa, *Untitled (Glasses on Tables with Chairs Series)*, 2007. Photography

8 Rubén Ramos Balsa, *To Blow*, 2004. Installation, table, glass of water, video and electronic system

United States of America
Felix Gonzalez-Torres: America

The art of Felix Gonzalez-Torres treads a fine line between social commentary and personal disclosure, equivocating between the two realms and obscuring the culturally-determined distinctions that separate them. It is this subtle shifting from cultural activism to intimate, autobiographical dimensions – and the subsequent erosion of the boundaries between – that forms the very essence of the work. *Felix Gonzalez-Torres: America* investigates the tension between these two poles, focusing on the artist's optimistic but critical relationship to his adoptive culture. In our current social and political climate, this content has become increasingly relevant, to the point that his work seems prescient today.

As a Cuban-born American citizen, Gonzalez-Torres condemned anything that compromised the integrity of our democratic system. He used the aesthetic allure of his art—its minimalist refinement and quiet referentiality—to stage a subversive assault on what he perceived to be failures of our public trust or breaches in our social contract. In Gonzalez-Torres's metaphoric universe, a stack of give-away (but endlessly replenishable) printed papers can be read as a rehearsal for the inevitable death of his lover from AIDS and a carpet of candies, free for the taking, as a portrait of the body politic. A string of glowing light bulbs can evoke dreams of a better place or the celebration of the here and now. With the mere power of suggestion, the artist transformed the most commonplace objects into poetic vessels for social content. Though all 'untitled,' his works convey their meaning through parenthetical subtitles, which function like whispered cues, subtle guides to interpretation that only imply and never prescribe.

The exhibition gathers key examples of the artist's work in and around the US Pavilion. In the entrance courtyard, a never-before-realised work has been installed: two adjoining reflecting pools, which serve as both a silent mirror on our culture and a beacon of hope. *"Untitled" (America)*, 1994, the artist's largest light string, which celebrates the United States as a haven for diverse populations, graces the entrance hall and extends into the courtyard. Nearby *"Untitled" (Natural History)*, 1990, a suite of photographs documenting the inventory of idealised (male) roles inscribed on the memorial to Theodore Roosevelt at New York's American Museum of Natural History, surrounds two paper stacks from 1989 bearing the inscriptions 'Memorial Day Weekend' and 'Veterans Day Sale,' respectively. *"Untitled" (Public Opinion)*, 1991, a carpet of liquorice candies, appears alongside photostat pieces that cite political and social events in eccentric inventories of our collective consciousness. Elsewhere, the single light string *"Untitled" (Leaves of Grass)*, 1993, illuminates an indoor billboard of a bird soaring through an open sky. Because Gonzalez-Torres conceived of his art as 'viral' in nature, existing both within the museum and dispersed throughout the community by means of its give-away components, the presentation also includes a series of outdoor billboards installed throughout the city of Venice.

Only the second deceased artist to represent the U.S. in the modern history of the Venice Biennale, Gonzalez-Torres had been previously nominated in 1995, and this exhibition expands upon and rearticulates his original proposal. Since his death, Gonzalez-Torres's generous and rigorously conceptual art has proven to be profoundly influential on a generation of younger artists investigating methods of distribution, audience participation and process-oriented aesthetic strategies. The presence of his work in Venice this year attests to its continued resonance today.

The official US representation at the 52nd Venice Biennale has been organised by the Solomon R. Guggenheim Museum and is presented by the Bureau of Educational and Cultural Affairs of the US Department of State.

—Nancy Spector

Commissioner
Nancy Spector

Artist
Felix Gonzalez-Torres

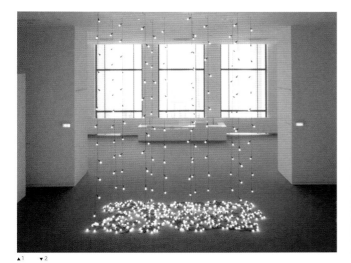

▲1 ▼2

▲3 ▼4

1 Felix Gonzalez-Torres, "*Untitled*" (*America*), 1994. 15-watt light bulbs, waterproof extension cords, waterproof rubber light sockets, overall dimensions vary with installation, twelve parts: 20 m in length with 7.5 m of extra cord each. Whitney Museum of American Art, New York, Purchase, with funds from the Contemporary Painting and Sculpture Committee. Installation view of *Felix Gonzalez-Torres (Girlfriend in a Coma)* at Musée d'Art Moderne de la Ville de Paris, Paris, 1996. © The Felix Gonzalez-Torres Foundation. Courtesy Andrea Rosen Gallery, New York
PHOTO MARC DOMAGE / TUTTI

2 View of the United States Pavilion showing proposed installation of "*Untitled*" (1992-1995), 2 circular pools of water, 2 parts: 365 cm or 730 cm in diameter each, overall dimensions 730 x 365 cm or 1,460 x 730 cm, height varies with installation; ideal visible height is 35-40 cm

3 Felix Gonzalez-Torres, "*Untitled*" (*America*), 1994. 15-watt light bulbs, waterproof extension cords, waterproof rubber light sockets, overall dimensions vary with installation, twelve parts: 20 m in length with 7.5 m of extra cord. Whitney Museum of American Art, New York, Purchase, with funds from the Contemporary Painting and Sculpture Committee. Installation at Lymington Road, London, across the street from the Camden Arts Centre, London, a satellite site for *Felix Gonzalez-Torres* at Serpentine Gallery, London, 2000. © The Felix Gonzalez-Torres Foundation. Courtesy Andrea Rosen Gallery, New York
PHOTO ANDREW CROSS

4 Felix Gonzalez-Torres, "*Untitled*" (*Strange Bird*), 1993. Billboard, dimensions vary with installation and "*Untitled*" (*Toronto*), 1992, 25-watt light bulbs, extension cord, porcelain light sockets, overall dimensions vary with installation, 12.8 m in length with 6 m of extra cord. Installation view of *Felix Gonzalez-Torres: Traveling* at The Museum of Contemporary Art, Los Angeles, 1994. © The Felix Gonzalez-Torres Foundation. Courtesy Andrea Rosen Gallery, New York
PHOTO SUE TALLON

Switzerland

In the éclat of the paintings by Christine Streuli (born 1975), ornaments and stylised figures are presented without apparent system or structure. Similar to wallpaper, the panorama – which is both all-embracing and engaging and consists of large acrylic, spray and lacquer paintings – takes the form of an ornamental mural painting created directly on site. Rhythmic changes as well as shrill and sudden sound variations would be suitable terms to describe the effects of this installation combining paintings and framed prints of medicinal plants, the latter bearing painted decorations even on their frames. Yet the room remains silent and seems to create a whirlpool of innumerable isolated worlds simply by dint of multi-layered combinations of totally different painting styles that blend with each other, emerge from each other or are unexpectedly juxtaposed to give the effect of a violent clash. The simultaneity of spatial pleasure, playing with boundaries and the sense of a synoptic loss transforms the static images into a process of visual perception.

In the works of Yves Netzhammer (born 1970), creatures and their instruments as well as instruments and their creatures are digitally animated (in both senses of the term, i.e. 'made to move' and 'given a soul'). In the course of their cinematic travels, they unhurriedly and seamlessly move from one scenery to another, from convoluted and mirrored interior rooms into endless landscapes or from sudden views even of what lies underneath the shell-like skin into the microcosm. With their simply stylised figures, requisites and spaces between shifting highlights and shadows, the clearly defined sequences do not follow a narrative pattern in the conventional sense of the term. Rather, association and action fields open up in which personal trains of thought on pre-individual and existential situations are born. Sparingly accompanied by sounds, the digital pantomime with its choreography involving morphing forms in constantly changing dimensions gradually gives way to projections on a large and partially painted membrane installed in the house and garden in the form of a wedge. The projection screen physically separates the interior from the exterior room we think we know as 'real space'.

On the face of it, Streuli's volcanic painting and Netzhammer's pictorial conjectures form a contrast in the modern geometry of the Swiss Pavilion. However, what monadically divides the two positions in a specifically contemporary sense at the same time unites them: the dilatation and refraction of immersive perception. Stylisation, patterns, morphing form, repetition and the strained tension between a total focus on the exhibition location and zooms into isolated worlds all play an important role in the works of both artists. Both worlds, though in different ways, could be used to illustrate what Alain Badiou describes as 'the transformation of the sensible in a happening of the idea' in his analysis of contemporary art: 'because happening is when appearing is the same thing as disappearing. I propose something like immanent difference, not immanent identity, not transcendent difference [...]; the subject is not reducible to its body, so there is something like an independent subjective process' (Alain Badiou, *The Subject of Art*, 2005).

All simple opposites dissolve in a process of constant and immanent differentiation within each one of the two installations. Similarly, the constellation as a whole does not create the effect of a contrast only.

—Hans Rudolf Reust, Hinrich Sachs

Commissioner
Urs Staub

Web Site
www.bak.admin.ch/biennale07

Artists
Yves Netzhamme
Christine Streuli

1 **Christine Streuli**, Studio with *Zoff*, 2007. Courtesy Galerie GreetingLine, Zurich and Milano; Galerie Andrée Sfeir-Semler, Hamburg
PHOTO ANDREAS ILG

2 **Yves Netzhammer**, *Wallpainting*, 2007. Courtesy Galerie Anita Beckers, Frankfurt a.M.

▲1
▼2

The baroque church of San Stae on the Grand Canal provides the setting for the works of Urs Fischer and Ugo Rondinone this year. The biographies of the two artists are similar in that they are both rooted in the vigorous Zurich art scene of the 1990s as well as in New York, where they have been based for some years. They also share an artistic approach manifesting itself in the creation of a strong spatial atmosphere, which in turn allows them to stage their works very adroitly within the context of the exhibition room.

The works of Ugo Rondinone are often associated with the theatre of the absurd, more specifically with Samuel Beckett. Indeed, numerous parallels can be drawn between the writings of the Irish author and the artistic productions of Rondinone, notably the surreally detached, gloomy and melancholy tenor running through many of Rondinone's spatial installations. Equally, a number of motifs which seem to be derived from the theatre of the absurd can be found in his works, for example the figure of the clown, an alter ego of the artist that has been present in his exhibition rooms for years, either just lying there, sleeping or breaking into occasional fits of hysterical laughter. Similarly to Beckett's Vladimir and Estragon, the clown seems frozen in an eternity of meaningless and purposeless waiting. Finally, the interplay between textual and pictorial worlds must be mentioned. Through this interplay, the beholder is seductively lured by insinuations of possible rational relations, though the meaning of Rondinone's art ultimately remains ambiguous and unfathomable. Ugo Rondinone's installations are characterised by a sparing use of condensed means. The artist thus succeeds in creating an atmosphere that is tranquil and dense at the same time.

Urs Fischer is generally seen as the creative muscle man among young Swiss artists. A drawer, photographer, painter and sculptor with a passion for fire and explosions, Fischer is also an untamed craftsman and demiurge who produces works of art in all media and styles. Nonchalantly rushing through the storehouses of modern art, he whisks together its icons, moving from Symbolism and Surrealism to Arte Povera and Pop Art and from Van Gogh and Duchamp to Beuys and Roth and, most notably, Fischli and Weiss whose brilliant grandson seems to live in him. In all this, Fischer is anything but the eclectic who leisurely yet solemnly fishes in the depths of art history to combine the old with the new. Rather, he seems to embody the equally ruthless and experienced alchemist who gets his ingredients where he can find them and brews what he pleases. What is striking is just how accurate and dexterous Urs Fischer ultimately is in his work. Despite all the humour in his artistic productions, it is nevertheless not facetiousness that defines and characterises his works, but rather an adept use of technology and materials as well as space and staging techniques. In the Swiss Biennale contributions of recent years, San Stae church provided the backdrop for the art works displayed. In contrast, the spatial appropriation of Urs Fischer and Ugo Rondinone is based on an absurd gesture which sits in the centre of the church's interior: a 'white cube', the archetype of the modern exhibition room. It is regarded as the secular successor of the church room and as a paradigmatic place for modern artistic pleasure and reflective contemplation. Just as the works of Rondinone and Fischer are situated in the 'white cube' and the latter blends in with the church, so the Art Biennale forms part of the scenery of Venice at large.

—Andreas Münch

Commissioner
Andreas Münch

Artists
Urs Fischer
Ugo Rondinone

3 Ugo Rondinone, *The second hour of the poem*, 2005. Cast wax, pigments. Courtesy Galerie Eva Presenhuber

4 **Urs Fischer**, *Spinoza Rhapsody*, 2006. Epoxy resin, pigment. Installation view, *The Vincent* 2006, Stedelijk Museum, Amsterdam, 2006. Courtesy Galerie Eva Presenhuber

▲3 ▼4

Thailand
Globalisation ... Please Slow Down

At present, globalisation and the advancement of communication technology have created a borderless global society. The lifestyles of various cultures have grown and interchanged with one another rapidly. Moreover, the enormous increase in the world's population has created more social complications and a lack of clear direction, whereas the Western world has been attempting to advance its culture to become the world's mainstream through various media channels and numerous strategies of consumerism.

In the meantime, Western society, which has long faced its own social complications, has turned to pay attention to the Orient and the philosophical concept of living life that has been inherited by generations for thousands of years. However, most of the Orient still has a lasting desire and chases after the West.

Being together on a common border impels us to be receivers of content, and the waves of strategies swoop down and attack our distinctive method, essence and identity. It also discourages the confidence and norm of the Orient to go its own way and makes it into a passive follower. It is shown that this imitation is actually the act of escaping oneself. Finally, we may be lost and disheartened but cannot make what used to be our identity return.

This exhibition wants viewers to see and understand about adopting an alien culture, concept, or philosophy of life as one's own whether or not its flow is East-to-West. Without careful consideration or proper selection, we may end up losing, or worse still feel like we are losing our own nationality. Therefore, we should 'stop' and 'consider' it carefully. In reality, there are people all around the world who quickly open their arms to embrace new cultures on their doorstep. If that is your case, we would like to remind you to 'slow down' on 'globalisation'.

The willingness to look back to calm oneself and let others overtake is something of interest. This gives us time to seek and review what we already have and adopt the way that others use to learn from. Halting our move in order not to step into a game determined by others and to start rejuvenating our dying spirituality is a brave, patient, perceptive deed, in keeping with Thai philosophy – Buddhism. This process itself would refine one's mind like a refreshing fountain. By considering what we have, who we are, and seeing through somebody's trick or idea would be a springboard for us to effortlessly pass any stiff competition.

Commissioner
Apinan Poshyananda

Curator
Apisak Sonjod

Artists
Amrit Chusuwan
Nipan Oranniwesna

1 **Nipan Oranniwesna**, *City of Ghost*, 2006. Talcum, sheet, wood construction, dimensions variable. Courtesy the Artist

2 **Nipan Oranniwesna**, *City of Ghost*, 2006. Talcum, sheet, wood construction, dimensions variable. Courtesy the Artist

▲1 ▼2

3

3 **Amrit Chusuwan**, *Being Sand*, 2005. Video installation in sand room, dimensions variable. Courtesy the Artist

4 **Amrit Chusuwan**, *Being Sand*, 2005. Video installation in sand room, dimensions variable. Courtesy the Artist

4

Turkey

Hüseyin Alptekin

On January 19, Hrant Dink, the apple of our eye, was gunned down in front of the newspaper office he had founded. Three shots in the back. Suddenly, even the remote notion of representing a country grew dim. But to imagine that the trigger boy represents the same country the artist is from would be equally preposterous. Turkey is going through the profound transformation from being a relatively disconnected country with its own brand of top down enforced modernism, to a globalised place on speed. It is hurting like a 14 year old whose organs are growing at different speeds. Although tamer, the tableau of contemporary art is equally confused. The artist in this year's Venice Biennale remains at the edge of the situation.

Hüseyin Alptekin's recent videos are called *incidents*. These are a quantity of single images; snapshots often taken from similar vantage points assembled in a stream. Incidents are exactly the moments when nothing spectacular happens. As opposed to the staunch rootedness and genuinely impenetrable nature of Murtezaoglu's photographs, Alptekin's videos weave together disparate geographies with a graceful empathy. When Alptekin records the hangout of a Nigerian garbage collector in Istanbul from the same point, days on end, the result is not a representation of destitution, but a touching impression of how this individual organises his space and in turn reorders the world while it continues its activities around him. In the *Incidents* series, on plain beaches in Bombay or Rio, people devoid of class signs are shamelessly poetic. Alptekin has been engaged with the invisible under-belly of globalisation for the last 15 years, engaging in a cosmos of anonymous, inter-textual displaced existences. His eyes invariably turn to moments that are socially overlooked and made invisible at the same time.

—Vasif Kortun

Commissioner
Vasif Kortun

Coordination
The Istanbul Foundation for Culture and Arts

Sponsors
Garanti Bank
Republic of Turkey Ministry of Foreign Affairs

Web Site
www.biennale07-turkey.org

Artist
Hüseyin Alptekin

Hüseyin Alptekin, *H-fact: History: Horses & Heroes*, 2005. 9th Istanbul Biennial, Platform Garanti Contemporary Art Center

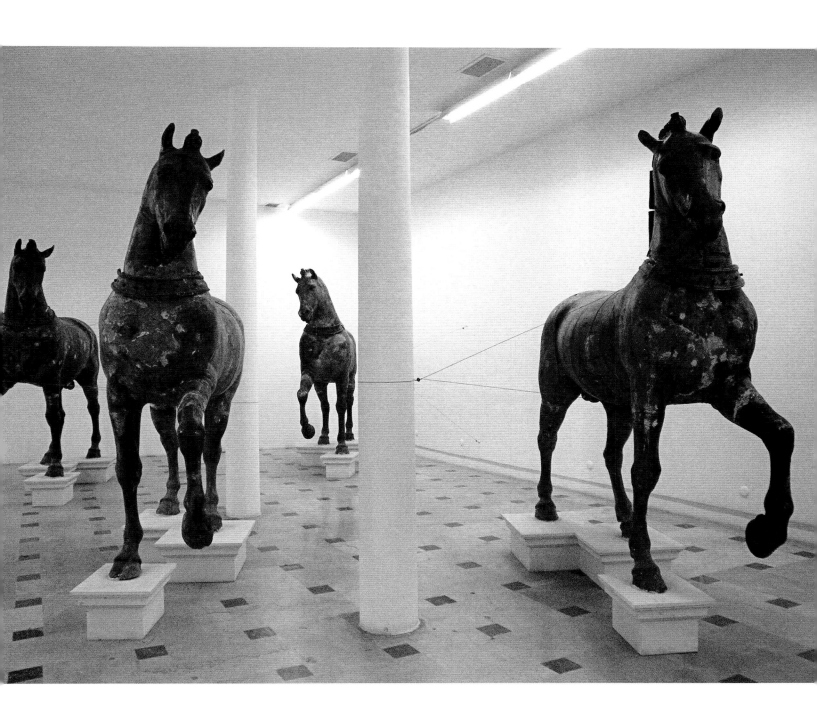

Ukraine
A Poem about an Inland Sea

Ukraine is vital to understanding the processes of postmodernism and globalisation taking place in other areas across Europe and the world. As the contradictions and negotiations between local and global issues continue, and as specific cultural traditions are fashioned by these processes, Ukraine becomes an area in which to explore key artistic and cultural trends.

Throughout the humanities and social sciences, scholarly work has turned to focus on how globalisation and trans-nationalism are altering our concepts of culture. We are living through a break from the era of totally separable societies. The idea of trans-culturalism points toward the new arrangements of people, identities and social practices that are currently emerging, and it belongs to a longer history that needs reinterpretation. As cultural systems of exchange break down former boundaries, people experience both a sense of liberation and anxiety, as the institutions and ways of life that had grounded their definitions of self are challenged. Because of inequalities among communities, regions and nations, moreover, different people will have unequalled power as well as distinct resources for shaping the trans-cultural future.

How do the terms 'culture' and 'community' function relative to one another in various disciplines, including, art history, literary theory, philosophy, cultural studies and architecture? The expressionist model often used to frame such inquiries – making a culture the expression of a singular community – is increasingly inadequate given the research into the many differences within communities and the incessant to and from of borrowings among cultural groups.

In light of the changes involved in trans-culturalism, how do globalising forces foreclose some forms of cultural life and open up others? What are the aims of culture in a globalised world? The answers we give to such questions will determine how we conduct ourselves as artists, citizens and scholars.

This project, which includes artists from Ukraine, the United Kingdom and the United States, will demonstrate the artists' cohesive vision and their commitment to exploring new and active roles for artists in society. The exhibition plans to raise questions such as the famous Ukrainian film director, Alexander Dovzhenko, did throughout his life – what is it to be Ukrainian? Who are the Ukrainian people? Where are the Ukrainian people? Like chroniclers appropriating knowledge, the artists – Serhiy Bratkov, Dzine (Carlos Rolon), Alexander Hnilitsky/Lesia Zaiats, Boris Mikhailov, Jürgen Teller, Mark Titchner and Sam Taylor-Wood are always on the lookout for whatever pushes the limits of their past and present. Their work is the product of a complex deliberation. Producing images from their own reality, they will offer that which is already embedded in our memory of Ukraine.

Commissioner
Peter Doroshenko

Curators
Aleksander Solovjov
Viktor Sydorenko

Artists
Sergey Bratkov
Dzine
Alexander Hnilitsky/Lesia Zaiats
Boris Mikhailov
Sam Taylor-Wood
Jürgen Teller
Mark Titchner

1 **Boris Mikhailov**, *By the Ground*, 1991. Black and white photograph, sepia toned, 15 x 30 cm. Collection the artist. Courtesy Pinchnk Art Centre, Kiev

2 **Sergey Bratkov**, *Untitled*, 2007. Color print, dimensions variable

1

2

▲3 ▼4

5

6

7

3 Jürgen Teller, *Gisele Bündchen,
London*, 2005. Color print, dimensions
variable. Collection and Courtesy
the Artist

4 Alexander Hnilitsky/Lesia Zaiats,
Sofa, 2006. Video installation,
dimensions variable
PHOTO LESIA ZAIATS

5 Mark Titchner, *To Breathe is not
enough*, 2007. Inkjet print, dimensions
variable. Collection and Courtesy
the Artist

6 Dzine, *Space Jungle*, 2006. House
paint on board, dimensions variable.
Tillburg, The Netherlands
PHOTO FUNDAMENT FOUNDATION

7 Sam Taylor-Wood, *Untitled*, 2007.
Video installation
PHOTO THE ARTIST

Hungary
Kultur und Freizeit (Culture and Leisure)

Andreas Fogarasi: 'Kultur und Freizeit'

The project *Kultur und Freizeit* consists of a series of single channel videos, all showing the present state of different cultural centres in contemporary Budapest, projected in separate black boxes which both physically and structurally include the spectators, as well. It is these black boxes that the viewers encounter first as huge, minimalist sculptural objects that seem to be utterly solidly built. As we move along them, however, their structure is revealed, creating an element of uncertainty in relation to their function – they are as much sophisticated micro-cinemas as they are simple wooden props.

These short videos are not straightforward documentaries as they don't aim at providing the visitor with a comprehensive, anthropological survey of the current situation of these centres in a given place and at a given time. Rather, they function as signifiers for a contemporary split between mass culture and popular (i.e. vernacular) cultures, and their respective institutional frameworks, as opposed to high culture and its locations. This is emphasised by the particular use of camera movement, the extensive use of stills, the subjective points of view and the atmospheric quality of the images that trust in the narrative qualities of the architecture itself.

The phenomenon and proliferation of cultural centres – at least in Hungary – unequivocally belong to the past political era in which one of the state's fundamental missions was to democratise culture in the form of disseminating high culture to the masses. The origins of this endeavour date back not only to French cultural policy of the 1950s and to one of its leading agents, André Malraux, but also to the nineteenth-century tradition of the workers' club. In this respect, Fogarasi's project has a geographic and political relevance that goes well beyond the Hungarian capital.

These centres are now either closed down or used by various sub-cultural groups as platforms in the process of forming identity via cultural means. They also function as stages of 'simultaneous collective experience', which 'the masses [are able] to organise and control' (W. Benjamin, *The Work of Art in the Age of Mechanical Reproduction*, p. 224, in H. Arendt [ed.], *Illuminations*, trad. Harry Zohn, Schocken Books, New York, 1968, pp. 218-251: p. 224). In spatial terms, the locations of both mainstream mass culture and high culture are to be found elsewhere, in the symbolically taken centres, while these cultural centres belong to the social and cultural peripheries. In the temporal matrix, these centres are part of Hungary's socialist past that has partly survived the political changes. Yet, for many people, the complete disavowal of the past is the only means of overcoming the effects of its traumatic experience.

The project *Kultur und Freizeit* can be described in terms of 'fierce sociology', a notion that the British group Inventory coined for its own activity, trying to tackle the everyday in a 'paradoxically emotional, yet objective' way. This 'discipline', among others, is able to take into account the multiplicity of subjectivities and the ways in which these subjectivities are socially formed and embedded (see the declaration in the Inventory sulla Sociologia Feroce: www.infopool.org.uk/inventor.htm). Fogarasi's project provides us with one possible answer to Georges Perec's question: 'What's really going on, what we're experiencing, the rest, all the rest, where it is? How should we take account of, question, describe what happens every day and recurs every day: the banal, the quotidian, the obvious, the common, the ordinary, the infra-ordinary, the background noise, the habitual?' (G. Perec, *Approaches to What?*, in B. Highmore [ed.], *The Everyday Life Reader*, Routledge, London and New York, 2002, pp. 176-178: p. 177).

—Katalin Timár

Commissioner
Zsolt Petrányi

Curator
Katalin Timár

Sponsors
Ministry of Education and Culture
of the Republic of Hungary
The National Cultural Fund
(of Hungary)
Műcsarnok / Kunsthalle, Budapest

Artist
Andreas Fogarasi

Andreas Fogarasi, *Kultur und Freizeit*, 2006-2007. Video installation. Courtesy Georg Kargl Fine Arts, Wien
PHOTO LISA RASTL

Uruguay
Imágenes (des) Imágenes

Imágenes (des) imágenes is the name of Ernesto Vila's installation, which will be exhibited at Uruguay's Pavilion during this year's Venice Biennale. The Pavilion is crossed by a 12-metre metal cord on which 40 pieces of paper, nylon and cardboard are hung, supporting Vila's paintings and containing local iconography consisting of musicians, painters and renowned football players, as well as the artist's friends and family who thus avoid oblivion and invisibility.

As a visual contrast, a number of mirrors and painted glasses, one over the other like layers, multiply the images on the floor. A row of five bottles turns into a screen that lights up with the movement of the audience, emitting flashing, changing images. This Uruguayan artist's piece is completed by painted cardboard lids shielding inscriptions that threaten to disappear or become fully visible.

Ernesto Vila collects the materials that will be used to fashion the piece itself from the debris generated by the city, then, once finished, they will be returned to the community that generated them.

Nowadays, we are exposed to an immeasurable production of images that end up overwhelming us and whose common characteristic is the indistinguishability arising from their serial nature. It is a stereotyped cultural schema that ends up losing all meaning.

But still, there are images that, being emblems of our culture, should not disappear or get lost in the indistinguishable flux mentioned above, leaving us with an impoverished iconography. The artist Ernest Vila resists this loss by producing a piece of art based on the recovery of images 'with their own names and history – as he himself writes – because, as is known, what is named is not forgotten'.

—**Enrique Aguerre**

Commissioner / Curator
Enrique Aguerre

Artist
Ernesto Vila

1 **Ernesto Vila**, *Sin título*, 2007. Mirrors and painted glasses, 50 x 70 cm. Collection of the artist
PHOTO ANTONELLA DE AMBROGGI

2 **Ernesto Vila**, *Sin título*, 2007. Metal wire, 40 objects of paper, nylon and cardboard, 250 x 1,200 cm. Collection of the artist
PHOTO ANTONELLA DE AMBROGGI

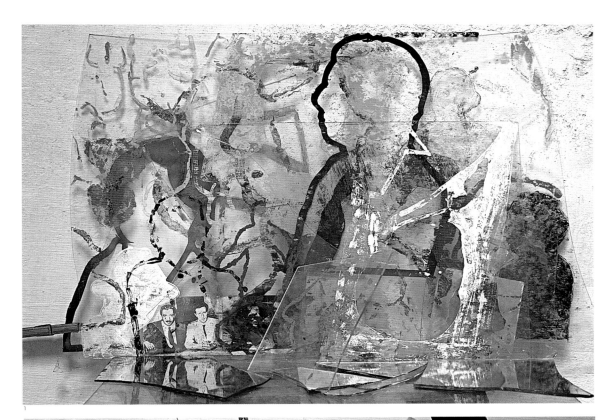

1

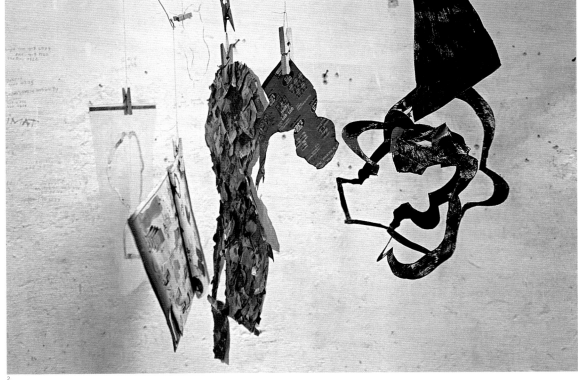

2

Venezuela
Gods of America, Antonio Briceño's photographs

It's an inmense dream. I can´t envision it all
Edward Curtis.

I

If we'd like to have a picture of what America was lie some 500 years ago, we ought to have a close encounter with some of the original ethnic groups that still roam the wild lands of North and South America. Such an encounter is what we experience in the uncompromising and risk-defiant field-work done by photographer Antonio Briceño on the Natural Lords

Seeking to be a witness to these oldest of peoples Antonio Briceño, a biologist, turned himself into a visual 'mythographer' able to build this new saga of the anciently excluded. The members of these ethnic groups, the landscapes, the elements associated with the myths and the collecting and making of these photographs have turned into a life-project for Antonio Briceño.

II

The common feature that identifies these indigenous peoples is dignity. Mature men and young women, in frontal portraits, strangely expressive and hieratic at the same time, all have this common feature. For this, unknowingly, Briceño reproduced the solitary steps taken by Edward Curtis (1868-1952), the great ethnographic photographer, who during 30 years of extensive field work photographed the main members of the Indian nations of the Southeast, the Northeast, and the Great Plains of the United States and Alaska.

Antonio Briceño is no ordinary traveller, as his long trips carried out in the 90's testify (India, Iran, Nepal, Syria, Yemen, Egypt, Morocco and Pakistan) . He went deep into the heart of the remotest regions of the long-storied lands and, in a very synchronic process, also went deep into the heart of its peoples.

When he obtained a scholarship that allowed him to establish himself for six months in the Western Sierra Madre (Mexico) with the Huichol people (2001), Briceño came up with the key element that has produced these astonishing series of mythographic portraits. He incarnated in each of his portrait subjects a section of the myth, as if they were priests of the rite that has sustained them in an act of collective faith.

In this way, each section of the *theogony* of these Indian nations is enacted by a member of the community, man or woman, young person or adult. Each posed for the camera with candour and generosity in a landscape linked to their culture and carrying the ornaments associated with the beneficent or destructive power of the nature deity he or she represents, incarnating the myth of creation that empowers their race.

Such is the level of representation of each of Briceño's portrait subjects that the viewer immediately recognises being in the presence of superior beings, the Natural Lords.

III

Each solitary portrait contains a multitude of primal inhabitants. A nomad photographer in the immensity of America, Antonio Briceño´s vision encompasses the long body of a continent that now, exactly 500 years after its first cartographic representation (1507) keeps itself alive through the ethnic groups that have survived for 500 years. Here we find not only the Venezuelans like the Wayúu from the Guajira, and the Piaroas, Pemones and Yekuanas of the Orinoquia, but also the Mexican Huicholes, the Kuna of the San Blas archipelago in Panama, the Wiwas and Kogui in Colombia, the Quero of the Peruvian highlands and the Kayapó of the Brazilian Amazon.

—Luis Ángel Duque

Commissioner
Zuleiva Vivas

Curator
Luis Ángel Duque

Artist
Antonio Briceño

1 **Antonio Briceño,** *Tatei Urianaka,* 2004. Polyester Kodak Endura on Dibond, 120 x 171 cm. Collection of the artist

Multipolar Resituation

V+F. A Multipolar Resituation

Artistic representations at the end of the twentieth century and early twenty-first are built by and develop from the use of principles, concepts and organisational systems derived from science and technology. Contemporary artists produce and share their experiences in very different surroundings from what we know as the traditional 'Atelier des Arts'. The neighbourhood, the street, an exploration ship or a classroom are the ideal frames for showcasing their artistic proposals. The famous 'widened notion of Art' coined by Joseph Beuys (1921-1986), the German artist whose campaigns in favour of direct democracy and defence of the environment understood as art, which gave many a headache to the profane adorers of modernism, continues expanding in an unlimited and unpredictable blast. Conceptualism, which gave precedence to the idea over the artistic object, is today seen to be kilometres away due to the unfathomable universe of options taking up positions in the art of our time.

We see as normal that the written word, political action or social matter are key pieces in the waiting-to-be-solved puzzle of recent art. Matters such as climatic changes, the act of participation, the painful marks of wars and human conflicts, the invitation to share a personal experience, the unstoppable information that navigates on the web, the fleeting image of a webcam or existence itself have become real art objects. Thanks to this, the equation ART=LIFE is rightfully legitimated.

Artists Françoise Vincent and Eloy Feria, a Franco Venezuelan duo, became partners in 1966 under the name of Vincent + Feria (V+F), have been known on the international art circuit since the late '80s. In their work they develop an art of intention and of participation through installations, performances, conferences, situations, and websites, intending to spotlight real spaces for thought.

In 2000 they created *The Pirate University*, an immaterial and timeless device, whose antecedent was the material and evolutional device they named *T House*. This action took place for the first time in an uninhabited lot (Cité Champagne, Paris, XX Arrondisement), and the following year at the Jacobo Borges Museum as a life workshop *Casa T Caracas*. The research and actions of V+F take place regularly as sessions at *The Pirate University*, through performances, conferences or inside an exhibition; they always act in relation to the context (kind of location, profile of guests, a noteworthy subject etc.)

In 2004 they participated in a scientific campaign in the Weddell Sea (Antarctica) that allowed them to develop a 'participative observation', and to question the notion of transdisciplinarity.

In this terrain they propose their *Weddell Sea Manifesto* in Buenos Aires, where they advocate '...preservation of Antarctic environment; the presence of artists in decisions, agreements and treaties of the member states; peace and non-aggression pacts; the creation of an observation and investigation site for artists in one of the temporary or permanent bases in Antarctica; and the end of the territorial appetites and resource exploitation even after 2041...', among other petitions. V+F are faithful representatives of Misión Conciencia (Conscience Mission) which has taken place in Venezuela. For decades they have travelled the world contaminating, with their life experience, *Symposia*, collective interventions, laboratories and *Exploratorium* into the essence of our identity and the diverse wealth of our cultural traditions and society. Participation, inclusion, re-siting and multipolarity are the elements that generate an expansive work whose outreach builds bridges between the Old and New Worlds.

—Zuleiva Vivas

Commissioner / Curator
Zuleiva Vivas

Deputy commissioner
Luis Ángel Duque

Artists
Vincent + Feria

2 **Vincent + Feria**, *Conversation avec un iguane*, Palais de Tokyo, Paris, 2006. Performance

3 **Vincent + Feria**, *Rap à Beaubourg*, Paris, 2003. Performance

▲2 ▼3

Central Asia Pavilion
Muzykstan. Media generation of contemporary artists from Central Asia

Muzykstan: Melodies In-between Globalization and Locality

The name 'Muzykstan' has a resemblance to the names of Central Asian countries: Kazakhstan, Kyrgyzstan, Uzbekistan and Tajikistan. Central Asia is actually all-round Muzykstan, as it has a rich musical heritage. All genres of music can be heard everywhere in the streets, cafes, markets, mosques, schools etc. Through music here you can recognise the region, time/epoch, generation, spirit, humour etc.

Today a new generation of artists (around 30 years old) is very pro-active in Central Asia. This generation absorbed all the achievements of the first contemporary artists, and at the same time have a different post-Soviet background. They use all kinds of information technologies as important tools in their everyday life and work. They have a different mentality, a so-called 'clip-mentality'. They are working in international media-corporations, keep headphones under their pillows, watch MTV, go to nightclubs, produce internet magazines and write emails in 'Runglish' (a crazy mix of Russian and English slang). 'Isn't it a cyber-like, globe generation?' you might ask, and I'd say: 'Almost!'

When I started this project, I thought about the opportunity of connecting Central Asian video-art and Central Asian popular music. But while creating their works the artists not only chose the music, sound-tracks and performers, but also often modified musical artefacts based on their own perception of Asian melodies.

Most of music presents a mixture of traditional music roots and global popular music tools. Roman Maskalev from Kyrgyzstan expressed his feelings towards his lovely surroundings through a song by a local rock musician, who performs in a traditional nomadic singing manner – so called Akyn, who sings in the narrative style – just describing what he sees around. Alexander Ugay from Kazakhstan used one of the most famous songs of Depeche Mode *Enjoy the Silence* as a pro-image for the new

Kazakh song. He translated the words of the song into Kazakh and invited a traditional dombra singer to perform it.

Alexander Nikolaev from Uzbekistan organised a 'Rapshi' music festival. He invited Uzbek teenagers to use traditional Muslim singing in rap-reading etc.

One of the main messages of the project is continuity. Most of the video works presented give a clear idea of the crossover of Asian and European cultures, local traditions and popular international brands. One can feel this in the image of the lovely Grandma singing a lullaby, created by Kazakh artist Gaukhar Kiyekbayeva, and realise that this is a song for all Eurasians and all of us are just her grandchildren.

Aleksei Rumyantsev from Tajikistan has also presented the idea of tradition and modernity by demonstrating traditional Asian round bread – 'lepeshka', which is still handmade in the big city, full of problems, mess and tragedies.

However all of the artists' works more or less reflect the human and political problems of the Central Asia region. Kazakh artist Natalya Dyu ironically presents the specific mentality of the so-called 'new rich people', who even hope you can buy music if you have too much money.

Yura Useinov from Uzbekistan has created his work in partnership with young Uzbek women-composers and dedicated it to the unnamed Uzbek train-station, where trains do not come any more. Jamshed Kholikov from Tajikistan has made a traditional Suphyi prayer, as a digital prayer to help a lonely Tajik woman fall pregnant.

Finally, it was a surprise to realise the strength of traditional influences on young contemporary artists in the region. They identify self-generation through melodies they absorbed with their mother's milk. Their works answer the question: 'What is so unique about Muzykstan and who are its citizens?'.

—**Yuliya Sorokina**

Commissioner / Curator
Yuliya Sorokina

Deputy curator
Ulan Djaparov

Advisor
Viktor Misiano

Collaborators
The Direction of Art Auctions and Exhibitions, Kazakh State Enterprise
Asia Art+, Public Foundation
HIVOS, Humanist Institute for Co-operation With Developing Countries
Open Society Institute
Associazione Culturale Spiazzi

Web Site
www.caprojects.org

Artists

Kazakhstan
Natalya Dyu
Gaukhar Kiyekbayeva
Alexander Ugay

Kyrgyzstan
Roman Maskalev

Tajikistan
Jamshed Kholikov
Aleksei Rumyantsev

Uzbekistan
Alexander Nikolaev
Vyacheslav (Yura) Useinov

1 **Gaukhar Kiyekbayeva**, *Mamma-Aziya*, 2007. Video, 3'. Courtesy the Artist

2 **Natalya Dyu**, *Happystan*, 2007. Video, 3'. Courtesy the Artist

▲1 ▼2

Сөз дегенім Алтон күш көтері
Тоноштоқта бірсәтте бұзатұғон.
Әр жанонұшінәлеміне о. о—о и
өткір семсер салатұғон
жанонсозғонбо.
бірақ сезанім
Сен жоқсоң иззік аяулом.

Бар ойом менің сүйгенім
Бар арманом, жетелеп
Ойласаң өзіңніңқолоңда
Сөз мұнда рақсет емеспе
Сөз деген Алтон күш ғой
Тоноштоқто бұзатұғон

Ант үшін үміт беріледі
Болашақто жаралауға
Сезім өткір сөзім бос
Ләззатқа бөлеп әндилеп
Силауро көзге жас
жатонжато толо жас 2-рет
бірақта жон бәрі бос

Бар ойом менің сүйген.
Бар арманом жетелеген
Ойласам өз қолоңда
сөз мұнда қажет емес
Сөз деген Алтон күш ғой
Тоноштоқто бұзатұғон
Тоноштоқто аела

3 **Alexander Ugay**, *Enjoy the silence*. Video, 3'20". Courtesy the Artist
4-6 **Vyacheslav Useinov**, *Nepribytie Poezda*. Video, 4'. Courtesy the Artist
7-10 **Roman Maskalev**, *Leto*. Video, 5'. Courtesy the Artist

4

▲5 ▼6

▲7 ▼8

▲9 ▼10

11

▲12 ▼13

14

▲15 ▼16

17

11-13 **Aleksei Rumyantsev**, *Krugi Vremeni*. Video, 4'. Courtesy the Artist

14-16 **Jamshed Kholikov**, *Pustotsvet*. Video, 5'. Courtesy the Artist

17 **Alexander Nikolaev**, *Rapshi*. Video, 4'. Courtesy the Artist

IILA Istituto Italo Latino Americano
Territorios

'Territory' is intended as a specific space that is circumscribed (by nature, politics, beliefs) or a history the determines us as people and is reflected in all our actions and creations.

Latin America, consisting of countries that have many historic events and geographic features in common, is nevertheless made up of many different 'territories'. They are islands that form the 'archipiélago de tierras firmes' ('archipelago of mainlands': see E. Martínez Estrada, *Radiografía de la Pampa*, critical edition edited by L. Follmann, Madrid, Alica XX, 1996) that is our continent.

The word 'territorial' is inflected in this Biennale through the works exhibited in the Italo-Latin American Pavilion.

We may interpret it as a portion of the terrestrial surface belonging to a nation, as Manuela Ribadeneira (Ecuador) does with her profound and involved work, or as a scene of political resistance inside a landscape, as seen in the work of the Colombian Mario Opazo.

'Territory' also means national symbol, reformulated as in the case of Patricia Bueno (Peru), who opts for a symbolic representation of the search for identity.

Paola Parcerisa (Paraguay) works with the flag and coat of arms of her country. Deprived of its symbolic contents, *Bandera Vacía* leaves only the seams and joins of colours visible, speaking of the migratory flight sparked off by the search for work and the consequences of this, such as the current globalised circulation, the hybridisation of countries and de-territorialisation.

That which is missing from Wilfredo Prieto's (Cuba) spectral library is made visible, and blank books, lacking in information and imagination, and the increasingly lower quality of many magazines, books and television shows are indicted.

Redefining the relationships between art and history in a singular way, Ernesto Salmerón (Nicaragua) talks of immigration and the damage caused by unstable governments or those that 'help' without teaching how to react to defeats.

Xenia Mejía (Honduras) tells us a story different from the official one. In her work she alludes to the stories of outcasts, subordinates, invisible people, those of mistreated, degraded, prostituted women and abandoned children, in short, of people on the margins of political and social life.

In her animated film, Narda Alvarado (Bolivia) speaks of the unofficial symbols of her country such as the coyas, the

Commissioner / Curator
Irma Arestizábal

Deputy commissioner
Alessandra Bonanni

Organisation and coordination
Alessandra Bonanni

Organisational secretary
Roberta Forlini
Martina Spagna

Exhibition project
Paola Pisanelli

Sponsor
Centro Cultural del BID, Washington, USA

Museo di Arte Contemporanea Italiana in America, San José, Costa Rica

Centro Ricerche e Documentazione Amedeo Modigliani, Massa Marittima (GR), Italy
Under the aegis of the Modigliani Institut Paris-Rome

With the contribution of
Artealdía, Miami, USA; Artnexus, Bogotà, Colombia; Arts finans Trust, S.A., Switzerland; BRICAPAR (Briquetas & Carbones del Paraguay), Paraguay; Kevin Bruk Gallery, Miami, Florida, USA; CNAP (Consejo Nacional de las Artes Plásticas), Cuba; CONCULTURA (Consejo Nacional para la Cultura y el Arte), El Salvador; Copipunto; CORPEI (Corporación de Promoción de Exportaciones e Inversiones, Ecuador); Municipalidad de Cuenca, Ecuador; Di Saronno Originale, Saronno,

Italy; Karen and Robert Duncan Collection; Fundación Ortiz Gurdian, León, Nicaragua; IBECOSOL (Ibérica de Combustibles Sólidos), Spain; La Colección Jumex, Mexico; Kamastrobar; MARTE (Museo de Arte El Salvador) San Salvador, El Salvador; Nina Menocal, Zacatecas, Mexico; Nogueras Blanchard, Barcelona, Spain; Pan American Gallery, Dallas, Texas, USA; Prometeo Gallery, Milan, Italy; Fundación Punta del Este, Uruguay; Galería Sacramento; TEOR/éTica, San José, Costa Rica; Carlos Woods, Guatemala City, Guatemala

Artists

Bolivia
Narda Alvarado

Chile
Mónica Bengoa

Colombia
Mario Opazo

Costa Rica
Cinthya Soto

Cuba
René Francisco
Wilfredo Prieto

Ecuador
Pablo Cardoso
María Verónica León
Manuela Ribadeneira

El Salvador
Ronald Morán

Guatemala
Mariadolores Castellanos

Haiti
Andre Juste and Valdimir Cybil

Honduras
Xenia Mejía

Nicaragua
Ernesto Salmerón

Panama
Jonathan Harker

Paraguay
William Paats
Paola Parcerisa

Peru
Patricia Bueno
Moico Yaker

Homage to Jorge Eielson

Dominican Republic
Jorge Pineda

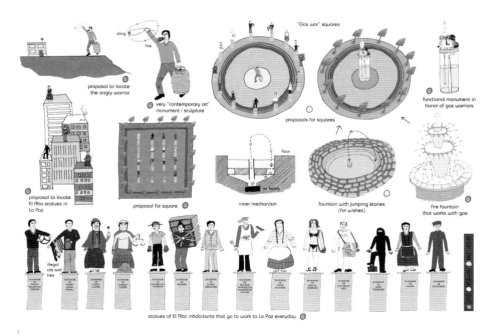

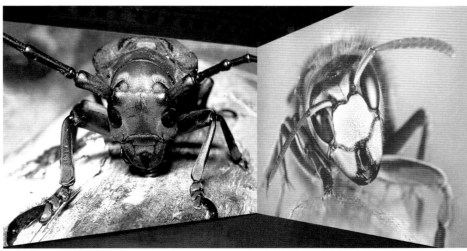

1 Bolivia
Narda Alvarado, *Construction of ideas*, 2006. 4 digital prints mounted on white light boxes, 110 x 75 cm, and DVD NTSC video animation, colour, sound, 4'30".
© The Artist

2 Chile
Mónica Bengoa, *some aspects of color in general and red and black in particular (algunos aspectos del color en general y del rojo y negro en particular)*, 2007. Installation of natural dried and coloured flowers, approx. 20 sq m, hgt. 4 m.

3 Costa Rica
Cinthya Soto, *Taller de Escultura Hidalgo*, 2006. 15 coloured photographs, 81 x 81 cm each, overall size 243 x 405 cm. Courtesy the Artist

fabrics, the altitude of its spaces where everything 'flies' and is transformed.

Not even Jonathan Harker's panama hat is an official symbol. In his work, Harker recalls that the hat, although made in Cuenca, Ecuador, has become the emblem of Panama and its famous canal.

Moico Yaker (Peru) returns to the foundation of the national identity of a particular territory that divides conquerors and conquered, migrants and natives. Cinthya Soto (Costa Rica) speaks of history, religion and the temporal and mental territories of death and transcendence with her photographs in series.

In the *La Política del Paraíso* series, Andre Juste and Vladimir Cybil (Haiti) assert that what leads to contemporary art is the search for social, political and cultural continuity, along with the formulation of a dialectic between past, present and future.

William Paats (Paraguay) cries out to save the wilderness and forests of his water-bearing Guaraní. He appeals to our conscience through his works of coal and sand in the face of the indiscriminate levelling of the forests.

The circumscribed space of the house or the view Nin (Marcelina Ochoa) has of her patio before and after its conversion into an 'almost paradise', is represented in *Patio de Nin* by René Francisco (Cuba). The scene then moves from the poor Cuban house to the noble ballroom of the Ca' Zenobio, where Mariadolores Castellanos (Guatemala) confronts us with a possible inhabitant of the Palazzo who allows us to glimpse her feelings, her stories, her situations and, perhaps, her memories of an elegant old colonial house.

Monica Bengoa (Chile), who always uses simple materials for her works, this time uses dried flowers (that are born dried) to represent pixels and reproduce gigantic photographic structures. The subjects of her work are usually scenes of her house, but here in Venice the artist proposes some insects from her garden.

We can experience the space of childhood in the disturbing, almost scenographic 'children's room' by Ronald Morán (El Salvador), which alludes to the violence that reigns between the domestic walls through toys covered with padding. The half-way station between childhood and adolescence is focused on rather by Jorge Pineda (Dominican Republic), who represents it using semi-hidden figures.

The lagoon territory that hosts us struck María Verónica León (Ecuador), who makes a video in which the reflections are the protagonist, and Pablo Cardoso (Ecuador) who, still following the line of a personal research into ontological shadings, offers us an exciting study on the changes Venice undergoes with the passing of the hours. At this year's Biennale, IILA pays tribute to the versatile Peruvian artist Jorge Eduardo Eielson, who died recently. In 1972 Eielson exhibited as part of the IILA's first participation at the Venice Biennale, presenting his 'knots' which speak in a contemporary language of the ancestral culture of his native Peru.

—Irma Arestizábal

4

4 **Cuba**
Wilfredo Prieto, *S/T (Biblioteca Blanca)*, 2004. 6,000 white books, bookshelves, tables and chairs, dimensions variable

5 **Cuba**
René Francisco, *Patio de Nin*, 2006. Video documentation on 5 simultaneous screens, DVD, 7', dimensions variable. Courtesy the Artist

6 **Ecuador**
Manuela Ribadeneira, ... *hago mío este territorio*, 2007. Installation, mixed media, dimensions variable

7 **Ecuador**
Pablo Cardoso Allende, 2007. Acrylic on canvas, 70 paintings 36 x 60 cm each. Courtesy dpm Gallery, Guayaquil, Ecuador
PHOTO FRANCESCO LIGGIERI/PABLO CARDOSO

8 **El Salvador**
Ronald Morán, *Habitación Infantil*, 2005. Installation, mixed media, dimensions variable

▲5 ▼7

▲6 ▼8

9

10

11

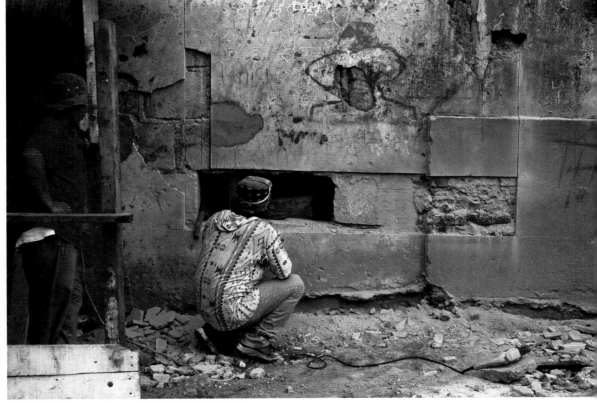

12

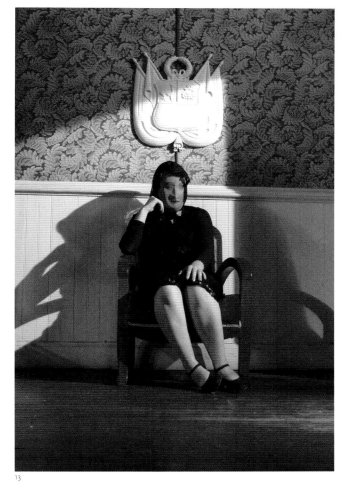

13

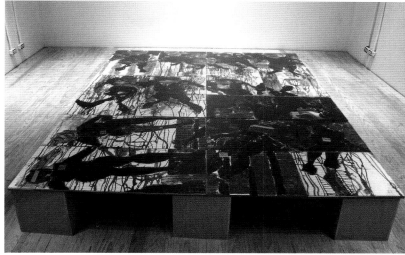

14

▲15 ▼16

9 Ecuador
María Verónica León, *Los espejos de Venecia*, 2005. Video art and digital photograph. Courtesy Collezione dell'artista, Collezione (MAAC), Museo de Arte Contemporáneo, Guayaquil-Ecuador, Familia Icaza, Guayaquil-Ecuador

10 Haiti
Andre Juste and Vladimir Cybil, *Buy the yard* Series, *Jungle Scene* (working title), 2007. Cloth, wood, acrylic, metal structures, photo transfer, 304.8 x 548.64 x 81.28 cm

11 Guatemala
Mariadolores Castellanos, *A través de los mares*, 2007. Epoxy, wood, stoneware, 82 x 168 x 82 cm
PHOTO THE ARTIST

12 Nicaragua
Ernesto Salmerón, *Proceso de Extracción de El Muro*, Granada, Nicaragua, 2006. Salmerón Family Collection. From series *Auras of War: Public Interventions in the Nicaraguan Revolutionary. Public Space: 1996-2007*
PHOTO ERNESTO SALMERÓN

13 Peru
Patricia Bueno, *Tuyo es el Reino*, 2007. HD video, 9'18'', device in epoxy, 60 x 55 cm

14 Honduras
Xenia Mejía, *Perfil de ciudad*, 2006. Mixed media, Indian ink, graffito, acrylic, collage/paper, 24 paintings 182 x 304 cm each. Collection the artist. Courtesy the Artist
PHOTO VERÓNICA ROMERO

15 Panama
Jonathan Harker, *Panamá jat*, 2005. Installation (Pirelli rubber floor and digital print on adhesive vinyl), 285 x 601 cm
PHOTO FRANCISCO BARSALLO

16 Paraguay
William Paats, *Irreversibile*, 2006. Installation on the ground, vegetal coal, river sand, 10 x 2,000 x 200 cm (variable). Collection of the artist

17

18

17 **Dominican Republic**
Jorge Pineda, *De la serie Me voy: Norte*, 2005. Sculpture on cedarwood and graffito. Installation composed of drawings

18 **Colombia**
Mario Opazo, *Territorio Fugitivo.* Project composed of videos: *Olvido de Arena*, 2006, digital video, 7', and *Scarabeus Sacer*, 2007, digital video, 8'. Still from video *Scarabeus Sacer*

19

20

21

19 Paraguay
Paola Parcerisa, *Bandera Vacía*, 2007.
Cotton fabric flag, sewn and cut out,
device hand-embroidered with cotton
thread, 100 x 200 cm. Collection of
Centro de Artes Visuales CAV/Museo
del Barro
© PHOTO FRANCO FERRETTI

20 Peru
Moico Yaker, *Descendimiento*, 2007.
Oil on canvas, 183 x 168 x 5 cm

21 Jorge Eielson, *Untitled*. Relief
on glased wood, Ø 150 cm

Venice Pavilion

Tribute to Vedova

The Venice Pavilion Venezia at the Biennale returns to its city: Luca Massimo Barbero, Chiara Bertola and Angela Vettese, respectively appointed by the provincial administration, the regional administration and the Comune di Venezia, were called on to open up a new direction focusing on the creativity of the area. The three curators were selected on the basis of their roles in three institutions that are the most active in contemporary art in Venice: the Peggy Guggenheim Collection, the Fondazione Querini Stampalia and the Fondazione Bevilacqua La Masa.

Considering that a solid foundation must start from recognition of the past and of a local identity who managed to assert himself internationally, the curators duly turned their attention to Emilio Vedova, who died less than a year ago. He was primarily an artist who left an indelible mark on the Accademia di Belle Arti di Venezia, influencing whole generations of students. At the same time, being constantly invited to exhibit at the Biennale, he was able to act as an intermediary between the fecundity of Venice and the world context of the exhibition. His mere presence in the city, on the other hand, was sufficient to 'do the honours' for foreigners, and generated a coming and going of critics, artists and musicians. With his extraordinary physical and mental energy, Vedova was the hub of a system of relations that helped keep Venice at the centre of the international debate.

Thanks to the essential cooperation of Fondazione 'Emilio e Anna Bianca Vedova' it has been conceived an hypotetical exhibition relating the homage to the Master with those artists who were in good relations of esteem, friendship and reciprocal influence with him.

The Venice Pavilion

After more than 30 years of abandon, used as a press room, assigned to hosting Italian exhibitions (such as the celebration of Alighiero Boetti) and, finally, the competitions for young artists promoted by the Ministry of Culture's Direzione Generale per l'Architettura e l'Arte Contemporanee (DARC), the Comune di Venezia, which owns it, and the regional and provincial administrations have jointly decided to take charge of managing the pavilion.

Built in 1932 on the island of Sant'Elena to house examples of the decorative arts produced in the Venice area, the building was conceived as an exedra by the architect Brenno del Giudice. The first exhibition featured precious glass works from Murano and mosaics and lace from Burano. In 1938 the focus shifted to painting, with a personal exhibition of Guido Cadorin alongside a small collection of paintings and sculptures from the Veneto area. Glass came to the forefront again in 1952, in an exacting exhibition of the best of Murano production.

In 1970 the pavilion was loosened up from the rigidity of sectoral exhibitions but, paradoxically, this opening coincided with its decline: design, photography and graphics were placed alongside the so-called 'fine arts'. The decorative arts exhibition, with an increase both in quality and quantity, was transferred two years later to the former church of San Basso. The Venice pavilion then hosted an exhibition solely of drawings dedicated to the city, entitled 'Venice, yesterday, today, tomorrow', but the event marked the exhibition area's loss of any constant cultural identity.

— Luca Massimo Barbero, Chiara Bertola, Angela Vettese

Curators
Luca Massimo Barbero
Chiara Bertola
Angela Vettese

Artist
Emilio Vedova

1 International Art Exhibition, Venice Pavilion, detail (arch. Brenno Del Giudice). Fototeca A.S.A.C. della Biennale. © Fondazione La Biennale di Venezia

2 26th International Art Exhibition, Venice Pavilion, 1952, Padiglione Venezia. Fototeca A.S.A.C. della Biennale. © Fondazione La Biennale di Venezia

▲4 ▼5

3 Emilio Vedova, *Senza titolo (als ob)*
'96/97, in the studio, disk
PHOTO F. GAZZARRI, PRINTED BY PAOLO VANDRASCH
2/2, MILAN, 9 MAY 1997

4 Emilio Vedova, *Senza titolo*
(als ob) '96/97, studio installation,
detail, Venice 1996
PHOTO F. GAZZARRI, PRINTED BY PAOLO
VANDRASCH, MILAN, MAY 1997

5 Emilio Vedova, *Senza titolo*
(als ob) '96/97, studio installation,
detail, Venice 1996
PHOTO F. GAZZARRI, PRINTED BY PAOLO
VANDRASCH, MILAN, MAY 1997

Collateral Events

Prize for Young Italian Art,
4th edition (2006-2007)

The DARC - Direzione generale per l'architettura e l'arte contemporanee is presenting the winner of the fourth Prize for Young Italian Art at the 52nd International Art Exhibition. The prize, being awarded to Nico Vascellari, was instituted by the DARC and by MAXXI - Museo nazionale delle arti del XXI secolo, to which the artist's work will be consigned.

The Prize for Young Italian Art was conceived to promote Italian artistic research and identify its most promising examples. Conditions for participation in it have been altered from this year to encourage an increasingly closer link to the diverse regional situations. The DARC asked the directors of 18 Italian museums of contemporary art to name one artist. A jury consisting of five museum directors and curators – Giovanni Castagnoli, Edoardo Cicelyn, Paolo Colombo, Gianfranco Maraniello and Anna Mattirolo – then judged the entries received and chose Nico Vascellari as winner 'for the multiplicity of linguistic codes with which the artist expresses himself and the interesting interaction in his work between contemporary visual and musical culture'.

In the allusively entitled *Revenge* presented on this occasion, Nico Vascellari constructs a network of relations with alternative music production centres and spaces and, subsequently, a personal exhibition involving a series of collective performances and acoustic actions conceived and performed by himself.

The artist Nico Vascellari, born in Vittorio Veneto (Treviso) in 1976, lives and works between Bologna and New York where he attends the Italian Academy at Columbia University. H e is a visual artist and the front-man of the punk band With Love, which has performed numerous times in Italy and abroad, and is known for its eccentric performances. He lived and worked in Rotterdam, after spending the last year of his education as artist in residence at Fabrica, the Benetton Group's Communication Research Centre in Treviso. In 2004 he took part in the tenth advanced course in visual arts at the Fondazione Antonio Ratti in Como; in 2005 he won the first National Performance Prize organised in Dro (Trento) by the Trento Galleria Civica d'Arte Contemporanea. He presented his latest work *A Great Circle*, at Rassegna K (themed film festival held in Vittorio Veneto, Treviso, from November 2004 to January 2005; Cinema d'essai - expo. Microeventi), a short film in which he reworks and plays with the images of his most recent performances, talking about how his way of working. In 2006 Vascellari had numerous personal exhibitions including: *Io ballo da solo* (Rome, Galleria Monitor); *Cuckoo* (Milan, Galleria Viafarini) and *Death Blood War* (Ljubljana, Galleria Skuc). He is currently taking part in the 2007 Furla Art Prize (Bologna, Villa delle Rose) and working on an installation for the exhibition *Apocalittici e Integrati. Utopia nell'arte italiana di oggi* (Rome, MAXXI - Museo nazionale delle arti del XXI secolo). His works have been exhibited in Italy, Holland, Finland, Germany and England.

He says of himself: 'I love it when my work is able to combine instinct and reason, destruction and creation or, in general, opposite elements. This occurs in my work in different ways regardless of what media I use. My early performances always took place in public spaces like streets or squares because I wanted to be able to be surprised by the attitude of a casual audience. Improvisation is something I impose on myself as a form of research on the body, as I am an artist who also communicates through my own image' (statement taken from the interview published on www.foodstock.it/rassegnak_artistik.htm).
—Monica Pignatti Morano

Organisation
DARC - Direzione generale
per l'architettura e l'arte contemporanee,
Ministero per i beni e le attività culturali
MAXXI - Museo nazionale delle arti
del XXI secolo, Ministero per i beni
e le attività culturali

Commissioner
Anna Mattirolo

Curators
Paolo Colombo
Monica Pignatti Morano

Web Site
www.darc.beniculturali.it

Artist
Nico Vascellari

1 Nico Vascellari, *Nico & The Vascellaris*,
2005. Photo from the performance.
Courtesy the Artist and Galleria Monitor,
Roma
PHOTO ELA BIALKOWSKA

2

2 Nico Vascellari, *Glitter Secondario*,
2003. Photo from the performance.
Courtesy the Artist
3 Nico Vascellari, *Cuckoo*, 2006. Photo
from the performance at the expositive
space Via Farini, Milan. Courtesy
the Artist

3

And so it goes: Artists from Wales

Richard Deacon, Merlin James and Heather & Ivan Morison

Richard Deacon's diverse practice has consistently challenged and extended notions of what sculpture is, and what it might be. It has included works in wood, clay, leather, ceramic and steel on both a domestic and monumental scale.

Deacon is intrigued by the inventive thoughts that stem from the seemingly innocuous passing of time. These moments of intuitive creative boredom are the springboard for a manifold set of references and ways of seeing that appear to be both accessible and indefinable.

Deacon's works encourage movement around and through them, and are defined as much by this as they are by the solidity of their form. For Venice, in a departure from his stand-alone sculptures, a number of works in a range of materials hang from handmade nails that uniformly punctuate the surface of the walls. These 'shown' or 'stored' works navigate the viewer through the space, raising questions about the way in which we shape things.

In the same way that Richard Deacon is interested in the fundamentals of sculpture, Merlin James is interested in the nuts and bolts of painting.

The painted surfaces of Merlin James' canvases are testament to the endeavour of the artist over time; they are rich and rewarding and draw the eye back and forth across the canvas. He has shunned the lush seduction of oil paint in favour of the 'deadness' of acrylic, so that each considered mark is imbued with a sense of urgency, seeking to transcend the prosaic nature of the surface.

They are playful and gestural, and diverse and unpredictable in form and subject. They are often slashed, collaged, layered with hair or dirt and can include landscapes, interiors, nude figures, dwellings, doorways and interpretations of old photographs.

Whilst articulating a range of human experience (mood, memory, sexuality), James sees his practice as a kind of 'non-verbal art criticism' in which his investigations in paint evoke a collage of different painting styles and points of historical reference. He has no interest in subverting tradition but his painting evolves out of a meticulous analysis that remains fresh and, refreshingly, manages to avoid nostalgia.

Heather & Ivan Morison are interested in the perceived banality of everyday endeavour. To present their observations they use formal and conceptual devices, engaging with and responding to their surroundings. They survey, meticulously record and collect to rebuild and re-present the familiar, investing their observations and discoveries with vigorous fascination.

Whilst the Morisons examine the extraordinary beauty and detail of the natural world, they also acknowledge the presence of threat and often these two worlds come together to create a sense of disorientation. Recently, they have begun to further probe the notion of the 'unknown' through an investigation that sees a mapping of history and the natural world, coming intriguingly close to alien intent. The resultant forms – which can take shape through drawing, slides or sculpture – both disturb and embody notions of beauty derived from nature.

In 2005 the Morisons acquired a wood in North Wales. They will develop the area of mature conifers into an arboretum, a collection of trees that will be gathered from around the world. As old trees are cleared to make way for new species, they will be cut into timber that will be used to realise new projects, including the exhibition in Venice.

—**Hannah Firth**

Organisation
Arts Council of Wales

Commissioner
Michael Nixon

Curator
Hannah Firth

Project manager
Nia Roberts

Technician
Dean Woolford

Collaboration in Venice
Vittorio Urbani
Barbara del Mercato

With the support of
Arts Council of Wales
British Council
Castle Fine Arts
CBAT: The Arts and Regeneration Agency
Chapter
Cywaith Cymru. Artworks Wales
Hilton Molino Stucky Venice Hotel
Nelmes Design

The Esmeé Fairbairn Foundation
Tŷ Nant
Wales Arts International
Welsh Assembly Government

Web Site
www.walesvenicebiennale.org

Artists
Richard Deacon
Merlin James
Heather & Ivan Morison

1 Interior Capannone 1, Ex-Birreria, 2007

2 Richard Deacon, *Infinity #30, #29, #31*, 2005. Stainless steel. © Richard Deacon. Courtesy Lisson Gallery, London
PHOTO THE ARTIST

3 Richard Deacon, *Work in progress*, 2007
PHOTO THE ARTIST

4

5

6

4 **Merlin James**, *Don Quixote*, 1997.
Acrylic and mixed media on canvas,
51 x 61 cm. © Merlin James
PHOTO THE ARTIST

5 **Merlin James**, *Edges*, 2006. Acrylic
and mixed media on canvas, 39 x 54 cm.
© Merlin James
PHOTO THE ARTIST

6 **Merlin James**, *Untitled (Building)*,
1995. Acrylic and mixed media on
canvas, 45 x 53 cm. © Merlin James.
PHOTO THE ARTIST

7 **Heather & Ivan Morison**, *Study
(Grateful Dead Concert)*, 2007.
Photographic collage. © Heather &
Ivan Morison

8 **Heather & Ivan Morison**, *Study for
Earthwalker (Carabou)*, 2006. Lambda
print. © Heather & Ivan Morison.
Courtesy Daniel Arnaud contemporary
art, London

9 **Heather & Ivan Morison**, *Study
(Roger's House truck number 4, Eugene,
Oregon)*, 2007. Digital photograph.
© Heather & Ivan Morison. Courtesy
the Artists

▲7 ▼9

8

Aniwaniwa

Aniwaniwa is a collection of *wakahuia* – a treasure box, a vessel containing precious things – with internal projections and sound components suspended from the ceiling. These *wakahuia* are large carved sculptures holding memories of a place now submerged under water. While *Aniwaniwa* is based on a specific historical event and local Aotearoa New Zealand geography, the provincial subsides and the experiential begins in a global context and continues with their reflection on the forced migration of the Pacific peoples. This work highlights the submerged Waikato town of Horahora and uses flooding and submersion as a metaphor for cultural loss with specific reference to local *iwi* (people indigenous to the region) or specifically, how rising sea levels caused by global warming are literally drowning many low lying Pacific islands and causing the widespread devastation of coral reefs. *Aniwaniwa* as a Maori place name also evokes the blackness of deep water, storm clouds, a state of bewilderment, a sense of disorientation and confusion as one is tossed beneath the waters. It can also refer to a rainbow, a symbol of hope. Defining identity in terms of water rather than land has implications for the entire Pacific.

The 'submersion' of one's history is the subconscious theme of many of the conversations Graham has had with both his father (himself a well respected sculptor) and grandfather. His father's childhood hometown of Horahora was flooded with the creation of the hydroelectric power station in 1947. His grandfather and many other local Maori of Ngati Koroki Kahukura, were employed here. His stories about the power station were touched with nostalgia for a place that is now under water, existing only in memory. By creating Lake Karapiro, ancient sites of historical significance were flooded, such as the rock where the chief Waharoa (Ngati Haua) had cremated the corpses of his men, killed in the last intertribal battle of Taumatawiwi, lest he be defeated and their bodies desecrated (hence the name Karapiro-foul smell). As Graham says: 'I had expected to be moved by this. I had not anticipated being moved by the fact that our people had mourned the loss of the power station and the community it had created'.

'The generators themselves became a focus for the suspended sculptures. Their location, above the viewer, was intended to disorientate one's perception, suggestive of the other meanings of *Aniwaniwa*. They are covered in a pattern that evokes the gnawed paths of insects, gouging through wood and hence the origin of the word *whakairo*, to carve. This is reminiscent of the legend of Ruatepupuke, where the art of carving was itself retrieved from under the waters, from the sacred house of Tangaroa'.

Maori identity is usually defined in terms of a relationship to land, as in the expression, *tangata whenua*, literally, 'people of the land'. In many of Rakena's works, however, this identity is explored as being in a state of flux, a fluidity that like the borders of a river, is constantly changing, likened to intangible cyberspace digital networks, exploring water as a context for people, communication and culture. 'As I worked with people in water, I found culturally specific relationships between Maori and water impossible to ignore. We are island people living in a vast ocean. We belong to water just as we belong to land', Rakena explains.

In *Aniwaniwa* the villagers go about their lives and daily tasks, even though their town now exists only under water. They have been preserved, their actions, like history, are forever suspended in space and time in pools that defy gravity.

—Alice Hutchison, Brett Graham and Rachael Rakena

Organisation
Nga Pae O Te Maramatanga - The National Institute of Research Excellence for Maori Development and Advancement
Te Manawa Museums Trust
Plug Non-Profit

Curators
Alice Hutchison
Milovan Farronato
Camilla Seibezzi

Sponsor
Byblos

Web Site
www.temanawa.co.nz

Artists
Brett Graham
Rachael Rakena

1 **Brett Graham and Rachael Rakena**, *Aniwaniwa*, 2006-2007. Video stills from the installation, multi-media materials (fiberglass, DVD players, projectors, audio components, mattresses), dimensions variable (5 suspended forms 250 x 250 x 150 cm each). Collection of the artists. © Brett Graham and Rachael Rakena

2

2 Brett Graham and Rachael Rakena, *Aniwaniwa*, 2006-2007. Video stills from the installation, multi-media materials (fiberglass, DVD players, projectors, audio components, mattresses), dimensions variable (5 suspended forms 250 x 250 x 150 cm each). Collection of the artists. © Brett Graham and Rachael Rakena

3

4

3-4 Brett Graham and Rachael Rakena,
Aniwaniwa, 2006-2007. Views of the
installation. Collection of the artists.
© Brett Graham and Rachael Rakena

ATOPIA

Atopia is a 'non-place', unconstrained by borders, due to the politico-economic dynamism of globalisation. The disappearance of boundaries the mixing and merging of cultures, virtual space shaped by technology, and transnational consumption and production means no single identity can account for contemporary spatial configurations. Yet an atopia does not necessarily assure individual freedom. No longer the expressions of pure will and desire, our bodies are marked by the regulation of individual life by the combined powers of the new empire. The omnipresence of this condition makes true individualism possible, through the self-empowering recreation and rewriting of identities.

Atopia also means that a place cannot be placed, or simply be not-a-place. The impossibility of legitimate representations makes atopia a state of *de facto* without *de jure* a place without its name can only be attended as an exception. Anachronistic histories and dislocated sites all assume the status of atopias. One can envisage that Taiwan is a non-national nation, or a nation without nationality, yet neither post-nation nor pre-nation: in short, an atopian state *par excellence*. Its name as listed in international settings is confusingly inconsistent and endlessly reinvented: Taiwan (ROC), China (Taiwan), China (Taipei), Taipei/China, Taipei, Chinese Taipei, and so on. Within these brackets, slashes, and aliases, an atopia performs 'in-the-name-of-other-names', i.e., to claim its identity through *différance*, not difference. Its true identity has always-already been inscribed through reiterations of supplements, arresting the open secret of atopia.

Internationally renowned filmmaker Tsai Ming-liang bases his work on alienated existences, ungrounded in place, lost in transition. The bewildering temporal-spatial settings of his films are non-places at best, where sexuality, adultery and incest all become the sole actions that people on the margins of society can take. Long and maddening sequences propel the radical silence of his images, evoking fragmentary realities of pathos.

Building on recollections from a well-known Taiwanese postcard, Tang Huang-chen embarks on a heroic performance, taking participants from international cities on a voyage to reconstruct the scene and moment of that photograph. The impossibility of her action addresses the collective *anamnesis* of the allegory of travel. Through the untranslatability among different sites and histories, Tang creates an absurd blurring space in between the individual action and collective visual culture.

Lee Kuo Min's photography documenting vanishing communities is not just an artistic expression but a social action against Taiwan's urban policy. Revealed in his photographs are chaotic personal dwelling places, once lived in and on the verge of being torn apart. Lee's work witnesses the transition of political pasts and urban histories, and shows the human conditions of a quasi-community in a state of emergency.

Organisation
Taipei Fine Arts Museum of Taiwan

Commissioner
Huang Tsai-lang

Deputy Commissioner
Paolo De Grandis

Curator
Hongjohn Lin

Coordination in Venice
Arte Communications

Web Site
www.tfam.museum

Artists
Tsai Ming-liang
Tang Huang-chen
Lee Kuo Min
Huang Shih-chieh
VIVA

1 Tsai Ming-liang, *Is A Dream*, 2007.
35mm film. Courtesy the Artist

2 Tsai Ming-liang, *The Wayward Cloud*,
2005. 35mm film. Courtesy the Artist

3-4 Tang Huang-chen, *I Go Traveling V
- A Post Card with Scenery*, 2003-2007.
Action in Korea / Taiwan / France / Italy.
Courtesy the Artist

Huang Shih-chieh, a *bricoleur* of low-tech objects, alters mass-produced consumer appliances through hands-on instructions. His installation generates an interactivity with archi-textures of manipulated home appliances. Not a technocratic utopian, Huang orchestrates a hysterical dialogue between technology and humanity.

VIVA draws comics of new social realism to depict the everyday life of computer geeks in the format of *doujinshi*, a cultural mimicry from Japan. Quite the opposite of a pop artist who appropriates culture for art, VIVA is a practitioner of culture that speaks for the *otaku* generation. His work and life altogether render a topsy-turvy picture of the traffic of cultures found in globalisation.

The exhibition's selected artworks invite viewers to attend not only a showcase of art, but an acting-out of the everyday reality of Taiwan, which in turn is intertwined with the global order. Here, travelism, urbanization, technology, subculture and individual existence all meet at the same crossroad, a *terra incognita* of self-refabrication in the name-of-other-names.

— **Hongjohn Lin**

5

6

5-6 **Lee Kuo Min**, *Treasurehill*, 2006.
Chromogenic color prints, 45 x 45 cm.
Courtesy the Artist

7

8

9

10

7 **VIVA**, *VIVA*, 2006. Mixed media. Courtesy the Artist

8 **VIVA**, *VIVA*, 2006. Mixed media. Courtesy the Artist

9 **Huang Shih-chieh**, *Slide Din Don*, 2006. Interactive installation. Courtesy the Artist

10 **Huang Shih-chieh**, *Out of Context*, 2006. Installation. Courtesy the Artist

Camera 312 – *promemoria* per Pierre

What sudden and violent emotion the evening they told me that Pierre Restany was dead. I knew he was ill, but hope and faith emerged from his letters I'd received. When I met him in the mid-1970s at the Hotel Manzoni in Milan, I told him about my travels in Peruvian Amazonia. 'Amazonia' was the password for us that immediately kicked off a spiritual contact. He, too, was a great lover of and expert on that forest and its world. After that we met various times and always, immediately, the memory of this common love of nature came up again. Nature that, in its most complete essence, Pierre could now only glimpse from planes, as he had ironically pointed out in some letters, but continued to fascinate him with its eternal mystery.

Pierre Restany, founder of New Realism and charismatic critic and free thinker, who had a preponderant influence on the world of contemporary art, stayed in the now historic room 312 of the Hotel Manzoni in Milan continuously for more than 30 years. After his death I decided to make a tribute to him with a project not only dedicated to him, but centred on him.

The original furnishings of room 312 at the Hotel Manzoni are presented in the exhibition space, whose walls are completely lined with fluttering yellow Post-it notes.

The Post-it note, now used almost everywhere as an everyday object and the most widespread synonym for remembering an event, is the basic element of the project *Camera 312 - promemoria per Pierre*: a simple, direct, colourful and 'fluxus' way of allowing every invited artist to make a note of their own poetic testimony.

In order to grasp the intimate atmosphere of the room through the specially created artistic messages, the installation begins on the walls and continues over the furniture, covering the surrounding space with islands of strictly yellow colour that will involve and enfold the observer. It is precisely this diversity of approach and use of various materials (digital prints, manual interventions, video etc.) on the same Post-it notes that gives the operation the broadest possible view of contemporary art languages and will interest visitors with the total vision of the site-specific work and the multiplicity of the individual works. As an integral part of the installation, the performance presented on the opening day and the episode of the art and culture programme *Passerpartout* that featured Pierre Restany, presented by Philippe Daverio.

—Ruggero Maggi

Organisation
Milan Art Center

Curator
Ruggero Maggi

Scientific committee
Stefania Carrozzini
Jacqueline Ceresoli
Gavina Ciusa
Matteo Galbiati
Maria Laura Gelmini
Lorella Giudici
Alberto Mattia Martini
Mimma Pasqua
Loredana Rea
Vanda Sabatino
Massimo Scaringella
Viviana Tessitore
Marisa Zattini

Collaborators
Isabella Fiore
Hotel Manzoni
Openartstudio
Vittoria Cappelli srl

Sponsors
3M Italia
Atelier51 snc
Concaverde costruzioni sas
Edilpali Genova srl
Edis SpA
Galleria d'Arte 'La Nassa'
Incisione Arte snc
MC service srl
Technology Communication Group srl

Web Site
www.camera312.it

Artists
Lorenzo Alagio
Cristina Alaimo
Fernando Andolcetti
Salvatore Anelli
Enzo Angiuoni
Calogero Barba
Fiorenzo Barindelli
Paolo Barlusconi
Antonino Bove
Nirvana Bussadori
Carlo Cane
Angelo Caruso
Bruno Cassaglia
Marilù Cattaneo
Renato Cerisola
Cosimo Cimino
Mario Commone
Nelli Cordioli
Francesca Romana Corradini

Marzia Corteggiani
Carla Crosio
Teo De Palma
Adolfina De Stefani
Gianni De Tora
Gabriella Di Trani
Marcello Diotallevi
Fedi & Gini
Alberto Ferretti
Roberto Franzoni
Fabrizio Galli
Annamaria Gelmi
Guglielmo Girolimini
Lillo Giuliana
Salvatore Giunta
Isa Gorini
Giuliano Grittini
Franca Lanni
Mya Lurgo
Ruggero Maggi
Carlo Maglitto

Antonello Mantovani
Renato Marini
Maria Grazia Martina
Fabrizio Martinelli
Rita Mele
Antonio Menenti
Renato Mertens
Simona Morani
Giorgio Nelva
Paolo Nutarelli
Clara Paci
Giorgio Pahor
Salvatore Pepe
Giovanna Pesenti
Renata Petti
Plumcake
Teresa Pollidori
Tiziana Priori
Rosella Restante
Chiara Ricardi
Giuseppina Riggi

Fiorenzo Rosso
Alba Savoi
Gianni Sedda
Eugenia Serafini
Elena Sevi
Oliana Spazzoli
Franco Spena
Maria Gabriella Stralla
Edoardo Stramacchia
Micaela Tornaghi
Judit Török
Danila Tripaldi

Performers
Gioia Fruttini
Gianmarco Gaviani
Kappa
Sarah Pini
Cristina Vighi

1, 3, 5 Detail from the installation
Camera 312 - promemoria per Pierre,
2007. Mixed media on Post-it
PHOTO GIORGIO PAHOR

2 Ruggero Maggi, set up of the
installation *Camera 312 - promemoria
per Pierre*, 2007
PHOTO GIORGIO PAHOR

4 Milan Art Center, mail sent by Pierre
Restany to Ruggero Maggi, January 31,
1983

▲6 ▼7

6-7 Details from installation *Camera 312 - promemoria per Pierre*, 2007. Mixed media on Post-it
PHOTO GIORGIO PAHOR

Keep on mailing us Ruggero, don't give up! You'll end in a post-office as the Michelangelo delle poste

MAIL ART/DEBATE - INQUEST

Mail Art is a necessity which many artistic operators, in all the world, have felt.
"The most evident "purposes" wich M.A. is pursuing are the need to feel close to eachother, overcoming the difficulties of physical and, some times spiritual distances, the political and geographic barriers and the "natural contrast" with the, so called, "official" art and with "its world" (like the squalid "chain": artcriticism - gallery)."
The total "elimination" of every barrier between the same mail artists is producing also a major "availability" for the Society wich the same operator "is living" with more sensibility.

Ruggero Maggi

I agree totally Restany

8

9

10

8 Milan Art Center, mail art by Pierre Restany

9-10 Details from installation *Camera 312 - promemoria per Pierre*, 2007. Mixed media on Post-it

PHOTO MARIA GRAZIA MARTINA

CAOS Project

Infinite, predating the creation and potential matrix of the cosmos, from *Genesis* to the mythological cosmogonies, chaos is the principle of truth that gives meaning and value to the complex diversity of the existing. Without chaos it seems that nothing new can be born. Life itself seems to be based on non-linear systems. The heartbeat and the actual physiological fractal structures of the human body are evidence of this. Over the centuries a crystalline, transparent view of the world, rigidly ordered like a clock (the deterministic theory) gave way to a vibrating one of a changeability intransigent before scientific forecasts and, especially in art, providing very fertile ground for showing the philosophical value of a change in thinking. As Heidegger asserted, chaos, however, 'does not mean the simply tangled in its tangle, nor the non-ordered for having neglected all order, but rather that which is imminent [...] which torrentially flows and is moved'. Every artistic intervention is thus defined as a changing and imminent combination of materials and works intended as disorder/order in a profound connection of reciprocal necessity. In short, art separates the world to speak of the world, and it is on these premises that the expressive direction of the *CAOS Project* exhibition by artists Alba Amoruso, Stefano Fioresi, Massimo Franchi and Giuseppe Linardi is based; Fioresi, Franchi and Linardi were presented during the ninth *OPEN*, International Exhibition of Sculptures and Installations at the Lido, Venice. The project gives form to an intuitive logic that puts new, liberating elements together. The engine of this continuous process is fuelled not only by the highly imaginative power of chaos, but also by a socio-political meditation on the powers imposed by communication conventions where art has the right tools for contrasting a vital, saving creative logic. In the works of Massimo Franchi, the symbols relating to a common cultural substratum and the tragedy of 11th September act as a bridge toward new cognitive perspectives and, in particular, activate contents of an ethical depth and social commitment. Alba Amoruso is not far from this position, although the conflicts and differences of the megalopoli lie behind her research; hers is a romantic attitude, an attempt at emotional and spiritual involvement that makes use of an intensely warm and chromatic 'all over'. Stefano Fioresi's pop language plays rather on symmetries, on dynamic equilibrium; it tends to communicate energy, to put into relation many elements of widely praised icons that allusively refer to the original message in a kind of self-referencing state. In Giuseppe Linardi, the forms and lines are not still but move decisively toward the observer, provoking, stimulating and immerging her in an experience that aims to submerge her individuality, dragging it into the heap. Painting prevails in all its declensions; it is gift, exchange and gesture that puts energy into circulation. Order and chaos together, then, to recount the importance of these two states of existence that directly and perceptibly coincide in the perception.

—Paolo De Grandis

Organisation
Arte Communications

Curator
Paolo De Grandis

Coordination
Carlotta Scarpa

With the patronage of
Association Internationale des Arts
Plastiques, AIAP - UNESCO
Regione Veneto
Provincia di Venezia
Comune di Venezia

Web Site
www.artecommunications.com

Artists
Alba Amoruso
Stefano Fioresi
Massimo Franchi
Giuseppe Linardi

1 **Alba Amoruso**, *Megalopoli*, 2002. Wall paint on canvas, 250 x 170 cm. Courtesy the Artist
PHOTO EUGENIO GIAMBALVO

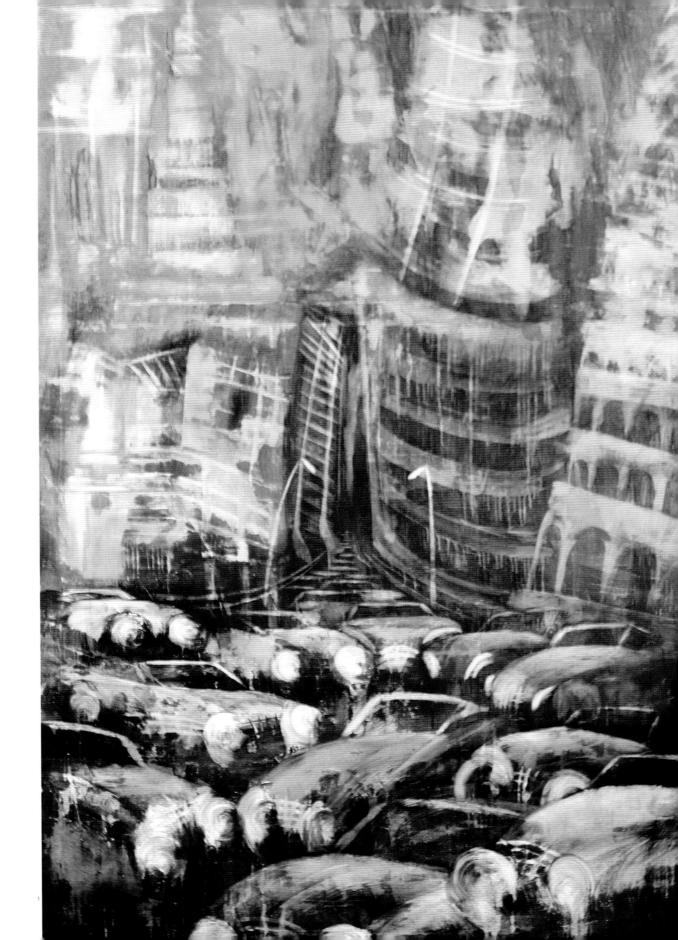

2

3

4

4 Stefano Fioresi, *Caos*, 2007.
Installation. Collage, stencil, acrylic and
epoxy on canvas, many works, 50 x 50
cm each, dimensions variable. Courtesy
the Artist

Chiese... a regola d'arte
The adjustment of worship places to the liturgy of the Vatican II

The International Conference this year, as on the previous four occasions, looks at the subject of art and architecture for the liturgy, but further defines its aim by focusing on the very topical subject of the liturgical adaptation of churches.

Many works have been carried out on religious buildings since the Vatican Council II (1962-1965) to adapt them to the devotions of the Christian community in keeping with the *Sacrosanctum Concilium* council constitution.

Liturgical adaptation is thus a very interesting subject, but also a very delicate and complicated one. It defines the planning orientation for spaces that are often already powerfully characterised both artistically and architecturally, and the addition of new art works that sparkle with beauty. Beauty, in fact, 'is not a decorative factor of the liturgical act, nor is it a constituent element, in that it is an attribute of God himself and his revelation' (Benedict XVI, *Sacramentum caritatis*, 35).

On the other hand, the history of mankind teaches that church architecture often has a powerful influence on the urban and social context of its setting, while it is also evident that alterations and developments are inevitably made to every single church building over the centuries, documenting its history. Such changes cannot be explained only by a simple stylistic, artistic or epochal factor, but often have an immediate connection to the development of the faith of the Christian community that meets in the churches to celebrate the sacraments and to pray, and creates a dynamic, vital relationship with it.

Only by starting from this fact is it possible to fully 'understand' the significance and value of the religious building. On the contrary, not adapting a church to the liturgy of its time for fear of altering it means making it less a church and unavoidably condemning it to disappearing with the passing of time.

Every liturgical adaptation is therefore a challenge for the various actors involved: the architects, who have to insert their plans into places already built and powerfully characterised; the artists called on to communicate with a specific client who is not identified as a single individual and to make their contribution in a language that often moves far away from that of the past; the liturgists involved in their fundamental task of involving professionals, to 'take on' the forms of the liturgy; the State institutions charged with protecting the cultural heritage, who are called on to confer and cooperate with the client on the delicate subject of the relationship between new plans and conservation.

This all gives rise to a linked picture that highlights the need for the training and constant updating of all those involved, encouraging and allowing opportunities for comparison and exchange. The conference is intended as a contribution in this sense, in the awareness that only a 'broad and open' dialogue and assessment can enable all to meet the expectations and needs of the Christian community and at the same time to leave important signs of the passing of our epoch in the spaces given over to worship, without upsetting the signs of the times that preceded us.

—Don Gianmatteo Caputo, Don Stefano Russo

Organisation
Ufficio Nazionale per i Beni Culturali
della Conferenza Episcopale Italiana
Patriarcato di Venezia

Technical-scientific coordination
Gianmatteo Caputo
Giorgio Della Longa
Antonio Marchesi
Stefano Russo
Massimiliano Valdinoci

Coordination
Ufficio Promozione Beni Culturali,
Venezia
Culturart srl

With the patronage of
Pontificia Commissione per i Beni
Culturali della Chiesa
Ministero per i Beni e le Attività Culturali
Regione del Veneto
Provincia di Venezia
Comune di Venezia

1

2

3

4

5

1 Roberto Priod, *Croce*, 2005. Church
of San Lio, Venice. Courtesy archivio
Culturart, Venezia

2 Giuliano Giuliani, *Altare*, 2005.
Church of San Lio, Venice. Courtesy
archivio Culturart, Venezia

3 Antonella Pomara, *Tabernacolo*, 2005.
Church of San Lio, Venice. Courtesy
archivio Culturart, Venezia

4 Antonio Spanedda, *Ambone*, 2005.
Church of San Lio, Venice. Courtesy
archivio Culturart, Venezia

5 Elisabetta De Luca, *Madonna svelata*,
2005. Church of San Lio, Venice.
Courtesy archivio Culturart, Venezia

6

7

6 **Stefano Pizzi**, *Via Crucis*, 2005.
Church of San Lio, Venice. Courtesy
archivio Culturart, Venezia

7 **Cosetta Mastragostino**, *Fonte
battesimale*, 2005. Church of San Lio,
Venice. Courtesy archivio Culturart,
Venezia

8

9

10

11

12

8 Carlo Marchetti, *Ceriera*, 2005. Church of San Lio, Venice. Courtesy archivio Culturart, Venezia

9 Daniele Franzella, *Calice, patena e candelieri*, 2005. Church of San Lio, Venice. Courtesy archivio Culturart, Venezia

10 Luigi Pagano, *Cero pasquale*, 2005. Church of San Lio, Venice. Courtesy archivio Culturart, Venezia

11 Branislav Petric, *Madre Teresa di Calcutta*, 2005. Church of San Lio, Venice. Courtesy archivio Culturart, Venezia

12 Oleg Supereco, *Sant'Antonio*, 2005. Church of San Lio, Venice. Courtesy archivio Culturart, Venezia

Claudio Bravo

Extraordinary to behold, the monumental package triptychs by Claudio Bravo are trompe-l'œil masterpieces that vibrate with colour, intensity and mystery, simultaneously reinvigorating a format that arose over a thousand years ago in early Christian art and expanding the limits of another art historical trope – the still life genre – through an ingenious use of scale and subject. In each of the triptychs on view, *Triptych (Red)*, 2006; *White Package Triptych*, 2004; *Eternum/Phillip II*, 2005 and *Blue Triptych*, 2006, Bravo depicts large packages wrapped in paper and tied with twine on a single plane. On each central panel a large package is divided into four sections by string, while the side panels are tall vertical packages with single strands of twine tightly bound from top to bottom. *White Package Triptych* differs from the others in that the side panel packages are tied from both sides, with knots slightly off-centre over very rumpled paper. Filling almost every inch of the picture plane the packages dominate as solid masses, leaving just a thin border of dark brown or black background behind. One of Bravo's most important influences is the still life painting of the Spanish Baroque, specifically the work of Juan Sánchez Cotán, Juan van der Hamen y Léon and Francisco de Zurbarán, in which the specificity of the individual objects was paramount. In the package paintings by Bravo, all else but the specific object – the wrapped package – is removed. The wrapped package becomes the entire painting and all atmosphere, support and environment are displaced.

What remains in these exquisite canvases? The viewer is enticed to explore the intricate and minutely detailed wrinkles, the elegant folds and crumpled edges of the papers as they are wrapped forever around the unknown objects inside. The strings also remain, sometimes frayed or plucked, daring to be touched, with their shadows finely painted on the paper beneath. As equally important to these works are the colours that Bravo chose: creamy whites, celestial blues, blacks reminiscent of Velázquez and scintillating reds that exhilarate the eye. Each canvas becomes a very modern exploration of pure colour, as one is almost overwhelmed by the intensity of the visual experience. But the true subject, the object that is wrapped inside the package, will never be discovered. In this sense, the paintings may be viewed as expressions of the Great Unknown and of the vast time and space that precedes a human's life on this earth and continues after his death, for each person a unique mystery that in his lifetime remains unsolved.

Bravo, committed to painting in a realistic manner, found in the packages a subject suited to an exploration of colour field abstraction, but on his own terms. Likewise, the focus of artists in the Arte Povera movement perhaps rekindled in Bravo the desire to paint humble objects, to make beauty from those simple materials that would normally be discarded, such as paper and string. Extremely conscious of currents in contemporary art, Bravo has throughout his career maintained a rigorous approach to his own work, while keeping an eye fixed on themes and movements in the wider artistic sphere.

Luminous, balanced, essential: these words describe the extraordinary finesse with which Bravo paints each work, be it an epic triptych, a discreet still life or a detailed depiction of crumpled paper. Bravo has said that art is made to communicate with other people. It is through the ineffable qualities of a masterly painted work of art that he chooses to speak.

—Janis Gardner Cecil

Organisation
Consejo de la Cultura y las Artes de Chile
Dirección de Asuntos Culturales del Ministerio Relaciones Exteriores de Chile
Ambasciata del Cile in Italia

Curator
Eva Menzio

General coordination
Claudia Barattini

Organising coordination and sponsor
Marlborough Gallery, Inc

Web Site
www.chileit.it

Artist
Claudio Bravo

1 Claudio Bravo, *White Package Triptych*, 2004. Oil on canvas, right and left panels 200 x 75 cm each, center panel 200 x 150 cm, overall 200 x 300 cm. Courtesy Marlborough Gallery, New York. © Claudio Bravo
PHOTO ADAM REICH

2 Claudio Bravo, *Eternum*, 2005. Oil on canvas, left and right panels 200 x 75 cm each, center 200 x 150 cm, overall 200 x 300 cm. Courtesy Marlborough Gallery, New York. © Claudio Bravo
PHOTO ADAM REICH

3

4

5

3 **Claudio Bravo**, *Purple and Grey-Blue Package*, 2005. Oil on canvas, 130 x 98 cm. Courtesy Marlborough Gallery, New York. © Claudio Bravo

4 **Claudio Bravo**, *Blue Triptych*, 2006. Oil on canvas, right and left panels 200 x 75 cm each, center panel 200 x 150 cm, overall 200 x 300 cm. Courtesy Marlborough Gallery, New York. © Claudio Bravo
PHOTO JEAN VONG

5 **Claudio Bravo**, *Triptych (Red)*, 2006. Oil on canvas, right and left panels 200 x 75 cm each, center panel 200 x 150 cm, overall 200 x 300 cm. Courtesy Marlborough Gallery, New York. © Claudio Bravo
PHOTO JEAN VONG

Emilio Vedova

Finally, Vedova's 'Carnivals'

I remember their discovery, along with Luigi Nono. Unexpected, secret encounters. Unforeseen obstacles for our research. Authentic 'scandals'.

It was the period when Luigi Nono was working on *Guai ai gelidi mostri*. The work was first performed in Cologne, in October 1983. In the programme notes my essays were accompanied by reproductions of four works from the 'Carnivals' cycle, which bore the same titles as the four parts of Nono's opera: *In Tyrannos*; *Lemuria*; *Das grosse Nichts der Tiere*; *Entwicklungsfremdheit*. These are the four dimensions through which Vedova's painting cycle is developed, or rather the four dimensions that each individual moment of the cycle assumes in itself, and interrogates and transforms according to its particular aspect.

In Tyrannos: the cry that would free itself from the idol of the 'past-state', from the glance turned toward the *paupertas horrida* of the past-state's 'power', which corrupts everything, which preaches death, which turns every light into a desert. The past-state 'buries' man's destiny. [...]

Lemuria: figures emerge from this night, ungrateful and spectral guests. When darkness can exist no longer, the lemurs threaten from the forests of shadow. They are the guardians of the past-state, with bodies of words, wreckages of discourse, the dead that kill the living, corruption and stench, without any refuge of peace. The cry *in tyrannos* still resounds, but its echo seems shattered, its hope becoming ever more desperate. The cry resounds again, but will it be able to transform itself into a figure, will it be able to become form? [...]

Das grosse Nichts der Tiere: perhaps the animals know or predict it. Perhaps openness, which the word 'buried' cannot express, is guarded in the eyes of the animal. [...] And then the sign, the tone, the color must practically bow down at the fount of the animal, at the mirror of its glance – they must obey its silence. [...]

Entwicklungsfremdheit: is this the new word? That everything that exists is not born to die? That everything that tends toward form is not superfluous vanity? That a truly 'convinced', measured, shaped song, beaten on the anvil, fibre upon fibre, is not the prey of Chronos, and nothing more? 'The force of the Earth, of the body, fades away,' everything, from nothing, returns to nothing. [...]

Like a sphinx, Vedova's *Narcissus* expresses the enigma. It is the 'instant' in which Narcissus sees his own shadow, his own reflection, and wants to bring them out. Narcissus's 'obsession' is the same as that of the work: to recall the image into itself, to draw it into itself, 'to safety', to remove it from the flow that condemns everything to the past-state. [...]

Vedova's *Carnival* has the following itinerary: to follow, try, probe, with the hands and with all the nerves, one might say, every trace, every flash, every stammering of words in this 'state of misery'. To be alert, listening. When will night come to an end? Here, a mask seems to open up to one possible answer – or to invite one not to tire of questioning. What is Carnival, if not the repetition of the invitation to 'know oneself', in the mask and beyond every mask? To put on the mask that always terrifies anew, and to put it down again? [...]

[...] And yet Vedova's 'Carnivals' always safeguard within themselves the idea of an instant strong enough to shatter the 'cycle', to escape the vice-like grip of the already-said. While *respectans funera*, Vedova's Mask is also always a nostalgia for going, waiting, listening. No 'icy monster' can consume the 'Adveniens' that might be – and the work is none other than the place of this invisible, the abode of this ever-future.

—Massimo Cacciari

Organisation
Istituzione 'Parco della Laguna'
- Comune di Venezia

Curator
Fondazione Emilio
e Annabianca Vedova

Sponsors
Stefanel SpA
Veneto Banca

Web Site
www.parcolagunavenezia.it

Artist
Emilio Vedova

1 Emilio Vedova, *Arbitrio (7/22)-12*, 1977. Mixed media on paper, 70 x 50 cm. Courtesy Fondazione Emilio e Annabianca Vedova

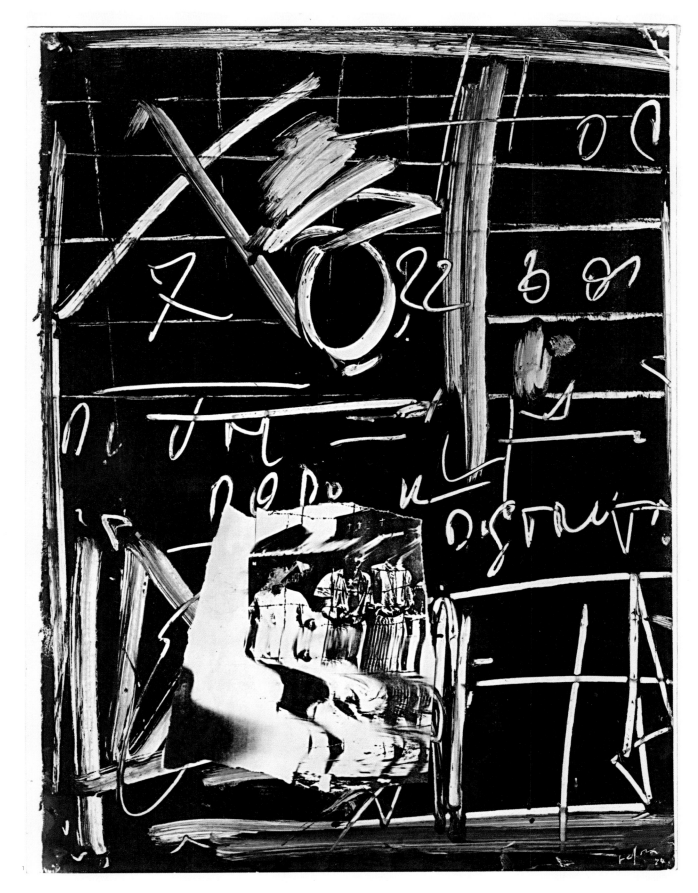

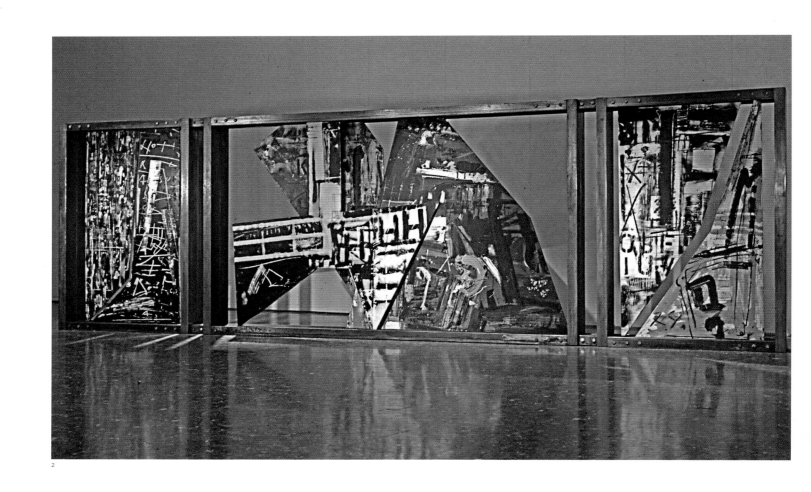

2

2 Emilio Vedova, *Ciclo Lacerazione '77-'78 - II - Plurimi-Binari 1.2.3*, 1977-1978. Mixed media on two-faced wood, iron structure and steel slides, 203 x 650 x 35 cm. Courtesy Fondazione Emilio e Annabianca Vedova

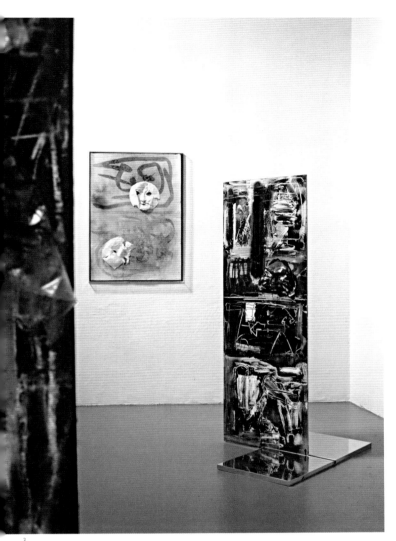

3

4

3-4 Emilio Vedova, *Dal ciclo dei...
cosiddetti carnevali '77/'83*, 1977-1983.
Installation. Courtesy Fondazione Emilio
e Annabianca Vedova

Energy of Emptiness

The communication and interaction between multiple human civilisations is accelerated under globalisation. However, the dissemination of strong cultures currently makes the existence and borders of different cultures rapidly disappear. Globalisation is a symbiosis concept, which facilitates life, but it is different from the unification of cultures. Hence, nowadays the free spirit of individual cultures is more important and precious than before.

Li Chen was born in central Taiwan. He is a very talented artist, who widely studies a variety of Buddhist and Taoist scriptures and seeks truth beyond the material world. In his artistic work he uses sculptures to convey the spirit and connotation of oriental culture. Li Chen takes 'Emptiness' as the important concept in his creative aesthetics. 'Emptiness' is an important ideology of Buddhism and Taoism in Chinese culture. 'Emptiness' does not mean 'nothing', but a huge, quiet wise state of birth and death. Li Chen's sculptures investigate the energy of emptiness, but the sculpture substances he manifests are full of vital energy, which is not empty at all. This is because Li Chen uses a spiritual style to reproduce energy and uses exaggerated and complete pitch-black substances to manifest the material spirit that attracts people, but the sculptures convey sweet, romantic, happy and satisfied spiritual concepts. Just because of this, even though some of his works are very big, they don't appear oppressive and heavy, but seem to be floating in the air. The entire work has an allure of ambiguity between lightness and heaviness, which is due to the perfect combination of spiritual and material energy. Furthermore, Li Chen even makes a breakthrough from the existing style of Buddhist sculptures over thousands of years. He changes the thick and full sculptures in Buddhist, Tang Dynasty (AD 618-907) style and the pretty and elegant spiritual and image characteristics of the Song Dynasty (AD 960-1279), making the faces and lines of his sculptures extremely simple.

He extracts the elements of China's five thousand years of history and culture, such as the Chinese celestial being, the Buddha, the dragon, fairy tales, folk tales, etc. to then pour contemporary artistic elements into his works. He successfully combines classical and contemporary perspectives, giving his works unprecedented models and shapes and endowing the oriental sculptures with new life.

The exhibition named *Energy of Emptiness* will exhibit a number of Li Chen's large outdoor sculptures.

For example, *All in One* is one of the representative early works by Li Chen of 1998. *All in One* is the action of putting the palms together, which is a common Buddhist ceremonial act. It can not only make people concentrate their minds, but also can give others a sincere and modest impression. Putting the palms together has the implication of strengthening the reciting ability to make people concentrate their minds to attain a free and tranquil state. The traditional expression and posture of slightly bowed head, closed palms, and solemn appearance are still presented, yet the complicated pleats of clothes and physique are simplified into a concise yet natural and powerful image. The true spirit of the 'union and perfection' is realised in this piece. Li Chen's artwork is not only a simple motion, but also the supreme state of devoutness, purity and union of body and mind.

Li Chen uses round and soft line and clear contemporary method to convey profound classical Chinese spirit in his artistic pursuit. He looks inward to the oriental realm of thought and empathizes and liberates himself through his works, which is very precious in today's busy society. It is also the projection of Li Chen's self-pursuit of inner harmony. This kind of primitive and innocent beauty is Li Chen's style.

—Jiunshyan Lee

Organisation
Kaohsiung Museum of Fine Arts

Commisioner
Jiunshyan Lee

Deputy commissioners
I-Hsun Steven Lee
Yi-Lin Alan Lee
Carlotta Scarpa
Paivi Tirkkonen

Curator
Paolo De Grandis

Coordination in Venice
Arte Communications

With the contribution of
Bank SinoPac
Council for Cultural Affairs, Taiwan
Asia Art Center Co., Ltd

With the patronage of
Regione Veneto
Provincia di Venezia
Comune di Venezia

Web Site
www.kmfa.gov.tw

Artist
Li Chen

1 Li Chen, *Dragon-Riding Buddha*, 2001. Bronze, 472 x 376 x 306 cm. Courtesy the Artist

2

3

4

5

6

2　Li Chen, *Landscape in Heaven*, 1998.
Bronze, gold, silver, 244 x 165 x 130 cm.
Courtesy the Artist

3　Li Chen, *Pure Land*, 1998. Bronze,
466 x 243 x 133 cm. Courtesy the Artist

4　Li Chen, *Clear Soul*, 2002. Bronze,
229 x 180 x 110 cm. Courtesy the Artist

5　Li Chen, *All In One*, 1998. Bronze,
338 x 148 x 134 cm. Courtesy the Artist

6　Li Chen, *Avalokitesvara*, 1999. Bronze,
250 x 207 x 110 cm. Courtesy the Artist

Floating Territories - A 'transbiennial project'

A Passenger

Mr. Vidokle will spend his time at sea re-reading *Forthcoming* (2000) and *Over-Sensitivity* (1996), by Jalal Toufic.
—Anton Vidokle

On the Boat - a boat movie project

On the Boat will be a movie made during the journey and conceived from a fictional catastrophic scenario of a drifting world.

It will gather a collection of interventions made in front of a video camera (placed in a isolated cabin) or sent by mobile phone, sms and email.

People involved in the biennials (artists, curators, collectors, gallery owners, intellectuals, local public etc.), as well as people who cannot attend these events for different reasons, will be asked to answer or comment on one of the questions proposed for this fictional catastrophic scenario of the world; a world in which the dominant system would generate only hate, violence and inequality between human beings; a world in which the values of this dominant system would be uniquely based on the pursuit of economic and financial interests; a world in which even the engagement of art would become completely constrained by these conditions...

The goal and essential challenge of this ironic and ludic exercise is to point out the limits of actions to achieve conceptual/ discourse plans in the real world; the inefficiency of art's political commitment today. It's a kind of resignation, but also a way of playing the big game of fake responsibility that we all play, while rejecting it.

The title *On the Boat* refers to Kerouac's *On the Road*, published 50 years ago, and his journey to encounter people, things, social facts and realities that were easily forgotten or ignored. *On the Road* has become a catalyst for the 1960's counterculture movement. Developed along the trajectory of the *Floating Territories*, *On the Boat* aims to reveal the hidden but powerful voices of those who claim a new world in our epoch; a sort of bottle thrown beyond the seas.
—Evelyne Jouanno

'Swimming is saving'

Three artists, as the rescue team, make a 'saving action' (boat, crew, environment, art).

A rescue operation as an existential action in a u-topic place.

Floating territory of resistance, invites these artists to send a strong signal to the biennials (Istanbul/Athens/Venice). The power of this sign will reveal itself when the boat docks in the harbours.

The journey's logbook will be held by the '3+1st' artist and become the testimony of these existential actions.
—Chiara Parisi

A 'transbiennial project'
Istanbul/Athens/Venice
6-16/9/2007

Floating Territories is a journey
Floating Territories is a laboratory
Floating Territories is a programme.

How to articulate determination and openness in the context of contemporary 'Modernities' – between freedom of movement and fear of insecurity.

The Evens Foundation, in its search for new issues connecting art, culture and the world, is interested in creating a dynamic perspective between the major art events of Summer 2007: the established International Art Exhibition of the Venice Biennale, the International Biennial of Istanbul, Documenta in Kassel and the

Organisation
Evens Foundation

Project director
Germana Innerhofer-Jaulin

Curators
Bart De Baere
Anselm Franke
Evelyne Jouanno
Chiara Parisi
Anton Vidokle

In collaboration with
unitednationsplaza
Centre international d'art et du paysage,
Ile de Vassivière
Extra City
MuHKA

Web Sites
www.evensfoundation.be
www.floatingterritories.org

Istanbul - Athens - Venice - A WEATHER-PROJECT

We will use a boat as a platform to discuss a set of questions which for us, working in institutions, are urgent and yet need be discussed at a distance from the institutions we come from - a distance like the one on the boat (even if only allegorically). This should allow us to look at institutions in an open way. On the shore we will stage three themes in the three cities we pass; each of which goes beyond the mere theoretical and asks for practical engagement. In Istanbul, we suggest a moment of considering the notion of lucidity as a configuration of the Enlightenment; in Athens the concept of negativity, and in Venice the idea of atmospheric politics.

A necessary resurgence of the heritage of the Enlightenment and its rationality has been gaining momentum; primarily by exploring the hidden, naturalised power relations it releases, in asking: Who is it that sheds the light?

We identify with the need for continued engagement with the emancipatory tradition of the Enlightenment – in its ability to speak to its shadows, to insist that all changes and transformations occur in the shadows, in the epistemic darkness of the night. In this way we may discuss the possibilities of a reconstructive practice, a practice that is informed by deconstruction but also by its object, that wants to rejoin its initial journey.

– In Istanbul, we ask about the relation between 'understanding' and 'change'. Isn't the causal relation between the two the magic at the heart of enlightenment? Rather then just calling for change, we ask what kind of understanding may be needed to necessitate change. What kind of involvement may such understanding produce and in which setting does it come about?

– In Athens, we speak about shadows and negativity, about that realm of change, transformation and dissociation occurring outside the light.

– In Venice, finally, we will speak about what should have been discussed before the voyage even started: the weather. What is up in the sky has long been understood as a model or mirror of the human soul. Only recently has the way we speak about the sky and the stars changed; even dreaming like children about populating the moon and suddenly fearing our urban body to be abandonable as feverish.

But we never stopped speaking about the immediate horizon, the weather, the atmosphere.

In taking the poetics of the weather as literate metaphors, what is at stake now is no longer the engineering of the depths of the soul, as in the age of metaphysics, but the social atmospheres, which, as we know, determine not what can be said, but the effects it can have.

'Not only territories, but the imagination', says Godard, 'is occupied land'. For the culture industry, places and trade routes serve as the favourite relational metaphors. Political geography, understood in the widest sense, seems to have become a bastion of critique, and, to a certain degree, has replaced critiques of state and ideology as the 'really-real', providing rare evidence of increasingly elusive and unnameable forces.

But what will follow after discovery (the ability to locate and give things a name)? Say the Mediterranean as a political archipelago, or documents that prove who can and who cannot go somewhere?

Can they give an adequate account of the silent violence of these mechanisms, of their unspeakability? Or can the language of events and locations be translated into the language of speaking-positions, and even further, into empathy-positions, so that we can see the conditions under which we can actually share?

—Bart De Baere, Anselm Franke

'younger' biennials in Lyon, Brussels, Athens and Thessalonica.

The Mediterranean trajectory along the Istanbul-Athens-Venice axis will enable an exploration of the relation between all these events, raising the question of a *mare nostrum* and its contemporary resurfacing as a frontier under negotiation.

The Evens Foundation invites as crew on board Bart De Baere / Anselm Franke / Evelyne Jouanno / Chiara Parisi / Anton Vidokle to share these concrete and imaginary territories:
_Concretely a boat
_Imaginarily a 'heterotopia'
_A journey as 'work show', an experience of its constitution and emerging form to be revealed as it enters each harbour.
—Germana Innerhofer-Jaulin

The Language of Equilibrium

Joseph Kosuth at San Lazzaro Island, Venice

The influence of the work of Joseph Kosuth can be seen at this 52nd International Art Exhibition and the current Documenta, as a result of what his work has initiated. He is a major figure in the redefining of the art object that took place during the 1960s and '70s. Conceptual Art, a movement closely associated with him, questions art's traditional practice, forms and assumptions. To do this, Kosuth was among the first to initiate installation work, to employ appropriation strategies, texts, photography and the use of public media. The approach now known as 'institutional critique' began with his work. With Kosuth, art itself is essentially a questioning process, with all aspects of the activity of art being reconsidered, from the signifying role of objects put in the context of art to the kinds of meanings generated by the exhibition itself. Indeed, the total context of art – how it both produces meaning and is itself affected by the world – comes into play in *The Language of Equilibrium*, his extensive installation on the Isola San Lazzaro. For Joseph Kosuth, the 'visual' is but one part of a complex structure that produces meaning within art, but not its basis.

Installation work has been a central part of Joseph Kosuth's practice since the 1960s, beginning with his series of smaller installation works in 1965, such as *One and Three Chairs* as seen in The Museum of Modern Art's Information exhibition in 1970 or *The Information Room* exhibited in The New York Cultural Center's *Conceptual Art and Conceptual Aspects* exhibition, also in 1970. Since then Kosuth's installation work has used both architectural interiors and exteriors, and has also been, permanent and temporary. Locations of installation works in museums around the world include the Museo di Capodimonte in Naples, the Sigmund Freud Museum in Vienna, the Wiener Sezession, the Brooklyn Museum, the Van Abbemuseum, the Villa Medici in Rome, the Irish Museum of Modern Art in Dublin, the Schirn Kunsthalle in Frankfurt, and the Chiba Museum in Japan. His permanent outside installations include works in cities such as Frankfurt, Lyon, Yokohama, Amsterdam, Leipzig, Brussels, Berlin, Turin, Sapporo, Denver, London, Hanover, Tokyo and Venice.

Joseph Kosuth has described his work for the Armenian Mekhitarian Monastery of San Lazzaro in Venice, *The Language of Equilibrium*, as follows: 'This project, in yellow neon, has as its basis language itself. It is a work that is both a reflection on its own construction as well as the history and culture of its location. This work uses words from the Armenian, Italian and English languages. Language here is used as a signifier of the history of the project of the Mekhitarian Order. Yellow neon is chosen for this work because of the symbolic understanding of yellow at the time of the founding of the monastery (Böckler, 1688) as meaning 'virtue, intellect, esteem and majesty'. The two supportive components of the work are comprised of words arrived at through a view of their history and use. One aspect of the installation shows this relationship. The other part reflects the role of these words in the *Haygazian Pararan*, or Armenian Dictionary (1749) written by Abbot Mekhitar, founder of the Order. The structure of the installation has two elements, which are integrated at specific locations on the island. These locations reflect the diversity of the island's architecture while also articulating the history and culture of the island. The work engages the cultural and social history of the evolution of language itself, how the history of a word shows its ties to quite distinct and disconnected cultures and social realities. Here, in this work, language becomes both an allegory and an actual result of all that it would want to speak of.'

—**Adelina von Fürstenberg**

Organisation
ART *for The* World

In collaboration with
Hangar Bicocca

Curator
Adelina von Fürstenberg

Joseph Kosuth Studio collaborators
Liz Dalton
Seamus Farrell
Sanna Marander

Filippo Armellin
Fiona Biggiero
Benedetta Bovoli
Romana Fiechtner
Cindy Smith

ART *for The* World collaborators
Chiarastella Cattana
Marie Claude Esnault
Laura Frencia
Michela Negrini
Massimo Ongaro

Hangar Bicocca collaborators
Lucia Crespi
Olimpia Piccolomini
Federica Schiavo

Thanks to
Congregazione Mekhitarista
di San Lazzaro

Martin Angioni
Peter Cowe
Alessandro Guglielmi

Paola Manfrin
Sonya Orfalian
Don Ringe

Fundación Almine y Bernard Ruiz-Picasso para el Arte
Galerie Almine Rech
Galerie Gmurzynska
Galleria Lia Rumma
Galerie Sprueth Magers
Sean Kelly Gallery
NABA, Nuova Accademia di Belle Arti

Web Site
www.artfortheworld.net

Artist
Joseph Kosuth

1 Joseph Kosuth, *Was war also das Leben? (Berlin, T.M. und R.H.)*, 1998-2001. Installation at Paul-Loebe-Haus (German Parliament), Berlin. Steel text in floor, 240 x 10,220 cm. © Joseph Kosuth
PHOTO STEPHAN ERFURT

▲ 2 ▼ 4

2 Joseph Kosuth, *Ripensare il Vero (B.C.)*, 2001. Installation at Piazza del Plebiscito, Naples. Neon mounted directly to the wall, 78 x 14,700 cm. © Joseph Kosuth

3 Joseph Kosuth, *À Propos (Réflecteur de Réflecteur)*, 2004. Installation at Sean Kelly Gallery, New York. Text applied to glass, warm white neon behind, mounted directly to the wall, 390 x 4,400 cm. © Joseph Kosuth

4 Joseph Kosuth, *The Language of Equilibrium*, 2007. Neon mounted directly to the wall, dimensions variable. © Joseph Kosuth

3

Jan Fabre

The sense of Form in every sense

Art is made up of forms, but not only *beautiful forms*, because it remains art provided that its *beautiful ugly forms* represent life. The *beautiful dense forms* of Jan Fabre interpret metamorphosis. *Beautiful strong forms* in an era that has made mobility and the complexity of knowing the new being-non-being of existence. In this Young and Magnificent world in which 'of tomorrow there is no certainty', the *beautiful new forms* of Fabre are crucial. He is an artist who has made the metamorphosis of *beautiful visionary forms* – of life that dies and is reborn – the meaning of his art and life. A visual and theatrical artist who also writes, Fabre draws, paints, photographs, films, installs, sculpts, casts, acts, writes, directs, dramatises and performs... *beautiful unconventional forms. Beautiful energy-filled forms* expressed by 'techniques-disciplines' that contain the specificity and complexity of all the others. The complexity of these *beautiful true forms* is the state of grace of Fabre's art, an art that blends tradition and innovation, past and future in the interdisciplinary complexity of the Renaissance, but which has its roots even further back in time – the Middle Ages – in the company of the 'founding fathers', the early Flemish artists. It was they who began the emancipation from classical beauty, and founded the pre-Romantic idea of wild beauty so dear to Fabre's *beautiful metamorphic forms.* Here the past does not exist only in memory, it is a time in which experience affects history and life with its *beautiful spiritual forms.* It was the rebirth of the beauty of ugliness that provided the stimulus in the late nineteenth and early twentieth centuries for the modern art of *beautiful rational-irrational forms.* In holding together the life and death of *beautiful cosmic forms*, he is an artist of different techniques and disciplines, of materials more natural than artificial, in a continuous body art of tears, blood, sweat... These liquids renew the secrets of the experimentation made by the artists of the past, and become symbolic images of that which always takes the place of something else, like life takes the place of death, something with *beautiful resistant forms.* Living art always contains the elaboration of the image of death as the central dimension of humanity, the dimension with which artists dialogue, creating *beautiful poetic forms.* It is a continuous metamorphosis, a mythical search for the origin, that places Fabre's work in the cosmic framework of the sense of the existence of *beautiful radical forms.* It is a cosmic work, in which cosmology and cosmogony are the overturning of the sky on earth and the earth on the sky, a vice versa that humanises and/or animalises both with its *beautiful symbolic forms*, to the extent that we have created the constellations – the destiny of our life – in the form of animals: Aquarius-Pisces-Aries-Taurus-Gemini-Cancer-Leo-Virgo-Libra-Scorpio-Sagittarius-Capricorn. And thus Fabre's work, with its *beautiful enquiring forms*, where being-not-being is stripped of the mystery of identity, a self-portrait-portrait that is executed beneath our very eyes in the Enlightenment domain of the being of seeing, but illuminated by the romantic totality of the senses, continues to ask us:
'Who are we?'
'Where have we come from?'
'Where are we going?'
Thus, if the ancient philosophers said that philosophy was the consequence of the wonder of the world, we should not be surprised if Jan Fabre says to us that 'today animals make the best doctors and the best philosophers', alluding to the origin with *beautiful thoughtful forms.* This creative historical-anthropological dynamism is aimed at creating a moving relationship between the finite and infinite, aided and abetted by an all-round mind and body, a circular being, a full existence in the true sense of the word, by a man-artist-world-cosmos that with its *beautiful ugly dense strong new visionary unconventional energy-filled metamorphic spiritual rational-irrational cosmic poetic radical symbolic enquiring thoughtful living forms* generates the birth and rebirth of life and art, in that the body of life could not exist without the corporality of art, or perhaps the corporality of art could not exist without the body of life.
—Giacinto Di Pietrantonio
Fiore del Bene Fiore del Male, Fiore del MenoMale

Organisation
GAMeC - Galleria d'Arte Moderna
e Contemporanea di Bergamo

Curator
Giacinto Di Pietrantonio

Collaboration
Angelos BVBA

Coordination in Venice
Živa Kraus

Production
Guy Pieters

Web Site
www.gamec.it

Artist
Jan Fabre

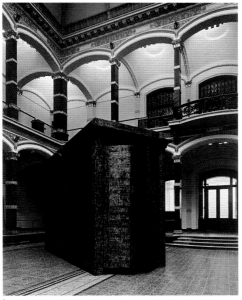

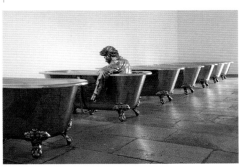

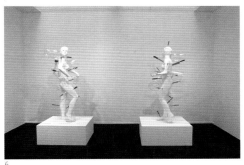

1 Jan Fabre, *Heaven of Delight*, 2002. Shields of the jewelbeetle on ceiling, installation. Hall of Mirrors, Royal Palace, Brussels. Collection of the Belgian Royal Family
PHOTO DIRK PAUWELS

2 Jan Fabre, *Sanguis Sum*, 2002. Bronze, 24Car gold, wood, messing, glass and grinded humain bone, 235 x 185 x 95 cm each. French private collection
PHOTO STUDIO GHEZZI

3 Jan Fabre, *Knipschaarhuisje II*, 1991. Bic ink on wood, 450 x 250 x 300 cm. Metropolis, Martin-Gropius-Bau, Berlin. Collection of the artist
PHOTO WERNER ZELLIEN

4 Jan Fabre, *The Man Writing on Water*, 2006. Siliconed bronze and water, 195 x 90 x 60 cm each. Private collection.

5 Jan Fabre, *The Brains of my Mother and my Father*, 2006. Silicone, pigment, 23 x 15 x 21 cm, base 110 x 110 x 50 cm. Italian private collection. © Angelos

6 Jan Fabre, *Tearsculptures*, 2006. Plaster, wood, glass, 200 x 100 x 100 cm each. Collection of the artist.
© Angelos

7 Jan Fabre, *Carnaval van de dode straathonden (Dead Stray Dogs Carnival)*, 2006. Stuffed dogs, party goods (confetti, garlands, festoons, paper hats), wooden table, butter, dimensions variable. Mamco, Geneva.
© Angelos

8 Jan Fabre, *Searching for Utopia*, 2003. Siliconed bronze, 300 x 500 x 700 cm. Beaufort, Nieuwpoort. © Angelos
PHOTO ERIC DE MILDT

Joseph Beuys, 'Difesa della Natura - The Living Sculpture. Kassel 1977 Venezia 2007'. Omaggio a Harald Szeemann

Presenting the F.I.U. (Free International University) at *Documenta* 6 in Kassel in 1977 for 100 days, Joseph Beuys, one of the most emblematic and significant people in the postwar history of world art, analysed the cultural, environmental, social, economic, humanitarian and political questions concerning the existence of all the people on planet Earth at that historic moment. Hundreds of people from all social and humanitarian categories took part in the open discussions. Beuys' active and concrete philosophy is based on *protection of the environment and man who lives in the environment*, on *communication, cooperation and the free and creative energy* that all people in the world possess. A *social plastic*. The famous *Living Sculpture* by the German master Joseph Beuys is the biggest humanitarian artistic masterpiece of the twentieth century and concerns the united, free cooperation of people of different races, origins, religions and social, economic, political and cultural strata.

Now, 30 years later in the Thetis space, Lucrezia De Domizio Durini, who worked continuously with Joseph Beuys in the last 15 years of the master's life on the famous *Difesa della Natura* (*Defence of Nature*) operation, is re-presenting the famous *Living Sculpture* in compared analysis; the *post Beuys*: 100 days of *permanent conference* in which full expression is given to the artist's thinking, still topical and relevant to all people on Earth and all social situations.

—**Lucrezia De Domizio Durini**

Organisation
Il Luogo della Natura - Servizi
e Magazzini della Piantagione Paradise
- Associazione Culturale Onlus
'Il Clavicembalo'

Conceiver and curator
Lucrezia De Domizio Durini

Cultural direction
Antonio d'Avossa

Scientific committee
Felix Baumann
Gérard George Lemaire
Italo Lupi
Antonio Paruzzolo
Arturo Schwarz

Collaborators
Massimo Donà
Vitantonio Russo
Pierparide Tedeschi

Coordination
Antonietta Grandesso

Web Site
www.enel.it/dharmaofenel

Artist
Joseph Beuys

1 Joseph Beuys, *Difesa della Natura - Bolognano*, 1984
PHOTO BUBY DURINI. COURTESY ARCHIVIO STORICO
DE DOMIZIO DURINI

2

2 Exterior Documenta 6, Kassel, 1977
PHOTO BUBY DURINI. COURTESY ARCHIVIO STORICO
DE DOMIZIO DURINI

3 Interior Documenta 6, Kassel, 1977
PHOTO BUBY DURINI. COURTESY ARCHIVIO STORICO
DE DOMIZIO DURINI

Loredana Raciti
The Artist's Room

Loredana Raciti presents a project that develops and extends her working horizon in the light of her conception of artistic multimedia and multiplicity. For her, a work of art is a complex of elements talking to each other, connected not only by a joint theme but also by a coherent situation in which it will be possible to detect the single factors through a series of passages, each one containing all the assumptions making the whole.

Therefore, the idea is to create a Room, which on one hand is the artist's Studio and the workshop where the work of art is conceived, elaborated and created, and on the other the work of art itself, in the exact moment when it is presented and explained in its perfection.

However, in Loredana Raciti's vision, *The Artist's Room* is the realisation of an emotional state, not of an organic tale, which remains closed in certain unexpressed and inexpressible limits, but of the artistic inspiration itself, which, after all, is the essential content of the Room. In other words, the Room is art itself, appearing as a kind of inner epiphany. After all, the Room is also a real room, whose six fundamental elements are concrete and symbolic at the same time. Therefore, there is the bright Door, the Floor Lamp suggesting Aladdin's Lamp, the Wooden Table, symbol of nature itself and, on a wall, one of Loredana Raciti's former experiences, one of her *P/Art* cycle videos. This is a series of four very short DVDs, each based on a colour and expressing the four fundamental moments of the aesthetic experience, a sort of painting in motion. Here, the *Yellow Tale* symbolises freedom from mystery to attain greater generosity. There is then the Bed, hard and rough, and, next to the Bed, the riding Boots, extreme allegory of the wait for inspiration.

Seen together, the Room seems to carry the idea, expressed many times in twentieth-century poetics, of a journey across the mental evocations clearly-defined by specific objects connected to the different stages of life and scattered according to relationships arbitrarily pre-established by the artist, through a sort of ancestral and oniric dimension. It is a metaphysical and surrealist poetics. However, Loredana Raciti, who is certainly aware of such assumptions, transforms that kind of experience into an overall image. More precisely, the totally 'sentimental' Room is not intended to create a contemplation space or rest for the imagination, but to arouse 'active' speech, enclosing concrete expectations. Through it, we will be able to recreate that astonishment to which the creative process is implicitly connected, but with the prospect of happiness and real emotional involvement.

—Claudio Strinati

Organisation
Soprintendenza Speciale al Polo
Museale Romano - Museo Nazionale
di Castel Sant'Angelo

Curators
Claudio Strinati
Valerio Dehò
Fabrizia Buzio Negri

Collaborators
Anna De Santis
Matilde Amadi Calini
Ricorda Montanari
Valentina Zolla

With the contribution of
Fondazione 3M
Politecnico di Milano
INA Assitalia Ag. P/4
Ditta Masserdotti
Ditta Montenovi
Euromed srl
Leonardo Arte
Progress fine art
Yuasa Italy
Strategie di immagine
SDI International

Web Site
www.castelsantangelo.com

Artist
Loredana Raciti

1 Loredana Raciti, *The Artist's Room*, 2007. Image elaboration Eliostile

2 Loredana Raciti, *The Artist's Room*, 2007. Installation, detail of artist's bed
PHOTO GIORGIO COMO

3 Loredana Raciti, *The Artist's Room*, 2007. Installation, detail of floor
PHOTO GIORGIO COMO

4 Loredana Raciti, *The Artist's Room*, 2007. Installation, detail of flying boots
PHOTO GIORGIO COMO

5 Loredana Raciti, *The Artist's Room*,
2007. Installation, detail of luminous
door (front)
PHOTO GIORGIO COMO

6 Loredana Raciti, *The Artist's Room*,
2007. Installation, detail of luminous
door (back)
PHOTO GIORGIO COMO

7 Loredana Raciti, *The Artist's Room*,
2007. Installation, detail of Alladin lamp
PHOTO GIORGIO COMO

Lech Majewski Blood of a Poet

Blood of a Poet – a unique cycle of interrelated video art features – opened last year's retrospective of Lech Majewski films and videos at the Museum of Modern Art in New York. Rejecting dialogue and chronology it marks an innovatory approach to traditional film narration. A simultaneous flow of images, events and visual associations creates a cross-section of a human mind.

The elaborate project, which originally began as a single film cycle that would incorporate seven short films, grew consistently during its making. In the end *Blood of a Poet* consists of 33 short-films and a series of photographs, which are themselves original and autonomous works.

Lech Majewski's newest work tells the story of a young poet at odds with himself and with the world. The struggling young mind is part of a motif that resurfaces from earlier Majewski works, such as *Basquiat* (he wrote the original story) and *Wojaczek*, and that visually represents and questions the existence of creative consciousness and the psychological role-playing that occurs between 'childhood' and 'adulthood'.

After the death of his mother – although the possibility of 'after' is always, in *Blood of a Poet*, relative – the young poet finds himself shut away in a psychiatric ward. The short films that compose the work show the poet's memories of childhood unfolding before him. From his isolation he sees his mother, his violent father and his father's lovers. Through this process of remembering, the film absolves any traces of formal dialogue and chronological narration. Even the situation of memory within the past is held in contention.

The collected short films themselves over-lap and communicate visually and thematically with one another, and continually ask the viewer to develop a new method of interpretation and to conceive of new narrative intersections.

The viewer can depend on his own creative capacities to find a way through the labyrinthine structure of *Blood of a Poet*.

—**Marek Zieliński**

Organisation
Instytucja Kultury Ars Cameralis Silesiae Superioris

Curator
Marek Zieliński

Web Site
www.cameralis.art.pl

Artist
Lech Majewski

1-3 Lech Majewski, *Blood of a Poet*,
2006

4

7

▲5 ▼6

8

4-13 Lech Majewski, *Blood of a Poet*, 2006

9

▲10 ▼11 ▲12 ▼13

Lee Ufan 'Resonance'

Lee Ufan, Korean artist and founder of the Mono-Ha group, lives in Japan but is a nomad who has managed to combine the language of Western avant-gardes and the culture of Eastern ones. Avoiding the readymade of the Cartesian Duchamp and the cut of the baroque Fontana, Lee Ufan replaces the principle of representation with that of 'presentification' in a course that runs from the sculptures and installations of the 1960s to the *Correspondances* of the 1990s, through to the painting of today. He has set up a time-space intersection without contrasts, replacing the concept of form with that of 'structure', of space with that of 'field', as a system of relations open to developments that tend to merge the solid and the empty. Lee Ufan's entire research disconcerts the 'found object' and its metaphysics: a dead form blocked out in the aesthetic space and delivered from life.

Lee Ufan does not represent, though, he 'presentifies' an idea of active earthliness that sustains the meeting of the artist with the world and that of the work with the observer. Now a *tache* shines on the active surface of a painting that develops the epiphany of a meeting with the public. Now he creates painting in which he is entirely the artifice of everything. The signs orchestrated on the canvas have a tension, a direction and a spatial duration played out in a sign of a size standardised to the hand. It is a size memorised by a gesture that has not forgotten precision and energy, artisan fluidity and geometry of extension. Often in the order of two or three, they organise the spatial field in terms of visual essentialness, tending to emphasise precision and indetermination, constriction and potential modification. The artist seems to want to give the strong sign traced onto the pictorial surface the distinctive volume of the object or material previously used in his installations. The strength of the drawing serves precisely to intensify the moment of meeting between the work and the observer through a weaving of time and space, both dimensions necessary to appreciate the value of art, that of 'presentification'.

Lee Ufan here resolves the problem of the immortality of the work without wanting to lay claim to the future, but rather establishing the persistence of the present. Extending the present becomes for the Eastern artist a way of removing the pathetic system of future forecasts on one hand and rather of laying claim, through a different dimension of space, to a field so vast as to contain time in its constant beat.

—Achille Bonito Oliva

Organisation
Fondazione Mudima

Curator
Achille Bonito Oliva

Commissioners
Gino Di Maggio
Paolo De Grandis

Coordination in Venice
Arte Communications

With the patronage of
Korea Foundation
Japan Foundation

Web Site
www.mudima.net

Artist
Lee Ufan

1 **Lee Ufan**, *Correspondance*, 2000. Oil on canvas, 218 x 291 cm

2 **Lee Ufan**, *Relatum*, 1979-2005. Iron plates, natural stone, 280 x 200 x 150 cm

3 **Lee Ufan**, *Correspondance*, 1995. Oil on canvas, 260 x 786 cm. Courtesy Lisson Gallery

4 **Lee Ufan**, *Relatum*, 2003. Iron plate, natural stone, wood pole

1

2

3

4

6

7

8

5 **Lee Ufan**, *Correspondance*, 2005.
Oil on canvas, 218 x 291 cm. Courtesy
Yokohama Museum of Art

6 **Lee Ufan**, *Correspondance*, 2005.
Wall painting. Courtesy Yokohama
Museum of Art

7 **Lee Ufan**, *Relatum - Discussion*, 2003.
4 iron plates, 4 natural stones. Courtesy
Lisson Gallery

PHOTO DAVE MORGAN

8 **Lee Ufan**, *Relatum - A response*, 2003.
Iron plate, natural stone. Courtesy
Lisson Gallery

PHOTO DAVE MORGAN

▲9 ▼10

9 Lee Ufan, *Correspondance*, 2005.
Oil on canvas, 218 x 291 cm
10 Lee Ufan, *Relatum - Suggestion*,
2005. Iron plate, 250 x 200 x 3 cm;
natural stone, 120 x 120 x 120 cm

The Inner-soul Island: Isolation and foolery

I have always known Vettor Pisani and always appreciated his sensitivity and irony. We also share a common experience: a love of German romantics, especially Böcklin. This is why his references to great European artists like Yves Klein and Joseph Beuys and to that cryptic, esoteric culture that inspires his work are familiar to me.

I am fascinated by his intervention in space and his unique taste for the installation and the performance. His contradictions: on one hand he loves the spotlights; on the other he dreams of returning to his mother's womb.

He took part in the Biennale for the first time in 1976, to then return at least five times, if I remember correctly. I have watched him in his strange wandering in search of stimuli, like one of those moths attracted by the play of light. He takes on new forms every time he comes to a halt. Often risking being burnt, he has never been afraid to dare.

Vettor Pisani excites me. He is an artist of depth, restless and corrosive, but who knows how to laugh at himself.

—Umberto Vattani

The Inner-soul Island: Isolation and foolery

The island is not only a geographic reality, but also a symbolic one. In the collective imagination it sums up themes and myths that art has always represented. Survival, return, departure, shipwreck, nostalgia and landfall are the interior aspects of an island contemplated by art in multiple forms.

The island of San Servolo, after *The art of survival*, continues to be the theatre within whose enclosure, surrounded by the waters of the Venetian lagoon, an artist each year emblematically presents one of the themes. But the island can also cause isolation, it can lead to a state of introspection that borders on madness.

The Inner-soul Island: Isolation and foolery is the theme taken by Vettor Pisani, an artist who has always been ahead of his time, foreshadowing incest, anti-nature, the hostage, plagiarism, the anti-hero, the overwhelming of ideology and art.

Always in balance between art and critical citation, Vettor Pisani's work offers a rich mix of symbologies, alchemies, iconographies and contents in which there is no interruption between past and present. A desecrating artist who is strongly imbued with a sense of history, intended as thought and world view, Vettor Pisani takes Marcel Duchamp and Joseph Beuys as his starting point, considering symbolist, philosophical and psychoanalytical references, with Masonic and Rosicrucian echoes, in which passions and myths are investigated with intelligent, necessary irony using photography, sculpture, installations and performances.

Vettor Pisani's labyrinthine conceptual direction could already be seen in the '70s when he intentionally pushed plagiarism toward the historic avant-gardes and Duchamp through to bordering on Leonardo. One work entitled 'inclination to pain' introduces this possibility of a journey that is not backwardly nostalgic, regressive, but the flexible capacity of the memory to plunge into a distance that only art can reduce and bring to a cultural fragrance of significance to the present.

Vettor Pisani exhibits a series of works in the spaces of the island of San Servolo, which housed a psychiatric hospital for more than two centuries. They include *La Venere di cioccolato* of 1970, the sculpture *Hermes* of 1975 and *L'Addolorata* of 2007, a Madonna placed on an overturned upright piano, centred on themes of mourning and melancholy. The work is the mask, the threshold that the artist cannot cross, because the world recognises it definitively and nothing can take away such recognition: no slipping into silence can reduce it to being a producer of everyday events.

Art is posited as a means of gauging culture and history, capable of condensing themes of eternal appeal linked to the enigmatic emblems of existence into their own forms.

San Servolo once again becomes the interior island that safeguards the treasures of being, of having, of wanting and of knowing.

—Achille Bonito Oliva

Organisation
Venice International University

Curator
Achille Bonito Oliva

Scientific coordination
Martina Cavallarin

Sponsors
Fondazione Morra
Galleria Cardelli & Fontana

Web Site
www.univiu.org

Artist
Vettor Pisani

1 Vettor Pisani, *Napoli Borderline*, 2007. Digital photograph on PVC, 160 x 120 cm. Courtesy the Artist

2 Vettor Pisani, *Museo Criminale Francese (Teoria della Follia)*, 2001. Collage. Courtesy Fondazione Morra

3 Vettor Pisani, *Camera dell'Eroe
(Venere di cioccolato)*, 1970. Mixed
media and chocolate coating. Courtesy
Galleria Cardelli & Fontana
PHOTO MASSIMO BIAVA

4 Vettor Pisani, *Hermes*, 2005.
Installation with piano, sculpture on
golden bronze, sword. Courtesy Galleria
Cardelli & Fontana

Migration Addicts

In the last few years, since Deng Xiaoping's visit to the south of China, Shanghai has been transformed into an experiment of Chinese modernisation. An outstanding site in the Asia Pacific region, the highest attention of foreign curiosity and capital investment have rapidly brought social, material and environmental transformations. Shanghai is now possibly one of the most exciting cities on the planet.

Migration Addicts began as an ongoing project two years ago, investigating how migration determines issues related to human identity, gender and spiritual needs, touching on topics that concern not only Shanghai but many other expanding Asian and Western cities. The structure of the exhibition is based on a series of interventions that will take place in public spaces throughout the city, facilitating a direct relationship with the local social sphere, reflecting on the peculiarity of the territory.

The tension between Western and Chinese traditional values and lifestyles, as well as the late arrival of capitalism and persisting communism, have recently not hindered the Chinese impulse towards assimilating 'international standards', while fostering its own economic development.

The fast expansion of urban spaces, following the model of Shanghai, has led to new social conflicts within the Chinese social structure. The urban environment and consumers' desires pull from the countryside and small towns into the cities. This flow challenges the existing social structure and at the same time brings its own vitality into the life of the city. Migration is a phenomenon all big cities around the world are dealing with. The communities and migrant populations are those that actually participate in the process of reconstructing and transforming the developing urban space.

Migration Addicts investigates questions of temporal and spatial strategies that characterise this situation. On political and aesthetic levels, these projects represent a bridge between art and life, interacting with people from outside artistic circles, expanding the idea of art and its experience to continue an engagement with the public sphere.

Venice is currently undergoing profound changes with respect to the urban landscape, and its own future depends on the new structure it undertakes. More and more Venetians are leaving the lagoon to settle in other towns. In the next 30-40 years, it is certain that Venice's population will certain fall dramatically.

The artists participating in *Migration Addicts* confront the topic of migration in their own culture and artistic practices, articulating new perspectives entrenched directly in the urban environment and methodologically operating in time and space.

—Biljana Ciric, Karin Gavassa

Organisation
ddm warehouse

In collaboration with
Vision

Curators
Biljana Ciric
Karin Gavassa

With the contribution of
ShanghArt Gallery
Creative Capital Foundation
New Margin Ventures

Media partner
DROME magazine

Web Site
www.ddmwarehouse.org

Artists
Hasan Elahi
Htein Lin
Hu Li Ping
Josefina Posch
Jin Shan
Yap Sau Bin
Kui Huang

Rizman Putra
Miljohn Ruperto
Mogas Station (Gulschan Gothel, Cam Hoang Duong, Jun Nguyen Hatsushiba, Sandrine Llouquet, Bertrand Peret, Rich Streitmatter-Tran, Tam Vo Phi, Vu Lien Phuong)
TODO (Alessandro Capozzo, Andrea Clemente, Fabio Cionini, Fabio Franchino, Giorgio Olivero)
Belén Cerezo

1 Josefina Posch, *Posch Iceberg Campo Iceberg, right ahead!*, 2007. Site specific installation, 400 x 800 x 600 cm
PHOTO COURTESY THE ARTIST

2 Miljohn Ruperto, *Acting Exercise: Adrian Leftwich's I Gave the Names?*, 2007. Installation/potential performance two-way mirror, LCD screen, microphone, speakers, stand. Courtesy the Artist
PHOTO ULRIK HELTOFT

3 Mogas Station, *Rokovoko*, 2007. Sketches for video work. Courtesy the Artists

4 TODO, *are You here?*, 2007. Urban mobile game, site specific dimensions. Courtesy the Artists

6

7

8

5 Hasan Elahi, *Tracking Transience: Altitude v3.0*, 2007. Excerpt from a collection of over 450 airline meals eaten between 2002 and 2007, dimensions variable. Image database. Courtesy the Artist

6 Hu Li Ping, *About Light 2006*, 2006. Performance. Courtesy the Artist

7 Rizman Putra, *Love with Evol Kapitan at Armenian Street*, 2004. Performance
PHOTO JULIANA YASIN

8 Jin Shan, *A Cloud on Beirut and Shanghai*, 2006. Art action. Courtesy the Artist

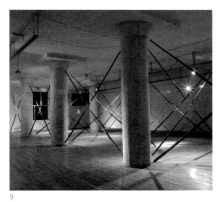

9　　　　　　　　　　　10　　　　　　　　　　　11

12

9　Kui Huang, *Superstructure*, 2005.
Installation. Courtesy the Artist

10　Htein Lin, *Man in the Moon*, 2006.
Solo performance in the cupboard
under the stairs, London, August 2006.
Courtesy the Artist

11　Yap Sau Bin, *ARTraceKL*, 2006.
Postcard for Art tour project. Courtesy
the Artist
PHOTO PATRICIA LEONG

12　Belén Cerezo, *Far and close*, 2007.
Series of photographs in posters
and mms via bluetooth, dimensions
variable. Courtesy the Artist

Mobile Journey

Venice International University looks to contemporary art as an area of experimentation for promoting innovative lines of research. The *Mobile Journey* project is an important stage in this, aimed at creating a still untried dialogue between artistic research, technological innovation and social sciences. The artist has the task of exploring new ways of using the new technology; the electronics engineer that of identifying and developing new possibilities of artistic expression by rethinking some fundamental aspects of the near future; the researcher that of proposing a synthesis of the meeting between the two worlds.

The themes of mobility and sustainable development are a crucial test bench for the social sciences in the next decade. The meeting with artistic experimentation is the starting point for a reconsideration of the results achieved so far using the most consolidated methodologies and for the launch of new lines of original reflection.

—Stefano Micelli

The challenge of contemporary art is to give meaning and content to new technological tools by trying out interactive solutions. This is the aim of *Mobile Journey*, an exhibition that revolves around the concept of mobility, presenting interactive and wireless works conceived by artists and developed in conjunction with electronic engineers.

Silver & Hanne Rivrud's *Visitor* is an interactive work inspired by video games, but which also moves away from them by using a real avatar: a person who moves on the island according to the will of the player. In this way the work is intended to stimulate the responsibility of the player, taking her from the virtual world to the real one. Laura Beloff's installation, created together with Erich Berger and Elina Mitrunen, also creates an interactive dialogue with the public. The work *Heart Donor* has developed a technology that uses a special vest to record the heartbeat of the visitors, who in turn can send the graphic to their friends. The artist has been developing wireless and wearable works for some time now, such as *Boots*, a pair of boots that allow a person in movement to be connected to the web. An imaginary journey is activated by Peter Callesen with his installations floating on the water, in which the artist, as performer, invites spectators to take part in his fairy-tale utopia. The Italian duo Globalgroove is inspired by the movements of the camera in their project entitled *Douze études*. It is a series of short clips that start from and are named after cinema shooting techniques such as sequence, pan etc., that give a video work its abstract-evocative connotations. Crispin Gurholt's 'live performance' draws from the world of cinema the charisma and commitment of professional actors. Some actors remain 'frozen' in their pose for several hours, creating a scene that revolves around the idea of Venice and its social changes. From the Venetian lagoon to the Alps with Kalle Laar's sound installation, which allows the sound of the thawing glaciers to be heard live. The work, made for *Ouvertures*, is intended to sensitise the public to climatic change using a live recording transmitted via mobile phone. The duo Empfangshalle present the video, *As if we were alone*, which ironically and intelligently recounts our habits when using a mobile phone, such as the search for a private and comfortable space. The public is once again the protagonist in the work of Gaston Ramirez Feltrin, focused on the concept of cyber-democracy. The artist invites visitors to make their own videos of the *Mobile Journey* event with mobile phones, which can then be transmitted by streaming and projected onto a screen. In this way a further level of reading the event is created from the point of view of the user.

—Lorella Scacco

Organisation
Venice International University

Curator
Lorella Scacco

Coordination
Lorenzo Cinotti

With the patronage of
The Royal Norwegian Embassy
Embassy of Finland
Embassy of Denmark
Embassy of Germany
Embassy of Mexico

In collaboration with
Vodafone
Danish Arts Council
Artcircolo
Arild Wahlströms Fond
Bryt as. Path-Breaking Investments
Kunsträdet Storebrand
Forum Austriaco di Cultura

Web Site
www.univiu.org

Artists
Laura Beloff & Erich Berger
& Elina Mitrunen
Peter Callesen
Empfangshalle
Globalgroove
Crispin Gurholt
Kalle Laar
Gaston Ramirez Feltrin
Silver & Hanne Rivrud

1 Crispin Gurholt, *1st March*, 2003.
C-print, 121 x 188 cm. Edition of 3.
Courtesy Galleri K, Oslo
2 Gaston Ramirez Feltrin, *urban
(play) traces*, Belgrade 2005. Video
performance. Collection Raffaella and
Stefano Sciarretta, Rome

3

4

3 Empfangshalle, *As if we were alone*,
2006. Video still

4 Kalle Laar, working on *Calling the
Glacier: Mobile Elegy*, Vernagt Glacier,
Oetz Valley, Austria, March 2007

PHOTO LUDWIG BRAUN

5

6

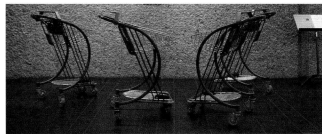

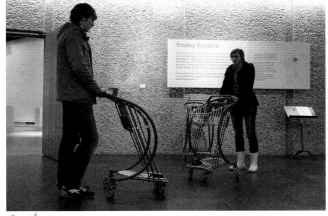

▲7 ▼8

5 Peter Callesen, *Palace of dreams*, 2003. 5 days interactive performance, Helsinki Sea, Finland. Styrofoam and glue 300 x 200 x 350 cm. Courtesy Emily Tsingou Gallery, London

6 Laura Beloff & Erich Berger & Pichlmair, *Seven Mile Boots*, 2003-2004. Wearable wireless networked leatherboots with pda, sensors, audio

7 Silver & Hanne Rivrud, *Trolley Singers*, 2006. Interactive sound installation, Nokia N70 smartphones, J2ME code, 3,000 x 3,000 cm

8 Globalgroove, *Tracking*, from *Douze études*, 2007. Video projection, loop

Most Serene Republics

Edgar Heap of Birds is the creator of some of the earliest and most memorable conceptual Native American art in the United States. Drawing on language and history, Heap of Birds' installations, prints, paintings, and drawings explore the often contested relationships between non-Indian historical accounts and Native memory, and the negotiated alterity of the contemporary Native experience. The artist is perhaps best known for his public art installations, which – employing the framework of official signage – engender a dialogue between place, history and a sometimes unsuspecting audience.

The exhibition *Most Serene Republics* refers to Heap of Birds' interest in the creation of republics or nation-states through acts of aggression, displacement or replacement of populations and cultures. As he states, 'The nature of their creation is to eclipse or absorb previous societies and governmental groups'. Two temporary public installations of signage seek to engage Venetians, passing tourists and members of the international art community who temporarily occupy this unique place, steeped in its multifaceted history.

The first installation is in the Giardini Reali near Piazza San Marco, the site of Napoleon Bonaparte's obliteration of local architecture to create a pastoral view of the Grand Canal from the Palazzo Reale. Heap of Birds' installation of 8 signs examines and deconstructs elements of Venetian history, including the Fourth Crusade, stolen plunder and Venetian achievements, both artistic and nautical. Yellow borders on the signs underscore parallels between the first 'ghetto' established in Venice to contain and control the Jewish population and Indian reservations created to contain and control Native people. This work is both an examination of the past and a critical dialogue about present-day global conflict and 'crusades'.

The second installation is between the Giardini Napoleonici and Via Garibaldi, along the Viale Garibaldi, a site where homes were destroyed by Napoleon in order to create a grand, processional avenue. Here the artist pays homage to the Native actors/warriors who travelled to Venice and other European cities as part of Wild West shows in the 1880s while simultaneously commenting on their displacement both from and within their own country. Heap of Birds' choice of this location – a space with both symbolic and literal reference to the end of Venetian independence and existence as a sovereign entity – adds further depth and resonance to the memory of these events. The words 'HONOR' and 'RAMMENTARE' repeat in a fugue of 16 signs, reciting the names of Native 'Show Indians' who perished during nineteenth-century European tours. 'It is a human right to have a voice and be heard,' the artist observes. 'So often our Native American heritage is represented by silent faces, stoic in their repression.'

In both installations, Heap of Birds' multilingual signs (Italian/English/Cheyenne) repeat in multiples of 4 – a symbolic, ceremonial number among the Cheyenne. The green borders of the Viale Garibaldi signs incorporate the repeating ceremonial symbols of an eagle and a shield with a Christian cross, alluding to sacrifice and spirituality, as well as the medieval crusades; the borders of the Giardini Reali signs feature a fitched cross associated with war and religious zeal. *Most Serene Republics* re-examines the past while questioning our complicity in events of the present.

—Truman Lowe, Kathleen Ash-Milby

Organisation
Smithsonian's National Museum
of the American Indian (NMAI)

Curators
Truman Lowe
Kathleen Ash-Milby

Web Site
www.AmericanIndian.si.edu

Artist
Edgar Heap of Birds

1 Edgar Heap of Birds, *Most Serene Republics*, 2007. Design layout for Giardini Reali sign, 60.96 x 91.44 cm. Courtesy the Artist

2 Edgar Heap of Birds, *Most Serene Republics*, 2007. Design layout for Via Garibaldi sign, 60.96 x 91.44 cm. Courtesy the Artist

GRAZIE VENEZIA
REPUBBLICA
MARKED FIRST GHETTO
U. S. CAPTURE INDIENS
RESERVATIONS

MOST SERENE REPUBLICS HOCK E AYE VI EDGAR HEAP OF BIRDS 2007

1

HONOR

NUMSHIM

LITTLE RING

RAMMENTARE

MOST SERENE REPUBLICS HOCK E AYE VI EDGAR HEAP OF BIRDS 2007

2

HONOR
NUMSHIM
LONG WOLF
RAMMENTARE

3 Edgar Heap of Birds, *Most Serene Republics*, 2007. Prototype layout for Via Garibaldi sign. Courtesy the Artist

1 EA. SINGLE SIDED .063" THICK ALUMINUM SIGNS WHITE EG REFLECTIVE BACKGROUNDS WITH RED (EC) EG REFLECTORIZED LEGEND AND KELLY GREEN NON-REFLECTIVE BORDERS
1 - 3/8" HOLE IN EACH CORNER FOR TWO POST MOUNTING

4 **Edgar Heap of Birds**, *Most Serene Republics*, 2007. Production layout for Via Garibaldi signs. Courtesy the Artist

New Forest Pavilion

New Forest Pavilion brings together seven international artists whose work explores, in a variety of methodologies and approaches, the experience of transformation, modification and change.

Simon Faithfull exploits journeys that veer between the radical and the mundane. *Escape Vehicle No. 6* (2004) sent a chair to the edge of space, *Antarctica Dispatches* (2005) transmitted drawings from a journey to the end of the world and *Orbital* (2003) created a hypnotic Mandala from London's circular roads. Faithfull modifies the commonplace to create visions of the extraordinary. He was the first visual artist to receive an ACE Fellowship with the British Antarctic Survey and took up an ArtSway Residency in 2003.

Beate Gütschow's recent video work transforms two, seventeenth-century, Jacob van Ruisdael paintings into moving digital montages. Entitled *R#1 / R#2* (2006) the videos acknowledge Ruisdael's methodology; yet offer a distinctly contemporary engagement with notions of the Utopian. Gütschow has previously exhibited her photographs widely in Europe and the USA, and was awarded the Ars Viva Prize and an ArtSway Residency, both in 2006.

Anne Hardy's photographs deal with architectural space yet represent a literal journey of creation to subsequent destruction. The intimate interiors she constructs with painstaking detail depict a transformation in hiatus, an extended moment in time recorded from one fixed angle. Hardy recently exhibited at Maureen Paley, London, and was the first recipient of a Laing Solo Award, Laing Art Gallery, Newcastle, UK in 2004, when she also took up an ArtSway Residency.

Igloo (Ruth Gibson and Bruno Martelli) make interactive works that explore the poetics of time, space and natural phenomena. They question the notion of the reality of nature and how it can be influenced by individual experience and collective mythology. *Summerbranch* employs the tools of the military entertainment complex to investigate the role of the 'real' in virtual environments. Igloo took up an ArtSway/ SCAN Residency in 2005.

Melanie Manchot's video installation *Shave* (2007) deals with physical, emotional and psychological transformations as a hirsute man is shorn of hair from his head and upper body. Increasingly international in scope, her works aim to locate cultural investigations within an area of constructed activity and the staged documentary, which can occur at the threshold between real life and fabricated situations. Manchot took up an ArtSway Residency in 2003; she exhibited at the Photographers Gallery, London, in 2005 and exhibits widely in Europe and the USA.

Stanza is a London based British artist who specialises in net art, networked spaces, installations and performances that have been exhibited internationally. Through data mining of imagery and information already available online his works explore artistic and technical opportunities using this data to enable new aesthetic perspectives based on urban and social mapping. Stanza is the recipient of an AHRC Creative Fellowship 2006-2009 for the project *The Emergent City* and is working with SCAN on curatorial contexts for his work.

ArtSway's Production Residency scheme began in 2001 and promotes methods to underpin the creation of new work by artists in a supportive and critically engaged environment. Each residency fosters a liberated approach to creativity and is not restricted by theme, bureaucratic priorities or other qualified approaches. *New Forest Pavilion* aims to explore, promote and exchange ArtSway's approach as a public organisation engaged in providing legacy support and new opportunities for artists it has previously supported.

—Mark Segal, Peter Bonnell

Organisation
ArtSway

Curators
Mark Segal
Peter Bonnell

In collaboration with
text + work (The Arts Institute
at Bournemouth)
Helen Sloan (SCAN)

With the support of
Arts Council England
Arts and Humanities Research Council

Sponsor
Hallett Independent

Web Site
www.artsway.org.uk

Artists
Simon Faithfull
Beate Gütschow
Anne Hardy
Igloo (Ruth Gibson & Bruno Martelli)
Melanie Manchot
Stanza

1 Anne Hardy, *Untitled VI*, 2005. Diasec mounted c-type print, 120 x 150 cm. Courtesy Maureen Paley, London. © Anne Hardy

2 Igloo (Ruth Gibson & Bruno Martelli), *Summerbranch*, 2005-2006. Computer installation with sound, dimensions variable. © Igloo

1

2

▲3 ▼4

3 Beate Gütschow, *R#1 / R#2*, 2006.
HD Video, double-screen projection,
sound. Courtesy Produzentengalerie
Hamburg, Gallery Barbara Gross,
Munich, and Louise and Eric Franck
Collection. © Beate Gütschow

4 Simon Faithfull, 4 stills from *Escape
Vehicle no.6*, 2004. Single channel
video, 25'. Courtesy Parker's Box, New
York, and ArratiaBeer, Berlin. © Simon
Faithfull

5 Melanie Manchot, *Shave*, 2007.
Installation view, two channel
synchronised video, on DVD,
for 1 projector and 1 monitor,
dimensions variable. Courtesy FRED,
London, and Galerie m, Bochum ©
Melanie Manchot
PHOTO ERIC JACOBS

6 Stanza, stills from *Amorphoscapes*,
1999-present. Touch-screen, audio-
visual interactive 'painting'. © Stanza

▲5 ▼6

Ocean Without a Shore

Ocean Without a Shore is about the presence of the dead in our lives. The three stone altars in the fifteenth-century church of San Gallo become transparent surfaces for the manifestation of images of the dead attempting to return to our world.

The shape of a human figure gradually coalesces from within a dark field of luminous particles and slowly comes into view, moving from obscurity into the light. As the figure approaches, it appears to become more solid and tangible until it crosses an invisible threshold and struggles to enter the physical world of the living. The crossing of the barrier between the two worlds is an intense moment of infinite feeling and acute physical awareness. Poised at this juncture, for a brief instant all beings can touch their true nature, equal parts material and ethereal. However, once incarnate, these individual beings are at risk of becoming constrained and overcome by their emotions, desires and sensations, so must eventually turn away from mortal existence and return to the emptiness from where they came.

—Bill Viola

Hearing things more than beings,
listening to the voice of fire,
the voice of water.
Hearing in wind the weeping bushes,
sighs of our forefathers.

The dead are never gone:
they are in the shadows.
The dead are not in earth:
they're in the rustling tree,
the groaning wood,
water that runs,
water that sleeps;
they're in the hut, in the crowd,
the dead are not dead.

The dead are never gone,
they're in the breast of a woman,
they're in the crying of a child,
in the flaming torch.
The dead are not in the earth:
they're in the dying fire,
the weeping grasses,
whimpering rocks,
they're in the forest, they're in the house,
the dead are not dead.

—Birago Diop

From *DEATH - An Anthology of Ancient Texts, Songs, Prayers, and Stories*, edited D. Meltzer, translated by D. Meltzer, San Francisco, Northpoint Press, 1984, p. 190.

Organisation
Peggy Guggenheim Collection
(The Solomon R Guggenheim
Foundation)

Curator
David Anfam

Artistic collaborators
Kira Perov
Harry Dawson
Brian Pete

Technical collaborators
Becky Allen
Genevieve Anderson
Chris Centrella
Giuliano Fiumani
Brian Garbellini
Michael Hemingway
David Max
David Norbury
Jung Oh
Tom Ozanich

Chuck Roseberry
Michael Sangrin
Bobby Wotherspoon

Performers
Luis Accinelli
Anika Ballent
Helena Ballent
Melina Bielefelt
Eugenia Care
Carlos Cervantes
Liisa Cohen
Addie Daddio
Chris Devlin
Jay Donahue
Howard Ferguson
Weba Garretson
Tamara Gorski
Darrow Igus
Page Leong
Richard Neil
Oguri
Larry Omaha

Helena Ottoson-Carter
Sophia Ottoson-Carter
Jean Rhodes
Lenny Steinberg
Julia Vera
Blake Viola
Ellis Williams

Exhibition coordination
Stephanie Camu
Kevin David
Bettina Jablonski

Sponsors
Haunch of Venison Gallery
James Cohan Gallery
Kukje Gallery

Thanks to
Graham Southern
James Cohan
Tina Kim
John Kaldor
Lee Hyun Sook
Museo Diocesano di Venezia
Studio Dal Ponte

Web Sites
www.guggenheim-venice.it
www.oceanwithoutashore.com

Artist
Bill Viola

San Gallo project- Venice

Transition Zones

Water Sheet

Walking through a Sheet of Water

Water Sheet

Space, distant Room?

Figure

Can the water be smoothed so it reads as an image disturbance before the figure enters?

Camera

Trough to prevent splash back

Shaft of High Intensity Light

• from B+W to color
• from dim/grainy to bright color
• from textured/abstract to
 • high resolution colored clarity

VEIL

Gauze Sheer Fabric, stretched and pulled to the breaking point. Figure tears through.

FOG

Cloud of dense smoke.
Figure approaches, clarifies...
passes through the fog into harsh clarity.

Lighting effects can produce multiple figures, shadows and silhouettes.

Feb 17, 2007

1 **Bill Viola**, preliminary sketches
for *Ocean Without a Shore*, February 17,
2007. Ink on paper

2-3 **Bill Viola**, *Ocean Without a Shore*,
2007. High Definition video/sound
installation. Production stills. Courtesy
the Artist
PHOTO KIRA PEROV

P³ Performative-Paper-Project

PERFORMANCE, MEMORY, TECHNIQUE:
towards a 'dematerialisation' of historic processes
and experience

Performance is one of the artistic forms that perhaps best reflects the sense of the contemporary. Arising out of genuine aesthetic revolutions such as Dadaism and Futurism, it combines some contradictory and problematic instances emerging from the art of the past (the nature of the event, the *détournement*, unpredictability, social interaction), highlighting how the work of art can no longer be confined to its mere objective nature.

The function of art tends to alter with historical ages; its way of understanding itself is constantly being modified. Today it is essentially 'conceptual' and plays the role of creating those 'innovative' or 'heretical' instances that tend to destabilise the commonplaces, stereotypes and knowledge shared by the consumer society.

Beyond the ephemeral-interactive complex that defines the performance as artistic expression, the P³ Project (Performative-Paper-Project) introduces another equally topical factor: dislocation. In the current globalisation processes, the dimension of space has changed completely, reducing distances and transforming our perception of the world. The mass media (primarily the internet) and the increasingly rapid circulation of goods impose an equally de-spatialised idea of art: no more specific, almost ghetto-like centres (the gallery, the museum), but widespread circulation that allows the ideas and concepts formulated there to penetrate every layer of society. The *P³ Project* then, being based on events performed in every part of the world and connected by media to the Venice venue, makes the lagoon city into what Foucault defined as heterotopia, that is, an almost unreal, immaterial place that may be located in a specific geographical point, but at the same time is widespread and in contact with countless other places.

The other element of *P³* concerns paper. It is the thematic and/or technical object of the performances made by the artists, but is *deprived* of its traditional function of being a medium for writing, drawing and human memory in general. Such deprivation becomes significant if confronted with the progressive emergence of digital technology in the field of information memorisation. Digital filing technologies are replacing the function of the paper support, both because of the savings in cost and for 'ecological' reasons. It is therefore legitimate to ask whether this does not indicate the forthcoming 'death' of paper (or its radical limitation, as happened in the past with clay, papyrus, parchment etc.) and, at the same time, a potential risk for the conservation of historic data. Indeed, electronic memories also tend to perish and deteriorate: tradition is not built *una tantum*, but through an incessant process of *re*-inscription or trading (whence the concepts of delivery, transmission, trade) that, in being renewed and repeated, risk *betrayal* at every stage.

P³ highlights how paper, though losing its material 'usefulness', 'dematerialises' rather into a transcendental function of tracing and re-tracing, thanks to which human civilisation itself has over time built its own self-knowledge and collective identity.

—**Emiliano Bazzanella, Carlo Damiani**

Organisation
C.R.O. (Centro di Riferimento Oncologico), Aviano

In collaboration with
ESU Venezia, ESU Cultura
Accademia di Belle Arti di Venezia
Istituto Veneziano per la storia
della Resistenza e della Società
contemporanea
Vela-Actv
Galleria 'Spazio Arte dei Mori', Venice
Teatro Miela, Trieste
Palazzo Frisacco, Assessorato
alla Cultura, Città di Tolmezzo
Tensta Konsthall, Stockholm
Museo 'Stock20', Taichung City

Artistic direction
Emiliano Bazzanella
Max Ceschia
Carlo Damiani
Guglielmo Di Mauro

Coordination
Emiliano Bazzanella
Max Ceschia
Carlo Damiani

Workshop curator
Emiliano Bazzanella

Sponsors
ITALCOPY sas
PROFILI PHOTO STUDIO TRIESTE
Vela SpA
Gruppo Giovani Pittori Spilimberghesi
Quadreria Museo C.R.A.S. Spilimbergo
VESTA SpA
Henkel
CLAIM srl
Tcontact srl

Web Site
www.p3project.it

Artists
Mauro Arrighi
Emiliano Bazzanella
Milena Bellomo
Lin Bing
Bluer (Lorenzo Viscidi)
Giancarlo Caneva
Max Ceschia
Emanuele Convento
Antonella Craparotta
Adolfina De Stefani
Guglielmo Di Mauro
Ye Fang
Ferruccio Gard
Hiroko Loco
Gianpaolo Lucato
Piero Ronzat
Gabriella Santuari
Cesare Serafino
Silvano Spessot
Yazuo Sumi
Tensta Konsthall

Yan Huang
Yang Zhichao
Yuan Chen Mei

**Participants from the Accademia
di Belle Arti di Venezia**
Martin Emilian Balint
Leonardo Boldrin
Marco Buziol
Giorgia Franzoi
Simona Granziero
Masa Granic
Andrea Gastaldi
Laure Keyrouz
Radun Lovorka
Doris Luger
Lisa Perini
Linda Suran
Franco Volpago
Riccardo Zuliani

1 Yang Huang, *Farmer Landscape*, 2005
2 Yuan Chen Mei, *Casa e radici-cielo*, 2006
3 Yazuo Sumi, Liceo Artistico Statale di Venezia, May 30, 2005

PHOTO ALBERTO FAVARETTO

4

5

6

7

8

9

4 Giancarlo Caneva, *Net-blindness*, 2005
PHOTO MAX CESCHIA

5 Emiliano Bazzanella, *Cross-flow*, 2005
PHOTO MAX CESCHIA

6 Emiliano Bazzanella, *In touch with*, 2006
PHOTO MAX CESCHIA

7 Max Ceschia, *Immaterialistic 43*, 2006
PHOTO MAX CESCHIA

8 Gianpaolo Lucato, *La messa a nudo*, 2007

9 Mauro Arrighi, *Braquisme007*

10 Guglielmo Di Mauro, *Sono fragile*,
2005
11 Riccardo Zuliani, *Soffio*, 2005
12 Konst 2, *Leopard 1*

Pan-European Encounters
International Curators Forum-Symposium

Pan-European Encounters

The first major gathering of international Black curators, writers, artists and critics at the Venice Biennale to discuss and explore the changing idea of identity and the diaspora in the twenty-first century.

This symposium is the inaugural presentation of the ICF, which aims to initiate and stimulate international discourse on the impact of diaspora cultures on the visual arts. The symposium will provide a necessary platform for critical dialogue on emerging tropes of representation within the accelerated globalisation of culture. It will also pose essential questions about the economies of exhibition, urbanisation and regeneration and the infra-structural developments necessary internationally to nurture and sustain a more representative and culturally diverse professional ecology for the visual arts.

It takes as its point of departure an essay by Jacques Derrida on the future to come after Apartheid, and asks where we are now and what spectres haunt this scene in the year South Africa will exhibit for the first time as guests in the Italian Pavilion and Britain celebrates the 200th anniversary of the Abolition of Slavery Act.

—David A Bailey, Mark Waugh

'Nothing is delivered here in the present, nothing that would be presentable – only, in tomorrow's review mirror, the late, ultimate racism, the last of many'
Jacques Derrida, *Racism's Last Word*, 1983

Black Moving Cube

In Europe, representations of the black body constitute a ubiquitous presence across fine art and popular culture, yet up to now the subject has received only marginal critical attention. Over the past two decades, new generations of artists working with the moving image have begun to reverse this trend – revealing how images of 'otherness' have been central to commonplace definitions of identity within the symbolic order of the modern West. The *Black Moving Cube* will bring together for the first time in history over 20 years of black visual art film practice in a conference/symposium format. This will involve a selection of key works from 1986 to 2007 that explore the black body by European film and visual artists, with newly commissioned works to be produced alongside a wide range of archival and contemporary material, to both document these critical developments and provoke further debate within the visual arts.

Historically, the work of the black artist working with the moving image in Europe has always been neatly confined to the discourse of identity politics. Yet if one looks 'historically' at the work of artists such as Isaac Julien, Jess Hall, Martina Attille, Black Audio Film Collective, Yinka Shonibare, Aliya Syed, Jananne Al Ani, Zineb Sedira, Steve McQueen, Zarina Bhimji, and Keith Piper, it is quite clear that their film work, individually, explores a diversity of concerns. What is distinctive about their work, which connects them to white innovative experimental postwar film artists such as Maya Deren and Kenneth Macpherson, is that these artists use the black body within film as a site to comment upon and make strategic inputs into the colonial terrain of Western art practices.

The *Black Moving Cube* will represent a body of black artists who have used the physical space of the gallery and museum to re-frame a particular set of ideas that comments upon film art culture. Hence the phrase 'Black Cube' as an ironic metaphor to describe the way the black artist has 'blackened' the white cubist spaces of the museum and gallery sectors. Over the years, a number of artists have been working with museum and gallery archives/collections and through the process have re-created museum and gallery environments with photography, film and cross artform installations. These interventions fall into several categories such as: film projects, theme group shows, residencies/invitational interventions and non-invitational interventions. It is my intention to explore these past moving images works with new commissions that will be launched in Venice in June 2007 and then travel to London in October-December 2007.

—David A Bailey

Organisation
decibel, Arts Council England

Curator
David A Bailey

Collaborators
Mark Waugh
Nike Jonah
Axel Lapp
Terry Adams
Ellie Stout

In collaboration with
Università IUAV di Venezia -
Facoltà di Design e Arti

With the support of
British Council
The Black Moving Cube
ICA
TATE BRITAIN
DCMS - British Government
Department for Culture Media & Sport

Web Sites
www.artscouncil.org.uk
www.blackmovingcube.co.uk

Speakers
John Akomfrah
David Adjaye
David A Bailey
Gus Casely-Hayford
Ekow Eshun
Thelma Golden
Kim Yu Yeon

David Lammy
Courtney Martin
Simon Njami
Otolith Group
Mike Phillips
Jacques Rancière
Niru Ratman
Mariam Sharp
Zineb Sedira
Deborah Smith
Gilane Tawadros
Jalal Toufic

1 John Sealey, *They Call Me... Dont Call Me*, 2005-2006

2 Zineb Sedira, *Saphir*, 2006. Stills
from the video, two screen video
projections, commissioned by
The Photographer's Gallery and Film
and Video Umbrella, London. Courtesy
Galerie Kamel Mennour, Paris. © Zineb
Sedira

3 Lynette Yiadom Boakye, *Magret
de Canard*, 2005. Oil on linen,
162 x 213 cm

▲2 ▼3

Paradise Lost
The First Roma Pavilion

Paradise Lost is the first contemporary show representing an international selection of Roma contemporary artists.

The exhibition showcases the visual art talents of the largest European ethnic minority. The artists embrace and transform, deny and deconstruct, oppose and analyse, challenge and overwrite the existing stereotypes in a confident intellectual manner, reinventing the Roma tradition and its elements as contemporary culture.

The archetypal motives provide a firm underlying sentiment, but the result unexpectedly suggests a new interpretation, one that is created by the Roma artists themselves. The envisioned alternative identity highlights the strengths of Roma, the capacity for fusion, the sense of glamour, humour and irony, adaptability, mobility and transnationalism.

The intention of opposing and denying the existing (mis)representations and promoting the contrary carry an irresolvable dichotomy, which embodies an art unfree from sorrowful beauty, paranoia, schizophrenia, and post traumatic syndromes.

If the terra incognita of exotic gypsies has been the target of escape for Europe since nineteenth-century modernism, have we all lost our search for Paradise?
—Tímea Junghaus

Background information

As there is no infrastructure for Roma representation in Europe, the first Roma Pavilion alongside the Venice Biennale's National Pavilions will be the first significant step toward giving Roma contemporary culture the audience it deserves. In addition to allowing contemporary Roma artists to present their work and ideas on a world stage, a pavilion at the premier international art forum will send a message of inclusion that has so far eluded the Roma community: Roma have a vital role to play in the political and cultural landscape of Europe.

Young, innovative and creative Roma artists are represented at the most prestigious art festival in Europe and challenge the prevailing negative attitudes towards Roma in Europe and of Roma artists simply as folkloristic street musicians.

For centuries, Roma people have been the subjects, and the victims, of representations created exclusively by the non-Roma. They have been romanticised as subject matter for artists, and to this day an imaginary 'world of Gypsy romance' conjures up images of barefoot dancers happily banging on tambourines.

A new generation of Roma intellectuals and artists is emerging, however, along with a new Roma consciousness. Successful and well-educated Roma proudly acknowledge their origin, rather than opt for assimilation and relinquish their cultural heritage. Roma contemporary artists, directly and indirectly, explore the position held by the Roma in contemporary societies. By creating images of the Roma that oppose those of the mainstream culture, Roma artists are fighting to reverse long-held stereotypes.

A Roma presence at the 52nd International Art Exhibition – the marking of cultural as well as physical space – will show that Roma artists speak in a visual language that can be understood worldwide. It will be a historic move toward banishing the stereotypes and misconceptions surrounding an entire culture.

Organisation
Open Society Institute

Curator
Tímea Junghaus

Scientific committee
Viktor Misiano
Thomas Acton
Barnabás Bencsik
Dragan Klaic
Marketta Seppala
Katalin Székely

With the support of
European Cultural Foundation
Allianz Kulturstiftung

Web Site
www.soros.org

Artists
Daniel Baker
Tibor Balogh
Mihaela Ionela Cimpeanu
Gabi Jimenez
András Kállai
Damian Le Bas
Delaine Le Bas
Kiba Lumberg
Omara
Marian Petre
Nihad Nino Pušija
Jenő André Raatzsch
Dusan Ristic
István Szentandrássy

1

2

3

4

5

1 Daniel Baker, *Sign looking glass*, 2005. Mixed media on perspex, 21 x 85 cm. Collection of the artist, London
PHOTO © DANIEL BAKER

2 Kiba Lumberg, *The Black Butterfly*. Installation (wood, fabric [skirt], paint), 280 x 310 x 30 cm. Collection of the artist, London. © Kika Lumberg
PHOTO ERKKI VALLI-JAAKOLA

3 Daniel Baker, *Static*, 2006. Photographic image, dimensions variable. Collection of the artist, London
PHOTO © DANIEL BAKER

4 Jenő André Raatzsch, *The Apron of my Mother*, 2005. Mixed media (seamed copperplate, paint), 100 x 60 x 3 cm. Collection of the artist
PHOTO © JENO ANDRÉ RAATZSCH

5 Gabi Jimenez, *Caravanes linge*, 2006. Acrylic on canvas, 18 x 24 cm. Private collection, Paris. © FX LOPEZ Jimenez
PHOTO GABI JIMENEZ

6

7

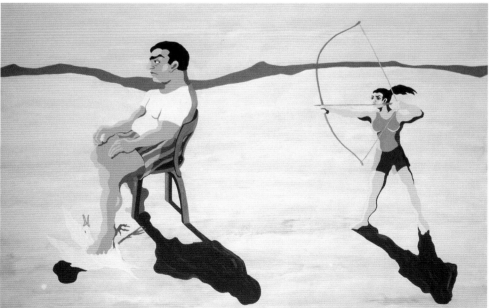

8

9

6 Kiba Lumberg, *Death on the trotting-track*, 1995. Gouache, 62 x 88 cm. Collection National Bureau of Antiquities, The Archives for Prints and Photographs, Finland. © Kiba Lumberg

PHOTO RITVA BÄCKMAN

7 Delaine Le Bas, *CRUCIFIED*, 2005. Mixed media, height 50 cm approx. Collection of the artist. © Delaine Le Bas

PHOTO DANIEL BAKER

8 Kiba Lumberg, *Bird Killer*, 1995. Gouache, 55 x 78 cm. Collection National Bureau of Antiquities, The Archives for Prints and Photographs, Finland. © Kiba Lumberg

PHOTO RITVA BÄCKMAN

9 Delaine Le Bas, *DAMAGED GOODS PART I*, 2004, detail. Mixed media on fabric, 70 x 58 cm. Collection of the artist. © Delaine Le Bas

PHOTO TARA DARBY

10

11

12

13

14

10 Daniel Baker, *Gold rose looking glass*, 2006. Mixed media on glass, 36 x 35 cm. Collection of the artist, London
PHOTO © DANIEL BAKER

11 Delaine Le Bas, *INSTALLATION: ROOM @ 28 ST ELMO ROAD*, 2005. Mixed media Dolls I, II & III with collected objects, dimensions variable. Collection of the artist. © Delaine Le Bas
PHOTO TARA DARBY

12 Damian Le Bas, *North Western Africa*, 2006. Pen on printed map, 48.2 x 63.5 cm. Collection of the artist. © Damian Le Bas
PHOTO DELAINE LE BAS

13 Kiba Lumberg, *The Black Butterfly*. Installation (wood, fabric [skirt], paint), 280 x 310 x 30 cm. Collection of the artist. © Kiba Lumberg
PHOTO ERKKI VÄLLI-JAAKOLA

14 Omara, *Little Mara in First Grade*. Oil, fibreboard, 50 x 70 cm. Private collection. © Omara
PHOTO LASZLO SIPOS

Place

A 'place' in time

This year marks the first appearance of Macao's art works in the grand event of the International Art Exhibition La Biennale di Venezia, an occasion on which Macao's artists will deliver their messages under the theme of 'Place'.

What are the consequences for a society that receives over 20 million visitors a year – albeit an admirable figure – in a miniscule area of 28 square kilometres? When the ratio of residents to visitors expands from 1:17, as it was 8 years ago, to 1:44, as it did last year, are the residents of the city ready for such 'sudden' change, or are they reluctant to accept the irresistible fact? When the cultural heritage of five continents is copied and pasted onto a timeworn city, itself listed as a World Heritage Site, are the attractions of its native cultures and unique glamour enhanced or do they fade away? Raising such questions and taking action to reflect concerns about the living environment undoubtedly rank among the most important functions of contemporary art. It is true that the best way to seek answers to these questions is to personally feel and experience Macao, a beautiful coastal city lying on the southern tip of China. Yet it is also true that one can taste and explore the city through the representations of its residents, of which artists are an important group.

The participation of Macao's artists in the 52nd International Art Exhibition reinforces the brand new positioning and role Macao has assumed on the world art stage, and provides an opportunity to further familiarise art fans in the rest of the world with Macao's art. The Macao Museum of Art proposes two works by Macao artists to be presented in this exhibition.

1. *Macao's Gondola* by Lui Chak Keong and Lui Chak Hong

It is the ultimate ambition of many artists to affect or inspire their audience with elaborately created works of art. Any phenomenon in daily life can be a starting point for the exploration of power relationships, culture, social mores and other topics. The cities of Macao and Venice are both recognised for their world heritage and have both been important trading ports in the annals of history. Despite a similar background, they have never enjoyed a connection of any kind over the past centuries.

In 2007, Macao will complete a Venice-themed commercial project, making it possible to experience in Macao the 'romance of Venice' on a gondola in an artificial canal. Today, Macao is engaged in diverse, large-scale construction to attract even more visitors. With enormous amounts of foreign investment pouring in and increasing globalisation, what will happen to the city? Through their works of art – *Macao's Gondola*, featuring the A-Ma Temple, the oldest temple in Macao, and the Ruins of St. Paul's, one of the territory's oldest churches, together with a concrete gondola which cannot be used in water – the Lui brothers are conveying the message that our heritage is in fact 'sinking'.

2. *Si monumentum requiris, circumspice* by Konstantin Bessmertny

Flying in the sky was a dream that humankind long pursued and has now been fulfilled by the invention of the aeroplane, a symbol of dreams that has created a new chapter in the history of communication and invention.

There is a 'plane' ready to reveal how life is mazy near the seaside of Arsenale in Venice.

Made of scrap iron, mechanical parts, cartons and assorted recycled materials, the work is unrelated to aerodynamics or modern technology. The body is sprayed with graffiti in Latin, English, Portuguese and Chinese, in words and symbols that are pleasant and humorous, fantastic and senseless. The two open doors invite visitors to explore their dreams. Inside, the curious will find decorations that the *nouveau riche* like very much – vulgar wallpaper with fake paintings of Venetian scenes and Nam Van in Macao. A second-hand crystal pendant, large enough to occupy the whole space and imbue a feeling of 'breathlessness', hangs down to the floor.

It is not a plane for flying, nor is it a place for living in. Yet, isn't it the noble life that people aspire to? Nothing is more perfect than a dream that comes true, right?

Experience real heritage, and explore!

—Ung Vai Meng

Organisation
Civic and Municipal Affairs Bureau
of Macao
Macao Museum of Art

Commissioner
Ung Vai Meng

Curator
Ng Fong Chao

Coordination in Venice
Arte Communications

Web Sites
www.iacm.gov.mo
www.artmuseum.gov.mo

Artists
Konstantin Bessmertny
Lui Chak Keong & Lui Chak Hong

1-2 Konstantin Bessmertny,
Si monumentum requiris, circumspice,
2007. Installation, 190 x 400 cm

▲1 ▼2

3

4

5

6

7

3-7 Konstantin Bessmertny,
Si monumentum requiris, circumspice,
2007. Installation, 190 x 400 cm

8

MACAO'S GONDOLA

Lui chak keong & Lui chak hong

9

10

8-10 Lui Chak Keong & Lui Chak Hong,
Macao's Gondola, 2007. Installation,
210 x 250 cm

Ruin Russia

The *Ruin Russia* documentary art project is an installation featuring a cycle of large-format photos made by young Moscow photographer Stas Polnarev, accompanied by a collection of visual, textual and object-based documents illustrating the history of the hotel. The story line of the project is the last year in the life of the Moscow 'Russia' hotel, when the building was almost completely demolished by construction workers.

The hotel was built in 1964-1967 in the immediate vicinity of the Kremlin and the Red Square (in Zariadye district). It was designed by the architect Dmitry Chechulin, a key figure in the urban construction of the capital city of Russia during the Stalin era. With its 2722 rooms in four, 12-storey buildings covering a space of nearly 13 hectares, the 'Russia' was the biggest hotel in Europe. During its lifetime it accommodated over 10 million people, including some outstanding international political and cultural personalities.

The structure, gigantic and yet quite ordinary in architectural terms, had existed for nearly 40 years, having survived a number of important periods in the life of the nation. The construction of the 'Russia' hotel coincided with the first years of the rule of Leonid Brezhniev, the General Secretary of the Central Committee of the Communist Party of the USSR, while its last days were also the last days of the presidency of Vladimir Putin.

The hotel's best years were the last years of Soviet communism, also known as the 'era of stagnation'. It was the time of the drawn-out decay of the socio-political system and, yet, a time characterised by quite original culture and an inimitable 'life feeling', the years of youth of several generations of people representing a considerable part of the current Russian population.

This is at least one of the reasons there is a very distinct nostalgia for these times, seen from today as a sort of paradise out of time, a period of peaceful sleep, where the present-day problems were simply unimaginable. As any image of a paradise or a dream, this *time* appears as a uniform *anonymous space* with no distinct features but permeated, instead, with life itself. The principal aim of the *Ruin Russia* project is to try and show something that is usually absent from the visual arts: the emotional *space of the ordinary*, rather than any remarkable events or notable objects. The space of this kind can primarily imprint itself on the human mind in the mode of the past, as a reminiscence. Its best visual form and memorial symbol is a ruin, that is, the last material trace of the past in the present lending itself to immediate contemplation of its contemporaries. In this sense, the ruin of the 'Russia' hotel works like an empty vessel craving to be filled and becomes a unique object due to the very fact of its pretentious ordinariness.

—Vladimir Levashov

Organisation
Stella Art Foundation

Curator
Vladimir Levashov

Web Site
www.stellaartfoundation.com

Artist
Stas Polnarev

1 **Stas Polnarev**, from the series *Ruin Russia*, 2006-2007. Digital color photograph, 53.3 x 80 cm. © Stella Art Foundation. Courtesy Stella Art Foundation

2 **Stas Polnarev**, from the series *Ruin Russia*, 2006-2007. Digital color photograph, 36 x 80 cm. © Stella Art Foundation. Courtesy Stella Art Foundation

▲ 1 ▼ 2

3

4

5

3 **Stas Polnarev**, from the series
Ruin Russia, 2006-2007. Digital color
photograph, 80 x 53.2 cm. © Stella
Art Foundation. Courtesy Stella Art
Foundation

4 **Stas Polnarev**, from the series
Ruin Russia, 2006-2007. Digital color
photograph, 53.4 x 80 cm. © Stella
Art Foundation. Courtesy Stella Art
Foundation

5 **Stas Polnarev**, from the series
Ruin Russia, 2006-2007. Digital color
photograph, 53.2 x 80 cm. © Stella
Art Foundation. Courtesy Stella Art
Foundation

6 **Stas Polnarev**, from the series
Ruin Russia, 2006-2007. Digital color
photograph, 80 x 53.2 cm. © Stella
Art Foundation. Courtesy Stella Art
Foundation

Scotland and Venice 2007

Scottish art is at one of its most progressive moments and our chosen artists represent this position in the form of six highly individual talents. As with the heterogeneous character of the Biennale, the work of Charles Avery, Henry Coombes, Louise Hopkins, Rosalind Nashashibi, Lucy Skaer and Tony Swain is diverse, exciting and unpredictable. Each artist seems to share as part of their concern an interest in cultural similarities and differences, and the issues such differences present. Some on occasion use invented worlds to investigate their concerns; others make use of comparisons, real situations or look back into art and history. Each works with such ability and often with such surprising and new means that they have the power to alter perceptions.

Working across a range of media, Charles Avery's art is characterised by formal beauty, humour and a spirit of philosophical enquiry. Avery's most high-profile work to date is his ongoing *Islanders* project, in which over a ten-year period he has described in drawing, painting and sculpture the topology and cosmology of an imaginary island, inspired by his childhood living in the Inner Hebrides. Avery was born in Oban in 1973 and is based in London.

Henry Coombes' work is concerned with investigating entrenched political, cultural and class issues. Film, oil paint and watercolour are used to produce apparently familiar and comfortable imagery, which on closer inspection reveals itself to be of dark and subversive subject-matter. Coombes was born in London in 1977 and is based in Glasgow.

Using materials such as furnishing fabric, newspapers, song sheets, maps and comic strips as a basis for her work, Louise Hopkins' art can at first appear playful and sensuous. Her primary intention, however, is not one of embellishment, but of disruption. Her use of paint to alter meaning is disorientating and at times disturbing, as for example in her map pieces, where her modification of boundaries and landscape changes our world perspective. Hopkins was born in Hertfordshire in 1965 and is based in Glasgow.

Observation of group interaction and social rituals are the starting point for Rosalind Nashashibi, who uses primarily 16mm film. She is concerned with portraying the psychological atmosphere of locations and detecting subconscious projections. To do this she films scenes from reality, often filtered through the visual language of primitivism. Nashashibi was born in Croydon in 1973 and is based in London.

Lucy Skaer makes public interventions, as well as paintings, sculpture and drawings. In the latter she frequently utilises imagery found in photojournalistic reportage. Working on paper – large stretches that resemble unfurled banners, flags or giant scrolls – she draws in graphite, adding enamel paint, ink and gold leaf to produce subtle imagery, fluid and shifting in appearance. Skaer was born in Cambridge in 1975 and is based in Glasgow.

A sheet or cut section of newsprint provides the basis for Swain's meticulously executed paintings, which offer a view into a complex and surreal private world. Using the disconnected images found across such a spread, Swain works over this, embellishing imagery, distorting and extending perspectives and introducing new figurative and abstract imagery to produce works that are mesmeric and intriguing. Swain was born in Lisburn (Northern Ireland) in 1967 and is based in Glasgow.

—Philip Long

Organisation
Scottish Arts Council
British Council Scotland
National Galleries of Scotland

Curator
Philip Long

Web Site
www.scotlandandvenicebiennale.com

Artists
Charles Avery
Henry Coombes
Louise Hopkins
Rosalind Nashashibi
Lucy Skaer
Tony Swain

1 Tony Swain, *Stuck Cuts*, 2006. Acrylic on newspaper, 67 x 64 cm. Courtesy the Artist, The Modern Institute/Toby Webster Ltd
PHOTO JON SNAPE

2

3

2 Charles Avery, *Dorothea
and Mr. Impossible*, from *The Plane of
the Gods*, 2006. Jesmonite, 41 x 40 x 54
cm. Courtesy the Artist, doggerfisher,
Edinburgh, S.A.L.E.S., Roma and Sonia
Rosso, Torino
PHOTO WILLIAM DANIELS

3 Henry Coombes, *Untitled*, 2007.
Watercolour, pastel and gesso on paper,
25 x 18 cm. Courtesy Sorcha Dallas,
Glasgow
PHOTO THE ARTIST

4 Louise Hopkins, *Aurora 13*, 1996. Oil
paint on reverse of patterned furnishing
fabric, 183 x 130 cm. Collection of Arts
Council of England
PHOTO IAN NICHOLS

5 Rosalind Nashashibi, *Proximity
Machines*, 2007. Two-channel 16mm
projection (looped). Courtesy the Artist
PHOTO POLLY BRADEN

6 Lucy Skaer, *Leonora (Death)*, 2006.
Installation view at Elisabeth Kaufmann,
Zurich. Permanent marker pen and
pencil on paper, 140 x 470 cm. Courtesy
the Artist, doggerfisher, Edinburgh
and Elisabeth Kaufmann, Zürich
PHOTO NIKLAUS SPOERRI

Star Fairy: Hong Kong in Venice

The Hong Kong Arts Development Council's participation in the 52nd International Art Exhibition with new works from Hong Kong, China.

Cities create and employ representational strategies in promotion of a particular identity. As a city identity becomes a brand, it wants real cultural artefacts to substantiate itself. From tourism boards to architectural firms, from government departments to independent arts, city images are created and disseminated globally in vast quantities and in varying quality. Enormous amounts of time and money are spent in making ours cities, and ourselves, visible to the rest of the world. This generates intricate networks of imaging strategies, interacting and competing for economic and cultural gain.

The city's motivations are not mysterious – this is primarily a promotional, income-generating exercise. But it's also about making meaning. It empowers real-world intervention into the state of a city's culture and, importantly, influences how that culture is produced, then packaged and consumed (how it is *perceived*) internationally. This process is the focus of *Star Fairy*'s critique.

We set out to question this process, where a city seeks fame, and then purposefully engage with the various strategies a city might use to represent itself.

Star Fairy asks: How does Hong Kong show itself to the world? What sorts of strategies does it use to say 'This is Hong Kong', when showing ads, tourist promotion, cinema, design and so on? More specifically, why are we going to Venice? What can we say about our city in an event as multi-faceted and prestigious as the International Art Exhibition?

Star Fairy sees this 'representational' problem as the primary concern for the city's presentation in the Biennale. And we have developed a custom-made, site-specific project in response, presenting photographs, elaborate installations and sound.

Star Fairy offers some playful and engaging responses to these questions. Featuring Map Office (Gutierrez + Portefaix), Amy Cheung and Hiram To – three experienced international artists, the project reveals the artists' unusual and critical manipulation of representational strategies. Map Office presents *Concrete Jungle / The Parrot's Tale*, an artificial, mist and plant filled 'urban jungle' with talking parrots peppering visitors with humorous, critical questions. Amy Cheung's ambitious two-part project *Devil's Advocate*, consists of an elegant Ferris wheel like structure with frozen figures and bumper-cars that destroy each other, both connecting with carnivalesque mystery. Lastly, Hiram To's elaborate installation *I Love You More Than My Own Death* weaves multi-layered references to game shows, cinema and contemporary art into Hong Kong's fascinating relationship with fame.

Star Fairy does not provide answers. But it does present articulate, critical responses to important questions of how meaning is generated through our representational strategies, how we show our cities to the world – and how we perceive ourselves within these processes.

—**Norman Ford**

Organisation
Hong Kong Arts Development Council

Commissioner
Fung Kwok Ma

Deputy commissioners
Peter K.K. Wong
Kam Yin Lee

Curator
Norman Ford

Coordination in Venice
Arte Communications

Web Sites
www.hkadc.org.hk
www.venicebiennale.hk

Artists
Amy Cheung
Map Office (Laurent Gutierrez
and Valérie Portefaix)
Hiram To

1 Amy Cheung, *Untitled (The Population)*, 2002, detail. Installation. Acrylic, video, objects

2 Amy Cheung, *Devil's Advocate*, 2007. Illustration of installation

GUTIERREZ + PORTEFAIX present CONCRETE JUNGLE | PARROT'S TALE - HK ART LAB : STRATEGIES OF REPRESENTATION

3

4

3 Map Office (Laurent Gutierrez
and Valérie Portefaix), *Concrete Jungle/
The Parrot's Tale*, 2007. Illustration
of installation: artificial plants,
mechanical parrots, misting system,
foam, dimensions variable
PHOTO COURTESY THE ARTISTS

4 Map Office (Laurent Gutierrez
and Valérie Portefaix), *Back Home
With Baudelaire*, 2004. Installation
PHOTO COURTESY THE ARTISTS

5 Hiram To, *In Visible Difference*, 2002, detail. Collection of The Winnipeg Art Gallery. Courtesy the Artist
PHOTO ERNEST MAYER, THE WINNIPEG ART GALLERY

6 Hiram To, *...you don't know how I feel*, 2002. Courtesy the Artist
PHOTO ERNEST MAYER, THE WINNIPEG ART GALLERY

The Storm and the Harbour
We Are Waiting for the Change

From the Front

January 1992 Everyone's running you no longer understand in what direction I see you have to be very fast! How fast do you have to be?? they crowd, cram and now they want everything or there'll be nothing left! They want it immediately, finally! many are so scared: what will become of us? they have to grasp everything they can age divides and from the old people, who run slower, they'll take everything!!!!! They already know that they are taking something from them Where are the Komsomol, the pioneers, where everything is grey // radio: 25 December 1991 Gorbaciov hands in his resignation and the day after the USSR formally ceases to exist end radio //
??? Everything finished Everything starts from scratch What strange joy You don't know why, given that everything falls Moscow Piter Moscow Piter Moscow Piter Moscow Piter -- What will our mothers do? The state, the state is no more The state has lost its teeth It can't bite The market then, we have to understand this new ground It seems weak, it won't stand all these bodies Yeltsin, Yeltsin, Yeltsin tanks Old people; the pension That little they gave us... What a mess! Are those who were rich before still rich? Yes, certainly, the rouble has collapsed, but the rich are rich in dollars How much? Bread 5,000 roubles? Meat 10,000? Ah, there is no meat I'll paint No, I don't live there I didn't live there before Now I can show them to you Before it was harder I had to hide them You only saw them in the shadows of a factory without machinery or workers A room who knows where, three visitors Then the police and you grabbed the canvases and ran Running with a painting is difficult 1988 we started seeing the doors seem to open I went on a trip I saw How everything moves outside here How everything moves outside here First exhibitions Do you know Beuys Kounellis Rauschenberg??? These Latin characters are so hard We've got new magazines Well, maybe not new but you can see something of what is on the other side of this enormous wall that is crumbling You can see through the holes, there's Novikov, Yegelsky, Africa, Mamyshev-Monroe, Zakharov Osmolovksy Gutov Gurianov Yufit Monastirsky and others besides and they seem, we seem reborn Ideas how many ideas We want to start a movement avant-garde avant-garde A new one, at least for us We'll call it .. we've got lots of names Timur his desire to live to discover, his New Academism Necrorealism ideas and others and others still Freedom Autonomy After this long black hole we all want horizons of another colour // 1989 November the Germans on one side can go across to the other without being killed // Parallel Cinema, Kino-Viktor Zoi Group, Pop Mekhanika hurdles communism, Pushkinshkaya 10 performances videos happenings rock rock rock pop pop new media actions Moscow Piter Moscow Piter 'I want to speak a language of emotions' (A. Brener) with us too here too beyond that curtain of tanks we are immersed in chaos but it's ok we see that it happens They're coming!! Which of us is ready to take on the market We are used to our own intimacy, free but confined What will we do with the monster that eats artists!?!?! But with dollars in your pocket you feel like a new Russian Fleeting sensations??!!!!?? Ours are coming and lots more behind Talent talent The Russians don't give up Start we have to at least start someplace!!!!!!!!!!!!!!!!!!! and end without ending...

—Oxana Maleeva

Organisation
Victoria Art Foundation
The Palaces of the Russian Museum
Restoration Fund

In collaboration with
Angleshots

Curators
Oxana Maleeva
Teresa Mavica

Coordination
Oxana Bondarenko
Anna Tsvetkova

Collaborator
Marco Rossi

Sponsor
Company Novatek

With the support of
Alexander Borovsky
Ol'ga Kudriatseva

Thanks to
Leonid Mikhelson
Art-Courier

Web Sites
www.victoriartfund.org
www.srmfond.nm.ru

Artists
Sergey Bugaev-Africa
Georgy Gurianov
Vladimir Mamyshev-Monroe
Timur Novikov
Denis Yegelsky
Evgeny Yufit

1 Vladimir Mamyshev-Monroe

2

2 Group photo at the New Academy.
Courtesy Novikov's family Archive

РАСЩЕПЛЕНИЕ

3

4

5

6

7

3 Sergey Bugaev, in the background the work by Yuri Leiderman *Rasheplenie pamyati*, Düsseldorf, 1990
PHOTO VADIM ZAKHAROV

4 Joseph Backstein e Vadim Zakharov. Courtesy Vadim Zakharov

5 Vladimir Mamyshev-Monroe at the exhibition *Dostoevskij a Baden Baden*
PHOTO COURTESY GALLERY D137

6 K. Novikova, Timor Novikov, O. Kudriatseva, Aidan Salakhova at the exhibition *Living Paintings*
PHOTO COURTESY GALLERY D137

7 Timor Novikov at the exhibition *Image of Timur Novikov*
PHOTO COURTESY GALLERY D137

Transcendental Realism:
the Art of Adi Da Samraj

My images are about how Reality Is – and they are also about how Reality seems, in the context of natural perception, like a construction of primary shaping-forces. My image-art is, therefore, not merely 'subjectively' or 'objectively' based. Rather, the images I make and do always tacitly and utterly coincide with Reality As It Is. Therefore, I have called the process of the image-art I make and do *Transcendental Realism*.

—Adi Da Samraj

Adi Da Samraj has established a new use of geometry, as a fertile field of unconventional aesthetic communication that takes delight in developing its principles asymmetrically, through surprise and feeling. However, there is no contradiction between these two elements and the principles of design. Rather, surprise and feeling strengthen those principles, through a pragmatic and un-preconceived use of 'representational' geometry.

It is no accident that the artist constantly shifts between two-dimensional imagery and three-dimensional fabricated shapes, between black-and-white formulations and polychromatic combinations. The final form – whether two-dimensional or three-dimensional – suggests a tangible rather than an abstract reality, which pulsates before the thrilled analytical gaze of the beholder. The work carries with it a potential for asymmetrical development implicit in the original concept. Such asymmetry is an integral aspect of the modernist approach, reflecting the nature of the world around us, full of unexpected events and surprises.

The classical quality of Adi Da Samraj lies in his readiness to accept the *intelligent chance* inherent in life, the potential of the universe. Art becomes the place where the artist formalises these principles and integrates them into his work, which is pervaded by a geometry that plays with asymmetry to produce a dynamic, rather than static, effect. The artist always creates *families of works*, stemming from matrices that can be multiplied to produce complementary but differing shapes.

Thus, the concept of design takes on a new meaning, in that the act of designing a work of art no longer stands as a singular moment of arrogant precision. Rather, design is open to multiple realisations, albeit guided by a method defined through practice and creative impulse.

Here we have digital images – figures, cubes, pyramids and other computer-generated geometric forms – that comprise the *figurative element* of our time, when technology tends to dematerialise and abstract all form. Art, on the other hand, tends to make form manifest, to materialise geometry. Adi Da Samraj's two- and three-dimensional shapes are always *concrete* communicative realities, statements of a mental order that is never repressive or closed off, but always germinating and unpredictable. In all instances, shapes germinate and multiply with sudden offshoots that reveal the potential of a new geometric eroticism. His shapes always have a *human-scale monumentality* far from the aggressive rhetoric of sculpture. Thus, the artist is not setting out to wage a conventional 'war' against real forms. Rather, he wishes to create a communicative framework for analysis and synthesis: analysis resulting from the possibility of verifying the germination of *families of shapes*, and synthesis resulting from the delicate power emanating from the works displayed before our eyes.

—Achille Bonito Oliva

Organisation
Colours of Freedom Foundation
Pacific Center for the Photographic Arts

Coordination
Da Plastique
Arte Communications

Commissioners
Paolo De Grandis
Stuart M. Gibson

Deputy commissioners
Patricia Karen Gagic
Lena Tabori

Curator
Achille Bonito Oliva

Co-curator
Peter Frank

With the support of
Ecstatic Art and Theatre Project

With the patronage of
Regione Veneto
Provincia di Venezia
Comune di Venezia

Web Sites
www.coloursoffreedom.com
www.pcpaphoto.org

Artist
Adi Da Samraj

1 Adi Da Samraj, *Alberti's Window I*,
from *Geome One*, 2006-2007, detail.
Mixed media, 137 x 1,419 cm. © ASA
2 Adi Da Samraj, *What Is Not An Idea?*
(#56), from *Geome Two*, 2006-2007.
Plasma screen installation (899 single
images). © ASA

3

4

3 Adi Da Samraj, *The Lover I*, from
*Oculus One: The Reduction
Of The Beloved To Love Alone*, 2006-
2007. Mixed media, 355 x 355 cm.
© ASA

4 Adi Da Samraj, *The Pastimes
of Narcissus I*, from *Spectra One*, 2006.
Mixed media, 231 x 396 cm (extended,
with mirror). © ASA

5 Adi Da Samraj, *The Subject In
Question*, from *Geome Four*, 2006,
detail. Mixed media, 228 x 457 cm.
© ASA

5

Between East and West. Omar Galliani and the great Italian drawing in China

The work of Omar Galliani, already well known and appreciated in Italy, is now being endorsed abroad with a series of rich exhibitions that is quite new for an Italian artist.

Particularly admired in China thanks to a travelling exhibition lasting more than a year, his work has been exhibited in more than ten museums with growing success, resulting in it being the focus of packed courses, conferences and lessons.

This success allows him to be placed among the most interesting artists on the international scene, at the cutting edge of a new direction in Italian contemporary art, which has not abandoned the distinctive sign of a typically Italic tradition: that 'of excellence'.

This 'excellence' is at the centre of the text written by Flavio Caroli for the catalogue of the exhibition at the 52nd International Art Exhibition:

'Almost 30 years ago, Omar Galliani was a very talented young man, perhaps with too many ideas and too generous (we all had too many ideas and were too generous 30 years ago), but with an objective that was so precise it never ceases to amaze me: seduction. Or grace. Whatever the case, the idea that everything is always played out in the work, in a single work, because that is – must be – a distillation of the world, of the poetry of the world.

Now, I do not want to fall into the obvious. I know very well that anyone involved in art (any art) has sooner or later claimed that his generation is the last to confront the utmost systems of the universe. But in this case I have the impression that it is exactly the case. I do not say that our generation has been the last to maintain that the work, that apocalyptic linkage of magic called style, is an all-engaging event, but I say that in that moment (in the early '80s) two roads opened up, both fertile and respectable. On one hand, the description, a little astonished and slightly grieved, often moving, of the little that is our life. Many young people of the latest generation follow this, and I understand them. I think, indeed, that when humanity collapses into the guano (if things must go that way, and I do not think they will go exactly like that), man's last thought will be dedicated to the manner in which to express, to recount, the ineffable flavour of guano.

On the other hand, there is the concentration of language, the absorbing ambition for style, the attempt to place the world in a room, or on a page. There are young people who also stick doggedly to this second road.

These young people start from the ideas of Galliani. And of Wim Wenders in the cinema. And of Fabio Vacchi in music. And Anselm Kiefer in painting. From the ideas, but I would say, better, much better, from the stake of my generation. From the gamble of those who think that, with art, the world (perhaps in mouthfuls, perhaps in shreds, ripped from truth, physical truth) can be enclosed in a room, or on a page.

If there is anyone who thinks that art is born from life, it is Galliani. I know because I know him well. And this is why he doesn't cease to amaze me. Because he then immediately has the power to spark off the second, decisive reasoning. How do you bite into the truth (physical truth) with art, if ignoring that enormous wealth of truth that art has created in the history of mankind? How can you express an afternoon of spleen if you don't know that Dante Alighieri, Leopardi, Keats and Baudelaire have already tried? How can you express life if not measuring it with art? [...]'.

—Flavio Caroli

Extract from the exhibition catalogue *Tra Oriente e Occidente. Omar Galliani e il grande disegno italiano in Cina*, Milano, Electa, 2007.

Organisation
Fondazione Querini Stampalia
Centro Italiano per le Arti e la Cultura
Chinese Artists' Association

Curators
Flavio Caroli
Vincenzo Sanfo

Scientific committee
Liu Dawei
Helmuth Friedel
Fiorella Minervino
Gioia Mori
Pan Lusheng

Collaborators
Laura Giordano
Enrica Gorgone
Giorgia Sanfo
Andrea Sassano
Marco Soave

Web Sites
www.querinistampalia.it
www.centroita.com
www.artistsassociation.org.cn

Artists
Omar Galliani
Liu Dawei
Wang Wei
Xiao Ge
Suzhou Ren Huixian Embroidery Art

1 **Omar Galliani**, *Santi*, 2007. Pencil on board and inks, 200 x 200 cm. Private collection. © Luca Trascinelli

2 **Omar Galliani**, *Santi*, 2006. Pencil on board, 150 x 150 cm. Private collection. © Luca Trascinelli

3

3 Omar Galliani, *Santi*, 2006-2007.
Pencil on board and inks, 200 x 200 cm.
Private collection. Courtesy Damiani
Editore. © Omar Galliani

4 Wang Wei, *Rustic Charm of Lotus
Pond*, 2001. Xylography, 40.5 x 30 cm.
Private collection. © Wang Wei

5 Liu Dawei, *One poem of Tang dinasty*,
2007. Ink on rice paper, 68 x 68 cm.
© Liu Dawei

6 Suzhou Ren Huixian Embroidery Art,
Ricamatrice al lavoro, 2006.
PHOTO © CENTRO ITALIANO PER LE ARTI
E LA CULTURA

7 Xiao Ge, *Made in China*, 2006.
Performance at Galleria Vecchiato,
Padova, 2006. © Centro Italiano
per le Arti e la Cultura

Willie Doherty

Out of Position: The Video Installations of Willie Doherty

Man does not live by words alone; all 'subjects' are situated in a space in which they must either recognize themselves or lose themselves, a space which they may both enjoy and modify.
Henri Lefebvre

In his book *The Production of Space*, Henri Lefebvre contends that in western thought a mathematical-philosophical schema comes to dominate our notions of space, conceiving space as a void waiting to be filled, or as a mental space superior to the lived space of the body and its social practices. According to Lefebvre, however, space is a *practice*, and 'like all social practice, spatial practice is lived directly before it is conceptualised; but the speculative primacy of the conceived over the lived causes practice to disappear along with life, and so does very little justice to the "unconscious level" of experience'. Hence, 'when institutional (academic) knowledge sets itself up above lived experience, just as the state sets itself up above everyday life, catastrophe is in the offing'. The separated categories of space – physical (perceived) space, ideal (conceived) space, and social (lived) space – can be mediated only when it is understood that space does not exist prior to subjects but is *produced* by them, or, more crucially, by the authorities that manipulate the political, social and economic dispositions of space. This raises the problem of political agency. To acquire agency – that is, for the individual or collective to construct itself as a political and historical subject – it must grasp the power to act and control elements of its world; it has to connect with power – those aesthetic and social structures capable of producing cultural meaning and an effective political voice. Agency, however, seems to be precisely that which is disappearing over a horizon of political impotence and social alienation, along with art as a potential intervening voice. Nonetheless, through its interrogation of the interactions of subjects, their surroundings and their representations, Willie Doherty's artistic practice puts back into relation those hitherto separated categories of space described by Lefebvre, enabling us to reflect on the contribution the politics of space and vision makes to the processes of social disempowerment.

Willie Doherty's work privileges the *act* of seeing and listening over the mediated landscape of the visible. Hence Doherty's formal aesthetic strategies bring something *into presence* for the viewer. Their unfolding of the scarred, lived-in surfaces and textures of urban existence, and of the lived-in faces of his actors performing ordinary, everyday acts, enter into dialogue with the viewer; they possess a singularity and immediacy that situate the viewer's body in a world given 'depth, breadth and flesh'. Thus, if the artist's video installations speak of a current climate of socio-political impotence and alienation, they do so less through what they 'show' than through our psychic identification with the experiences they evoke. What we understand from Doherty's poetics is that the affectivity of art lies less in what it purportedly says than in what it *does*: it opens a passage to the understanding of what is at stake when we surrender our own experience of life as shared human existence to the divisive realities promoted by hegemonic power. It exercises the right to critique the representations of existing social narratives in order to pave the way for more productive reconfigurations of reality.
—Jean Fisher

From M. Munguía, *Willie Doherty: Out of Position*, Mexico City, Laboratorio Arte Alameda, 2006.

Organisation
British Council Northern Ireland
The Arts Council of Northern Ireland

Curator
Hugh Mulholland

Web Sites
www.britishcouncil.org/northernireland
www.artscouncil-ni.org

Artist
Willie Doherty

1-5 **Willie Doherty**, *Closure*, 2005. Stills
from the video. Installation: one 16:9
video projector, one DVD player,
one stereo amplifer, two speakers,
one DVD (colour, sound) projected
to a size of 130 x 230 cm onto wall
of self-enclosed space, 11'20''.
Courtesy the Artist

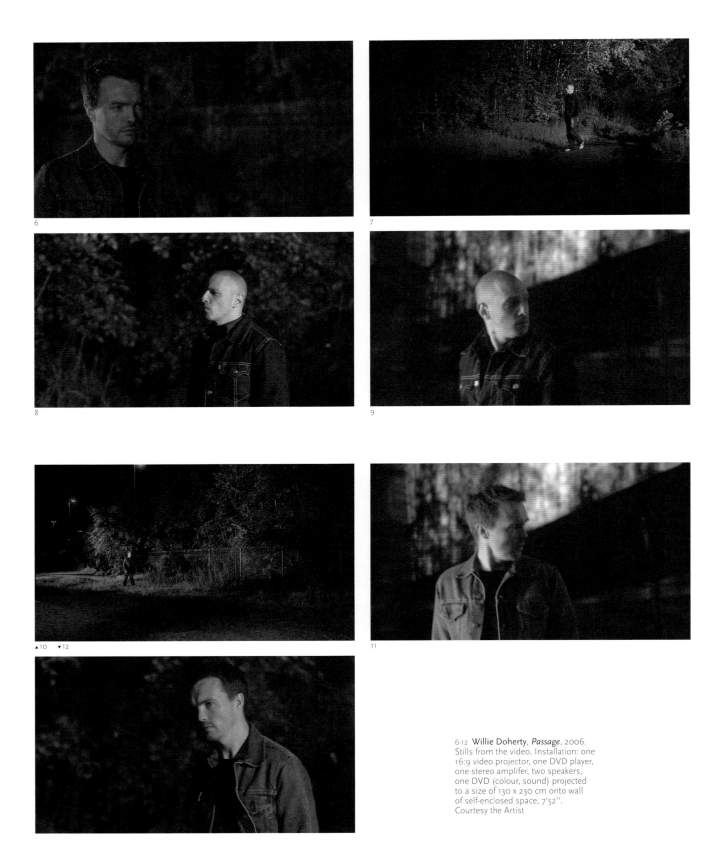

6-12 **Willie Doherty**, *Passage*, 2006.
Stills from the video. Installation: one
16:9 video projector, one DVD player,
one stereo amplifer, two speakers,
one DVD (colour, sound) projected
to a size of 130 x 230 cm onto wall
of self-enclosed space, 7'52''.
Courtesy the Artist

13-19 **Willie Doherty**, *Ghost Story*, 2007.
Stills from the video. Installation: one
16:9 video projector, one DVD player,
one stereo amplifer, two speakers, one
DVD (colour, sound) projected to a size
of 130 x 230 cm onto wall of self-
enclosed space, 12'. Courtesy the Artist

Indexes

computer, custom software, dimensions variable. © the Artist. Collection Museum of Modern Art, New York. Courtesy Bitforms Gallery, New York

Rafael Lozano-Hemmer, *Frequency and Volume*, 2003. Computerized surveillance system, 32 channel audio system, 4 projectors, 150 kHz radio scanners, anternae, dimensions variable. © the Artist. Collection of the artist. Courtesy Galerie Guy Bärtschi, Genève

Armando Lulaj 14

Born in Tirana, Albania in 1980.
Lives and works in Bologna, Italy.
Armando Lulaj, *Time Out of Joint*, 2006. Video DVD. © Armando Lulaj

Marko Mäetamm 44

Born in Viljandi, Estonia in 1965.
Lives and works in Tallin, Estonia.
www.maetamm.net
Marko Mäetamm, *Bear*, 2006. Object: playwood, rubber, plastic, molestkin, 120 x 200 cm. Courtesy the Artist
Marko Mäetamm, *No title*, 2006. Video on DVD, b/w, sound, 11'49''. Courtesy the Artist
Marko Mäetamm, *Sand-box*, 2006. Object: playwood, wood, sand, toys, 230 x 150 x 150 cm. Courtesy the Artist

Zulkifle Mahmod 136

Born in Singapore in 1975.
Zulkifle Mahmod, *Sonic Dome: An Empire of Thoughts*, 2007. Installation. Work comes in 2 sections parts. Dome: Ø 400 x 200 cm. Base: Ø 400 x 10 cm. Collection & Courtesy the Artist

Renato Mambor 100

Born in Rome, Italy, in 1936.
Lives and works in Rome, Italy.
Renato Mambor, *Progetto per Karma mutabile*, 2006. Mixed technique on paper, 43 x 49 cm. Private collection
Renato Mambor, *Karma mutabile*, 2006. 9 double-panels covered with canvas, enamel and oil, 200 x 70 x 4 cm each. Private collection
Renato Mambor, *Passeggeri - Malinconia passeggera*, 2006. Canvas on double-panel, mixed technique, 120 x 170 x 4 cm. Private collection
Renato Mambor, *Renato mani d'oro*, 2006. Sculpture on enamelled wood, 164 x 60.5 x 7.5 cm. Private collection

Victor Man 126

Born in Cluj, Romania, in 1974.
Lives and works in Cluj, Romania.
Victor Man, *Untitled*, 2007. Ceramics, dimensions variable
Victor Man, *Monument to Victor Man*, 2007. Assemblage (paintings + objects), dimensions variable

Blagoja Manevski 46

Born in Skopje, Republic of Macedonia, in 1957.

Lives and works in Skopje, Republic of Macedonia.
Blagoja Manevski, *Logical Paintings*, 2002-2007. Istallation, dimensions variable. Courtesy the Artist

Roman Maskalev 168

Born in Bishkek, Kyrgyzstan, in 1977.
Lives and works in Bishkek, Kyrgyzstan.
www.caprojects.org
Roman Maskalev, *Leto*. Video, 5'. Courtesy the Artist

Xenia Mejía 174

Born in Tegucigalpa, Honduras, in 1958.
Lives and works in Honduras.
Xenia Mejía, *Perfil de ciudad*, May 2006. Mixed media, Indian ink, graffito, acrylic, collage/paper, 24 paintings 182 x 304 cm each. Collection of the artist. Courtesy the Artist

Jill Mercedes 60

Born in Saarbrücken, Germany, in 1964.
Lives and works in Luxembourg.
www.casino-luxembourg.lu
Jill Mercedes, *Endless Lust*, 2007. Installation in situ, mixed media. 52nd International Art Exhibition. © Courtesy the Artist

Arseny Mescheryakov 130

Born in Moscow, Russia, in 1970.
Lives and works in Moscow, Russia.
Alexander Ponomarev and Arseny Mescheryakov, *Shower*, 2007. Installation. Multimedia complex of actual arts, 280 x 170 x 170 cm. © the Artist

Aernout Mik 90

Born in Groningen, The Netherlands, in 1962.
Lives and works in Amsterdam, The Netherlands.
Aernout Mik, *Training Ground*, 2006. 2 screen video installation, digital video on hard drive, rear projection screen embedded into temporary architecture, dimensions variable. Courtesy carlier | gebauer, Berlin and The Project, New York
Aernout Mik, *Untitled*, 2007. Video installation 2 screen, dimensions variable. Courtesy carlier | gebauer
Aernout Mik, *Untitled*, 2007. Video installation 4 screen, dimensions variable. Courtesy carlier | gebauer

Boris Mikhailov 156

Born in Kharkov, in 1938.
Lives and works in Berlin, Germany.
Boris Mikhailov, *By the Ground*, 1991. Black and white photograph, sepia toned, 15 x 30 cm. Collection of the artist. Courtesy Pinchnk Art Centre, Kyiv

Paul D. Miller Aka DJ Spooky 2

Born in Washington, USA, in 1970.
Lives and works in New York, USA.
www.djspooky.com
Paul D. Miller Aka DJ Spooky, *New York is now*, 2006. Video artwork, 60'

Julia Milner 130

Born in Novosibirsk, Russia in 1981.
Lives and works in Moscow, Russia.
Julia Milner, *CLICKIHOPE*, 2007. Net-art, toching-screen, multimedia complex of actual arts. © the Artist

Santu Mofokeng 2

Born in Johannesburg, South Africa, in 1956.
Lives and works in Johannesburg, South Africa.
Santu Mofokeng, photographs from the series "Urban landscapes", *Winter in Tembisa*, 1985. Fibre-based print, 67 x 100 cm. Courtesy the Artist
Santu Mofokeng, photographs from the series "Urban landscapes", *Democracy is forever, Pimville*, 2004. Fibre-based print, 67 x 100 cm. Courtesy the Artist
Santu Mofokeng, photographs from the series "Urban landscapes", *Safe sex, Slovakia*, 2004. Fibre-based print, 38 x 58 cm. Courtesy the Artist
Santu Mofokeng, photographs from the series "Urban landscapes", *Jaham Car Wash, Orange Farm Township*, 2003. Fibre-based print, 30 x 45 cm. Courtesy the Artist
Santu Mofokeng, photographs from the series "Urban landscapes", *Street Scene, Rockville*, 2004. Fibre-based print, 30 x 45 cm. Courtesy the Artist

Ronald Morán 174

Born in El Salvador in 1972.
Lives and works in El Salvador.
Ronald Morán, *Habitación Infantil*, 2005. Installation. Mixed media, dimensions variable

Callum Morton 20

Born in Montreal, Canada, in 1965.
Lives and works in Melbourne, Australia.
Callum Morton, *Valhalla*, 2007. Steel, polystyrene, epoxy resin, silicon, marble, wood, acrylic paint, lights, sound, 4.65 x 14.5 x 9 m. Courtesy the Artist, Roslyn Oxley9 Gallery, Sydney and Anna Schwartz Gallery, Melbourne

Nástio Mosquito 2

Born in Luanda, Angola, in 1981.
Lives and works in Luanda, Angola.
Nástio Mosquito, *Mulher fósforo*, 2006. C-prints on aluminium, 100 x 150 cm. Courtesy Sindika Dokolo african collection of contemporary art

Ivan Moudov 32

Born in Sofia, Bulgaria, in 1975.
Lives and works in Sofia, Bulgaria.
www.ivanmoudov.net
www.nationalartgallery-bg.org
Ivan Moudov, *Wine for Openings*, 2006-2007. Action, Cabernet Sauvignon, dry red wine, glass, specially produced label, 33 x 7 x 7 cm. © Courtesy the Artist
Ivan Moudov, *Fragments*, 2007. Installation, mixed media, dimensions variable © Courtesy the Artist

Ndilo Mutima 2

Born in Luanda, Angola, in 1978.
Lives and works in Luanda, Angola.
Ndilo Mutima, *Manroja*, 2006. 20 C-prints on aluminium, 75 x 100 cm. Courtesy Sindika Dokolo african collection of contemporary art

Ingrid Mwangi 2

Born in Nairobi, Kenya, in 1975.
Lives and works in Ludwigshafen, Germany.
www.mwangi-hutter.de
Ingrid Mwangi, *Masked*, 2000. Video artwork, 2'28''. Courtesy Sindika Dokolo african collection of contemporary art

Nasser Naassan Agha 100

Born in Idleb, Syria, in 1961.
Lives and works in Aleppo, Syria.
Nasser Naassan Agha, *Senza titolo*, 2006. Oil on canvas, 140 x 140 x 2 cm. © Nasser Naassan Agha
Nasser Naassan Agha, *Senza titolo*, 2006. Oil on canvas, 140 x 140 x 2 cm. © Nasser Naassan Agha
Nasser Naassan Agha, *Senza titolo*, 2006. Oil on canvas, 140 x 140 x 2 cm. © Nasser Naassan Agha
Nasser Naassan Agha, *Senza titolo*, 2006. Oil on canvas, 140 x 140 x 2 cm. © Nasser Naassan Agha

Sirous Namazi 92

Born in Kerman, Iran, in 1970.
Lives and works in Stockholm, Sweden.
www.sirousnamazi.com

Hadil Nazmy 42

Born in Alexandria, Egypt, in 1977.
Lives and works in Alexandria, Egypt.

Yves Netzhammer 146

Born in Schaffhansen, Switzerland in 1970.
Lives and works in Zürich, Switzerland.
www.bak.admin.ch/biennale07
Yves Netzhammer, *Untitled*, 2007. Video installation. © the Artist. Courtesy Galerie Anita Beckers, Frankfurt

Alexander Nikolaev 168

Born in Tashkent, Uzbekistan, in 1968.
Lives and works Tashkent, Uzbekistan.
www.caprojects.org
Alexander Nikolaev, *Rapshi*, Video, 4'. Courtesy the Artist

Stefan Nikolaev 32

Born in Sofia, Bulgaria, in 1970.
Lives and works in Sofia, Bulgaria, and Paris, France.
www.michelrein.com
www.nationalartgallery-bg.org
Stefan Nikolaev, *What goes up must go down*, 2007. Aluminium paint, liquid, gas, 350 x 180 x 180 cm. Courtesy Galerie Michel Rein, Paris

Manuela Ribadeneira 174

Born in Ecuador.
Lives and works in London, UK.
Manuela Ribadeneira, *... hago mío este territorio*, 2007. Installation, mixed media, dimensions variable

Ugo Rondinone 148

Born in Brunnen, Switzerland, in 1964.
Lives and works in New York, USA.
www.bak.admin.ch/biennale07
Ugo Rondinone, *Untitled*, 2007. Installation

Tracey Rose 2

Born in Durban, South Africa, in 1974.
Lives and works in Johannesburg, South Africa.
Tracey Rose, *The Wailers*, 2004. Video artwork, 6'21''. Courtesy Sindika Dokolo african collection of contemporary art
Tracey Rose, *Ongetitled*, 2004. Mixed media on banner, 200 x 170 cm. Courtesy Sindika Dokolo african collection of contemporary art

Aleksei Rumyantsev 168

Born in Dushanbe, Tajikistan, in 1975.
Lives and works in Dushanbe, Tajikistan.
www.caprojects.org
Aleksei Rumyantsev, *Krugi Vremeni*, Video, 4'. Courtesy the Artist

Ruth Sacks 2

Born in Port Elisabeth, South Africa, in 1977.
Lives and works in Cape Town, South Africa.
Ruth Sacks, *Don't panic*, 2005. Video artwork, 4'54''. Courtesy Sindika Dokolo african collection of contemporary art

Walid Sadek 82

Born in Beirut, Lebanon, in 1966.
Lives and works in Beirut, Lebanon.
Walid Sadek, *Mourning in the Presente of the Corse*, 2007. Printed text and wooden construction. © Walid Sadek. Private collection. Courtesy the Artist

Ernesto Salmerón 174

Born in Managua, Nicaragua, in 1977.
Lives and works in Nicaragua.
www.ernestosalmeron.com
Ernesto Salmerón, *Auras of War: Public Interventions in the Nicaraguan Revolutionary. Public Space*, 1996-2007. Photos and video, 300 x 500 x 800 cm. Collection Salmerón Family

Paata Sanaia 50

Born in Mikha Tskhakaia (Senaki), Georgia, in 1973.
Lives and works in Tbilisi, Georgia.
Tamara Kvesitadze with Paata Sanaia and Zura Gugulashvili, *Dragon Fly*, 2002. Fiber glass, metal, mechanism, 130 x 25 x 25 cm. Private collection
Tamara Kvesitadze with Paata Sanaia and Zura Gugulashvili, *Woman. 12 Pieces*, 2003. Fiber glass, metal, mechanism, 120 x 25 x 30 cm. Private collection

Tamara Kvesitadze with Paata Sanaia and Zura Gugulashvili, *Egg*, 2003. Fiber glass, metal, silver, mechanism, acrilic, 130 x 55 x 55 cm. Private collection
Tamara Kvesitadze with Paata Sanaia and Zura Gugulashvili, *Hanging Sphere*, 2005. Metal, resin, fiber glass, mechanism, 200 x 60 x 60 cm. Private collection
Tamara Kvesitadze with Paata Sanaia and Zura Gugulashvili, *Sitting Man*, 2005. Fiber glass, mechanism, 95 x 80 x 70 cm. © the Artist
Tamara Kvesitadze with Paata Sanaia and Zura Gugulashvili, *Woman. 2 Pieces*, 2006. Fiber glass, metal, mechanism, 165 x 30 x 30 cm. © the Artist
Tamara Kvesitadze with Paata Sanaia and Zura Gugulashvili, *One Man*, 2006. Fiber glass, 65 x 110 x 35 cm. © the Artist
Tamara Kvesitadze with Paata Sanaia and Zura Gugulashvili, *Circle*, 2006. Fiber glass, mechanism, metal, 155 x 155 x 50 cm. © the Artist
Tamara Kvesitadze with Paata Sanaia and Zura Gugulashvili, *Man-Woman*, 2006. Fiber glass, metal, mechanism, 165 x 100 x 35 cm. © the Artist

Yehudit Sasportas 68

Born in Ashdod, Israel, in 1960.
Lives and works in Berlin, Germany, and Tel Aviv, Israel.
www.sommergallery.com
www.eigen-art.com
Yehudit Sasportas, *The Guardians of the Threshold*, 2007. Space installation, mixed media, dimensions variable. The Israeli Pavilion, 52nd International Art Exhibition. Courtesy Sommer Contemporary Art, Tel Aviv & Galerie EIGEN + ART Leipzig/Berlin

Shen Yuan 122

Born in Xianyou, People's Republic of China, in 1959.
Lives and works in Paris, France.
Shen Yuan, *Le Première Voyage*, 2007. Installation, 450 x 200 x 200 cm. Collection of the artist

Yinka Shonibare 2

Born in London, UK, in 1962.
Lives and works in London, UK.
www.yinka-shonibare.co.uk
Yinka Shonibare, *How to blow up two heads at once*, 2006. Installation, 122 x 175 x 245 cm. Courtesy Sindika Dokolo african collection of contemporary art

Mounira Al Solh 82

Born in Beirut, Lebanon, in 1978.
Lives and works in Amsterdam, The Netherlands.
Mounira Al Solh, *As if I don't fit there*, 2006. Video installation on screen. © Mounira Al Solh. Courtesy the Artist

Monika Sosnowska 96

Born in Ryki, Poland, in 1972.
Lives and works in Warsaw, Poland.
www.zacheta.art.pl

Monika Sosnowska, *1:1*, 2007. Installation, steel, 600 x 1,700 x 700 cm. Courtesy Foksal Gallery Foundation, Warsaw

Cinthya Soto 174

Born in Costa Rica in 1969.
Lives and works between Zürich, Switzerland, and San José de Costa Rica.
Cinthya Soto, *Taller de Escultura Hidalgo*, 2006. 15 coloured photographs, 81 x 81 cm each, 243 x 405 cm. Courtesy the Artist
Cinthya Soto, *Matadero Ferji*, 2006. 16 coloured photographs, 81 x 81 cm each, 324 x 324 cm. Courtesy the Artist

Christine Streuli 146

Born in Bern, Switzerland, in 1975.
Lives and works in Zürich, Switzerland.
www.bak.admin.ch/biennale07
Christine Streuli, *Aussichten*, 2007. Mixed media, 500 x 6,000 x 500 cm. © the Artist. Courtesy Galerie Mark Müller, Zürich, Galerie Sfeir-Semler, Hamburg, Galerie Monica De Cardenas, Milan

Sophia Tabatadze 50

Born in Tbilisi, Georgia, in 1977.
Lives and works in Tbilisi, Georgia.
sophiatabatadze.blogspot.com
khinkalijuice.blogspot.com
Sophia Tabatadze, *Humanconone*, 2007. Fabric, silkprint, black-white print, embroidery, ink, dimensions variable. Courtesy the Artist
Sophia Tabatadze, *Humancontwo*, 2007. Fabric, silkprint, black-white print, embroidery, ink, dimensions variable. Courtesy the Artist
Sophia Tabatadze, *Humanconthree*, 2007. Fabric, silkprint, black-white print, embroidery, ink, dimensions variable. Courtesy the Artist

Tang Da Wu 136

Born in Singapore in 1943.
Lives and works in Singapore.
Tang Da Wu, *Untitled*, 2007. Installation with metal bed, table, headphone, drawings, objects. Installation: (A) steel bed, 86 x 150 x 183 cm; (B) steel table, 18 x 150 cm; (C) benches, 43 x 150 cm. Collection & Courtesy the Artist

Sam Taylor-Wood 156

Born in London, UK, in 1967.
Lives and works in London, UK.
Sam Taylor-Wood, *Untitled*, 2007. Video installation

Jürgen Teller 156

Born in Erlangen, Germany, in 1964.
Lives and works in London, UK.
Jürgen Teller, *Gisele Bündchen*, London, 2005. Color print, dimensions variable. Collection and Courtesy the Artist

Mark Titchner 156

Born in Luton, UK, in 1973.
Lives and works in London, UK.

Mark Titchner, *To Breathe is not enough*, 2007. Inkjet print, dimensions variable. Collection and Courtesy the Artist

Alexander Ugay 168

Born in Kyzylorda, Kazakhstan, in 1978.
Lives and works in Almaty, Kazakhstan.
www.caprojects.org
Alexander Ugay, *Enjoy the silence*, Video, 3'20". Courtesy the Artist.

Nomeda & Gediminas Urbonas 86

Gediminas Urbonas
Born in Vilnius, Lithuania, in 1966.
Lives and works in Vilnius, Lithuania.
www.nugu.lt

Nomeda Urboniene
Born in Kaunas, Lithuania in 1968.
Lives and works in Vilnius, Lithuania.
http://www.nugu.lt

Nomeda & Gediminas Urbonas, *Portrait of an Ambassador in Exile: Kazys Lozoraitis*, 2007. DVD single-channel projection. © the Artists
Nomeda & Gediminas Urbonas, *The Story of Villa Lituania*, 2007. DVD single-channel projection. © the Artists
Nomeda & Gediminas Urbonas, *Villa Lituania: Models for a Lithuanian Pavilion*, 2007. Mixed media installation, cardboard, modelling balsa, perspex. © the Artists
Nomeda & Gediminas Urbonas, *Villa Lituania: Trophy Room*, 2007. Mixed media installation, glass, paper, display furniture, adhesive vinyl. © the Artists
Nomeda & Gediminas Urbonas, *The Villa Lituania Cup: International Pigeon Race Performances*, 09-06-2007
Nomeda & Gediminas Urbonas, *The Villa Lituania Cup: International Pigeon Race Performances*, 09-09-2007

Vyacheslav Yuza Useinov 168

Born in Fergana, Uzbekistan, in 1962.
Lives and works in Tashkent, Uzbekistan.
www.caprojects.org
Vyacheslav Useinov, *Nepribytie Poezda*, 2007. Video, 4'. Courtesy the Artist

Minette Vari 2

Born in Pretoria, South Africa, in 1968.
Lives and works in Johannesbrug, South Africa.
Minette Vari, *Alien*, 1998. Video artwork, 2'21''. Courtesy Sindika Dokolo african collection of contemporary art

Mona Vatamanu & Florin Tudor 126

Florin Tudor
Born in Geneva, Romania, in 1974.
Lives and works in Bucharest, Romania.

Mona Vatamanu
Born in Constanta, Romania, in 1968.
Lives and works in Bucharest, Romania.
www.monavatamanuflorintudor.ro

Artists index
Collateral events

Kiba Lumberg 288

Born in Lappeenranta, Finland, in 1956.
Lives and works in Helsinki, Finland.

Mya Lurgo 204

Born in Bordighera, Italy, in 1971.
Lives and works in Lugano, Switzerland.

Ruggero Maggi 204

Born in Turin, Italy, in 1950.
Lives and works in Milan, Italy.

Carlo Maglitto 204

Born in Lentini, Italy, in 1940.
Lives and works in Cipressa, Italy.

Lech Majewski 248

Born in Katowice, Poland, in 1953.
Lives and works in Katowice, Poland, and
New York, USA.

Vladimir Mamyshev-Monroe 308

Melanie Manchot 272

Born in Witten, Germany, in 1966.
Lives and works in London, UK, and Berlin,
Germany.

Antonello Mantovani 204

Born in Occhiobello, Italy, in 1961.
Lives and works in Galzignano Terme, Italy.

Map Office 304

Laurent Gutierrez
Born in Casablanca, Morocco, in 1966.
Lives and works in Hong Kong, People's
Republic of China.

Valérie Portefaix
Born in Saint-Etienne, France, in 1969.
Lives and works in Hong Kong, People's
Republic of China.

Renato Marini 204

Born in Larino, Italy, in 1955.
Lives and works in Campomarino, Italy.

Courtney Martin 284

Lives and works in New York, USA.

Maria Grazia Martina 204

Born in San Cesario, Italy, in 1957.
Lives and works in Breganze, Italy.

Fabrizio Martinelli 204

Born in Lecco, Italy, in 1958.
Lives and works in Lecco, Italy.

Rita Mele 204

Born in Asmara, Eritrea, in 1962.
Lives and works in Frosinone, Italy.

Antonio Menenti 204

Born in Anagni, Italy, in 1948.
Lives and works in Anagni, Italy.

Renato Mertens 204

Born in Tarcento, Italy, in 1927.
Lives and works in Firenze, Italy.

Mogas Station (Gulschan Gothel,
Cam Hoang Duong, Jun Nguyen
Hatsushiba, Sandrine Llouquet,
Bertrand Peret, Rich Streitmatter-Tran,
Tam Vo Phi, Vu Lien Phuong) 260

Founded in Ho Chi Minh City, Vietnam, in
2005.
Located in Ho Chi Minh City, Vietnam.

Simona Morani 204

Born in Pavia, Italy, in 1966.
Lives and works in Pavia, Italy.

Heather & Ivan Morison 192

Heather Morison
Born in Desborough, UK, in 1973.
Lives and works in Arthog, UK.

Ivan Morison
Born in Nottingham, UK, in 1974.
Lives and works in Arthog, UK.

Rosalind Nashashibi 300

Born in Croydon, UK, in 1973.
Lives and works in London, UK.

Giorgio Nelva 204

Born in Lanzo Torinese, Italy, in 1940.
Lives and works in Turin, Italy.

Simon Njami 284

Born in Cameroun.
Lives and works in Paris, France.

Timur Novikov 308

Paolo Nutarelli 204

Born in Savona, Italy, in 1946.
Lives and works in Genoa, Italy.

Omara 288

Born in Monor, Hungary, in 1945.
Lives and works in Szarvasgede, Hungary.

Otolith Group (Anjalika Sagar,
Kodwo Eshun, Richard Cousins) 284

Located in London, UK.

Anjalika Sagar
Born in London, UK, in 1968.

Kodwo Eshun
Born in London, UK, in 1967.

Richard Couzins
Born in London, UK, in 1967.

Clara Paci 204

Born in Petacciato, Italy, in 1945.
Lives and works in Fermo, Italy.

Giorgio Pahor 204

Born in Rome, Italy, in 1963.
Lives and works in Rome, Italy.

Salvatore Pepe 204

Born in Praia a Mare, Italy, in 1962.
Lives and works in Praia a Mare, Italy.

Giovanna Pesenti 204

Born in Milan, Italy, in 1951.
Lives and works in Arese, Italy.

Marian Petre 288

Born in Draganesti-Olt, Romania, in 1963.
Lives and works in Bucharest, Romania.

Renata Petti 204

Born in Naples, Italy, in 1943.
Lives and works in Naples, Italy.

Mike Phillips 284

Lives and works in London, UK.

Sarah Pini 204

Born in Ponte dell'Olio, Italy, in 1984.
Lives and works in Bologna, Italy.

Vettor Pisani 256

Born in Naples, Italy, in 1934.
Lives and works in Rome, Italy.

Plumcake 204

Founded in Milan, Italy, in 1983.
Located in Cura Carpignano, Italy.

Teresa Pollidori 204

Born in Caserta, Italy, in 1946.
Lives and works in Rome, Italy.

Stas Polnarev 296

Born in Tashkent, USSR, in 1984.
Lives and works in Moscow, Russia.

Josefina Posch 260

Born in Askim, Svezia, in 1971.
Lives and works in USA and Europe.

Tiziana Priori 204

Born in Cremona, Italy, in 1955.
Lives and works in Milan, Italy.

Nihad Nino Pušija 288

Born in Sarajevo, Bosnia, in 1965.
Lives and works in Berlin, Germany.

Rizman Putra 260

Born in Singapore in 1978.
Lives and works in Singapore.

Jenő André Raatzsch 288

Born in Ilmenau, Germany, in 1978.
Lives and works in Nuremberg, Germany.

Loredana Raciti 244

Born in Khartoum, Sudan, in 1959.
Lives and works in Rome, Italy.

Rachael Rakena 196

Born in Wellington, New Zeland, in 1969.
Lives and works in Palmerston North, New
Zealand.

Gaston Ramirez Feltrin 264

Born in Tepic, Mexico, in 1973.
Lives and works in Venice, Italy.

Jacques Rancière 284

Lives and works in Paris, France.

Niru Ratman 284

Born in London, UK.
Lives and works in London, UK.

Rosella Restante 204

Born in Guarcino, Italy, in 1949.
Lives and works in Rome, Italy.

Chiara Ricardi 204

Born in Milan, Italy, in 1969.
Lives and works in Varese, Italy.

Giuseppina Riggi 204

Born in San Cataldo, Italy, in 1959.
Lives and works in San Cataldo, Italy.

Dusan Ristic 288

Born in Valjevo, Serbia, in 1970.
Lives and works in San Francisco, USA.

Piero Ronzat 280

Born in Spilimbergo, Italy, in 1934.
Lives and works in Spilimbergo, Italy.

Fiorenzo Rosso 204

Born in Vercelli, Italy, in 1955.
Lives and works in Olcenengo, Italy.

Miljohn Ruperto 260

Born in Manila, Philippines, in 1971.
Lives and works in Los Angeles, USA.

Adi Da Samraj 312

Born in New York, USA, in 1939.
Lives and works in the Fiji Islands.
www.daplastique.com

Gabriella Santuari 280

Born in Trento, Italy, in 1950.
Lives and works in Padua, Italy.

Alba Savoi 204

Born in Rome, Italy, in 1929.
Lives and works in Rome, Italy.

Gianni Sedda 204

Born in Nuoro, Italy, in 1951.
Lives and works in Genua, Italy.

Eugenia Serafini 204

Born in Tolfa, Italy, in 1946.
Lives and works in Rome, Italy.

Cesare Serafino 280

Born in Spilimbergo, Italy, in 1950
Lives and works in Spilimbergo, Italy.

Elena Sevi 204

Born in Tecchiena di Alatri, Italy, in 1953.
Lives and works in Frosinone, Italy.

Jin Shan 260

Born in Jiangsu, People's Republic of China,
in 1977.
Lives and works in Shanghai, People's
Republic of China.

Mariam Sharp 284

Born in London, UK.
Lives and works in Exeter, UK.

Zineb Sedira 284

Lives and works in London, UK.

Silver & Hanne Rivrud 264

Petr Svarovsky (Silver)
Born in Mlada Boleslav, Czech Republic, in
1962.
Lives and works in Oslo, Norway.

Hanne Rivrud
Born in Oslo, Norway, in 1982.
Lives and works in Oslo, Norway.

Lucy Skaer 300

Born in Cambridge, UK, in 1975.
Lives and works in Glasgow, UK.

Deborah Smith 284

Lives and works in London, UK.

Oliana Spazzoli 204

Born in Forlì, Italy, in 1943.
Lives and works in Forlì, Italy.

Franco Spena 204

Born in Caltanissetta, Italy, in 1944.
Lives and works in Caltanissetta, Italy.

Silvano Spessot 280

Born in Cormons, Italy, in 1957.
Lives and works in Udine, Italy.

Stanza 272

Born in UK, in 1962.
Lives and works in London, UK.
www.stanza.co.

Maria Gabriella Stralla 204

Born in Carrù, Italy, in 1967.
Lives and works in Carrù, Italy, and in France.

Edoardo Stramacchia 204

Born in Anfo, Italy, in 1949.
Lives and works in Brescia, Italy.

Yazuo Sumi 280

Born in Osaka, Japan, in 1925.
Lives and works in Hyogo, Japan.

Suzhou Ren Huixian Embroidery Art 316

School founded in 2000.

Tony Swain 300

Born in Lisburn, UK, in 1967.
Lives and works in Glasgow, UK.

István Szentandrássy 288

Born in Vásrosnamény, Hungary, in 1952.
Lives and works in Budapest, Hungary.

Tang Huang-chen 200

Born in Taipei, Taiwan, in 1958.
Lives and works in Taipei, Taiwan.

Gilane Tawadros 284

Lives and works in London, UK.

Tensta Konsthall 280

Founded in 2004.
Located in Stockholm, Sweden.

To Hiram 304

Born in Hong Kong, People's Republic of
China, in 1964.
Lives and works in Hong Kong, People's
Republic of China.

TODO (Alessandro Capozzo, Andrea
Clemente, Fabio Cionini, Fabio
Franchino, Giorgio Olivero) 260

Group founded in Turin, Italy, in 2005.
Located in Turin, Italy.

Micaela Tornaghi 204

Born in Milan, Italy, in 1961.
Lives and works in Monza, Italy.

Judit Török 204

Born in Budapest, Hungary, in 1947.
Lives and works in Cipressa, Italy.

Jalal Toufic 284

Born in Lebanon.
Lives and works in Paris, France.

Danila Tripaldi 204

Born in Molfetta, Italy, in 1965.
Lives and works in Milan, Italy.

Tsai Ming-liang 200

Born in Kuching, Malesia, in 1957.
Lives and works in Taipei, Taiwan.

Lee Ufan 252

Born in Kyunhsang Namdo, South Korea,
in 1936.
Lives and works in Kamakura, Japan, and
Paris, France.

Nico Vascellari 188

Born in Vittorio Veneto, Italy, in 1976.
Lives and works between Vittorio Veneto, Italy,
and New York, USA.

Emilio Vedova 220

Born in Venice, Italy, in 1919.
Died in 2006.

Cristina Vighi 204

Born in Imola, Italy, in 1963.
Lives and works in Bologna, Italy.

Bill Viola 276

Born in New York, USA, in 1951.
Lives and works in Long Beach, USA.
www.billviola.com

VIVA 200

Born in Yilan, Taiwan, in 1975.
Lives and works in Taipei, Taiwan.

Wang Wei 316

Born in Chongqing, People's Republic of
China, in 1942.
Lives and works in Beijing, People's Republic
of China.

Yan Huang 280

Born in Jilin, People's Republic of China, in
1966.
Lives and works in Changchun, People's
Republic of China.

Yang Zhichao 280

Born in Gansu, People's Republic of China,
in 1963.
Lives and works in Beijing, People's Republic
of China.

Yap Sau Bin 260

Born in Kuala Lumpur, Malaysia, in 1974.
Lives and works in Kuala Lumpur, Malaysia.

Ye Fang 280

Born in Suzhou, People's Republic of China,
in 1962.
Lives and works in Suzhou, People's Republic
of China.

Denis Yegelsky 308

Yuan Chen Mei 280

Born in Taipei, Taiwan, in 1964.

Evgeny Yufit 280

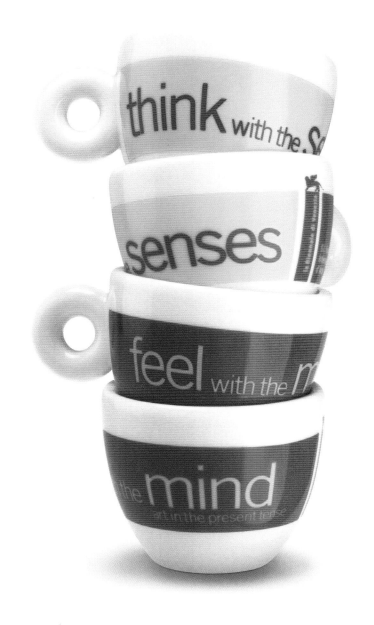

FLAVOUR AND BEAUTY, A NATURAL COMBINATION.
AN ELEGANT BLEND OF WISDOM AND WHIMSY.
A POWERFUL EXPRESSION OF EMOTION TO FEEL WITH HIGH INTENSITY.
ART LIKE COFFEE.

A sensory experience to savour in this 52nd International Art Exhibition
Think with the Senses - Feel with the Mind. Art in the Present Tense

HE IS NOT EXULTING FOR HOW THE CONTEST ENDED,
BUT BECAUSE HE KNOWS IT'S JUST THE BEGINNING.

Today your growth ambitions have more opportunities.
This is because you can count on an italian bank with international culture
that fulfils them together with you.

Antonveneta has joined the ABN Amro group, one of the biggest banking groups in the world, with 3000 offices in five continents and over 105.000 partners in 58 countries.

And now it offers you all the advantage of a local experience bank but with an international knowledge: global vision, best products, more closeness and experience, whole

advantage for clients. Starting today, with Antonveneta, you can look at the future with more safety, because your growth ambitions will have even more opportunities.

Making more possible **Antonveneta**
ABN AMRO

Acoustic solutions.

Topakustik is an innovative system of sound-absorbent elements designed for the highest degree of aesthetics and quality of sound in every area. Topakustik elements can also be bent, for use in stage sets, auditoriums and large public halls.

Your world
Our answers

www.aci.it

ACI<Club

ACI<Motocity

ACI<Sistema

ACI<Gold

Life made easier

ACI
Automobile Club d'Italia

Printed by
Offset Print Veneta - Verona
for Marsilio Editori® s.p.a. in Venice

edition _____ _____ year

10 9 8 7 6 5 4 3 2 1 2007 2008 2009 2010 2011